Second World
Postmodernisms

Second World Postmodernisms

Architecture and Society under Late Socialism

Edited by Vladimir Kulić

BLOOMSBURY ACADEMIC
LONDON • NEW YORK • OXFORD • NEW DELHI • SYDNEY

BLOOMSBURY ACADEMIC
Bloomsbury Publishing Plc
50 Bedford Square, London, WC1B 3DP, UK
1385 Broadway, New York, NY 10018, USA

BLOOMSBURY, BLOOMSBURY ACADEMIC and the Diana logo
are trademarks of Bloomsbury Publishing Plc

First published in Great Britain 2019
Paperback edition first published 2021

© Editorial content, introduction: Vladimir Kulic', 2019
© Individual chapters © the contributors

Vladimir Kuli c' has asserted his right under the Copyright,
Designs and Patents Act, 1988, to be identified as Editor of this work.

Cover design: Eleanor Rose
Cover image © Emil Přikryl

All rights reserved. No part of this publication may be reproduced or
transmitted in any form or by any means, electronic or mechanical,
including photocopying, recording, or any information storage or retrieval
system, without prior permission in writing from the publishers.

Bloomsbury Publishing Plc does not have any control over, or responsibility for,
any third-party websites referred to or in this book. All internet addresses given
in this book were correct at the time of going to press. The author and publisher
regret any inconvenience caused if addresses have changed or sites have
ceased to exist, but can accept no responsibility for any such changes.

A catalogue record for this book is available from the British Library.

Library of Congress Cataloging-in-Publication Data
Names: Kulić, Vladimir, editor.
Title: Second world postmodernisms: architecture and society under late
socialism / [edited by] Vladimir Kulić.
Description: New York: Bloomsbury Visual Arts, 2018. |
Includes bibliographical references and index.
Identifiers: LCCN 2018030763 | ISBN 9781350014442 (hardback: alk.paper) |
ISBN 9781350014428 (epdf)
Subjects: LCSH: Architecture, Postmodern–Former communist countries. |
Architecture and society–Former communist countries. | Communist aesthetics.
Classification: LCC NA682.P67 S43 2018 | DDC 720.1/03–dc23
LC record available at https://lccn.loc.gov/2018030763

ISBN: HB: 978-1-3500-1444-2
PB: 978-1-3501-6618-9
ePDF: 978-1-3500-1442-8
eBook: 978-1-3500-1443-5

Typeset by Deanta Global Publishing Services, Chennai, India

To find out more about our authors and books visit
www.bloomsbury.com and sign up for our newsletters.

CONTENTS

List of illustrations vii

Introduction *Vladimir Kulić* 1

Part One: Discourses

1 The retro problem: Modernism and postmodernism in the USSR *Richard Anderson* 17

2 Humanizing the living environment and the late socialist theory of architecture *Maroš Krivý* 33

3 The discontents of socialist modernity and the return of the ornament: The Tulip Debate and the rise of organic architecture in post-war Hungary *Virág Molnár* 47

4 An architect's library: Printed matter and PO-MO ideas in Belgrade in the 1980s *Ljiljana Blagojević* 62

Part Two: Practices

5 Bogdan Bogdanović's surrealist postmodernism *Vladimir Kulić* 81

6 One size fits all: Appropriating postmodernism in the architecture of late socialist Poland *Lidia Klein and Alicja Gzowska* 98

7 Werewolves on Cattle Street: Estonian collective farms and postmodern architecture *Andres Kurg* 111

8 Incomplete postmodernism: The rise and fall of Utopia in Cuba *Fredo Rivera* 128

9 Anti-architectures of self-incurred immaturity: A house-spirit in a *Plattenbau* *Alla Vronskaya* 143

Part Three: Exchanges

10 Cultural feedback loops of late socialism: Appropriation and transformation of postmodern tropes for Uran and Crystal in Česká Lípa *Ana Miljački* 163

11 Mobilities of architecture in the late Cold War: From socialist Poland to Kuwait, and back *Łukasz Stanek* 180

12 East-east architectural transfers and the afterlife of socialist postmodernism in Japan *Max Hirsh* 198

13 Expanding architectural discourse in early reform-era China, 1978–89 *Cole Roskam* 211

Postscript: A postmodernist international?
 Reinhold Martin 226

Index 237

LIST OF ILLUSTRATIONS

Figure 1.1 Aleksandr Riabushin and Vladimir Khait, 'Post-Contemporary Architecture – Minuses and Pluses'. Source: *Dekorativnoe Iskusstvo SSSR*, October 1979 [Courtesy of Richard Anderson] 18

Figure 1.2 A. Larin and E. Asse, Pharmacy No. 375, Orekhovo-Borisovo, Moscow, 1975. Photo courtesy of Eugene Asse 22

Figure 1.3 Leonid Pavlov, V. I. Lenin Museum, Gorki Leninskie, Moscow District, 1974–87. Photo courtesy of Richard Anderson 22

Figure 1.4 G. Zakharov, Academy of Fine Arts of the USSR, 1982 (competition project). Source: *Arkhitektura SSSR*, 1983, No. 3 [Courtesy of Richard Anderson] 24

Figure 1.5 Mikhail Posokhin, N. I. Pyshkin, S. I. Nekrasov, S. I. Kulev, Academy of Fine Arts of the USSR, competition project, 1982. Source: *Arkhitektura SSSR*, 1983, No. 3 [Courtesy of Richard Anderson] 25

Figure 2.1 A sketch by Iľja Skoček, 1965. Published without a caption in the essay 'Housing Problems'. Source: Iľja Skoček, 'Problémy bývania', *Projekt* 7.6 (1965), 120 34

Figure 3.1 'Tulip-Houses' in Paks, Southern Hungary, 1975. Photo by Péter Horváth © MTI 49

Figure 3.2 'Kádár cube' with ornament. © Katharina Roters 51

Figure 3.3 Imre Makovecz, Funeral home in Farkasrét, Budapest, 1977. Photo courtesy of Virág Molnár 56

Figure 3.4 Dezső Ekler, Folk art camp house in Nagykálló, 1986. © Dezső Ekler 58

Figure 4.1 Bogdan Bogdanović, *Urbs&Logos* (Niš: Gradina, 1976), book cover 67

Figure 4.2 Ranko Radović, *Prostor* (Belgrade: Nezavisna izdanja, 1979), book cover 68

Figure 4.3 *Komunikacija* (Belgrade), no. 36 (1985), bulletin cover with black&white reproduction of artwork 'Door to the Sea', by Marija Dragojlović 69

Figure 4.4 Miloš R. Perović, *Iskustva prošlosti* (Belgrade: Zavod za planiranje grada, 1985), book cover 75

Figure 4.5 *Arhitektura urbanizam* (Belgrade), no. 88–9 (1982), magazine cover 76

Figure 5.1 Bogdan Bogdanović, Remodel of Queen Natalija's Villa, Smederevo, Serbia, 1961. Photo by Bogdan Bogdanović. © Architekturzentrum Wien, Vienna, Collection 84

Figure 5.2 Bogdan Bogdanović, Page 28 of *The Book of Capitals* (1990). © Architekturzentrum Wien, Vienna, Collection 88

Figure 5.3 Bogdan Bogdanović, Jasenovac Memorial Park, Jasenovac, Croatia, 1966. Photo courtesy of Vladimir Kulić 91

Figure 5.4 Bogdan Bogdanović, Partisan Cemetery, Mostar, Bosnia-Herzegovina, 1965. Photo courtesy of Vladimir Kulić 92

Figure 5.5 Bogdan Bogdanović, Slobodište Memorial Park, Kruševac, Serbia, 1965. Photo courtesy of Vladimir Kulić 93

Figure 6.1 Zdzisław Lipski and Jakub Wujek, Radogoszcz-Wschód housing estate, Łódź, Poland, 1979–85. Photo courtesy of B. Ciarkowski 101

Figure 6.2 Marek Budzyński, Andrzej Szkop, Jerzy Szczepanik-Dzikowski with team, North Ursynów estate, Warsaw, 1972–7. Photo courtesy of G. Rutowska 103

Figure 6.3 Marek Budzyński, Zbigniew Badowski, Church of the Ascension of the Lord, Ursynów, Poland, since 1980. Photo courtesy of Marek Budzyński 104

Figure 6.4 Jerzy Gurawski, Drawing of the Church of the Blessed Virgin Mary Queen of Poland, Głogów, Poland, 1980s. Image courtesy of Jerzy Gurawski 106

Figure 7.1a Vilen Künnapu, Flower store in Tallinn, 1978–84. Photo courtesy of the Museum of Estonian Architecture 117

LIST OF ILLUSTRATIONS ix

Figure 7.1b Vilen Künnapu, architect, and Mari Kurismaa, interior designer, Flower store in Tallinn, 1978–84. Photo courtesy of the Museum of Estonian Architecture 118

Figure 7.2a Vilen Künnapu, Collective farm administration building in Peetri, Estonia. 1978–84. Photo courtesy of the Museum of Estonian Architecture 119

Figure 7.2b Vilen Künnapu, architect, and Mari Kurismaa, interior designer, Collective farm administration building in Peetri, Estonia. 1978–84. Photo courtesy of the Museum of Estonian Architecture 120

Figure 7.3 Vilen Künnapu, Collective farm sports hall in Peetri, Estonia, 1988–92. Photo courtesy of the Museum of Estonian Architecture 121

Figure 7.4 Vilen Künnapu, Laekvere sovkhoz administrative and cultural building, 1984–9. Photo courtesy of the Museum of Estonian Architecture 122

Figure 8.1 Jose Antonio Choy, Pool deck and exterior of Hotel Melia Santiago de Cuba, 1991. Photo courtesy of Hotel Melia Santiago de Cuba, c. 2015 129

Figure 8.2 Billboard for La Zafra, c. 1970. Photo courtesy of Roberto Segre 134

Figure 8.3 Exterior façade of Bloque GP-IV housing, Camagüey, Cuba, c. 1975. Photo courtesy of Roberto Segre 135

Figure 8.4 Billboard of Vladimir Lenin, La Rampa and Calle L, Havana, c. 1971. Photo courtesy of Roberto Segre 136

Figure 8.5 Exterior of Escuela Primaria Volodia, Havana, c. 1977. Photo courtesy of Roberto Segre 137

Figure 8.6 Streetside facades of Villa Panamericana housing units, Havana, 1991. Photo courtesy of Roberto Segre 139

Figure 9.1a–b Brodsky&Utkin, The House of Winnie-the-Pooh. Source: *Japan Architect* 8402, pp. 30–31. [Courtesy of Aleksandr Brodsky] 149

Figure 9.2a–b Belov&Kharitonov, Exhibition House. Source: *Japan Architect* 8202, pp. 12–13. [Courtesy of Mikhail Belov] 153

Figure 9.3 Gennadii Kalinovskii, Illustration of Lewis Carroll's *Through the Looking-Glass*, 1980. Image courtesy of Raisa Kalinovskaya 155

Figure 9.4	Aleksandr Florenskii, Illustration of Sergei Dovlatov, Enthusiasts' Demarche (1985). Image courtesy Aleksandr Florenskii 156
Figure 10.1	Perspective drawing of the Stavoprojekt proposal for Tegel Harbor in Berlin. Drawing by Michal Brix, 1980. Source: Internationale Bausausstellung Berlin 1984, Sie Neubaugebiete, Dokumente – Projekte, 1984: 141. [Courtesy of Michal Brix] 164
Figure 10.2	SIAL, IBA apartment block, Berlin, 1985. Source: Rostislav Švachá (ed.), *SIAL Liberec Association of Engineers and Architects, 1958–90: Czech Architecture Against the Stream* (Prague: Arbor Vitae, and Olomouc: Museum umění, 2012): 184. [Courtesy of Jiří Suchomel] 168
Figure 10.3	Emil Přikryl, Axonometric drawing of the urban plan of the southern periphery of Česká Lípa including both Uran and Crystal and projecting a number of architectural elements that would complete this edge of town, 1985. Image courtesy of Emil Přikryl 170
Figure 10.4	Emil Přikril, Long back façade of the Uran shopping centre, 1980–4. Photo courtesy of Emil Přikryl 171
Figure 10.5	Jiří Suchomel, Photograph of Crystal culture house, 1976–90. Photo courtesy of Jiří Suchomel 171
Figure 10.6	Perspective of the Museum and Archive in Most, Emil Přikryl, 1975. Source: Emil Přikryl 172
Figure 11.1	A. Bohdanowicz, W. Jarząbek, K. Wiśniowski for Shiber Consult/ INCO, Site C, Sabah Al Salem, Kuwait, 1982, general plan. K. Wiśniowski archive, Kuwait City 186
Figure 11.2	E. Lach, W. Jarząbek for KEG, Al Othman Center, Hawally, Kuwait, 1995. Photo courtesy of Ł. Stanek (2014) 187
Figure 11.3	Chyczewski, A. Wiśniowska, K. Wiśniowski for INCO, Baloush Bus Terminal, Kuwait City, 1986. Photo courtesy of Ł. Stanek (2014) 188
Figure 11.4	W. Jarząbek, E. Lach for KEG, Audit Bureau Headquarters Building, Kuwait City, 1996. Photo courtesy of Ł. Stanek (2014) 191

LIST OF ILLUSTRATIONS xi

Figure 12.1 Perspective drawing of the Hotel Bellevue, Dresden. Image courtesy of Takeshi Inoue 201

Figure 12.2 The Hotel Bellevue, Dresden, with a Baroque townhouse incorporated into the building's central façade. Image courtesy of Takeshi Inoue 202

Figure 12.3 The Hotel Bellevue (left), sharing the copper cladding and vertical window treatments with the adjacent Japanisches Palais (right). Photo courtesy of Max Hirsh 204

Figure 12.4 The Grand Hotel, Berlin. Photo courtesy of Kajima Corporation 205

Figure 12.5 The façade of the Grand Hotel, Berlin. Photo courtesy of Max Hirsh 206

Figure 12.6 Hotel Monterey, Sapporo. Photo courtesy of Max Hirsh 207

Figure 12.7 The Hotel Monterey, Kyoto, deploys contextual strategies, similar to those used by Kajima's architects in Dresden, in order to reference an adjacent building designed by Kingo Tatsuno, one of Japan's first Western-educated architects. Photo courtesy of Max Hirsh 207

Figure 13.1 Yang Yun, "Some Ideas Connected with New Trends in Western Contemporary Architecture," *Architectural Journal*, no. 1 (1980): 26–27 216

Figure 13.2 Zhang Jinqiu, Northwest Institute of Architectural Design and Research, Shaan'xi Museum of History, Xi'an, Sha'anxi, 1985–91. Source: *Chinese Architecture Since 1980* (Zhongguo dangdai zhuming jianzhushi zuopin xuan), 1998 220

Figure 13.3 Wang Shu, Youth Recreation Center, Haining, Zhejiang, 1989–91. Photo courtesy of Cole Roskam 220

Figure 13.4 Wei Dazhong, Beijing Institute of Architectural Design and Research. Guanghua Chang'an Building, Beijing, 1993–6. Source: *Chinese Architecture Since 1980* (Zhongguo dangdai zhuming jianzhushi zuopin xuan), 1998 221

Introduction

Vladimir Kulić

Sometime in the second half of 1980 – thus coinciding with the *Strada Novissima* exhibition at the first Venice Architecture Biennale – the Zagreb journal *Arhitektura* published an issue dedicated to postmodern architecture.[1] A series of articles revealed that Yugoslavia's leading architects were well informed of postmodernism's ongoing formulation in the West. Moreover, for many participants in the public debate organized by the journal, the ideas of the movement were nothing new, but rather the latest reiteration of concerns that had long been on their own minds. Nevertheless, the occasion was symbolic: it signalled the onset of a new architectural era, as postmodernism was about to become the new mainstream in Yugoslavian architecture of the 1980s.

The same issue of *Arhitektura*, however, marked a new era in another sense. Laid out in white text over solemn black background, the journal's first two pages announced the passing of Yugoslavia's long-term president Josip Broz Tito, who had died just a few days before the issue went into print. The death of Tito, the founding figure of the Yugoslavian socialist state, is widely considered the beginning of the end for post-war Yugoslavia, or the onset of the period of 'late socialism', which was marred by the political and economic crises that, a decade later, would lead to the country's final collapse. In other words, *Arhitektura*'s first 1980 issue announced in no uncertain terms the coincidence of postmodernism and late socialism for the local Yugoslavian context.

Architectural postmodernism and late socialism are the two themes of this book, as they intersected across the so-called 'Second World'. In that respect, *Arhitektura* was by no means an exception: at the turn of the 1980s, journals in the Soviet Union, China, Cuba, and other socialist countries also discussed postmodernism, as its manifestations became increasingly apparent both in theory and practice. Whether in the 'stagnation-era' Soviet Union or in the 'normalization-era' Czechoslovakia, whether in post-Mao China or in post-Tito Yugoslavia, formal complexity, ornament, and colour made their return into architectural design, together

with the renewed concerns for history, identity, and popular reception. Theoretical speculation and 'paper architecture' became goals in their own right. The various versions of 'high modernism' espoused by socialist states were regularly questioned, to be either reformed or completely rejected.[2] This conglomerate of phenomena took on shapes that resembled and often directly referenced what in the West became known as postmodernism, but was generated under very different political and economic conditions and with dissimilar social and cultural aspirations. Critics and theorists actively wrestled with these concerns and agonized over the appropriateness of importing their articulation from the West. At the same time, the shifting geopolitical boundaries introduced new, 'postmodern' forms of architectural practice, sparked by the much intensified transnational and trans-systemic exchange. Whichever way we look, it appears that socialism produced its own forms of postmodern architecture.

In contrast to the recent surge of interest in 'socialist modernism' of the 1950s and 1960s, the two decades following this period remain almost completely uncharted and unknown, not only to the international scholarly audience, but often even in their own native contexts.[3] We term that period 'late socialism', leading as it did to the collapse of the Berlin Wall and the subsequent dismantling of most socialist states. In some instances, the emergence of postmodernism indeed announced this historic change. Art critics and historians have long been engaged with this topic, certainly ever since Western art markets discovered East European conceptualism and the retro-avant-gardes and interpreted them as forms of political dissidence against late socialist regimes.[4] But architecture lends itself less comfortably to interpretation through such teleological lens: it offers many examples of postmodernisms that were not dissident, but deeply entangled in the socialist networks of patronage and production. Architecture thus complicates the simplistic distinction between official and dissident culture, illustrating how state socialist systems were able to assimilate differing and even dissenting aesthetic approaches and the changing preoccupations and concerns.

The recent years have seen a growing interest in the historicization of architectural postmodernism, to which this book adds a hitherto unexplored dimension.[5] However, if the label should indeed include the former socialist world (thus expanding beyond its canonical reach, limited as it is to Western Europe, the United States, and Japan), what are the repercussions of such an opening, especially in relation to postmodernism's existing historico-theoretical elaboration? What happens, for example, to the definitions of postmodernism as 'the cultural logic of late capitalism' (pace Fredric Jameson) or as the architecture of neoliberal 'Reaganism' (pace Mary McLeod) if they are to encompass Estonian collective farms, Polish churches or Yugoslavian war memorials?[6] What happens to Charles Jencks's famous proclamation of the spectacular 1972 demolition of the Pruitt-Igoe housing complex as the threshold between modernism and postmodernism if we take into account the vast amounts of prefabricated mass housing built

in the 1970s in Hungary, Cuba, and Central Asia that combined functionalist *Zeilenbau* typology with *völkisch* ornament and pop art supergraphics?[7] These and other related questions arise from the material presented in this book, forcing us to reconsider the architectural history of the recent past from a rather new angle.

Spanning the vast geographical space from the Caribbean to East Asia, the thirteen case studies collected here adopt a broad global perspective to explore architecture's transformations under late socialism. At the same time, they cover an equally broad range of topics: theories and criticism, as well as their practical implementations; a variety of typologies – including mass housing, churches, collective farms, hotels, schools, and monuments – as well as paper architecture; the transmissions of architecture culture, as well as native inventions. Taken together, they sketch out an international map of late socialist architecture, an effort that has not been attempted since Udo Kultermann's pioneering book *Contemporary Architecture in Eastern Europe,* published in West Germany in 1985.[8] However, as necessary and useful as maps are, the goal of this book is to provide more than just a map; rather, it aims at situating architecture within the societies that produced it, not simply in the sense of establishing the proverbial 'context' for it, but by demonstrating how architecture was shaped by social relations and how it actively participated in shaping them in return. In that sense, postmodernism indeed appears to be – to paraphrase Jameson – the cultural logic of late socialism, whether in its revived commercial motivations, in its nationalist aspirations, or in the self-conscious retreat from everyday practice into paper architecture.

The ultimate goal of the book, however, is to question the term at its very heart: postmodernism. The diversity and, in some instances, the relative uniqueness of the case studies may suggest that some of them perhaps should not be labelled 'postmodern' at all. Indeed, with their lack of irony, with their straightforward replacement of one metanarrative with another, or with their unusual origins, some of them may appear to contradict the foundational motivations of postmodernism as it has been defined in the West. Why, then, cling to an existing term that ultimately may be inadequate? The reason is historiographic: to pry open a canonical historical formation in order to relativize its definition (however vague it may already be) as a way of destabilizing the established hegemonic narratives. If we were to invent a new term for the Second World phenomena described here, they could be easily relegated to their peripheral confines and continue to be ignored, as they have been for the past several decades. But by bringing them into the fold of a canonical concept and by demonstrating that they may have offered something dissonant and unexpected to its established definitions, we inevitably burst the very bubble of the canon. That is the price of victory: just like the colonial conquests could not but contaminate the cultures of the metropoles, so the First World's victory in the ideological struggles of the Cold War ultimately cannot but contaminate its own architectural

narratives, however slowly and belatedly. For wherever we look in the conquered lands of the once real-existing Utopias, we run into the leftovers of Utopia: not its postmodern ghosts, as Reinhold Martin has argued, but very tangible shells that in the meantime became emptied of their original purpose and meaning.[9]

Late socialism

In contrast to 'late capitalism', there is an actual historical rationale for designating the lateness of socialism: the collapse of the world socialist system at the turn of the 1990s. However, the lateness of the period was by no means uniformly defined: it rather unfolded according to differing dynamics highly dependent on local conditions. To begin with, the very duration of state socialist systems greatly varied between the Soviet Union, Eastern Europe, China, and Cuba, with neither their beginnings nor their endings necessarily coinciding. What counts as 'late' under such conditions is also necessarily relative, both in terms of chronology and the actual historical content. For example, in the 'first country of socialism', the Soviet Union, late socialism is sometimes considered to begin as early as Stalin's death in 1953, sometimes with the ascendance of Leonid Brezhnev in the mid-1960s and sometimes with the economic stagnation in the early 1970s. In Czechoslovakia, it was identified with 'normalization' following the crushing of the Prague Spring in 1968. In China, the watershed period stretched from Richard Nixon's visit in 1972, through Chairman Mao's death in 1976, to the initiation of market reforms in 1978. In Yugoslavia, Tito's death in 1980 signalled the onset of economic austerity and increasing nationalism. And in Cuba, the crisis known as the 'Special Period' did not begin until the Soviet Perestroika and the subsequent dissolution of the USSR. Indeed, in many instances, late socialism was identified with some form of a decline, for example, with economic stagnation that replaced the optimistic growth of the early post-war years. But even decline was not universal: in some pockets of the Second World, late socialism brought prosperity and growth, most famously in China, as well as in places like Estonia of the 1970s, where affluent agricultural cooperatives were able to finance massive construction projects of social infrastructure and housing that gave rise to a great deal of architectural experiments.

Despite its general linkage to the conditions of sociopolitical crisis, however, postmodernism should not be read teleologically as a cultural signal of the inevitable downfall of the socialist project. To paraphrase the title of the influential book by the anthropologist Alexei Yurchak, 'socialism was forever, until it was no more'; in other words, the socialist lifeworld maintained its apparent solidity all the way through to its abrupt end.[10] Whether its collapse was inevitable is a contentious question that is more suitable to political science than architectural history; what is certain,

though, is that such a collapse was not obviously predictable, coming as it did as an enormous surprise, not only for the denizens of socialist states, but also for the entire world. Consequently, political dissidence discernible in some manifestations of architectural postmodernism was far from its only motivation, and critique of the system often took the form of proposals to improve on its shortcomings rather than proclaiming it beyond repair.

Herein lies the fundamental difference between architecture and art. Art historians have long dealt with what they termed '(post)socialist postmodernism': late socialist art motivated by a 'desire to hasten the end of the "actually existing socialist societies".'[11] The result was a highly politicized art that relied on irony to question and mock the system. Its products varied from compelling to what from a historical distance appears as no more than banal visual puns. In the final stages of the Cold War, some of this art enjoyed a great deal of success in the Western art markets. Architects, in contrast, did not enjoy the luxury either to comment from the sidelines, or to capitalize on their dissidence. Architecture is not only inherently limited in its ability to pass social criticism, but also fundamentally entangled with political and economic powers, which was especially the case in systems that all but abolished private practice. However, architecture's very raison d'être is to reimagine and transform; its practitioners thus constantly faced the elusive possibility to improve the existing world, even if their powers were sometimes severely restricted. A history of massive undertakings that various socialist states came to realize with more or less success set a horizon of expectations that further encouraged architecture's transformative promises. Such circumstances perhaps explain the continued promulgation of certain techno-utopias, sincerely and without a hint of irony, long after their appeal ceased in the West: all-encompassing visions such as Oskar and Zofia Hansen's 'Linear Continuous System' in Poland, Vjenceslav Richter's 'Sinturbanizam' in Yugoslavia, or Elemér Zalotay's 'Strip House' in Hungary were all still intended as serious proposals in the late 1960s and 1970s, in stark contrast with the openly hyperbolic or ironic contemporaneous projects by Archigram or Superstudio.[12] As several chapters in this book demonstrate, such subduing of irony (or even a complete lack thereof) was transposed into much of postmodernist architecture produced under state socialism, thus differentiating it not only from (post)socialist postmodernism in art, but also from much architectural postmodernism produced in the First World.

Understanding architecture's active role in shaping late socialist societies carries special weight in the light of the recent wave of mediatization of buildings produced during the period. The spectacular images of all kinds of structures constructed across Eastern Europe in the 1970s and 1980s – from sanatoria to crematoria – are currently in broad circulation in the digital media, amounting to a veritable pop-cultural phenomenon.[13] However, the bemused astonishment these structures typically arouse is accompanied by a very limited understanding of their origins and meanings. The often

exoticizing interpretations reveal the persistence of Cold War stereotypes and biases, which reduce architecture to one-dimensional reflections of 'totalitarian' politics. Architects' names are rarely featured in such representations, all agency being ascribed to arbitrary flights of dictatorial imagination dissociated from any cultural, artistic, and intellectual lineages.[14] Paradoxically, while privileging politicians as the progenitors of architecture, such misrepresentations obscure, rather than reveal, the actual politics embedded in the built environments, which is typically far more complex – and often far more interesting – than thus represented. An already massive body of scholarship in urban and architectural history, historical sociology, anthropology, and other disciplines have disputed the simplifications of the so-called totalitarian paradigm, recovering the multitude of competing agencies at work in socialist societies. The essays in this book contribute to such efforts by highlighting the numerous professional agents in the field of architecture: not only practitioners, but also critics, editors, publishing houses, construction companies, commissioning enterprises, and so on. If politicians are rarely mentioned in these accounts, it is a testimony to the degree to which the production of the built environments became professionalized under late socialism, leaving the stories of more direct political incursion in the past.

The Second World

In addition to late socialism, another key term that ties this book together is the 'Second World'. It refers to the group of communist-governed countries during the Cold War, which were organized according to varied state socialist systems. The term connotes an eminently geopolitical dimension, in distinction to the industrialized capitalist states of the so-called First World, as well as the recently decolonized developing countries of the Third World. Nevertheless, neither the boundaries of the Second World nor the actual geopolitical alliances of the countries that comprised it were as monolithic as the term suggests. Most socialist states were at one moment or another allied with the Soviet Union, but some, such as China, broke the alliance and went on to establish their own networks. To further compound the matter, two other independently acting states covered in this volume, Yugoslavia and Cuba, belonged to the Non-Aligned Movement, which largely (but not entirely) coincided with the so-called Third World and sought to escape the imperial ambitions of both the United States and Soviet bloc. In addition, most socialist countries, whether non-aligned or under Soviet tutelage, also maintained close connections with the recently decolonized states of the global South, many of which, in turn, themselves aspired to some form of socialism. The boundaries of the Second World were thus both fuzzy and in constant flux.[15]

Because it was coined in the West for the purpose of geopolitical haggling, the term 'Second World' denotes a hierarchy of development that

self-servingly places the capitalist West at the top. But rather than fighting it, this book takes that term as a badge of honour by aiming to shift its meaning from an ordinal to that of alterity. Indeed, in some Slavic languages, the words for 'second' and 'other' are homonyms and the Second World can easily be understood as 'Another World', or an alternative to the world of capitalism. In that sense, this book is as much about the geopolitics of architecture as it is about an alternative to the existing classifications of architectural history, investigating hitherto unexplored couplings of architectural aesthetics and politics. For the past two decades, scholars have theorized alternative modernities, demonstrating the fundamentally multiplicitous nature of the very concept.[16] Modernism consequently became plural as well.[17] This book aims at a similar goal in relation to architectural postmodernism, highlighting both the specificity of its Second World manifestations vis-à-vis the First World and their mutual interconnectedness, not least via the Third.

The question of growing global interconnectedness is crucial because the international exchange of architectural culture and expertise not only intensified in the late Cold War, but also acquired new forms and pathways across the increasingly porous borders of the three-world system. For the first time in history, for example, Eastern Europe started exporting architecture on a global scale, at the same time when it began importing know-how from such far-away places as Japan.[18] At the same time, the ebbs and flows of the détente in the later years of the Cold War made the border between the First and the Second World far more permeable than is conventionally assumed, allowing the inventions of postmodernist architects in the West to be widely discussed in socialist countries as well. Postmodernist aesthetic was frequently the object of such exchanges, becoming the paradoxical emblem of a new age that simultaneously sought to strengthen local identity and establish global connections. In the process, new networks began competing with the old ones, unsettling the cultural hierarchies inherited from the colonial times and establishing new world-systemic formations that can themselves be rightfully termed 'postmodern'.

Even though postmodernist architecture in the socialist world emerged in part through interactions with the West, it had its own themes and prominent figures that were unique to it. For example, the influence of the Moscow theorists Aleksandr Riabushin and Vladimir Khait greatly exceeded their local context, reaching as far as Estonia and Czechoslovakia.[19] It is, therefore, tempting to compare their transnational authority to that of influential theorists in the West. Another specificity was the connotation ascribed to colour as an antidote to the pervasive greyness of socialist modernization – in curious distinction to the United States, where modernism was associated with whiteness and where the leading postmodernists called themselves the Grays.[20] To further compound the matter, mass prefabricated housing painted in bright colours, as was the case in Hungary and Central Asia, also appealed to nationalist sentiments, thus reviving the socialist realist

demands for an architecture 'socialist in content and national in form'.²¹ A rather different strategy to counter the dullness of modern daily life was to resort to the deliberately irrational, oneiric, and mythical – again strategies less commonly associated with postmodernism in the West.²² Socialist postmodernism thus acquired its own flavour, even if it exhibited general affinity with postmodernism in the West.

One of the specificities of Second World postmodernism was that some of its manifestations developed in the looming shadow of (or even in direct reference to) the grandiose historicist architecture of Stalin's era. In a way, that architecture, defined at the time as socialist realism, was indeed the first 'post/modernism', reacting as it did against the aesthetic revolution of the Soviet avant-garde of the 1920s. In contrast to the linguistic opacity of the avant-garde, socialist realism foregrounded easy communicability and the embrace of historical conventions, which puts it in close proximity to some of postmodernism's own tenets. It should thus come as no surprise that discussions in various socialist countries in the 1970s and 1980s would often bring up this connection, which was all the more pertinent due to the fact that some of the original protagonists of 1930s' architecture were still alive and practising at the time.²³ What should not be forgotten, though, is that the Stalin-era architecture was also formative for some of the key strains of postmodernism in the West. The most prominent case in point is certainly the circle around Aldo Rossi, who was an admirer of East Berlin's Karl-Marx-Allée and who cultivated links with colleagues in the German Democratic Republic.²⁴ When speaking of this reverse impact, it is also worth remembering that Dalibor Veselý, the influential proponent of architectural phenomenology and another formative figure for Western postmodernism, was an émigré from socialist Czechoslovakia, where he had studied with the philosopher Jan Patočka.²⁵ These two episodes, among a number of others, suggest that the Second World was not merely a passive recipient of postmodernist ideas from the West, but an active agent in their production and exchange.

The structure of the book

This book is organized into three parts, even though most of the individual chapters in some ways straddle the thematic division. The three-part structure should therefore be taken only as a tool for easier orientation through fundamentally interrelated material.

Part One, Discourses, focuses on the theories, debates, and written sources that contributed to the formulation of architectural postmodernism in the Second World. It demonstrates the degree to which explicit theoretical engagement constituted an intrinsic part of architecture under socialism, so much so that it became institutionalized through the foundation of various departments and institutes, as the first two chapters point out. In the opening chapter, Richard Anderson focuses on the discussions about postmodernism

that emerged in the Soviet Union around 1979, centring largely on the translatability of ideas that originated in the West under an alien ideological system. Anderson registers multiple tensions that emerged in these discussions: between the need to 'humanize' the built environment and the resistance to give up on architecture's socially transformative promise, or between the responsibility to educate the taste of the masses and the lure to respond to market's populist demands. In Chapter 2, Maroš Krivý focuses on the related theoretical discussions in Czechoslovakia, where the question of the environment came to the fore to become articulated through the lens of phenomenology, semiotics, and cybernetics. The case is fascinating because all of these themes paralleled postmodernist discussions in the West, but in Czechoslovakia they grew in part out of the native soil prepared by institutions organized by the socialist state. In Chapter 3, Virág Molnár traces another instance of a home-grown theoretical discussion that can be termed 'postmodernist': the so-called Tulip Debate concerning the use of vernacular ornament in prefabricated mass housing, which shook the architectural profession of Hungary in the 1970s. In contrast with postmodernist architecture in the West, which rarely included nationalist concerns, the Hungarian debate revolved around the question of national identity, thus replacing one metanarrative – that of socialist progress – with another – the nation – that would continue to percolate after the collapse of socialism. Finally, Ljiljana Blagojević's chapter analyses a typical architect's library in Belgrade to demonstrate how the history of publishing in Yugoslavia since the 1960s contributed to the shaping of its vibrant postmodernist scene of the 1980s. The numerous translations reveal Yugoslavia's interconnectedness with the wider international context; however, the analysis also points out the relevance of several prominent local figures whose writings were equally formative for the rise of postmodernism, thus yet again suggesting its home-grown origins.

Part Two, Practices, situates architectural postmodernism in the conditions of socialist production and use. Chapter 5 continues Blagojević's discussion of the Belgrade scene by focusing on Bogdan Bogdanović, one of the above-mentioned formative figures, whose entire surrealist-inspired career challenged the rationalist principles underlying socialist modernization. The chapter discusses the arguments *pro et contra* designating Bogdanović as a postmodernist in order to pry open the definition of the movement for the inclusion of properly socialist manifestations. In Chapter 6, Lidia Klein and Alicja Gzowska focus on two rather different typologies in late socialist Poland, mass housing and Catholic churches, to show how a diverse set of practices typically associated with postmodernism came to serve politically divergent interests, simultaneously in support and in defiance of the socialist system. In the following chapter, Andres Kurg discusses another category of late socialist clients, the prosperous collective farms in Estonia, which became leading patrons for postmodernist ideas in the 1970s. These projects highlight the paradoxes of Second World postmodernism, built as they were for one of the prototypical economic units of socialism, and at the same time

prefiguring post-socialist practices and tastes. Chapter 8 takes us to Cuba: Alfredo Rivera traces the continuity of postmodernist strategies, which encompassed a range of changing sociopolitical conditions. We thus find them at the height of revolutionary zeal in the early 1970s, as well as in the times of crisis during the so-called Special Period, when utopia succumbed to commercial pressures. Chapter 9 returns to the Soviet Union, as Alla Vronskaya discusses how a group of young Moscow architects sought to reenchant socialist modernity through paper architecture. In the process, they found a convenient outlet in participation in the recurring competitions organized by the journal *Japan Architect* (JA), one of the international forums for emerging architects frequently judged by the luminaries of postmodernism, thus crossing the boundaries of the Cold War.

The entirety of Part Three, Exchanges, focuses precisely on the crossings over geopolitical boundaries. It explores the global circulation of postmodern practices, which by the turn of the 1980s was no longer limited to the dissemination of printed matter, as the know-how and labour came to travel with increasing regularity. In Chapter 10, Ana Miljački draws attention to the little-known fact that the Second World had its representation at the 1987 *Internationale Bauausstellung-Berlin*, IBA '87, in West Berlin, one of the seminal events for postmodernism in the First World. She revisits the careers of the Czechoslovakian architects who took part in the show to reveal the framework of socialist professional organization in which they practised. In Chapter 11, Łukasz Stanek explores Polish architectural exports to Kuwait, one of the many instances of the Second World's architectural agency in the Global South, which acquired an increasingly commercial dimension in the late socialist period. Stanek demonstrates that the exchange went both ways: architects brought to Kuwait the expertise developed in Poland, but in the process they also acquired new forms of knowledge – both technological and aesthetic – that made them particularly competitive on the labour market after the collapse of socialism. In Chapter 12, Max Hirsch discusses another instance of two-way exchange: the work of a Japanese construction company on two hotel complexes in the 1980s German Democratic Republic. The interests in this trans-systemic collaboration were mutual: East Germans benefited from the advanced construction and management methods of the Japanese, whereas the Japanese learnt from their hosts about historicist postmodernism. Finally, Chapter 13 brings us back to the beginning: the question of translatability of postmodern ideas across ideological boundaries raised in Chapter 1. Cole Roskam traces the implantation of postmodernist discourse in China in the early 1980s as an essential part of the reformist processes initiated in the previous decade. In this case, however, ideas were mediated through direct personal participation of their progenitors from the First World and under the aegis of the Chinese state, thus instituting far more immediate – even if no less contentious – connections.

Reinhold Martin's Postscript concludes the book by reading its thirteen case studies against their common background: the broader semantic

field of the Cold War. It argues that the many fragmented, dissonant postmodernisms in the First and Second Worlds alike constituted something akin to a 'postmodernist international', brought together into an 'impossible, cacophonous unity', perhaps forming – to borrow from Robert Venturi – a postmodern 'difficult whole'. Martin raises further pertinent questions that follow from the material presented here, concerning the issues such as the nature of collective authorship and the effects of the postcolonial movements of transnational solidarity. If this book provides impetus for further research into these questions, its purpose will be fulfilled.

Notes

1. See *Arhitektura* (Zagreb), no. 172–3 (1980).
2. The term 'high modernism' was coined by the anthropologist James C. Scott to describe a 'strong, one might even say muscle-bound, version of the self-confidence about scientific and technical progress', which the states of both East and West espoused as the model of development after the Second World War. In Scott's view, post-war urban planning was the prime example of high modernism in practice. See James C. Scott, *Seeing Like a State: How Certain Schemes to Improve the Human Condition Have Failed* (New Haven, CT and London: Yale University Press, 1998), 4.
3. Among the rare exceptions are Florian Urban's *Neo-Historical East Berlin: Architecture and Urban Design in the German Democratic Republic, 1970–1990* (Farnham, UK: Ashgate, 2009); the two-volume collection *Postmodernizm polski. Architektura i urbanystika*, edited by Lidia Klein and Alicja Gzowska (Warsaw: 4000 Malarzy, 2013); and Łukasz Stanek's *Postmodernism is Almost All Right: Polish Architecture After Socialist Globalization*, exhibition catalog (Warsaw: Fundacja Bec Zmiana, 2013).
4. For a thorough overview of postmodernist art under socialism, see Aleš Erjavec, ed., *Postmodernism and the Postsocialist Condition: Politicized Art under Late Socialism* (Berkeley: University of California Press, 2003).
5. See, among other titles, Reinhold Martin, *Utopia's Ghost: Architecture and Postmodernism, Again* (Minneapolis: University of Minnesota Press, 2010); Aron Vinegar, *I Am a Monument: On Learning from Las Vegas* (Cambridge, MA: The MIT Press, 2008); Martino Steirli, *Las Vegas in the Rearview Mirror: The City in Theory, Photography and Film* (Los Angeles: The Getty Research Institute, 2010); Glenn Adamson and Jane Pavitt, eds., *Postmodernism: Style and Subversion,1970–1990,* exhibition catalog (London: V&A Publishing, 2011); Lea-Catherine Szacka, *Exhibiting the Postmodern: The 1980 Venice Architecture Biennale* (Venice: Marsilio, 2017).
6. See Fredric Jameson, *Postmodernism, or The Cultural Logic of Late Capitalism* (London: Verso, 1991), and Mary McLeod, 'Architecture and Politics in the Reagan Era: From Postmodernism to Deconstructivism', in *Assemblage,* no. 8 (February 1989): 22–59.

7 For Pruitt-Igoe, see Charles Jencks, *The Language of Postmodern Architecture* (New York: Rizzoli: 1984), 9. For housing in Central Asia, see Meuser, Zadorin.

8 See Udo Kultermann, *Zeitgenössische Architektur in Osteuropa* (Cologne: DuMont Buchverlag, 1985).

9 See Martin, *Utopia's Ghost*.

10 See Alexei Yurchak, *Everything Was Forever Until, It Was No More: The Last Soviet Generation* (Princeton: Princeton University Press, 2005).

11 See Martin Jay, 'Foreword', in Erjavec, ed., *Postmodernism and the Postsocialist Condition,* xvii.

12 For the Hansens, see Andrzej Szczerski, 'LCS, or What Is a City?', in Aleksandra Kędziorek and Łukasz Ronduda, eds., *Oskar Hansen: Opening Modernism* (Warsaw: Museum of Modern Art, 2014), 91–114. For Richter, see Maroje Mrduljaš and Vladimir Kulić, 'Richter's Synthurbanism: The Expanded Field of Synthesis: Urbanism, Art, Politics', in Martina Munivrana and Vesna Meštrić, eds., *Buntovnik s vizijom / Rebel with a Cause,* exhibition catalogue (Zagreb: Muzej suvremene umjetnosti, 2017), 120–61. For Zalotay, see Virág Molnár, *Building the State: Architecture, Politics, and State Formation in Post-War Central Europe* (Abingdon, UK and New York: Routledge, 2013), 92–100.

13 For a partial list of photo monographs recording the architecture of the former socialist world, see Roman Bezjak, *Socialist Modernism* (Berlin: Hajte Cantz, 2011); Frédéric Chaubin, *CCCP: Cosmic Communist Constructions Photographed* (Cologne: Taschen, 2011); Christopher Herwig, *Soviet Bus Stops* (London: Fuel, 2015); Jan Kempenaers, *Spomenik* (Amsterdam: Roma Publication, 2010); Armin Linke and Srđan Jovanović Weiss, *Socialist Architecture: The Vanishing Act* (Zurich: JRP-Ringier, 2012); and Nikola Mihov, *Forget Your Past, Communist-Era Monuments in Bulgaria* (Plovdiv: Janet-45 Print and Publishing, 2015).

14 For a critique of such interpretations, see my essay 'Orientalizing Socialism: Architecture, Media, and the Representations of Eastern Europe', *Architectural Histories* 6, no. 1 (13 June 2018): 7. DOI: http://doi.org/10.5334/ah.273.

15 The discussion about the fuzziness of the Second World very much informed the founding of the research platform *Second World Urbanity,* which has brought together a large number of scholars through an online publication and a series of conferences. See http://www.secondworldurbanity.org.

16 See Dilip Parameshwar Gaonkar, ed., *Alternative Modernities* (Durham, NC: Duke University Press, 2001).

17 See 'Other Modernisms: A Selection from the Docomomo Registers', entire issue of *Docomomo Journal,* no. 36 (March 2007).

18 For the architectural exports of socialist countries to the Global South, see Łukasz Stanek's work, especially the article 'Architects from Socialist Countries in Ghana (1957–67): Modern Architecture and *Mondialisation*', *Journal of the Society of Architectural Historians* 74, no. 4 (December 2015): 416–42. See also Łukasz Stanek, ed., 'Cold War Transfer: Architecture and Planning from Socialist Countries in the "Third World",' special issue of *The Journal of*

Architecture 17, no. 3 (2012). For the Japanese presence in Eastern Europe, Max Hirsh's chapter in this book, as well as Ines Tolić, *Dopo il terremoto. La politica della ricostruzione negli anni della Guerra Fredda a Skopje* (Reggio Emilia, Italy: Edizioni Diabasis, 2011).

19 It is indicative that Aleksandr Riabushin is mentioned in no less than three chapters in this book; see those by Richard Anderson, Maroš Krivý, and Andres Kurg.

20 For the connotations ascribed to the greyness of concrete, see Krisztina Fehérváry, *Politics in Color and Concrete: Socialist Materialities and the Middle Class in Hungary* (Bloomington: Indiana University Press, 2013). For 'gray postmodernism' in the United States, see Robert A. M. Stern, 'Gray Architecture as Post-Modernism or, Up and Down from Orthodoxy' [1976], published in *Architecture Theory since 1968*, ed. K. Michael Hays, (Cambridge, MA: The MIT Press, 1998), 242–5.

21 See Virág Molnár's chapter in this book, as well as Philipp Meuser and Dimitrij Zadorin, *Towards a Typology of Soviet Mass Housing: Prefabrication in the USSR 1955–1991* (Berlin: DOM Publishers, 2015).

22 See Alla Vronskaya's chapter in this book, as well as my chapter.

23 See, among other sources, Richard Anderson and Maroš Krivý's chapters in this book.

24 For Rossi's connections with the German Democratic Republic, see Angelika Schnell, 'The Socialist Perspective of the XV Triennale di Milano: Hans Schmidt's Influence on Aldo Rossi', *Candide. Journal of Architectural Knowledge,* no. 2 (July 2010): 33–72.

25 See Joseph Bedford, 'Being Underground: Dalibor Vesely, Phenomenology and Architectural Education during the Cold War', in Akos Moravanszky and Torsten Lange, eds., *Re-Framing Identities, Architecture's Turn to History, 1970–1990* (Basel: Birkhauser, 2017), 89–104. See also Krivý's chapter.

006# PART ONE

Discourses

1

The retro problem:

Modernism and postmodernism in the USSR

Richard Anderson

From its first emergence in Soviet architectural discourse, 'postmodernism' was a highly contested term. It was unclear whether postmodernism referred to a broad reorganization of professional conventions that could adequately describe parallel developments in the capitalist and socialist worlds, or whether postmodernism was merely an expression of late capitalist ideology – and therefore foreign to Soviet theory. The early Soviet debates on this concept, which unfolded from the late 1970s roughly to the announcement of Mikhail Gorbachev's program of *Perestroika* in 1985, betray a tension between a clear enthusiasm for the theories and projects emerging in Western Europe and North America and an awareness of the specificity of Soviet architectural culture and production. Occurring in the decades Leonid Brezhnev called 'developed socialism', the debates on postmodernism register the theoretical and practical development of the Soviet profession in an era commonly described as one of 'stagnation', for postmodernism served as a catalyst for Soviet architects to conceptualize an enriched, humanized, and communicative architecture appropriate to the growing needs of a mature socialist society. Yet some critics suspected that the alleged permissiveness and dependence on historical forms characteristic of Western postmodernism might correspond to a desire among an older generation of Soviet architects to return to the formal 'excess' of the Stalin era. Postmodernism would thus become entangled with the so-called retro

problem that confronted Soviet architects. Ultimately, the debates that enveloped postmodernism precipitated a theory of Soviet architecture's historical development that not only questioned the validity of the term as a description for Soviet production, but also cast doubt on the applicability of 'modernism' as such to the Soviet context.

The first sustained discussion of postmodernism in architecture appeared in Soviet discourse in 1979. In October of that year, the journal *Dekorativnoe iskusstvo SSSR* (Decorative Art of the USSR) published an essay entitled 'Post-Contemporary Architecture – Minuses and Pluses' co-authored by Aleksandr Riabushin and Vladimir Khait (Figure 1.1).[1] The very title of the essay – 'post-contemporary' (*postsovremennaia*) as opposed to 'postmodern' (*postmodernistskaia*) – registered the novelty of the concept of postmodernism in Russophone discourse. It also highlighted the fact that Soviet architects consciously avoided the term 'modern' when discussing architecture of the Soviet period. The latter was typically described as 'contemporary' (*sovremennaia*) architecture. Both the venue of publication and the status of the authors lent authoritative weight to the essay. *Dekorativnoe iskusstvo SSSR* was a widely read journal published by the Union of Artists of the USSR. Khait was a well-known architect and critic who had written extensively about the architecture of Brazil while also serving as a director of the Department of Contemporary Foreign Architecture

FIGURE 1.1 *Aleksandr Riabushin and Vladimir Khait, 'Post-Contemporary Architecture – Minuses and Pluses'.*
Source: Dekorativnoe Iskusstvo SSSR, *October 1979 [Courtesy of Richard Anderson]*.

at the Institute for the History and Theory of Architecture.[2] Riabushin commanded even greater authority. A doctor of architecture, Riabushin had risen to the heights of professional leadership in the 1970s. In 1975 he was elected to the executive committee of the Union of Soviet Architects, for which he served as chairman of the 'Theoretical Club'. In 1981, he would become a secretary of the Union's executive committee, ensuring that his ideas would shape official architectural discourse in the USSR.[3]

Riabushin and Khait began their essay of 1979 with a description of a well-known moment in the genealogy of postmodern architecture: 'On July 5, 1972 at 3:32 pm in the American city of St. Louis the slab blocks of the Pruitt-Igoe housing estate, which were constructed in accordance with the "modern movement", were blown up.'[4] This appeal to the famous opening statement of Charles Jencks's *The Language of Post-Modern Architecture* – which would itself be published in Russian translation in 1985 – served as a preface to a wide-ranging discussion of recent trends in the architectural production of the capitalist world. Following the American critic Paul Goldberger, Riabushin and Khait described the absence of utopian ambitions as a characteristic feature of postmodern architecture.[5] Among the other elements of the new trend, they noted a desire for a rich formal language, in opposition to the alleged symbolic poverty of what they vaguely referred to as 'functionalism'; a typical orientation towards 'upper-middleclass' consumers; and an interest in historical citation. Riabushin and Khait wrote that although postmodernism was 'to a certain extent a foreign phenomenon', they maintained that it was the task of Soviet architectural criticism to observe 'strict objectivity' in criticizing both the architecture of the modern movement and the emergence of postmodernism. In their analysis, the latter represented a 'capitulation' of the utopian aspirations of the 'pioneers' of the modern movement and a turn towards 'submissive service to the client'.[6]

Such an assessment of the role of postmodern architecture in the West did not, however, mean that this work was not of fundamental interest to Soviet architects.[7] On the contrary, Riabushin and Khait insisted that it was vitally important for Soviet architects to understand recent developments in the West, suggesting that they might have an impact on Soviet practice as well. To establish this point, while simultaneously enforcing the ideological gap separating Soviet architecture from that of the capitalist world, Riabushin and Khait were driven to difficult, but rhetorically necessary circumlocutions. Their most important statement of the value of postmodernism for Soviet practice was the following:

> Of course, a significant part of the professional methods in the work of creative artists of the West prove to be linked with bourgeois ideology – owing to their existence [*bytovanie*] in the system of bourgeois society. [But] experience shows that in a different environment such techniques may be determined by fundamentally different ideological content. That

is why it is important to clearly define their ideological content – to 'cleanse' [*ochistit'*] the new professional methods of work developing in architecture and building today.[8]

With this, Riabushin and Khait suggested that Soviet architects might assimilate practices derived from the work of architects in the capitalist world. These practices needed only to be 'cleansed' of their ideological content.

But as postmodernism emerged in Soviet architectural discourse in the late 1970s and early 1980s, it did so against the background of fundamental transformations in the aims and ambitions of Soviet architectural practice. The interest that Riabushin and Khait expressed in the 'professional methods' associated with postmodernism corresponded to a widespread interest among Soviet architects and critics in the 'humanization' of architecture. By the late 1970s, objections to the dominance of the material and technical qualities of architectural production had become a commonplace in Soviet architectural discussions. The emphasis on production had, many claimed, led to the impoverishment of the 'emotional' aspects of architectural design. Regional architectural forms from the Soviet Union's republics often served as sources for emotionally communicative properties.[9] The critic and historian Iulia Kosenkova, for example, described the assimilation of national forms as a method for the emotional enrichment of Soviet architecture. Writing in 1978 on the architecture of Tashkent, Kosenkova noted that 'the birth of an emotional architecture that is directed at the human senses is one of the most characteristic features of today'.[10]

When Riabushin and Khait wrote of the need to 'cleanse' foreign methods for potential use by Soviet architects, they did so in full awareness of the widespread desire for a reorientation of Soviet practice towards national and communicative forms. In 1982, Riabushin, now serving as secretary of the executive committee of the Union of Soviet Architects, reiterated these themes at a conference on architecture and ideology held in Kiev. He urged his colleagues to 'critically evaluate the state and new tendencies in our creative practice, giving attention to the real expectations of Soviet people, their desire for a varied, rich architecture that is nationally and historically inflected'.[11] More importantly, he stated that Soviet architects 'must evaluate the dogma of functionalism, our preoccupation with technological aspects of architecture, and the tendency of modernism in architecture'.[12] This was a double imperative: to re-evaluate Soviet architecture's relationship to modernism in an effort to achieve an architecture rich in historical and national inflections. Such statements indicate that whatever impact postmodern theory had on Soviet architecture, it did not initiate the reorientation of Soviet practice in the 1970s and 1980s; rather, it served as a catalyst for processes already underway.

The parallels between the USSR and the advanced capitalist world that became apparent at the turn of the decade provoked a range of reactions among Soviet critics. Some felt that postmodernism could aptly describe

these shared interests. Others rejected the concept of postmodernism outright. The variable reception of American architecture by Soviet critics over the course of the 1970s provides evidence of these divergent views. This is particularly clear in the Soviet reception of Robert Venturi. As early as 1972, key portions of Venturi's *Complexity and Contradiction in Architecture* had been translated into Russian and made widely available.[13] The translation editor of Venturi's text, Andrei Ikonnikov, offered a critique of this work, writing that 'pessimism, born of social passivity, is the principal weakness of the theory and practice of Robert Venturi'.[14] In 1979, the same year that Riabushin and Khait published their seminal essay on 'post-contemporary' architecture, Ikonnikov offered further condemnation of Venturi's work in his book *Arkhitektura SShA* (Architecture of the USA).[15] In this book, he interpreted Venturi's position as a call for the architect to renounce an active position in society and avoid assigning professional architectural concerns to the user. The architect's task, in Ikonnikov's interpretation of Venturi's theory, was to create a neutral structure – the decorated shed (*zdanie-sarai*) – that could be activated by its occupants.[16] In their initial assessment of the elements of 'post-contemporary' architecture of 1979, Riabushin and Khait were more receptive to Venturi's work. They described the decorated shed not simply as a means of elevating the tastes of the user over the architect, but rather as an indication that 'ordinariness often becomes an important criterion of artistic value in an architectural object'.[17] This charitable interpretation of Venturi's work was an example of how Riabushin and Khait were willing to abstract what they called 'architectural or professional principles' from the ideological milieu in which they were articulated – a move that other critics were unwilling to make.

A set of built projects dating from the mid-1970s to the early 1980s offers insight into why the idea of postmodernism had such purchase on the minds of critics like Riabushin and Khait. As early as 1975 the desire for a more communicative architecture was translated into built form in a small pharmacy building by Aleksandr Larin and Eugene Asse in Moscow. They called this project a *zdanie znak*, or building-sign.[18] It combined a low, box-like building, and an entry façade in the shape of a cross. Painted bright red, the cross stands out from the white ground of the rest of the building and offers a stark contrast to the surrounding residential towers (Figure 1.2).[19] It conjures immediate associations with medical practice and the care of the self. In addition to the use of symbols to enhance the communicative capacity of architecture, Soviet architects pursued a new engagement with historical forms in the 1970s and the 1980s. In his Lenin Museum in Gorki Leninskie (1974–87), Leonid Pavlov incorporated an entrance portico constructed with columns that recall ancient Egyptian forms and described the building as 'his Parthenon' (Figure 1.3).[20] Soviet architects drew on the more recent past for formal inspiration as well. Zinovii Rozenfel'd adapted his apartment building on Gorky (now Tverskaia) street in Moscow, built during 1976–7, to the scale, rhythm, and decorative scheme of its context – that is,

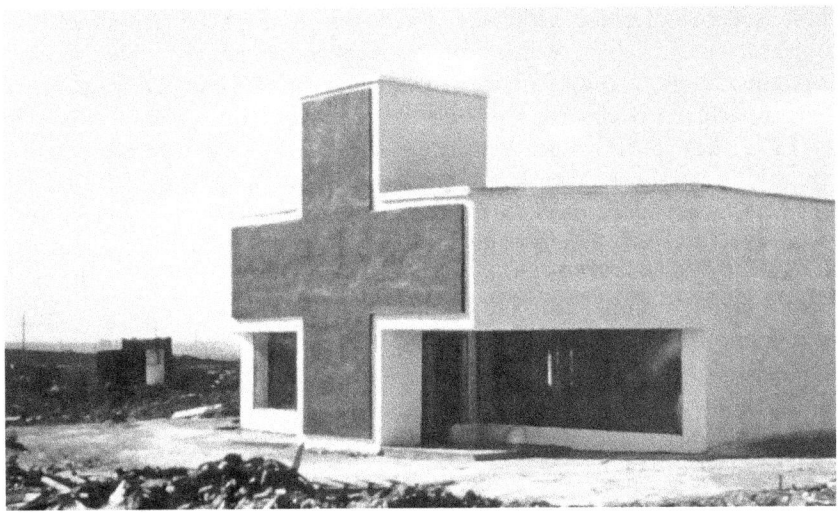

FIGURE 1.2 *A. Larin and E. Asse, Pharmacy No. 375, Orekhovo-Borisovo, Moscow, 1975. Photo courtesy of Eugene Asse.*

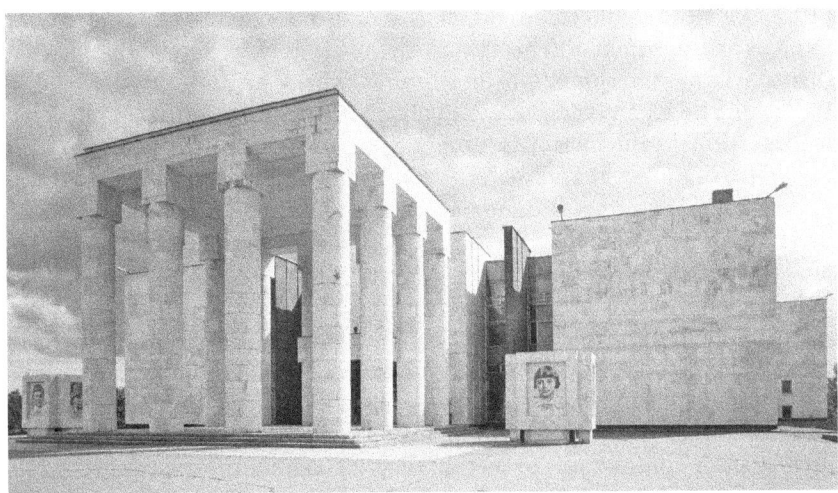

FIGURE 1.3 *Leonid Pavlov, V. I. Lenin Museum, Gorki Leninskie, Moscow District, 1974–87. Photo courtesy of Richard Anderson.*

to the urban architecture of the Stalin era. Likewise, the Government House of the Russian Soviet Federative Socialist Republic (1965–81), designed by Dmitrii Chechulin and others, made explicit reference to Chechulin's project for the Aeroflot Headquarters of 1934. This building divided professional and popular opinion more than most. In 1979, before the building was even completed, Riabushin reported that the public reception of the building was

increasingly positive, while differences of opinion within professional circles were pronounced.[21]

Despite the evident interest in historical citations and communicative strategies on the part of Soviet architects, there remained great scepticism about the potential value of postmodernism for Soviet practice. Architects who were trained during this period recall that when students at the Moscow Architecture Institute first sought to engage with postmodernist work arriving in Moscow through the press, there was a strong reaction from the administration against the high degree of receptivity among the student body.[22] Even Vladimir Khait, following the relative enthusiasm he and Riabushin had expressed in 1979, would himself recognize the difficulty in relating postmodern practice to Soviet culture. In an essay of 1982 entitled 'The Problem of the Relationship to the Architectural Experience of Capitalist Countries', Khait made the following concessions:

> Only an understanding of the architecture of the West not as a sum of professional techniques, but as an internally heterogeneous constituent element of the economic and ideological structure of capitalist society will help us grasp the processes currently underway and methodically ensure the use of all the progressive qualities they contain for the further betterment of Soviet architecture.[23]

While this can be understood as a refinement of the position Khait and Riabushin articulated with regard to postmodernism in 1979, the fact that Khait felt it necessary to offer theoretical justification for this procedure registers the degree of scepticism surrounding postmodernism in Soviet discourse. Indeed, some critics openly objected to the suggestion that there might be parallel interests among Soviet architects and their Western colleagues. To cite one example, the critic Viacheslav Glazychev wrote in 1983 that 'there is not and cannot be any substantial similarity between our work and postmodernism. ... Postmodernism is above all an amusement [*zabava*], and in our architecture ... the idea of amusement doesn't exist.'[24] Glazychev's insistence on the seriousness of Soviet architecture suggested a view that the Soviet architect's first priority was the production of space and that formal experimentation was only a secondary concern.

As the debate on postmodernism unfolded in the Soviet press, an event of 1982 invested it with a new sense of urgency: the competition for a new home for the Academy of Fine Arts of the USSR in Moscow. Despite the small number of entries – only eight were submitted – the jury and other commentators understood the event as an important moment in Soviet architectural design. Riabushin wrote that the discussion of the competition projects was in fact a discussion of the 'future path of development of our architecture as a whole'.[25] But the entries did not indicate a clear path forward. They ranged from Grigorii Zakharov's project, which many viewed as a direct return to the principles of the Stalinist 1940s and

1950s, to Evgenii Rozanov's and Iakov Belopol'skii's projects, each of which reinterpreted pre-Renaissance Russian forms (Figure 1.4). Mikhail Posokhin's project, which was awarded the first prize, combined a portico in the shape of a triumphal arch and a centralized plan (Figure 1.5). Riabushin described it as a 'combination of contemporary interpretations of Roman-baroque classicism'.[26]

In the published discussions of the projects, it emerged that both participants and commentators felt the works submitted raised serious problems for Soviet architectural design. Anatolii Polianskii, first secretary of the Union of Soviet Architects and competitor, identified the most pressing of these as the so-called retro problem (*problema 'retro'*). Indeed, the formal tendencies visible in projects for the Academy of Fine Arts induced an anxiety about the possible re-emergence of the 'decorativism' of a bygone era.[27] Polianskii went further still, noting that 'retro' buildings tended to display the same features that many critics had identified as negative aspects of postmodernism. 'Architectural works in the "retro" style', he wrote, 'are usually distinguished by a lack of taste and a high price; at the same time they are often highly valued by the client [*zakazchik*].'[28] Polianskii's criticism of a costly, tasteless, and consumer-oriented approach to architecture echoed many of the suspicions raised about postmodernism in the West, but he seemed to suggest that Soviet architects risked making the same mistakes. He reminded his colleagues that one of the tasks of the architect was 'to remember the responsibility for elevating the tastes of those for whom we

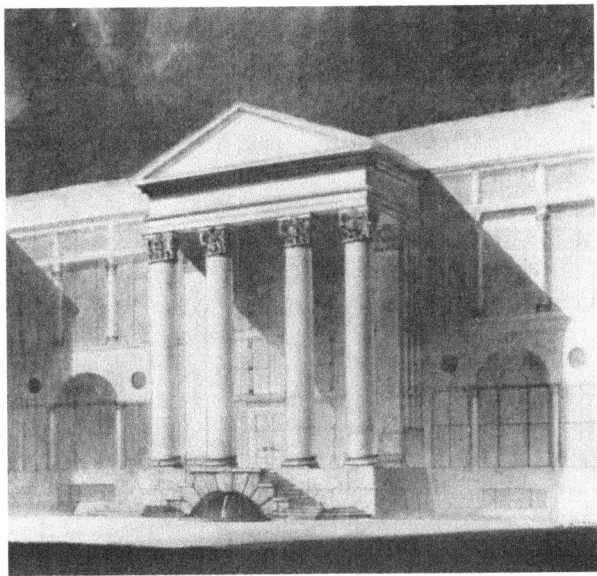

FIGURE 1.4 *G. Zakharov, Academy of Fine Arts of the USSR, 1982 (competition project).*
Source: Arkhitektura SSSR, *1983, No. 3 [Courtesy of Richard Anderson].*

FIGURE 1.5 *Mikhail Posokhin, N. I. Pyshkin, S. I. Nekrasov, S. I. Kulev, Academy of Fine Arts of the USSR, competition project, 1982.*
Source: Arkhitektura SSSR, 1983, No. 3 [Courtesy of Richard Anderson].

work'.[29] Iurii Gnedovskii brought the relationship between the results of the competition and the debate on postmodernism into even sharper focus:

> The competition is very interesting because it demonstrates the shift in the creative thinking of the leading architects of the country – their relationship to heritage and their work in a historical context. Here we find the same processes that are underway in world architecture, in which the values of the 'modern movement' [*sovremennoe dvizhenie*], which not long ago appeared unshakable, are under reconsideration. In these processes there is the positive desire for a more humanized and comprehensible social environment with its relationship to history. But there is also the danger of rejecting the indisputable achievements of 'modern architecture' [*sovremennaia arkhitektura*] and returning to an earlier 'decorativism'.[30]

While Gnedovskii did not mention postmodernism explicitly, his reference to this body of ideas is clear. But what was perhaps most significant about the statements made by Polianskii and Gnedovskii is that they introduced a new term into the debate on postmodernism, namely 'decorativism'.

In the competition for the Academy of Fine Arts, the tension between a desire for rich, historically inflected architecture and the memories of the 'decorative excess' characteristic of the Stalin era came into clear view.

It highlighted the particular relationship between formal richness and rationalist imperatives within Soviet architectural culture. 'Decorativism' and 'decorative excess' were the preferred terms of the Khrushchev era that contributed to the de-Stalinization of Soviet architecture; their re-emergence in 1982 signalled an anxiety among architectural professionals that tendencies refuted – or overcome – in the generation since Stalin's death might re-emerge as well. This anxiety was not unfounded. Most of the competition participants had practised and built during the late 1940s and the early 1950s using a rich palette of historical motifs. Understood in this way, the 'retro problem' identified in the early 1980s seemed to register the danger of a return to earlier positions, rather than a move forward.

The 'retro problem' raised additional problems for the interpretation of Soviet architecture of this moment as well. Concerns emerged about the relationship between postmodernism and the doctrine of 'socialist realism' in Soviet architecture – a relationship that has given rise to much confusion. As early as 1988, Soviet architects recognized that it had become commonplace among Western critics to identify parallels between the 'Stalinist architecture' of the 1930s–1950s and the aims of postmodernism in the West.[31] Likewise, Russian critics and historians have used the concept of postmodernism as a parallel to help explain the transformations of architectural culture in the early 1930s.[32] While such historical analogies might help describe the development of architecture in the USSR from the 1930s in general terms, they are of little use when trying to understand the specific relationship between postmodernism and late-Soviet architectural culture.

This is because 'socialist realism' was not a key term in the debate. As Catherine Cooke has pointed out, 'socialist realism' remained the orthodox theoretical framework within which Soviet architecture was practised well into the 1980s.[33] 'Socialist realism' was never repealed or revoked as a theory or a doctrine, but it did fade into the background of architectural discourse amid the Khrushchev era campaign against decorative excess. While 'socialist realism' remained a constant, a new keyword entered the Soviet vocabulary in the debates surrounding postmodernism – modernism. *Modernizm*, as a concept, had rarely appeared in Soviet architectural discourse.[34] *Sovremennaia arkhitektura*, roughly translated as 'contemporary' or 'modern' architecture, lacked the ideological baggage associated with 'modernism' and was the preferred term. Only in discussions of postmodernism did the interpretation of modernism become a problem for Soviet criticism. Riabushin and A. Shukurova pointed this out in an article on the 'Creative contradictions of new architecture in the West' of 1982, later published as a book in 1986, where they wrote,

> The problem of modernism [*modernizm*] for us remains unformulated. But we can already name with certainty a number of particularities

of modernist [*modernisticheskii*] consciousness in the way they are expressed in architecture. Thus, the orientation of artistic creation to total innovation, to the value of the new in and of itself, which corresponds to the conceptual values of the 'modern movement' [*sovremennoe dvizhenie*], stand out among other constitutive characteristics of the modernist worldview.[35]

Riabushin and Shukurova ultimately concluded that the features of recent postmodern architecture in the West were 'genetically linked' and 'predetermined by the evolution of modernism', despite the 'anti-contemporary position' (*kontrsovremennost'*) of many of its proponents.[36] This conclusion suggested a shift in Riabushin's understanding of postmodernism as a set of practices demonstrating parallel interests between architects in the USSR and those in the West. It placed a new limit on the degree of similarity Riabushin ascribed to this relationship. What is more, it confirmed his view that the question of postmodernism in the USSR could not possibly be raised, for modernism itself – as a distinct artistic and architectural ideology – played little role in the development of Soviet architecture.

While the analysis of postmodernism in the West as an epiphenomenon of modernism remained somewhat abbreviated and unresolved, the explanatory model offered by Riabushin and Shukurova offered insights into the relationship between postmodernism and Soviet architectural culture. The postulate that postmodernism was in fundamental ways predetermined by the evolution of modernism depended on the recognition of dynamics and traits specific to the development of architecture in the capitalist world. This in turn suggested that the evolution of Soviet architecture might possess dynamics of its own. Riabushin first outlined this process in an essay entitled 'Functionalism – a dialectic of negation' of 1983.[37] He reinforced and expanded his discussion of the 'dialectic of negation' [*dialektika otritsanniia*] in his book *Gumanizm sovetskoi arkhitektury* (The Humanism of Soviet Architecture) of 1986.[38] Riabushin differentiated the dialectical development of Soviet architecture from the work underway in the West using, again, the example of Venturi. He wrote that Venturi, among other Western architects, abandoned the principle of a necessary relationship between form and function, which was something that Riabushin's Soviet colleagues were unwilling to do. Instead, he described the evolution of Soviet architecture as the expression of an 'inner conflict' of architectural values. According to this logic, the formal asceticism of the 1920s gave way to a period of interest in formal richness of the 1930s to the 1950s. Likewise, the 'technical determinism' of the 1960s produced interest in expressive, communicative forms of the 1970s and the early 1980s. What was important for Riabushin – and important for understanding the relationship of postmodernism to Soviet architectural culture – is that the negations he described, as elements of a dialectical process, were simultaneously acts of assimilation and affirmation. He wrote that 'functionalism' was to be

rejected as an orthodox doctrine, but not as a fundamental element of contemporary architectural practice:

> Functionalism, it seems, still has its historical chance. It is too early to bury it. But there is no reason to try to artificially preserve it on the scene of architectural history. A dialectic of negation – thus, to all appearances, can we correctly formulate our relationship to it, proceeding from the humanist aspirations of our architecture.[39]

Riabushin's critique of functionalism was also a broader statement on the dynamics of the development of Soviet architectural culture. While perhaps too narrowly construed, Riabushin's dialectic of negation both captured the specificity of Soviet architecture's history and indicated why Soviet architects had devoted such attention in the 1970s and early 1980s to the problems of architectural expression, contextual design, and historical forms. This descriptive model also precluded interpretations of these interests as a return to the principles of the Stalin era; they appeared instead as a new articulation of aims in a forward-looking architectural culture.

For a few short years, roughly between 1979 and 1985, postmodernism had a specific force of attraction and repulsion within the dialectic described by Riabushin. Postmodernism named a number of Western architectural practices and aspirations that resonated deeply with Soviet professionals and critics. It seemed to represent a field of overlapping interests between Soviet architects and their Western colleagues. For optimistic critics like Riabushin, the professional, properly architectural, merits of postmodernism were worthy of study and possible adaptation to Soviet conditions. And although the divergence of views among Soviet architects on postmodernism would not be easily resolved, there is little doubt that the attention devoted to it by Soviet critics was due to the real recognition of parallel, though not convergent, interests in capitalist and socialist worlds.

But the year 1985 brought a significant change in the Soviet reception of postmodernism. Ironically, it was the publication of the Russian edition, edited and introduced by Riabushin and Khait, of Charles Jencks's *The Language of Postmodern Architecture* that registered this discursive shift. In their introduction to Jencks's book, Riabushin and Khait adopted a tone quite different from their first engagement with postmodernism of 1979. While their earlier essay spoke of the possibility of translating 'professional methods' across architectural systems, their introduction of 1985 diagnosed a widespread sense of crisis:

> There is no doubt that Charles Jencks's book *The Language of Postmodern Architecture* will be met with great interest by Soviet readers. Familiarity with it will help both architects and non-architects to critically understand this contradictory but influential movement in the architecture of capitalist countries of the 1970s and '80s – to understand

the sources and development of the crisis of architecture in capitalist society and the attempts to escape it.[40]

Gone was the openness and potential for ideological 'cleansing' of postmodern methods from the West. The theme of crisis as the ultimate meaning of postmodern architecture in the capitalist world would be reinforced only a few years later with the fourth volume of the influential series of anthologies *Arkhitektura zapada* (Architecture of the West), published by the Central Scientific-Research Institute for the Theory and History of Architecture, the institute where Riabushin and Khait worked. Appearing in 1987, the subtitle of volume four was 'Modernism and Postmodernism: Criticism of Concepts'.[41] This was a critical survey of the architecture of postmodernism in the West addressing the work of key figures including Kisho Kurokawa, Charles Moore, Philip Johnson, and others. The volume was nevertheless introduced by Khait with an unwitting paraphrase of Venturi's words: 'Postmodernism and "High-Tech" not only expressed, but also aggravated the immanent heterogeneity of the architecture of the West – its complexity and contradiction.'[42] There was no way out of this crisis, Khait concluded, without a radical change in the economic, social, and cultural conditions of its production.

Such a critical view of postmodernism would not hold for the younger generation of architects who were coming of age in the turbulent years of *Perestroika*. A remarkable essay by the young architect Mikhail Tumarkin entitled 'The Genesis of the Architecture of Postmodernism in the USSR' is a case in point. Written in 1988, Tumarkin's essay conveyed the desire of his generation for a new or new/old approach to architecture. But it also offered an interpretation of postmodernism that would have been foreign to his colleagues only a few years earlier. For Tumarkin saw the future prospects of postmodernism in the USSR in the development of new forms of architectural design cooperatives, individual construction, and the revival of an old architectural principle – 'he who pays the piper calls the tune'.[43] Thus, the capitulation to market forces, which had been so strenuously rejected by Soviet critics such as Riabushin, Khait, and Glazychev, was incorporated into the narrative of the 'genesis' of Soviet postmodernism. This simultaneously paved the way for the ensuing reorganization of the architectural profession to suit a market economy and obscured the complex role of postmodernism in Soviet architectural culture.

Notes

1 A. V. Riabushin and V. Khait, '"Postsovremennaia arkhitektura"- minusy i pliusy', *Dekorativnoe iskusstvo SSSR*, no. 10 (1979): 34–40. Architectural postmodernism had been mentioned by Soviet critics earlier that year, but this essay represented the first sustained engagement with the theory

of postmodernism in the Soviet Union. On the brief discussions of postmodernism in the newspaper *Arkhitektura* see Catherine Cooke, 'The "Meaningful Messages" of Post-Modernism', *Architectural Design* 51, no. 5 (1981): 41–3.

2. V. Khait, *Sovremennaia arkhitektura Brazilii* (Moscow: Stroiizdat, 1973).
3. See the short biography accompanying the essay A. V. Riabushin, 'Zrelost' professii', *Arkhitektura SSSR* 49, no. 9 (1981): 8.
4. Riabushin and Khait, '"Postsovremennaia arkhitektura"- minusy i pliusy', 34.
5. See Golberger's introduction to the special issue of *Architectural Design* (1977, no. 4) devoted to postmodernism in architecture.
6. Riabushin and Khait, '"Postsovremennaia arkhitektura"- minusy i pliusy', 39.
7. It is useful to note that in Soviet architectural discourse of the 1970s and 1980s the labels 'architecture the capitalist world' and 'architecture of the West' were used almost interchangeably. Significantly, the 'West' referred to here is not simply a geographic descriptor. It included advanced capitalist economies such as Japan as well.
8. Riabushin and Khait, '"Postsovremennaia arkhitektura"- minusy i pliusy', 39.
9. On the interest in the national architectures of the USSR, see Iu. Iaralov, *Natsional'noe i internatsional'noe v sovetskoi arkhitekture* (Moscow: Izdatel'stvo literatury po stroitel'stvu, 1971).
10. Iu. L. Kosenkova, 'Osvoenie naslediia kak sredstvo gumanizatsii arkhitekturnoi sredy', *Arkhitektura SSSR*, no. 4 (1978): 46.
11. A. V. Riabushin, 'Arkhitektura i ideologiia', *Arkhitektura SSSR* 50, no. 5 (1982): 17.
12. Riabushin, 'Arkhitektura i ideologiia'.
13. See Robert Venturi, 'Iz knigi "Slozhnost' i protivorechiia v arkhitekture",' in A. Ikonnikov, ed., *Mastera arkhitektury ob arkhitekture* (Moscow: Iskusstvo, 1972), 543–58.
14. A. Ikonnikov, ed., *Mastera arkhitektury ob arkhitekture* (Moscow: Iskusstvo, 1972), 542.
15. A. Ikonnikov, *Arkhitektura SShA* (Moscow: Iskusstvo, 1979).
16. Ikonnikov, *Arkhitektura SShA*, 161.
17. Riabushin and Khait, '"Postsovremennaia arkhitektura"- minusy i pliusy', 35.
18. For this description of the building as a 'sign' see Irina Korob'ina, 'Aleksandr Larin', *Arkhitektura SSSR*, no. 6 (1985): 49.
19. In a conversation with the author (July 2014), Asse described the pharmacy as an attempt to 'combine constructivism with the work of Robert Venturi'.
20. See Anna Bronovitskaia, ed., *Leonid Pavlov* (Milan: Electa, 2015).
21. A. V. Riabushin, 'Arkhitektura, sreda, kul'tura', *Arkhitektura SSSR*, no. 7 (1979): 3.
22. Mikhail Tumarkin, 'Genezis arkhitektury postmodernizma v SSSR', *Arkhitektura i stroitel'stvo Moskvy* 20, no. 11 (1988): 20.

23 V. Khait, 'Problema otnosheniia k arkhitekturnomu opytu kapitalisticheskikh stran', *Arkhitektura SSSR* 50, no. 3 (1982): 57.
24 V. Glazychev, 'Postmodern v aspekte sotsiologii', *Dekorativnoe iskusstvo SSSR*, no. 1 (1983): 31.
25 'Novoe zdanie Akademii khudozhestv SSSR', *Arkhitektura SSSR* 51, no. 3 (1983): 38.
26 A. V. Riabushin, *Gumanizm sovetskoi arkhitektury* (Moscow: Stroiizdat, 1986), 345.
27 See 'Novoe zdanie Akademii khudozhestv SSSR', 33. Many of the architects who participated in the competition had practised during the heyday of post-Second World War triumphalist excess.
28 Ibid., 33.
29 Ibid.
30 Ibid., 35.
31 Tumarkin, 'Genezis arkhitektury postmodernizma v SSSR', 22.
32 Tarkhanov and Kavtaradze describe the architecture of the Stalin era as 'anticipating postmodernism'. See, for example, Alexei Tarkhanov and Sergei Kavtaradze, *Architecture of the Stalin Era* (New York: Rizzoli, 1992), 6. Likewise, Selim O. Khan-Magomedov described the 'Post-Constructivist' phase of Soviet architecture, from 1932 to 1936, as undergoing the same transformations that would develop forty years later in the West. See S. O. Khan-Magomedov, *Arkhitektura sovetskogo avangarda*, 2 vols. (Moscow: Stroiizdat, 1996), 1: 638–9.
33 See Catherine Cooke, 'Soviet Reaction to Post-Modernism', *Architectural Design News Supplement* 1, no. 1 (1982): 18–21. Anatolii Polianskii would also continue to insist on the importance of socialist realism for Soviet architecture in the early 1980s. See A. Polianskii, 'Problemy tvorcheskogo soiuza', *Arkhitektura SSSR* 50, no. 5 (1982): 1–9.
34 In the 1970s, modernism was primarily addressed as an aspect of the fine arts. Many Soviet commentators described modernism as a concept specifically tied to the capitalist cultural system. See I. S. Kulikova, *Filosofiia i iskusstvo modernizma* (Moscow: Izdatel'stvo politicheskoi literatury, 1974); V. A. Kriuchkova, *Sotsiologiia iskusstva i modernizm* (Moscow: Izobrazitel'noe iskusstvo, 1979).
35 A. V. Riabushin and A. Shukurova, 'Tvorcheskie protivorechiia v noveishei arkhitekture Zapada', *Arkhitektura SSSR* 50, no. 10 (1982): 59. This essay would be greatly expanded in book form and published in 1986: A. V. Riabushin and A. Shukurova, *Tvorcheskie protivorechiia v noveishei arkhitekture Zapada* (Moscow: Stroiizdat, 1986).
36 Riabushin and Shukurova, 'Tvorcheskie protivorechiia v noveishei arkhitekture Zapada', 59.
37 A. V. Riabushin, 'Funktsionalizm - dialektika otritsaniia', *Dekorativnoe iskusstvo SSSR*, no. 10 (1983): 33–4.
38 Riabushin, *Gumanizm sovetskoi arkhitektury*, 362.

39 Ibid.
40 A. V. Riabushin and V. L. Khait, 'Postmodernizm v arkhitekture zapada i "Iazyk arkhitektury postmodernizma",' in A. V. Riabushin and V. L. Khait, eds., *Iazyk akhitektury postmodernizma* (Moscow: Stroiizdat, 1985), 9.
41 *Arkhitektura zapada. 4. Modernizm i postmodernizm, kritika kontseptsii* (Moscow: Stroiizdat, 1987).
42 V. Khait, '"Sovremennoe dvizhenie" i postmodernizm v arkhitekture kapitalisticheskikh stran', in *Arkhitektura zapada. 4. Modernizm i postmodernizm, kritika kontseptsii* (Moscow: Stroiizdat, 1987), 15.
43 Tumarkin, 'Genezis arkhitektury postmodernizma v SSSR', 22.

2

Humanizing the living environment and the late socialist theory of architecture

Maroš Krivý

In a diagram sketched in 1965, Slovak architect Iľja Skoček outlined the post-war history of housing design in socialist Czechoslovakia as a dialectical succession of three moments (see Figure 2.1). The 1950s were depicted by a monumentally ornate, yet compact housing estate, while the 1960s were characterized by an open-plan cluster of slabs and towers. These two sketches, representing, respectively, the socialist realist and functionalist variants of urbanism, were crossed out. The third moment was illustrated with a question mark and three symbols: a sun, a hand, and a cuboid. The challenge for socialist housing, intimated in this diagram, was to overcome the shortcomings of the first two moments by synthesizing their respective merits: the humanistic design of socialist realism and the scientific-technological rationality of functionalism.

Founded in 1948, *Stavoprojekt*, a state-wide network of design and engineering offices, was the bedrock of post-war architectural collectivization in Czechoslovakia. No sooner than the institution subscribed to inter-war functionalism and its key tenets (typification, standardization, mass production), that philosophy was challenged by the socialist realist revival of traditional architecture languages and urban forms, after the Soviet Union extended its influence to Central Europe. The socialist realist program, the first moment in Skoček's scheme of things, was displaced by the second coming of functionalism at the end of the 1950s, precipitated by Khrushchev's pivotal critique of Stalinist architecture, in 1956, for

FIGURE 2.1 *A sketch by Ilja Skoček, 1965. Published without a caption in the essay 'Housing Problems'.*
Source: Ilja Skoček, 'Problémy bývania', Projekt 7.6 (1965), 120.

prioritizing the qualitative over the quantitative. Yet within less than a decade, that program itself began to falter.

If the simultaneous crossing out of the two programs – by Skoček and by history, as it were – was ripe for a dialectical interpretation, then architectural theory played a critical role in articulating their synthesis. From the perspective of dialectical materialism, the functionalist principles of typification and standardization were invaluable to the construction of socialism. Yet, since the late 1960s, the same perspective charged architecture

for failing to resolve the 'quantitative' agenda of post-1956 functionalism at a qualitatively higher level. How would theorists come to grapple with that conclusion?

Institutional context

This chapter studies theoretical strategies to synthesize socialist realist and functionalist principles, as they pertained to socialist housing design. It turns to arguments elaborated at the Department of Architectural Theory (*Kabinet teorie architektury*, KTA) at the state-designated Research Institute for Building and Architecture (*Výzkumný ústav výstavby a architektury*, VÚVA); and the Department of Architectural Theory and the Living Environment (*Kabinet teorie architektury a životního prostředí*, KTAŽP) at the Czechoslovak Academy of Sciences' Institute of Theory and History of Art. The notions of the living environment[1] and architectural humanization,[2] debated within these departments between the mid-1960s and 1980s, foregrounded alternatives to the apparent tedium and monotony of socialist functionalism. Dialectical materialism made concessions to environmentally inflected strands of psychology, semiotics, and aesthetics, as they percolated into architecture via phenomenology, and later postmodernism. Yet theorists expanded rather than abandoned the functionalist creed, propounding that the satisfaction of residents' psychological, semiotic, and aesthetic 'needs' was vital to a cohesive and productive socialist society.

The institutionalization of architectural theory in post-war Czechoslovakia was coincident with the introduction of socialist realism to architecture. In 1954, VÚVA, as well as KTA as its relatively loose theoretical section, was founded under the auspices of the Czechoslovak Ministry of Construction. For Zdeněk Lakomý, a champion of the Soviet variant of socialist realism and VÚVA's later director, this was an important milestone 'leaving behind the era, when theory was considered superfluous and independent from practice, when architecture developed spontaneously, without a plan and theoretical foundations, on the basis of a superficial pragmatism'.[3] In contrast to the interwar left avant-garde (Karel Teige, Karel Honzík), theory was for Lakomý an epitome of socialist realism itself, opposed to the mere 'theses' of bourgeois functionalism. Lakomý did not reject industrialization, but foregrounded the ideological role of expressive architecture, cultivated environments, and artistic urban compositions.

The shift from socialist realism to functionalism coincided with the reorientation of VÚVA's research from the historical study of composition to experimenting with new construction techniques, as well as rethinking architecture as an environmental design. In 1964 Lakomý became the founding director of the short-lived KTAŽP (closed in 1971), an influential research centre that probed architectural aspects to post-Stalinist socialist

revisionism. Together with Otakar Nový, the former deputy director of Stavoprojekt, Lakomý contributed a chapter on the living environment to the *Civilization at the Crossroads,* an interdisciplinary report about the future of socialism, commissioned by the Communist Party and published in 1966. Edited by philosopher Radovan Richta, the author of the motto 'socialism with a human face', the report integrated Marxism with cybernetics and phenomenology, proposing that the scientific and technological revolution was prerequisite to transforming socialism into communism.[4] Managing collectively owned means of production, Richta highlighted, required technical expertise and automation, as well as creativity and subjectively meaningful self-development of socialist citizens.

Consistent with the dialectical thrust of the report was Lakomý's and Nový's argument that architecture is a synthesis of the technical and the aesthetic. Despite – or because of – the fact that Lakomý was a socialist realist exponent, while Nový championed functionalism, they jointly advanced the living environment concept as integrating the totality of spatial production with the singularity of embodied meanings.[5] Because architecture must simultaneously heed the scales of 'territories, countries and continents', and 'human development, human needs and the human factor as such', Lakomý and Nový argued, a differentiated and diversified living environment was critical to cultivating human productive forces, and facilitating the 'style of life as [the essence] of human self-realization'.[6]

The living environment and the natural world

How did phenomenology influence the programs of environmentalizing and humanizing architecture? Among participants in seminars organized by KTAŽP was Dalibor Veselý, the future exponent of the phenomenological theory of architecture, who emigrated from Czechoslovakia in 1968.[7] For Veselý, 'the problem of environment ... is primarily an outgrowth of the structure of our world', that is, 'the primary given reality ... as the natural world', revealing the influence of Czech philosopher Jan Patočka, the erstwhile student of Edmund Husserl.[8] For Patočka, the natural world was not the world of empirical facts, but the 'universal horizon ... on the basis of which alone real determinate facts can be apprehended'.[9] His transcendental idealism foregrounded the split between the worlds of techno-science and pre-theoretical attitudes. The production of truth by the former, according to Patočka, displaced the latter as a mere appearance: 'The reason why modern man ... no longer lives in the natural worldview, is that our natural science is ... a radical reconstruction of the naive and natural world of common sense.'[10]

In Veselý's phenomenology of architecture, however, transcendental idealism has regressed to the idealism pure and simple.[11] Since the transcendental

epoché of the empirical reality is inconsistent with architecture's practical interests, from the architectural theory perspective phenomenology tends towards a cultural critique of techno-scientific rationality. Recollecting the life 'on the east side of the wall', Veselý maintained that 'at stake was not politics itself but ... the humanity of institutions ... [and] architecture'.[12] While contrasting humanity and techno-science, he sidestepped how politics and history determine this very contrast. According to the historian Joseph Bedford, Veselý conceived history as 'a process of increasing abstraction from the original ground of lived experience'.[13]

In 1967, Veselý wrote an afterword to the Czech translation of Michel Ragon's *Where Shall We Live Tomorrow?*. Rejecting the French critic and futurologist's techno-positivist world view, he insisted that human beings have 'natural [*přirozené*] dispositions', and characterized the sense of space as a psychophysiological constant that 'has remained virtually unchanged since prehistoric times'.[14] Invoking the authority of 'biology, psychology and anthropology', Veselý argued that 'the experience of lived environment [*zážitek prožívaného prostředí*] was ingrained in the deeper and relatively stabilized strata of the human psyche'.[15] Turning to Husserl's critique of geometry and Heidegger's thematic of dwelling, the shift from forms to meanings was consistent with his conviction that architecture should affirm the 'natural world' (the afterword was interspersed with terms such as 'natural development', 'natural existence', and 'natural environment'). Even as Veselý turned Ragon's titular question into 'how shall we live tomorrow?', there remained a dearth of historical and political aspects to his 'environmental' definition of architecture as a reflection of sedimented psychological archetypes.[16]

Department of Architectural Theory

The concept of the living environment featured centrally in the late 1960s' revision of socialist architecture in humanistic terms – the fact testified by the very name of KTAŽP. The notion was introduced concurrently by Marxist aesthetics and phenomenology. However, rather than interpreting this as a local inflection of broader 1960s' trends (think Lefebvre), we need to consider the following paradox. If the Soviet invasion of Czechoslovakia put an end to socialist humanism in politics, and marked a political shift towards real socialism, then the program of humanizing and environmentalizing architecture only intensified during the 1970s to the 1980s. If KTAŽP was dissolved in 1971, then KTA carried that program forward.

In Czechoslovak post-1968 politics, phenomenology functioned as a principal alternative to state-sanctioned dialectical materialism, and it would not be off the mark to say it was the official philosophy of dissent. In the architecture of that period, however, there was hardly such a clear-

cut opposition: phenomenological attentiveness to meanings (psychological and environmental) converged obliquely with Marxist-Leninist inquiry into architecture's ideological efficacy. Even if they did not explicitly use phenomenological language, theorists at KTA advanced socialist architecture on the grounds of its meaning: environmental, psychological, semiotic, and aesthetic.

The appeal of the simplified and formulaic notion of the scientific and technological revolution to the Communist Party's post-1968 leadership, namely that popular politics can be eluded by fusing techno-science to quality-of-life policies, should not be discounted either.[17] The reification of socialism as really existing amplified the notion's latent ambivalences, splintering architecture further into technocratic prognostication on the one hand and pseudo-humanistic psychology on the other. Fraught attempts to fix this tension, as I discuss below, can be also interpreted as the very content of KTA's theoretical production. Compared to KTAŽP's institutional context of art history, KTA functioned alongside the applied research in construction and development, and was therefore more sensitive to contradictions between architectural theory and practice. Put otherwise, the late socialist architectural theory produced at KTA was a theory of how to fix the split between the theory and practice, and between the socialist ideal of architecture as an all-embracing living environment and the subsumption of architecture under the quantitative criteria of construction industry and economy.[18]

Yet if the environmental synthesis was a pervasive trope in architectural theory before and after 1968, there was a gradual shift from the ideal of an ordered totality to that of a synthetic diversity. While desirability of aesthetically and semiotically diverse environments was certainly precipitated by the cautious reception of Western postmodernism during the 1970s to the 1980s, the same period saw a circumspect rehabilitation of socialist realist housing projects built in the 1950s.[19] Architects indicted post-Stalinist architectural industrialization as a socially and ideologically dysfunctional 'pseudo-functionalism', and condemned obsolete types, forms, and moulds, typified and standardized according to yesteryear's functional demands.

Developing that critique further, theorists maintained that functionalism was wrongly implemented. Their charge was not that functionalism ossified into a style or an ideology, but that it was precisely no longer a 'living', sensibly apprehensible ideology. To put it in dialectical materialist terms, it was urgent to theorize why quantity did not produce quality, and how to fix it. The challenge for architecture set by theorists at KTA was to 'synthesize' the quantitative and the qualitative in a comprehensive yet internally differentiated living environment, balancing repetition and difference. Architectural industrialization, they maintained, must foster a meaningful living environment; the technological and ideological efficacies of architecture must be reconciled. The upshot was the turn in architectural theory towards human interiority, drawing on phenomenology inflected as the aesthetic, semiotic, and psychological study of environmental meaning.

Aesthetics, semiotics, psychology

An effort to reconcile two understandings of socialist realism, namely a specific architectural legacy and a universal design principle, informed the late socialist struggle for meaningful environments. Recuperating the centrality of theory to VÚVA, and of KTA to architectural theory, the psychology of architecture was systematized as a cognitive question of aesthetic perception and judgement formation. Modelling individuals as functional units, a well-balanced, semiotically legible environment was seen as determining requisite perceptual forms, instigating appropriate judgement, stimulating positive emotions, and fostering harmonic development of socialist individuals as versatile, well-rounded personalities.[20] In other words, environmentally induced sense perception was considered as an information need and a use value (intersecting phenomenological impulses with cybernetic ones). A doctoral student at KTA formalized it as a function $E = f(N, \Delta I)$, where E is emotion, N is basal needs, and I is information, and characterized such environmental psychology as a 'space therapy' (*prostoroterapie*) – as if surreptitiously implying that the residents of housing estates were so many patients in need of environmental treatment.[21]

Elaborating these ideas further, architectural theorist Bohuslav Dvořák explained that the statement 'we should erect buildings that are not only of a good quality, but also beautiful' was flawed, because it implied a possibility to build with quality, but without beauty. That statement was a contradiction in terms, because a 'high aesthetic level augments the use value, while a low one reduces it'.[22] Dvořák formulated the aesthetic principle that 'the origin and change of the architectural object's aesthetic value is conditional on the capacity of its outward form to signify non-aesthetic and other aesthetic values'.[23] The 'KTA aesthetic principle', as it was known, can be outlined as follows. Architecture has a semiotic function, where the perceivable form is the signifier, and values (rather than mere facts, Dvořák stressed) are the signifieds. Values can be positive, negative, neutral, or ambiguous, and they are intrinsic to the form as its latent potentials. The process of architectural semiosis is subconscious, and becomes conscious only when it is impeded, leaving semiotic potentials unrealized.

In seeking to revive the socialist realist principle of ideological efficacy (*ideovost*) in architecture, Dvořák's argument encapsulated another principle, namely semiotic objectivity, or truthfulness (*pravdivost*): architecture as a truthful reflection of social forms. Yet, unlike in the early socialist realism, where the aesthetic synthesis of ideology and objectivity functioned as a fervent political rallying cry – beauty as a route to the radiant future, as Catherine Cooke put it[24] – the rather dispassionate, late socialist synthesis functioned primarily as a critique of rampant post-Stalinist industrialization of architecture itself. This is suggested by the fact that Dvořák, compelled to qualify architecture's semiotic objectivity as existing in a state of potentiality, got caught in an idealistic position: if semiosis becomes conscious only when

it fails, how do we know that it failed? Semiosis fails only when it fails. In other words, the gist of Dvořák's argument is in the reversal of itself: late socialist architecture is ideologically ineffective (or even counterproductive) 'because' it is perceived as devoid of meaning.

Monotony

Demonstrating that architecture is devoid of meaning when it is monotonous, KTA charged monotony for the semio-political failure of *ideovost*. Theorist Michal Beneš remarked sardonically that 'everyone, who is familiar with … our recent housing projects, has an intuitive notion of monotony'.[25] Beneš, whose research project dealt with a 'struggle against monotony', argued that monotony was not simply the problem of repeating identical forms, but rather the problem of 'noise': 'The experience of stereotype, uniformity, and boredom … results from the repetition of identical information, signified by [these] forms. The absence of cognitive changes … has negative psychical consequences, such as frustration and stress.'[26]

Drawing on Abraham Moles and Kevin Lynch, Beneš formulated the question of monotony as the one of legibility and imageability. He referenced the 1978 study of housing estate residents by Czech historian of architecture Jiří Ševčík, who applied Lynch's mental mapping method in the context of a socialist mining town, and concluded that residents' way-finding was structured by abstract referents, such as house numbers.[27] Environmental monotony, manifest in the absence of semiotically charged landmarks and expressive facades, led to residents' disorientation. Following the KTA's aesthetic principle, Beneš related phenomenologico-psychological disorientation (the loss of meaning, and its negative effects on emotional balance and well-being) to the spatio-logistic one (the loss of one's way, which hinders individual and social productivity).

The quandary of monotony, according to Beneš, resulted from a wrongly practised standardization. Architectural standardization, embraced by functionalism as a means of fighting social inequality, regressed, since the 1960s, to the standardization of the user. If in the past progressive architecture facilitated equality by satisfying residents' basic needs, Beneš argued in the 1980s, then it needs to recognize residents' psychological diversity to sustain this progressive push. Monotonous living environments signified the insufficient variability of dwelling forms, and hence a deeper failure of the socialist society to acknowledge, through housing systems, policies, and design, diverse styles of life.

A socialist living environment worthy of the name would be integrated, yet internally differentiated. If the excess of differentiation (*izotónie*, or semiotic overload) was typical for capitalist urbanization, the basic struggle of socialism was with its absence.[28] Considering how to diversify environments

while maintaining their integrity, Beneš made a semiotic distinction between signs and super-signs. Standardized and prefabricated construction elements would function as signs composed into differentiated super-signs, namely apartment buildings and their living environment. The argument hinged on the 'scale' of standardization: in alignment with socialist realism, and in contrast to functionalism, the locus of meaning was situated not in the typical and generic, but in the specific and singular.

Yet Beneš also related monotony to social productivity. 'The satisfaction of diverse needs, interests and values, associated with diverse personality types, is contingent on the formal and typological diversity of housing. Housing diversity functions as an instrument to incentivize individuals to fulfil societal, economic and political goals, and to compensate them for contributing to these goals.'[29] For Beneš, the struggle against monotony conveniently circumvented the political question of defining societal objectives. And while the apparent impulse to reform architecture was to contain socialist revisionism, the subsumption of housing diversity under a productivist imperative foreshadowed, at the same time, how architecture would function under the post-socialist neoliberal condition.

Socialist realism and real socialism

Most prolific writer at KTA was architectural critic and editor Radomíra Sedláková. A graduate in architecture and aesthetics, in 1982 Sedláková earned a post-doctoral degree at the Research Institute of the Theory and History of Architecture in Moscow, under the supervision of Aleksandr Riabushin, the Secretary of the Union of Soviet Architects. Semiotically rich environments, Sedláková concurred with Beneš, could be achieved only by fundamentally reforming architectural industrialization, replacing the so-called 'closed' model of standardizing entire building types with an 'open' standardization of individual construction elements. Protesting that design creativity was checked under the closed model, she glimpsed in the open model a promise to reconcile the symbolism and modularity of architecture.

'A developed socialist society requires more than a quantity. ... Inevitably, it foregrounds the architectural quality of prefabricated apartment buildings ... and the quality of living environment these buildings generate', wrote Sedláková in a 1986 editorial, introducing an open construction system labelled P2.11.[30] The goal, she argued, was 'to offer a flexible instrument for real architectural design, ... a versatile yet universal kit of parts ... that would facilitate a truly creative design work. The stake of designers in architectural quality will be redeemed even under the condition of architectural industrialization.'[31] Although the P2.11 advanced a flexible interior planning, its primary effect, it could be argued, was symbolic. The kit of parts responded to the historical context of Prague's inner city, for which

it was developed: it liberated the facade as a medium of communication and historical simulation, and introduced a set of corner elements that facilitated site planning in conformity with the street and block morphology.

The pertinence of construction technology to ideological efficacy was not lost on Sedláková. While socialist realism was a design method, which conceived the future as a totality of human history's progressive elements, it was also a distinctive style of 1950s' housing design associated with open construction systems, street and block fabric, and articulated facades. Swaying back and forth between the methodological and stylistic notions of socialist realism was intrinsic to the late socialist theory of architecture. Its convoluted history (and historicity) was further complicated by the lateral reception of Western postmodernism, itself an image of the future representing history as a simulacrum.

Postmodernism

Reporting on the 1981 events of the International Union of Architects (its first Biennale in Sofia and a congress in Warsaw), which brought together participants from capitalist, socialist, and Third World countries, Sedláková wrote that the 'turn towards the historic, local, and vernacular is a manifest proof that distinctive national architectures are indispensable to the world architecture'.[32] Whereas 'pseudo-functionalism' was undoubtedly outdated worldwide, she continued, Western architects were deceived by fashionable retro-styles and postmodern mannerisms ignoring the urban context. As Sedláková argued, a true return to history cannot 'whine for lost historical values', it must 'ask why those values have been lost in the first place – and only then decide how to redeem them'.[33]

This question revealed the influence of Riabushin on Sedláková. 'Because we care today for the spiritual face of architecture', he exclaimed in a 1981 dialogue with the Czech theorist, 'we should look back to the 1930s'.[34] Riabushin condemned that 'as a consequence of the changes in the mid-1950s', namely the architectural industrialization initiated by Khrushchev, the architecture of the former period was rejected *in toto*.[35] A frequent guest in Czechoslovakia, Riabushin warned against the underlying 'theory' of postmodernism, but welcomed it as a critique of functionalism, and was receptive to its many parallels with socialist realism.[36]

In 1985, at an international conference on socialist realism in Poland, Sedláková reflected about 'the resemblance of socialist realism and postmodernism', insofar as both placed emphasis on legible urbanism and stylistic regionalism.[37] Her conference report was critical of the Soviet participants, who discussed socialist realism as a method and presented design projects from the 1970s and 'not from the stated period',[38] and noted that 'the value of socialist realism, as either a concept, or a period architecture

specific to the 1950s, is subject to a heated debate'.[39] While rejecting the commercial exuberance of postmodernism, like Riabushin, she was impatient with her Soviet colleagues' arguably abstract rendering of socialist realism as a method, thinking of it rather as a set of compositional principles.

Sedláková's stylistic revival of socialist realism – which rejected its ornate aesthetics and historically specific 'political futurism', but adopted its seemingly humane living environments as a design model for the 1980s – corresponded with her embrace of phenomenological and historicist strands of postmodernism. The loss of history in architecture was for her the loss of a meaningful unity-in-diversity. Maintaining that 'the beauty of old urban centers is in their ensemble-like quality ... synthesizing the language of diverse styles', she valued urbanity for its collage-like quality.[40] While 'good' postmodernism was for her a variant of classicism, describing it as a synthesis of historical styles, she defined the concept of style itself as a unity of function and beauty. Hence, if her notion of the classical converged with the 'synthetic' aesthetics of socialist realism, it also remained idealistic, grounded in a dubious 'historical law of stylistic alternation'.[41] Tellingly, Sedláková understood postmodern classicism literally as appearing after modern architecture as the 'worldwide revival of historical morphology and architectural communication'.[42]

Such idealistic views of postmodernism (and socialist realism) were reflected in the gradual substitution of socialist internationalism by 'multiculturalism' – Sedláková repeatedly associated postmodernism with nationalist, regionalist, and traditionalist revivals in late socialist architecture (highlighting the Baltic countries and Kazakhstan).[43] Under the real socialist condition, the notion of diversity was displaced from socialist politics onto architectural form, becoming a sum total of national particularities. There were ultimately no clear rules to set apart good postmodernism from the bad one, or to isolate the critique of modernism from consumerism. There were no clear rules for sorting out the methodological from the stylistic in socialist realism either. The synthesis became a Hegelian bad infinity, as it were, the postmodern world understood as an encyclopaedia of vernacular and regional styles.

Conclusion

Architectural theory was firmly embedded in the institutional structures of Czechoslovak state socialism, and it was perceived as important for articulating future directions of socialist architecture. The concept of the living environment, developed between the 1960s and 1980s at KTAŽP and KTA, challenged the monotony of functionalism, striving to synthesize its quantitative paradigm with the qualitative one. Revisiting socialist realist housing design, valued for its humanistic architecture and urbanism, theorists turned to the insights of semiotics, aesthetics, and psychology.

The answer to Skoček's question that opened this chapter was elaborated in the post-utopian context of real socialism. Even as it assimilated disparate influences – socialist realism, Marxist humanism, phenomenology, cybernetics, and postmodern aesthetics – the theory of the living environment gave way to forms of cultural moralizing, employing the weapons of beauty, identity, and authenticity against architectural monotony and urban tedium. The ambiguity of such a battle has not only persisted, but also intensified under the post-socialist condition, where the policies of creative, liveable, and sustainable cities facilitate uneven, segregating, and unjust forms of urban development.[44] Stripped from the public ownership of land, state-wide housing development programs, and centralized architectural practice – which late socialist theorists took for granted – the impulse to humanize the living environment nurtures today what we could call post-socialist – rather than socialist – realism.

Notes

1 Czechoslovak theorists used the term *životní prostředí*. Terms such as 'natural environment', 'human environment', 'man-made environment', or 'physical environment' do not capture this multilayered notion. Better but clumsy translation would be 'a physical and psychological environment of everyday life'.

2 This term alternated between *humanizace* and *polidštění*, and its meanings ranged from considering human beings in their individuality, to advocating human-scale architecture.

3 Zdeněk Lakomý, 'Úkoly výzkumného ústavu pro stavebnictví a architekturu ve vztahu k architektonické tvorbě', *Architektura ČSR* 10, no. 7–9 (1951): 287. Lakomý stated the above in 1951 when opening the Research Institute for Construction and Architecture, the VÚVA's short-lived institutional antecedent.

4 Radovan Richta et al., *Civilizace na rozcestí. Společenské a lidské souvislosti vědeckotechnické revoluce* (Prague: Svoboda, 1966).

5 Lakomý's name is carried on as a linguistic trace in the Czech word *sorela* (*so*cialist-*re*alism-*La*komý), a derogatory term for socialist realism. See Kimberly Elman Zarecor, *Manufacturing a Socialist Modernity: Housing in Czechoslovakia, 1945–1960* (Pittsburgh: University of Pittsburgh Press, 2011), 114. On Nový's support of functionalism see Ibid., 80.

6 In Richta, *Civilizace na rozcestí.*, 206–7.

7 Pavel Halík, 'Chodit vertikálně po horizontální zemi', ASB-portal.cz (12 February 2008), online at *http://www.asb-portal.cz/architektura/architekti/chodit-vertikalne-po-horizontalni-zemi*

8 Dalibor Vesely, *Architecture in The Age of Divided Representation: The Question of Creativity in The Shadow of Production* (Cambridge, MA: MIT Press, 2004), 60.

9 Jan Patočka, *The Natural World as a Philosophical Problem* (Evanston: Northwestern University Press, 2016), 83.
10 Patočka, *The Natural World as a Philosophical Problem.*, 8.
11 Theodor W. Adorno, *The Jargon of Authenticity* (Evanston: Northwestern University Press, 1973).
12 Dalibor Veselý, 'The Humanity of Architecture', in Neil Leach, ed., *Architecture and Revolution* (London: Routledge), 139.
13 Joseph Bedford, 'Being Underground: Dalibor Vesely, Phenomenology and Architectural Education During the Cold War', in Ákos Moravánszky and Torsten Lange, eds., *Re-Framing Identities. Architecture's Turn to History, 1970-1990* (Basel: Birkhäuser, 2017), 97.
14 Dalibor Veselý, 'Doslov', in Michel Ragon, ed., *Kde budeme žít zítra* (Prague: Mladá Fronta, 1967), 160.
15 Veselý, 'Doslov', 160.
16 Ibid., 164.
17 On life quality policies in post-1968 Czechoslovakia see Paulina Bren, *The Greengrocer and His TV. The Culture of Communism after the 1968 Prague Spring* (Ithaca: Cornell University Press, 2010).
18 On the notion of late socialism see Alexei Yurchak, *Everything Was Forever, Until It Was No More: The Last Soviet Generation* (Princeton, NJ: Princeton University Press, 2006). Whereas Yurchak marks the lateness of Soviet socialism by the end of Stalinism, the year 1968 is more apposite for Czechoslovakia.
19 See also Maroš Krivý, 'Greyness and Colour Desires: The Chromatic Politics of the Panelák in Late-Socialist and Postsocialist Czechoslovakia', *Journal of Architecture* 20, no. 5 (2015): 765–802; Maroš Krivý, 'Postmodernism or Socialist Realism? The Architecture of Housing Estates in Late Socialist Czechoslovakia', *Journal of the Society of Architectural Historians* 75, no. 1 (2016): 74–101.
20 Compare the convergent interest of Czechoslovak psychiatry in integrative human ecology. Sarah Marks, 'Ecology, Humanism and Mental Health in Communist Czechoslovakia', in Sarah Marks and Mat Savelli, eds., *Psychiatry in Communist Europe* (London: Palgrave Macmillan, 2015), 134–52.
21 Miluše Sedláková, *Úvod do architektonické psychologie* (Prague: VÚVA, 1981).
22 Bohuslav Dvořák, 'K některým estetickým a uměleckým otázkám architektury', in Kamil Dvořák, ed., *K aktuálním problémum dalšího rozvoje architektury a její teorie v ČSR* (Prague: VÚVA, 1984), 35.
23 Dvořák, 'K některým estetickým a uměleckým otázkám architektury', 58. See also Bohuslav Dvořák, *Základy estetiky architektury* (Prague: VÚVA, 1983).
24 Catherine Cooke, 'Beauty as a Route to "The Radiant Future": Responses of Soviet Architecture', *Journal of Design History* 10, no. 2 (1997): 137–60.
25 Michal Beneš, *Monotonie nových obytných souboru* (Prague: VÚVA, 1989), 10.

26 Beneš, *Monotonie nových obytných souboru.*, 6.

27 For an in-depth discussion of Ševčík see Krivý, 'Postmodernism or Socialist Realism?'.

28 Beneš, *Monotonie nových obytných souboru.*, 13.

29 Ibid., 83–4.

30 Radomíra Sedláková, 'Nová stavební soustava pro Prahu', *Architektura ČSR* 45, no. 1 (1986): 13. The author's name appeared in the initials, lending the editorial a semblance of objectivity. The label P1.1x characterized volumetric construction systems employed since the 1950s. The introduction of the label P2.11 suggested that there was a qualitative change to the system. The system was presented in Vlastimil Kolář, Miloš Pavlík, 'Nová stavební soustava pro Prahu', *Architektura ČSR* 45, no. 1 (1986): 14–21.

31 Sedláková, 'Nová stavební soustava pro Prahu', 13.

32 Radomíra Valterová, 'Kam kráčí soudobá architektura?' *Tvorba* 31 (1981): 4.

33 Valterová, 'Kam kráčí soudobá architektura?', 4.

34 Riabushin, cited in Radomíra Sedláková, 'Rozhovor s profesorem A. V. Rjabušinem. Sociální role architektury a architektonické výrazové prostriedky', *Československý architekt* 27, no. 13 (1981): 4. The reference is to the advent of socialist realism.

35 Alexandr Rjabušin, 'Od intuitivního k vědeckému předvídání', in Kamil Dvořák and Alexandr Rjabušin, eds., *Prognostika v architektuře a urbanismu* (Prague: SNTL, Nakladatelství technické literatury, 1984), 78.

36 Alexandr Rjabušin, 'Postmodernismus – slepá ulička, nebo rozcestí v západní architektuře', *Výstavba a architektura* 26, no. 8 (1980): 9.

37 Radomíra Sedláková, 'Socialistický realismus po létech', *Československý architekt* 32, no. 1 (1986): 4. Additional information from Radomíra Sedláková, 'Socialistický realismus včera a dnes', unpublished manuscript. Obtained from Sedlákové's personal archive.

38 Sedláková, 'Socialistický realismus po létech', 1.

39 Radomíra Sedláková, 'Zpráva o služební cestě do Polské lidové republiky, která se konala ve dnech 26.9. až 9.10.1985', unpublished manuscript. Obtained from Sedlákové's personal archive.

40 Radomíra Sedláková, 'Postmoderní architektura v Sovětském svazu', *Architektura ČSR* 43, no. 7 (1984): 322.

41 Radomíra Valterová, 'Postmodernismus, klasicismus, a co dál', *Výtvarná kultura* 8, no. 2 (1984): 23.

42 Valterová, 'Postmodernismus, klasicismus, a co dál', 24.

43 Sedláková, 'Postmoderní architektura v Sovětském svazu', 321–2.

44 On continuity between late socialism and post-socialism in Czechoslovakia compare Michal Pullmann, *Konec experimentu. Přestavba a pád komunismu v Československu* (Prague: Scriptorium, 2011), 226–7.

3

The discontents of socialist modernity and the return of the ornament:

The Tulip Debate and the rise of organic architecture in post-war Hungary

Virág Molnár

The first serious cracks on the ironclad modernist consensus, which was restored in socialist Hungary by the early 1960s, developed around the question of ornamentation and its significance as a measure of social modernity. This chapter suggests that the so-called Tulip Debate – which erupted in 1975 around an experimental prefabricated housing project where architects applied ornamentation to the façade that was inspired by Hungarian folk culture – presents a symbolic turning point in this process. This high-profile public dispute exposed a widening rift that has been brewing since the late 1960s between the growing discontents of a state-sponsored socialist mass modernism and the mainstream modernist establishment. It revealed the demand for greater intellectual pluralism in architecture while pushing architects to openly voice their criticism of architectural modernism despite possible political retribution such criticism might provoke. The debate also suddenly reintroduced long dormant themes

such as the status of national identity, historicity, and vernacular traditions into socialist architectural discourse.

This chapter uses this crucial episode as a starting point to explore the emergence of various 'postmodern' tendencies during the socialist period in Hungary. It does not aim to offer an exhaustive overview of all the postmodern currents under socialism, but focuses primarily on developments that grew out of renewed reflections on the place of regional, national, historical, and vernacular traditions in contemporary architecture, as well as the potential of architecture in transmitting a positive national identity.[1] These trends, I argue, demonstrate most clearly how socialist postmodernisms intersected with and deviated from Western European and North American trends.

The sprawling debates of the 1970s and 1980s on postmodern architecture in Western Europe and North America rarely made any mention of developments behind the Iron Curtain. Concurrently, the term 'postmodernism' did not become a regular staple of architectural vocabulary in Hungary until the 1980s. But if we define postmodernism broadly as a critique of the universalism and formalism of post-war modernism (equated largely with International Style); a return of 'wit, ornament and reference' and the denial of the idea of a privileged aesthetic realm; and as a critical reinterpretation of historical and regional traditions, then we can certainly identify similar developments in the socialist world as well.[2] One major difference, however – at least in the case of Hungary – is how these ideas and discussions acquired larger social and political significance. Namely, they did not only question the relevance of established aesthetic paradigms and building practices but increasingly cast doubt over the basic ideological and institutional tenets of the socialist status quo.

Historic turning point: The 'Tulip Debate' and the ambivalent role of the ornament in mass housing construction

The 'Tulip Debate' (1975–6) was sparked off when a group of architects in Southern Hungary embarked on building a prefabricated housing complex with a 'human face' by using surface decorations to break the monotony of modernist aesthetics. Such experimentation was in fact not unprecedented in this region. The regional prefab factory produced houses with façades resembling striped pyjamas, oval TV screens, and the logo of a coffee brand (Omnia) sold only in Hungary, but these attempts did not cause a stir. This time, however, architects used motifs from Hungarian folk culture (e.g. 'tulips') to decorate the façade of prefabricated blocks in a large housing complex (Figure 3.1). It was largely because of the association of the decoration with national folklore that the experiment provoked a

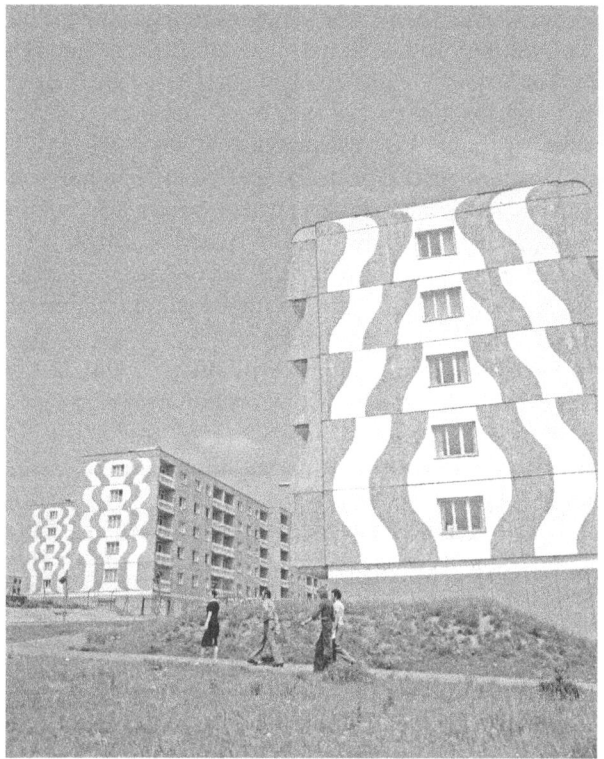

FIGURE 3.1 *'Tulip-Houses' in Paks, Southern Hungary, 1975*. Photo by Péter Horváth © MTI.

professional and public controversy. The puzzle of whether tulips are in ideological harmony with prefabricated blocks or simply an act of 'tasteless camouflage' prompted questions about the status of national culture and identity in architecture, striking at the heart of modernist architectural doctrine with its emphasis on abstract internationalism.

The heated discussions with their emphasis on the return of ornamentation, vernacular traditions, historicism, and local cultural references indicate that themes usually associated with the postmodern turn in architecture surfaced in Hungary long before the demise of the socialist political system. Even though these discussions were not explicitly tied to contemporary debates on postmodernism in Western Europe and the United States, they appeared around the same time and grappled with similar challenges to modernism.[3]

Moreover, the Tulip Debate also reveals some of the larger political issues at stake, as the highly polarized discourse followed the logic of a broader social controversy between so-called urbanists and populists that had busied Hungarian intellectuals and politicians since the late nineteenth century. The 'urbanist-populist discourse' (*népi-urbánus vita*) was waged as a kind of culture war between cosmopolitan intellectuals who turn towards the West

for bourgeois and civic values and populist intellectuals who emphasize the uniqueness and importance of national cultural heritage. The 'urbanist-populist discourse' was integral to defining Hungarian national identity and Hungary's relationship to Europe. I show elsewhere in greater detail that this discursive frame was instrumental in reinforcing the meaning of modernist architecture in the post-war period in Hungary as a bond to Western European modernity in the face of Soviet rule.[4] As a result, the fusing of modernism with traditional vernacular forms was rejected in Hungary because it was declared by the architectural establishment as a politically suspect project, one that threatened to undermine not socialism, but the grand scheme of social modernity.

The 'Tulip-Debate' marked, quite symbolically, the last year of the ambitious fifteen-year-long housing construction program that targeted the building of one million dwellings between 1960 and 1975. The program was launched with the intention of putting an end to the housing shortage and fulfilling the socialist promise of providing each citizen with adequate dwelling. The large volume of construction required the introduction of industrialized building techniques. From the beginning of the 1970s, the large prefabricated panel construction technology (the so-called house factory technology) gained widespread application in Hungary similar to other socialist countries, radically changing the character of public housing.[5] Residential construction rapidly shifted from low-rise, small-scale developments located close to the city centre to large-scale, high-density housing complexes planted in green field sites on the outskirts of cities. Fifty per cent of all the flats erected in urban areas between 1971 and 1980 were in prefabricated multistorey buildings.

By the late 1970s, however, there was a distinct sense of crisis among architects. They felt that the great hopes of modernist architecture, industrialization of construction, prefabrication, and functionalism translated into a macabre reality that brought only de-skilling and de-professionalization. Architecture and architects fell gradually victim to the rationalized mass production of housing. As a result of the fetishization of quantitative expansion, the 'housing factories' churned out prefabricated apartment blocks and housing complexes which were alienating in their monotony and uniformity. In the uninspiring atmosphere of 'routinized modernism', and in the bind of a rigid institutional structure with large state-owned and highly bureaucratized architectural offices, oversized construction companies, and a centrally controlled labour market, architects felt they had a limited playing field.[6]

Simultaneously, architects were frustrated by the proliferation of a largely self-help building practice that peppered the Hungarian countryside with single family homes which were not based on centrally designed prototypes and eluded architectural supervision.[7] This 'spontaneous architecture' (*spontán építészet*) was enabled because not only private construction was tolerated in socialist Hungary, but the state was also dependent on private builders'

contribution to meet its housing provision targets.[8] In fact, the spread of privately built family homes was integral to the one-million-home program from 1960 to 1975. Although by 1975 the overall targets of the housing program were met, the ratio of state to private construction projects was exactly the reverse of what was originally intended: publicly constructed units made up only 40 per cent and private dwellings accounted for 60 per cent of the newly built housing stock. The majority of private dwellings were built without architects in single family homes in small towns, villages, and the outskirts of large cities.

Architects saw this development as harmful, describing it as a form of 'visual and aesthetic architectural pollution'.[9] They perceived it as an alarming sign of the rapid decline of the architectural quality of the built environment due to the twofold damage inflicted by uniform public housing developments, and the equally uniform, poorly constructed, and 'aesthetically challenged' single family homes. Popular phrases that described this building type such as the 'Kádár Cube' (nicknamed after János Kádár, Hungary's long-time Communist leader) or 'pyramid-roof house' (*sátortetős ház*) became a shorthand for the critique of popular building practices and gaudy architectural tastes (Figure 3.2). The square-based, single-storey, pyramid-roof building actually originated in the 1920s and diffused quickly across the Hungarian landscape in the 1960s. By the start of the following decade it triumphed as the dominant house type of the village and satellite suburbs. This self-built structure has only recently begun to receive closer attention from artists, architects, and scholars as a socialist vernacular, and thereby a form of popular postmodernism.[10]

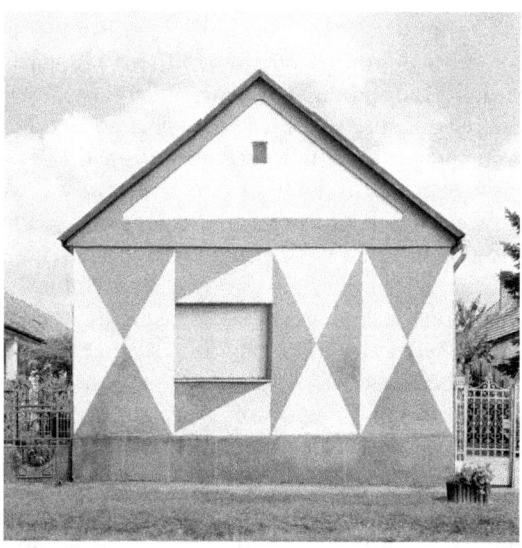

FIGURE 3.2 *'Kádár cube' with ornament.* © *Katharina Roters.*

But interestingly enough, despite growing dissatisfaction with and mounting challenges to the modernist program, at first architects did not openly call into question the basic tenets of architectural modernism. Nobody was really searching for alternatives until the 'Tulip Debate'. This was largely because in the context of the intensifying systems-race of the Cold War, the mature socialist state increasingly set up capitalist modernity (and the promise of economic prosperity) as the yardstick against which it measured itself.[11] In architecture this re-conceptualization enabled and legitimated the emulation of Western developments. Consequently, architectural modernism came to be understood as a linkage to Western European professional discourse and offered a tool for reimagining socialism as an alternative modernizing project by pointing out similarities between capitalist and socialist modernity.

Its authority was bolstered furthermore by the legacy of a detour into authoritarian architecture under Stalinism: the political prescription of socialist realism as an official architectural style and a literal ban on architectural modernism. Although in Hungary socialist realism was rather short-lived, extending roughly from 1951 to 1956, it left a lasting mark on the collective memory of the profession.[12] Architects looked back on socialist realism as a fatal mistake, an unfortunate detour, imposed on architecture by the Soviet Union and totalitarian politics. They blamed socialist realism for diverting Hungarian architecture from its 'natural' path of development and viewed it as the chief reason for why Hungary lagged behind international (i.e. primarily Western European) developments.[13] Hungarian architects therefore embraced all the more vehemently the modernist discourse after 1956 and sanctioned attempts that cast the smallest doubt on the primacy of architectural modernism, as the 'Tulip Debate' aptly illustrates.

The architects behind the controversial experimental housing complex were known as the Pécs Group after the Southern Hungarian city of Pécs. The group included Tibor Jankovics, Jenő Dulánszky, Gyöngyvér Blazsek D., and István Kistelegdi, among others, and was headed by György Csete. It developed from the Junior Studio set up within the large, state-owned Pécs Planning and Architectural Office (*Pécsi Tervezővállalat*), in the late 1960s.[14] The office hoped to revitalize its planning and architectural practice by employing talented young architects who did not shy away from experimentation. The region was also known for its more liberal, cultural, and political atmosphere. The regional housing factory was unique in producing a specific series of large-panel blocks that were adapted to suit regional tastes and peculiarities.[15] After a number of small commissions, the studio was assigned a big, state-sponsored project, the housing complex in Paks. This small village by the Danube in Southern Hungary became the site of Hungary's one and only nuclear power plant with a sudden population explosion and an urgent need for housing. The commission presented a perfect opportunity for putting into action the architectural program of the Pécs Group on a relatively large project.

The architectural credo of the Pécs Group can be summarized in three tenets. They strove to create an architecture that harmoniously combined traditional with modern architectural language, to design buildings that were both national and international in character, and to integrate 'progressive traditions' of folk culture into modern (socialist) culture because they believed folk culture had the power to make and maintain social communities.[16] The group upheld the example of the composers Béla Bartók and Zoltán Kodály, who successfully integrated folk music into modern classical music as evidence for a possible synthesis between modern and traditional as well as urban and rural culture.[17] Their program was also inspired by nineteenth-century Secessionist (i.e. Art Nouveau) forerunners such as the architect Ödön Lechner, and the architectural group named the *Fiatalok* (*Youngsters*), especially its most prominent member, Károly Kós. The Pécs Group appropriated selected aspects of the architectural oeuvre of these architects. They included in their program the search for a characteristically Hungarian architectural language that had preoccupied Secessionist architects.[18] They argued that under the unifying umbrella of modern architecture each nation should have the opportunity to speak its own (native) language. In addition to internationalism, 'architects should strive to discover, integrate and uphold local traditions in architecture'.[19] These traditions could embody the 'value added' element of Hungarian architecture, saving architects from being merely hopeless imitators of Western culture.

In this spirit, the Pécs Group embarked on the project within the technological and economic confines of modern industrial building methods. They used the large-panel construction system but expanded the supply of prefabricated elements (including cup- or shell-shaped elements for the balconies and the entrances) in order to break the monotony and 'mechanical geometric order' of the apartment blocks.[20] The façade of the buildings was decorated with expressive ornaments, classified as tulips, blown up to building-sized dimension (Figure 3.1). The ornaments, though highly abstract, were labelled tulips by the critics upon launching the debate to emphasize the Pécs Group's commitment to Hungarian folk traditions. The label stuck and dominated the debate, and the buildings are still referred to today as the 'tulip houses'. But the Pécs Group also introduced changes to the floor plan based on the internal functional structure of traditional peasant homes. Instead of the standardized floor plan that connected parts of the flat through a dark and narrow hallway, they made a multifunctional space in the centre of the flat. This room, modelled on a similar space in peasant homes, could be used in various ways as a dining and living room and provided connection to other parts of the flat.

The architects of the Pécs Group initially saw themselves as benign reformists, not as critics of modernism, responding to a professional crisis that grew out of the industrialization of architecture and a state policy that was interested only in the quantitative expansion of the housing stock.

But in the debate that their project flared up, they were attacked as arch enemies of modernism by some of the most influential architects of the era. The main thrust of criticism followed from the widely shared conviction that the modern is in inherent contradiction with the national, and modern industrial technologies cannot be reconciled with traditional aesthetics. Hence, the ornamentation applied to the façade was little more than ersatz, the construction of a 'Disney Land', which 'only masks but does not resolve the shortcomings of industrial building'.[21] In a more alarmist mode, Máté Major, the chief architectural theorist of the period, warned that architectural movements that turned to folk and national culture for inspiration tended to have a hidden political agenda ('reactionary' and 'retrograde') and rejected a modern, cosmopolitan, and progressive world view (Major 1981).[22] Major was a modernist hardliner, already active in the Hungarian modernist movement (as well as the Communist Party) in the interwar period and a member of CIAM from 1933 to 1938. After the Second World War, he no longer practised as an architect, but became an authoritative figure in shaping Hungarian architectural discourse. He sparked the Tulip Debate by attacking the Pécs Group on the pages of the prestigious and widely read literary weekly *Élet és Irodalom*. The attack on the Pécs Group was so vicious, and the debate, which dragged on for nearly two years, caused such an uproar that the experiment was stopped, the housing complex was left incomplete, and the studio of the architects was administratively dissolved.

Yet, the debate marked the beginning of a new era and a gradual shift towards greater pluralism in architectural views.[23] The dissolution of the Pécs Group pushed its members to the margins of the profession, from the mainstream of industrialized building to the periphery of traditional building methods and small-scale commissions. The young architects realized that their criticism of modernist practices could no longer be contained within the existing institutional framework of the socialist-modernist building industry. But they decided to accept this fact and adopt an openly critical position vis-à-vis the modernist establishment. The Tulip Debate in fact became integral to the genesis of so-called organic architecture, which developed into an influential and distinctive architectural school in Hungary by the mid-1980s, as well as to other smaller groupings of critical regionalism.[24] As a result, these alternative groupings grew increasingly critical of the architectural mainstream: industrial building technologies and architectural modernism.[25]

'Organic Architecture' and critical regionalism(s)

The Tulip Debate was certainly not a triumphal moment for the discontents of modernism, but it was still decisive. Members of the Pécs Group were dispersed across the country, and as an unintended consequence, this

ensured that their ideas spread more widely. The public visibility of the debate also turned the spotlight on emerging alternatives and encouraged more and more architects to turn away from the mainstream – that is, state sponsored and controlled – building, even if the professional costs of such defection promised to be high. 'Organic architecture' canalized many of these dissenters due in part to the personality of Imre Makovecz, probably the best-known representative of the movement. He not only managed to develop a unique architectural vocabulary antithetical to mainstream modernism but also acted as a mentor to younger architects, linking theory and education and cultivating a network of like-minded practitioners. Yet, organic architecture in Hungary can be best understood as a broad heterogeneous movement with interlocking groupings and fuzzy boundaries, rather than a close-knit school or a style.

Its adherents describe organic architecture as a philosophy and a holistic approach to a building that is contextually, ecologically, and socially engaged.[26] At one of the first comprehensive exhibitions of his work in 1976, Imre Makovecz identified the four main intellectual sources of the organic movement: peasant folklore, medieval small-town culture, the architecture of Frank Lloyd Wright, and the anthroposophic theory of Rudolf Steiner.[27] Regarding peasant folklore, organic architects were quick to stress that Hungarian Art Nouveau (called Secessionism in Hungary) was largely unique in its ability to draw on authentic folk traditions that were still very much alive at the time.[28] This explains the centrality of Secessionist architects, particularly Ödön Lechner and Károly Kós, mentioned also earlier in relation to the Pécs Group, as a key source of inspiration. The interest in medieval culture and traditional craftsmanship aimed to revive the legacy of the Arts and Craft Movement, while the oeuvre of Frank Lloyd Wright served as a model for exploring the ecological aspects of architecture. The anthroposophical theory of Rudolf Steiner – the founder of the Waldorf schools and the architect of the organic-expressionist building of the Goetheanum in Dornach, Switzerland, the centre of the Anthroposophical Society – gave the movement a spiritual and esoteric twist. Steiner's philosophy rooted in German idealism and mysticism, namely, postulates the existence of an objective, intellectually comprehensible spiritual world that is accessible by direct experience through inner development. Various groups of architects under the broad umbrella of organic architecture have differed in terms of the combination and the weight they assigned to each of these influences. For instance, the Pécs Group was more strongly anchored in folk traditions and the integrative (Gesamtkunstwerk) perspective of the Arts and Crafts Movement, while Imre Makovecz's work evidently owed the most to Rudolf Steiner's spiritualism.

The evolving intellectual program of organic architecture was clearly at odds with mainstream modernism, but its opposition did not stop there. It also shunned employment in highly centralized, bureaucratic, and soulless state architectural offices and rebuffed mass-produced architecture. It

rejected the mechanic application of industrialized building materials and prefabrication in favour of traditional techniques, ornamentation, and materials like timber, which were considered outmoded and pre-modern by the modernist establishment.

Imre Makovecz's professional career, for instance, illustrates how these principles translated into everyday work practice. Makovecz graduated from the Budapest Technical University in 1959 and worked in various state architectural offices until 1977. His talent was recognized early on, and he was awarded the Ybl Prize, Hungary's highest professional honour for an architect, already in 1969. But he had a hard time adjusting to the rigid circumstances and anonymity of large state architectural offices and conflicts with his employers multiplied over time. Nevertheless, one of his first iconic buildings, a stunning, vaguely anthropomorphic, wooden structure built as a funeral home in a historic cemetery in Farkasrét, Budapest (Figure 3.3), was completed while he was working for one of the largest and most prestigious of these state urban planning and architectural offices, VÁTI. He left this company after a bitter row over the construction of a cultural centre in the city of Sárospatak, where planning stalled because of disagreements over Makovecz's unconventional design.[29] He went on to work for a much smaller employer, a Forestry Company in the Pilis Mountains (Pilisi Parkerdőgazdaság) just outside Budapest. The time he spent there from 1981 to 1990 brought him even closer to nature and working with timber as a material, resulting, among others, in his much celebrated ski hut in

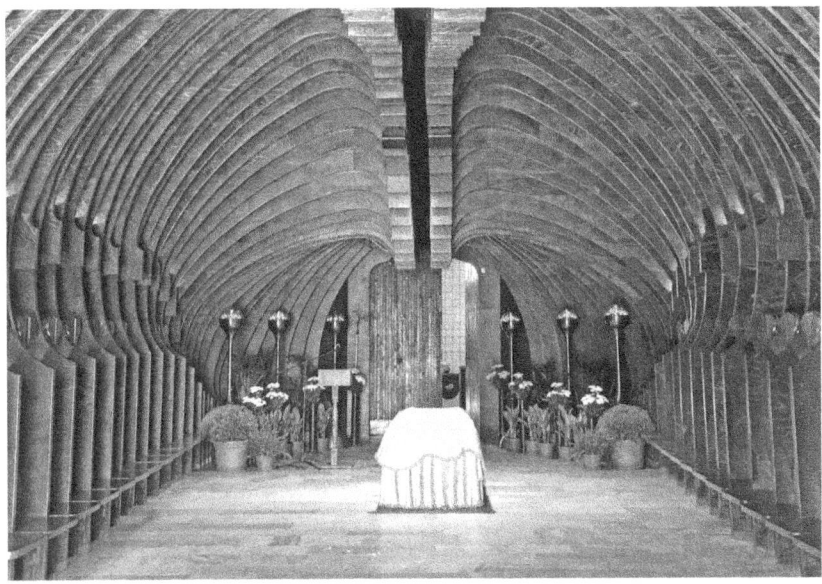

FIGURE 3.3 *Imre Makovecz, Funeral home in Farkasrét, Budapest, 1977. Photo courtesy of Virág Molnár.*

Dobogókő, a popular vacation destination. And a few years later, in 1984, he took advantage of new legislation enabling architects to get a private licence and set up a private architectural office under the name of MAKONA.

This move reflected the expanding role of the market in late socialist Hungarian society, which profoundly transformed the construction industry as well. The state ceased to be the sole source of architectural contracts, while the informal economy grew significantly, enabling architects to survive independent of state-owned architectural and planning offices. New informal arrangements and the tutelage of local politicians in small towns supplied organic architects with commissions, also because they were seen as different and critical of the official socialist architecture. In describing his relationship to clients in the 1980s, Makovecz noted the following:

> I normally work with clients who don't mind working with a private architectural office, with [clients] who don't have enough money and ask locals to participate in the construction as community service. I work on the periphery. I plan village community centers, and clusters of family homes as village extensions; a larger building commission or a wealthy client rarely come my way. But I'm fine with this. It follows from my principles and my take on life. Organic architecture strives to build direct contacts with both the client and the contractor, and this effort usually pays off in my work.[30]

Organic architects generally focused on small-scale commissions in the countryside – most typically local cultural centres, churches, single family homes, funeral homes, and wineries – and emphasized the importance of social engagement with the communities their buildings were meant to serve.[31]

Simultaneously, the network of organic architects expanded through a range of informal and formal activities. The unofficial (and basically illegal) summer workshops (*Vándoriskola*), led by Makovecz between 1981 and 1990, introduced architecture students to the 'ancient art of building', community building through architecture, and theoretical works (e.g. by Rudolf Steiner) that were not part of the university curriculum. Students also participated in field trips to the Hungarian countryside and Transylvania to collect folk and vernacular traditions in search of a national formal architectural language.[32] By the end of the 1980s, the organic movement further solidified and institutionalized through the founding of the Károly Kós Association and the architectural journal *Országépítő* (Country Builder) as alternatives both to the official Association of Hungarian Architects and its official journal, *Magyar Építőművészet*, the most important architectural journal under socialism, which had provided no coverage of the work of organic architects.

The first international exhibition of Hungarian organic architecture took place in 1981 in Helsinki, which is no surprise given the affinity with the work of Finnish architects like Alvar Aalto or Reima Pietilä, not to mention the extensive influence of the Finnish National Romantic movement on

early twentieth-century Hungarian architects like Károly Kós and the *Fiatalok*. A review of the exhibition and Makovecz's work also appeared in the *Architectural Review;* the reviewer Jonathan Glancey, the influential long-time architectural critic of *The Guardian,* became an important champion of Hungarian organic architecture in the English-speaking world. Such exposure to Western audiences lured architecture students to Makovecz's studio in Hungary from all over Western Europe and from the Hungarian diaspora in neighbouring countries throughout the 1980s. Further international exhibitions followed, first in Rotterdam in 1989, then at the Venice Biennale in 1991, and in Edinburgh in 1992, culminating with Makovecz's Hungarian Pavilion at the Seville World Expo in 1992.[33]

Despite Makovecz' towering figure over Hungarian organic architecture, the movement dynamically evolved and diversified over time. Even some of Makovecz's close disciples like Dezső Ekler ended up setting up their own ateliers and moving towards a somewhat different strand of contextual regionalism (Figure 3.4). Similarly, Sándor Dévényi, an architect also based in the Southern Hungarian city of Pécs, who was strongly influenced both by the Pécs Group and Makovecz without being closely affiliated with either, developed his unique approach of 'organic eclecticism'. He engaged reflexively with urban contexts that involved historical preservation, rethinking, and reconfiguring the historical elements of existing buildings into original new structures, as exemplified by his elaborate underground spaces constructed in 1980 as part of a cellar restaurant in the historic centre of Pécs.[34] Meanwhile, other groups emerged in regional city centres in Eastern Hungary, like the Architectural Atelier of Miskolc led by Csaba

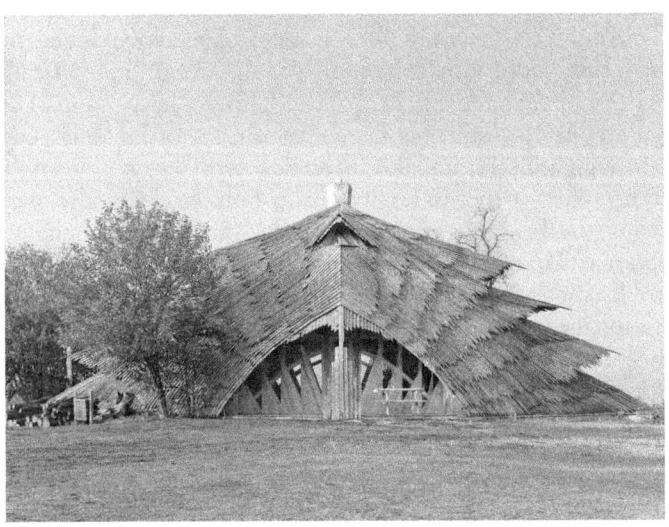

FIGURE 3.4 *Dezső Ekler, Folk art camp house in Nagykálló, 1986*
© *Dezső Ekler.*

Bodonyi, or Ferenc Bán's studio in Nyíregyháza. They formulated local brands of critical regionalism that were not at all or were only loosely associated with Makovecz's strand of organicism (Figure 3.4).[35] As a result, by the late 1980s quite distinctive trends came to define Hungarian architecture, especially in the countryside, offering sophisticated criticism of and alternatives to modernism.

Conclusion

By the late 1980s, architecture in Hungary became quite diverse, with various groups calling into question the primacy of modernism while searching for new alternatives. Their visibility remained relatively low in part because they originated and were mostly active in the countryside in a country in which cultural attention is famously confined to Budapest. But it was also this spatial and institutional marginality that allowed these architects to thrive despite the fact that their challenge to modernism was often interpreted (and intended) as a form of political criticism of the socialist system as well, as manifested in the trajectory of the organic architecture movement. They could therefore really come into full bloom only after 1989 in the post-socialist era, when postmodernism was also increasingly perceived as a Western European intellectual trend, giving a belated seal of approval to hitherto countercultural trends (Fehérváry 2013).[36] Nevertheless, an important divergence from Western European postmodernism, besides the degree of politicization, is that in Hungary the influence of radical historicist eclecticism was minimal. Postmodern architects strove to reinterpret and critically reconstruct historical and folk traditions, but this reflection was rarely playful or ironic. Instead, it was fraught with serious tensions regarding national and European identity as well as modernity. This is why divisions between the organic and rational (i.e. the 'populist' and the 'urbanist') factions have continued into the post-socialist period, while the legacy of vernacular practices under socialism has remained largely unexplored.

Notes

1 It does not, for instance, cover paper architecture, stage set design that served as an intellectual refuge to many architects disgruntled with industrial modernism, or high-tech architecture that began to emulate Western corporate postmodernism in the 1980s.

2 Robert Venturi, Denise Scott Brown, and Steven Izenour, *Learning from Las Vegas* (Cambridge, MA: MIT Press, 1971); Kenneth Frampton, 'Towards a Critical Regionalism: Six Points for an Architecture of Resistance', in Hal Foster, ed., *Postmodernism: A Preface in Anti-Aesthetic. Essays on Postmodern Culture* (Seattle, WA: Bay Press, 1983), 16–31.

3 Anna M. Eifert-Körnig, *Die kompromittierte Moderne: staatliche Bauproduktion und oppositionelle Tendenzen in der Nachkriegsarchitektur Ungarns* (Berlin: Reimer, 1994); Jonathan Glancey, 'Group Pécs', *Architectural Review* 170 (1981): 345–52; György Szegő and János Gerle, *Építészeti tendenciák Magyarországon 1968–1981*, exhibition catalogue (Budapest: Óbudai Galéria, 1982); Urban, *Neo-Historical East Berlin* (Farnham: Ashgate, 2009).

4 Virág Molnár, 'Cultural Politics and Modernist Architecture: The Tulip Debate in Postwar Hungary', *American Sociological Review* 70, no.1 (2005): 111–35; Molnár, *Building the State* (Abingdon, NY: Routledge, 2013).

5 Christine Hannemann, *Die Platte: industrialisierter Wohnungsbau in der DDR*, 3rd edn. (Berlin: Verlag Hans Schiler, 2005); Kimberly Elman Zarecor, *Manufacturing a Socialist Modernity*.

6 István Janáky, 'Magyarország két építészete', in Judit Lévai-Kanyó, ed., *A hely: Janáky István épületei, rajzai és írásai* (Budapest: Műszaki Könyvkiadó, [1985] 2000).

7 József Székely, 'Sátortetős családi házak', *arc'*, 6 (2001): 30–43.

8 Katharina Roters, ed., *Hungarian Cubes: Subversive Ornaments in Socialism* (Zurich: Park Books, 2014); see also Molnár, *Building the State*.

9 Kálmán Timon, 'Építészeti szennyeződés', *Magyar Építőművészet* 6 (1976): 62–63, 62.

10 Molnár, *Building the State*; Zoltán Tóth, 'Melyik ház a kockaház?', *Korall* 40 (2010): 5–44; Tibor Valuch, 'A hosszú háztól a kockaházig – a lakásviszonyok változásai a magyar falvakban a hatvanas években', in János M. Rainer, ed., *'Hatvanas évek' Magyarországon* (Budapest, 1956-os Intézet, 2004), 386–407. And especially on the ornamental practice associated with these buildings see Roters, *Hungarian Cubes*; Katharina Roters and József Szolnoki, 'Tetovált házak, avagy a gulyáskommunizmus ornamentikája', *Századvég* 2 (2016): 71–93.

11 Jeffrey Kopstein, *The Politics of Economic Decline in East Germany, 1945–1989* (Chapel Hill: University of North Carolina Press, 1997).

12 Anders Åman, *Architecture and Ideology in Eastern Europe During the Stalin era: An Aspect of Cold War History* (Cambridge, MA: MIT Press, 1992); Endre Prakfalvi and György Szűcs, *A szocreál Magyarországon* (Budapest: Corvina, 2010).

13 Szegő and Gerle, *Építészeti tendenciák*.

14 Jeffrey Cook, *Seeking Structure from Nature: The Organic Architecture of Hungary* (Basel: Birkhäuser, 1996); Lajos Jeney, *A Magyar Tervezőirodák Története* (Budapest: Építésügyi Tájékoztatási Központ, 2001).

15 Jeney, *A Magyar Tervezőirodák Története*.

16 Csete György, Gyöngyvér Blazsek D., László Deák, Tibor Jankovics, István Kistelegdi and Péter Oltai, *Csak tiszta forrásból*, exhibition catalogue (Budapest: Fészek Klub, 1973); György Csete, 'Építészeti anyanyelvünkről', in J. Zelnik, ed., *Régi és új formák* (Budapest: O.J, 1977).

17 Csete et al., *Csak tiszta forrásból*.

18 Ákos Moravánszky, *Competing Visions: Aesthetic Invention and Social Imagination in Central European Architecture, 1867–1918* (Cambridge, MA: MIT Press, 1998).
19 Csete, 'Építészeti anyanyelvünkről', 26, 30.
20 György Csete, *Hajlék. A Pécs Csoport építészeinek kiállítása a Budapest Kiállítóteremben*, exhibition catalogue (Budapest: Budapest Galéria, 1987).
21 Károly Weichinger, 'A paksi lakóházakról', *Magyar Építőművészet* 2 (1976): 60.
22 Máté Major, 'Nagypanel és tulipán', in Máté Major and Judit Osskó, eds., *Új építészet – új társadalom, 1945–1978* (Budapest: Corvina, 1981): 387–91.
23 Szegő and Gerle, *Építészeti tendenciák*.
24 Cook, *Seeking Structure from Nature*; Eifert-Körnig, *Die kompromittierte Moderne*; András Ferkai, 'Hungarian Architecture in the Postwar Years', in Dora Wiebenson and József Sisa, eds., *The Architecture of Historic Hungary* (Cambridge, MA: MIT Press, 1998): 277–98.
25 John Macsai, 'Architecture as Opposition', *Journal of Architectural Education* 38, no. 4 (1985): 8–14; Imre Makovecz, 'Szerves építészet', in Ferenc Vámossy, ed., *Építészeti kultúra – környezetkultúra* (Szeged: Conference Proceedings, 1983).
26 Csaba Bodonyi, Sándor Dévényi, Dezső Ekler, János Gerle, Tibor Jankovics, Mihály Kampis, Imre Makovecz, Ferenc Salamin, László Sáros and József Siklósi, *Interjúk a magyarországi szerves építészetről*. Supplement. *Országépítő* 4 (2004 Winter).
27 János Gerle, 2009, 'Magyar organikus építészet', *epiteszforum*, http://epiteszforum.hu/magyar-organikus-epiteszet (Retrieved 22 January 2017).
28 Organic architects argued that in Europe, only Gaudí's use of traditional forms could be considered comparable.
29 The protracted planning process lasted from 1972 to 1977, and the building was eventually built in 1983.
30 Imre Makovecz, 'Építész és megrendelő', *Magyar Építőművészet* 4 (1986): 19.
31 Makovecz, 'Szerves építészet'.
32 János Gerle, 'Sikerül-e a magyar tárgykultúra jövőjét összekötni a múltjával', *Országépítő* 2 (1991): 58–62.
33 Paolo Porthogesi, *Makovecz* (Budapest: MMA, 2014).
34 Gerle, 'Sikerül-e a magyar'.
35 Miklós Sulyok, 'Tézisek a Magyar Művészeti Akadémia Művészetelméleti és Módszertani Kutató Intézetének építészetelméleti kutatási programjához', Unpublished manuscript, n.d.
36 Fehérváry, *Politics in Color and Concrete*.

4

An architect's library:

Printed matter and PO-MO ideas in Belgrade in the 1980s

Ljiljana Blagojević

The chapter explores printed matter as agency of architectural discourse of postmodernism in Serbia (former Yugoslavia). Fairly consistent and rather dynamic architectural discourse of postmodernism, set against the grain of architecture production of socialist modernism, emerged in Belgrade from the mid-1960s from an intergenerational, heterogeneous, long, and discontinuous process of critique by research, theory, and design.[1] Discursive and artistic extension of the discipline, instigated by the architects and professors at the Faculty of Architecture in Belgrade, Aleksandar Deroko (1894–1988) and Bogdan Bogdanović (1922–2010) – both accomplished scholars, artists, architects, and writers – culminated in the 1980s through succeeding generations of postmodernist architects, such as Ranko Radović, also faculty (1935–2005, grad. 1962), Vesna Vujica (1942, grad. 1968), the group MEČ – founders Mustafa Musić (1949), Dejan Ećimović (1948– 2002), and Marjan Čehovin (1950), mid-1970 graduates, members Slobodan Maldini (1956, grad. 1981) and Stevan Žutić (1954, grad. 1980) – Đorđe Dašić (1957, grad. 1983), and the younger generation graduating from the University of Belgrade in the mid-to-late 1980s. In the circumstances of the 1980s' economic recession, decline of construction industry, and, as one architectural critic said, 'the bureaucratic dictatorship',[2] postmodern architects operated independently, that is to say, outside the state employment sector, substituting gallery for construction site, curator for client, and arts

and culture for real economy, technology, and production. Their principal media of expression were exhibitions of architectural drawings, art objects, and installations in galleries or urban space, critical-theoretical writing and public talks and lectures. Through intense exchanges across the Yugoslavian cultural space, participation in international drawing competitions, such as the Shinkenchiku Residential Design, or events, such as Venice or Paris biennials, or Graz Steirischer Herbst festival, and direct contacts through exhibitions, lectures, or panels with the leading figures Aldo Rossi, Paolo Portoghesi or Boris Podrecca, the local scene interconnected with the global postmodernisms in art and architecture.

The choice of publications exposes the reference frame of this new-wave and postmodernist culture turn in the narrow spectrum of available architectural literature and, even more so, in the wider context of theory and philosophy, that suggests deep point sources of architectural turn to phenomenology.[3] The time frame of postmodernism in Yugoslavian cultural space is marked by historical and sociopolitical watershed beginning in 1980 with the death of Josip Broz Tito, a leading figure of the resistance movement in the Second World War, the leader of the Communist Party and the country's lifelong president – the event generally deemed to have set in motion the processes of disintegration of the Socialist Federal Republic of Yugoslavia – and ending in 1991, the year of the eventual breakdown of the federation and collapse of the economic and political system of socialism. More precisely, crises-induced economic reform of 1965 had been the socio-economic forerunner, and the federal state Constitution of 1974, a major factor of change in state-political system – in sum, the decentralization of confederal type substituting socialist federalism of the previous 'self-management constitution' of 1963. The publication history studied for the purposes of this chapter points to the need of exploring the period between 1965 and 1991, as the extended time of germination of ideas and concepts that will have eventually engendered postmodernism as the cultural logic of late socialism, surely, a counterpart of late capitalism.[4]

To explore that history, I selected the sources that are deemed critical by following the dynamic of referencing through the content and bibliography analysis of architectural publications of the period, and, then, systematized the referenced sources into rough categories that might have formed paths that led to and engendered ideas and inspirations of architectural postmodernism. I focus on architectural, philosophical, and theory books and texts in comparative timelines of first edition versus translation into Serbo-Croatian language.

An architect's library

Considered at the outset is the library operative for critical reflection of an architect typical of the first postmodernist generation that studied

and graduated at the University of Belgrade in the 1970s and 1980s, such as, known from the first hand, the bookcase of the present author, restocked, as it were, for the purposes of this chapter. For clarity, omitted are university textbooks and teaching materials, survey histories of art (such as the ubiquitous one by H. W. Janson, published in translation by Jugoslavija, Belgrade art publishers, as from mid-1960s, sixth ed. 1982 in 10,000 print run), and representative art monographs published by the well-known international art publishers such as Thames and Hudson, Rizzoli, Mondadori, or, in translation, most often by Jugoslavija, which were abundantly available in the city bookshops from the 1970s, and would most likely have been part of an architect's library. Translations of architectural books, in most cases, came out through the specialized publishing house for construction engineering Građevinska knjiga established in 1948, that published more than 1,650 titles until the break-up of the country.[5] In Table 4.1, presented alongside the translations are books by Bogdanović and Radović. The reason to single out these two authors of all other notable publication production in Belgrade in the field of architecture and urbanism is twofold:[6] I would propose their publications had a critical impact on the local architectural discourse, a catalytic one even, and their writing uniquely brought innovative content and critical methodology. Each in their own stride a distinctive academic and public persona, both practised the art of architectural drawing, exhibited and lectured publically to great acclaim, and wrote inspired and inspiring texts in newspapers and magazines as well as articles in professional journals and books, the genre of which lay outside the architectural discourse of the period. Bogdanović combined ancient ethnographic, essayistic, and theoretical-mythological discourses, and Radović, who was exceptionally media savvy, had an activist, popular, and structuralist approach.[7]

As an appendix, I would add two books of criticism. The first is by Bogdanović, *Mali urbanizam* (1958, *Small Urbanism*), a collection of texts published previously as weekly columns in the leading national newspaper *Borba* or as articles in other dailies, weeklies, and literary and theory journals. Bogdanović criticizes sweeping monotony and reductive drabness of mass modern architecture, and advocates values of urban ambience, urban elements, and symbols pointing to historical examples and contemporary architects whose work lay outside the dominant discourses of modernism, such as Jože Plečnik or Gordon Cullen. In the similar vein, Radović collected his newspapers' criticism of contemporary urban space as from 1963, in *Živi prostor* (1979, *Living space*). Of note is the book's print run of 3,000, unusually large for a book about architecture (Figure 4.2). It was published by Nezavisna izdanja (Independent Editions), the first collaborative private publishing house in Yugoslavia, conceived in 1966 by the architect and designer Slobodan Mašić (1939–2016) with his wife Saveta and artist friends, and run over decades through their Studio Strukture design office, publishing some 500 titles.

TABLE 4.1 *A typical architect's bookshelf, order by year of 1st ed. of translation or 1st ed. original publication in Serbo-Croatian*

Author	Original Title (if published by Građevinska knjiga titles marked with '*')	1st ed. Original language	1st ed. translation
Le Corbusier François de Pierrefeu	La Maison des Hommes*	1942	1956
Bogdan Bogdanović	Zaludna mistrija	1963	
Le Corbusier	La charte d'Athènes	1943	1965
Ernst Neufert	Bauentwurfslehre. Handbuch für den Baufachmann, Bauherrn, Lehrenden und Lernende*	1936 29th ed.	1968
Sigfried Giedion	Space Time and Architecture*	1941	1969
Le Corbusier	Manière de penser l'urbanisme*	1946	1974
Kevin Lynch	The Image of the City*	1960	1974
Lawrence Halprin	Cities*	1963	1974
Christian Norberg-Schulz	Existence Space and Architecture*	1971	1975
Bernard Rudofsky	Architecture Without Architects*	1964	1976
Bogdan Bogdanović	Urbs & Logos: ogledi iz simbologije grada (Figure 4.1)	1976	
Le Corbusier	Vers une Architecture*	1923	1977
Françoise Choay	L'Urbanisme, utopies et réalités*	1965	1978
Bogdan Bogdanović	Gradoslovar	1982	
Charles Jencks	Modern Movements in Architecture*	1973	1982
Robert Venturi	Complexity and Contradiction in Architecture*	1966	1983
Ranko Radović, ed.	Texts by architects: Boullée, Ledoux, Sullivan, Wright, Vesnin brothers, Oud, Dobrović, Johnson, Tange, Bogdanović, Venturi, Moore, Portoghesi, Rossi, Kurokawa, Krier brothers, Site	1984	

(*Continued*)

TABLE 4.1 Continued

Author	Original Title (if published by Građevinska knjiga titles marked with '*')	1st ed. Original language	1st ed. translation
Charles Jencks	The Language of Postmodern Architecture	1977	1985
Ranko Radović	Antologija kuća*	1984 TV series	1985 book
Brent Brolin	Architecture In Context: Fitting New Buildings with Old*	1980	1985
Bogdan Bogdanović	Krug na četiri ćoška	1986	
Robert Venturi Denise Scott Brown Stephen Isenour	Learning from Las Vegas*	1972 1977 rev.	1987
Colin Rowe Fred Koeter	Collage City*	1978	1988
Gordon Cullen	The Concise Townscape*	1961	1990
Aldo Rossi	L'architettura della città*	1966	1991
Rob Krier	Urban Space*	1979	1991

It is highly probable that the bookshelves were additionally cramped by a wide spectrum of printed matter, ranging from architectural, art, philosophy, and theory journals and monographs to exhibition catalogues and the variety of ephemeral print, such as posters, fanzines, and flyers which started proliferating at the time. For instance, in 1983–84, the group Polis, consisting of two MEČ members and student-colleagues, produced a theory fanzine *Archipress* in the print run of twenty copies, focused on critical interpretations, for example thematic issue 'After the Post-Modern',[8] students' work, translations of texts, such as Giorgio Grassi's 'Avant-Garde and Continuity' from 1980, and the like. In 1987 Građevinska knjiga, printed the poster with elevation drawings of houses by Andrea Palladio that decorated many an architectural bureau or study on a path of historicist recognisance. Besides, one could easily find an issue or two of *Izgled* fanzine-magazine briefly printed in Belgrade at the beginning of the 1980s, aiming at new-wave oriented youth, or *Polet: Journal of the Association of Socialist Youth of Croatia,* activist, punk, and rock youth magazine that had a cult following across the country reaching top 80,000 print run.[9]

Specialized academic and institutional libraries, such as those in the city department of urban planning, the Yugoslav Institute for Urbanism

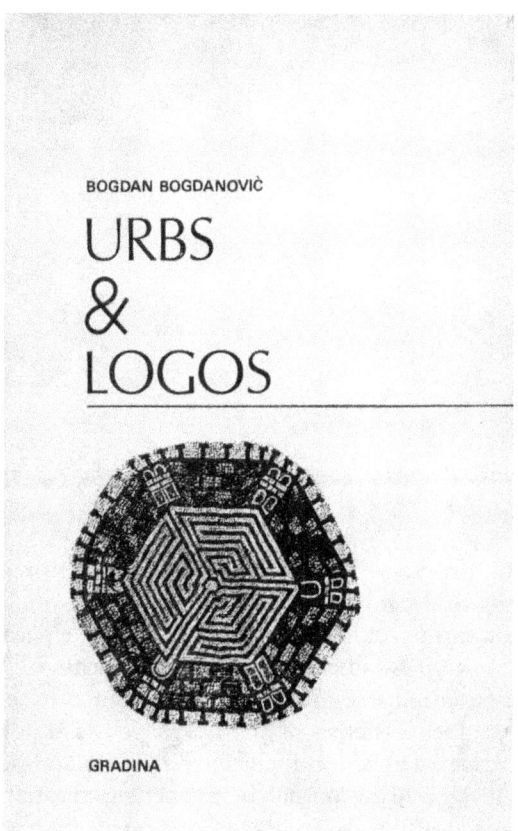

FIGURE 4.1 *Bogdan Bogdanović,* Urbs&Logos *(Niš: Gradina, 1976), book cover.*

and Housing – JUGINUS, or the Institute of Architecture and Urbanism of Serbia – IAUS, would keep regular subscriptions to major architectural, urbanist, and landscape journals. For instance, the Faculty of Architecture was subscribed, among many other journals, to *Architectural Design*, which had published the only local contribution that went into global circulation of postmodernisms, the freehand sketch from the 'Street of Memory' project by Mustafa Musić, as illustration on the editorial page to the thematic issue *Post-Modern Classicism* guest edited by Charles Jencks.[10] Collections of journals would likewise be featured on private architects' shelves, most often *Domus* or *L'Architecture d'Aujourd'hui*, occasionally *Casabella* and *Lotus*, as well as the established architectural journals printed in Yugoslavia, bimonthly *Arhitektura urbanizam* (Belgrade), and Zagreb journals *Arhitektura* or *Čovjek i prostor – ČIP*, the latter often including reports on exhibitions and some key programmatic texts by Belgrade postmodern architects.[11] Less frequently, because of language barrier, the list would also include Slovenian journals *arhitektov bilten – ab* or *Sinteza*.

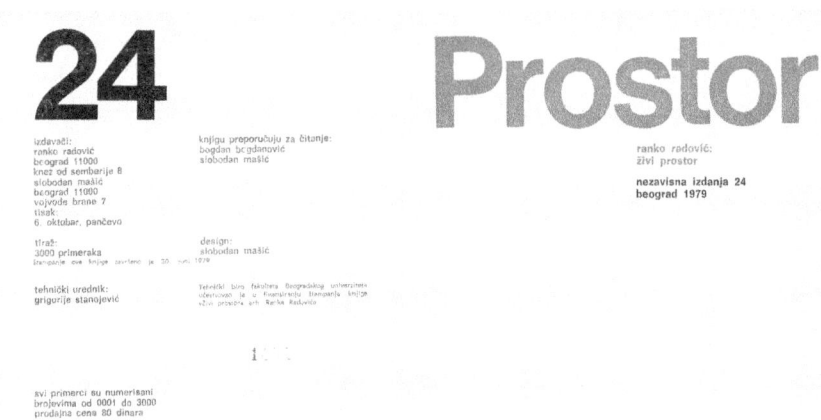

FIGURE 4.2 *Ranko Radović,* Prostor *(Belgrade: Nezavisna izdanja, 1979), book cover.*

As the 1980s progressed, culture funding and, with it, architectural print faced a crisis deepening and leading to closures and downfall with the disintegration of the county towards the end of the decade. The case of *Arhitektura urbanizam* is indicative: after twenty years of relatively stable financing and circulation, the journal was confronted by paper shortages, publishing delays, due to of crisis of finance, as well as of policy and content (Figure 4.5). Nominated as editor-in-chief in 1982, Ranko Radović attempted to innovate and invigorate the journal. In his opening editorial statement titled 'The house is being set in order … the door is open', he pledged 'to build a theoretical framework of the review … to appreciate the inner meaning of buildings and space, their spiritual and humanistic nature … (and to bring) information about foreign books and other publications, events and trends in the world now when it is rather difficult to obtain foreign publications seems … an important role of the review'.[12] The latter point relates to federal government economic crisis management underway from 1982 as a 'long-term program of economic stabilization', aiming to curfew import and mounting inflation. Nevertheless, the crisis deepened in all aspects of life; thus only eight issues were published in five years until the journal folded in 1987, six under Radović's editorship (1982–5), and two thereafter (1986, 1987). Nonetheless, the new editor succeeded in fostering the journal's discursiveness, nurturing critical writing through yearly architectural essay competitions, translations (e.g. a special issue of collected texts by architects from Étienne-Louis Boullée to the American group SITE), writings about local and European avant-gardes and the modern movement, recognition of urban studies, reviews of foreign publications, and the like.

In 1981, the interdisciplinary office of the Centre for Urban Development Planning – CEP, established in 1974, started to publish a monthly architectural bulletin *Komunikacija* under the enlightened editorship of the architect

Miloš Bobić, advocating green agenda, bicycling, social accountability, and critical writing (Figure 4.3). Cheaply produced, double-side printed folded A1 format with a vignette of an always different door on its front fold was distributed for free and widely followed across the country. It published both long interviews with carefully chosen collocutors, and short reports by critics, beginners, and experts alike – students, scholars, practising architects, urbanists, landscape architects, urban sociologists and psychologists. The bulletin also covered ongoing professional events: the announcements and results of design competitions for students and young architects organized by CEP, the reviews of competitions organized by professional bodies, or the participation of local architects in international competitions, such as the one for Paris La Villette.[13] In addition, *Komunikacija* regularly published vignettes from architectural history and timely translations of the various manifestos of postmodernism, notably Charles Jencks's 'Post Modern History' (*Architectural Design*, 48/1 [1978]),[14] or, in the ultimate, the fiftieth issue under Bobić's editorship (1986), Jürgen Habermas's 'Modern and Postmodern Architecture'. An index of authors and bibliography closed the issue 51, after which the bulletin continued under the new editor-in-chief, yet at a slower pace of thirty issues in six years.

Catalogues of art and architecture exhibitions that were seminal for postmodernism, held in the city's museums or galleries, and the Students Cultural Centre – SKC as from the late 1970s, were an important source for dissemination of ideas. Such had been the omnipresent catalogue of *Post Modern in Belgrade*,[15] an anthological exhibition of art and architecture in 1982, curated by the artist Dragoš Kalajić, incidentally the husband of the architect Vesna Vujica, one of the exhibitors,[16] or catalogues of MEČ show at SKC with the introduction by Bogdanović (1981), and exhibitions held at the Salon of the Museum of Contemporary Art, namely *Solar Architecture* (1980), *Earth Architecture* (1981), and *Water Architecture* (1983). International exhibitions came through the Federal Committee for International Cultural Exchange, for example, *Otto Wagner's School* (Museum of Applied Arts,

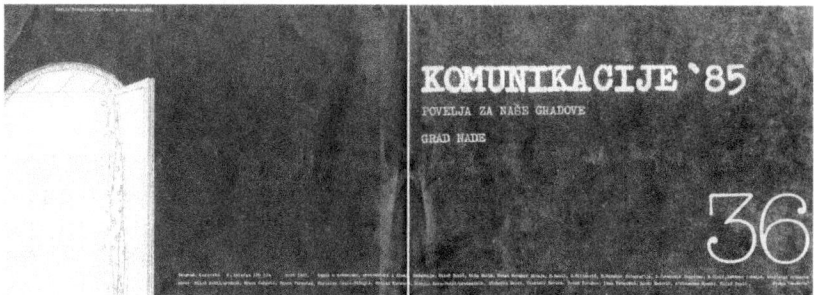

FIGURE 4.3 Komunikacija *(Belgrade), no. 36 (1985), bulletin cover with black&white reproduction of artwork 'Door to the Sea', by Marija Dragojlović.*

1983), or, in the Museum of Contemporary Art, *Tradition and Identity – Architecture in Finland* (1980) and *Alvar Aalto* (1987), with the latter two organized by the Museum of Finnish Architecture. Involvement of Juhani Pallasmaa in co-curating the first and in selecting illustrations and Aalto's excerpts and in the layout of the catalogue of the second exposed the Belgrade public to his views on architectural phenomenology. Both exhibitions accentuated nature and tradition in architectural identity, and, as noted in the introductory text in Serbian printout added to the original catalogue to Aalto's retrospective, 'anthropology component ... associative paths ... astounding mental bridges',[17] between textures, tactile qualities, freehand sketches, paintings, and 'building iconography'.

In 1984, the Association of Belgrade Architects organized at the SKC the exhibition of Italian architects engaged in the project for the *Isola Tiberina* 'La Nave di Pietra', conceived and realized by Slobodan Selinkić, the Belgrade architect living in Rome, that had an illustrated catalogue in Serbo-Croatian. The event program included lectures given by Aldo Rossi, Paolo Portoghesi, Franco Purini, Alessandro Anlselmi, Felice Cipriani, and Bogdan Bogdanović and a round-table discussion gathering participants and architects from all over the region, such as Boris Podrecca from Vienna, Aleš Vodopivec, Vojteh Ravnikar and Janez Koželj from Ljubljana, Zlatko Ugljen from Sarajevo, Ivan Crnković, Nikola Polak, and others from Zagreb, as well as colleagues from Belgrade, Radović, and Bobić, and other prominent architects including members of MEČ. During the visit, Rossi, Podrecca, and Anselmi participated along with Yugoslavian colleagues in the jury for the competition-exhibition *Living with Nature*, organized by CEP in the city's Art Pavilion. Subsequently, widely read were select transcribed statements from the jury's public discussion with the competitors and translated excerpts from Rossi's *L'architettura della città*, published preceding the event.[18]

In sum, the sources in the field of architectural publications offered fairly adequate scholarly scope and breadth, versatility of information, and, most importantly, pluralist even opposing views to the Belgrade professional public.

Translation of texts in the philosophy of art and aesthetics

Translation of key texts in phenomenology and the philosophy of art and aesthetics was one of the more significant sources of postmodernist discourse in architecture. As from the 1970s, lines by the philosophers Maurice Merleau-Ponty, Gaston Bachelard, and Martin Heidegger feature prominently in epigraphs or citations in architectural books and texts. The selection of authors and titles that is singled out is deemed the most representative and not in any way comprehensive and systematization is offered for purposes of clarity but not suggesting any order or hierarchy.

Translation of phenomenological literature in the post-Second World War period can be traced to a Croatian publication by Mladost Zagreb in 1959 of Martin Heidegger's essays 'Der Ursprung des Kunstwerkes' (1935–6) and 'Wozu Dichter?' (1946), originally published as part of his first post-Second World War book titled *Holzwege* (1950, *Off the Beaten Track*). The essays were translated by the leading Zagreb philosophers, Danilo Pejović, member of the original editorial board of the liberal left-wing journal *Praxis* (though, its later opponent), and Danko Grlić, the foremost aesthetician in the former Yugoslavia. In addition, periodicals established in the 1950s, such as the journal for literature and culture *Vidici* (Belgrade, established in 1953), or the monthly for art and culture *Polja* (Novi Sad), and the journal for theory, criticism, and poetry *Delo* (Belgrade), both established in 1955, to name but the most well-known examples, regularly brought fresh texts and important translations of theory, as would, later, journals dedicated solely to translation, such as *Marksizam u svetu* (Belgrade, est. 1974), that was exclusively committed to translating contemporary liberal and Marxist theory. Even though its scope is outside the scope of this book, in any more elaborate study of sources from the period, special attention should be paid to authors and to texts published in *Praxis*, the Marxist journal of political theory and philosophy established in 1964 in Zagreb, that directly brought critical contemporary left thinking to educated public in Yugoslavia.

Especially notable for providing a wide theoretical framework to the Belgrade cultural context was the book series 'Sazvežđa' published by the esteemed publishing house Nolit from 1964 well into the 1990s. Even though it included well-regarded books by Yugoslavian authors, the series was celebrated mainly for the liberal editorial policy of its editor-in-chief Miloš Stambolić and excellent translations into Serbo-Croatian of works by seminal authors in the extended field of theory and culture studies. Starting from Erich Fromm's *Escape from Freedom* (1st ed. 1941), as book no. 1 in the series, the essays by the Polish philosopher Leszek Kołakowski as no. 2, Pierre Francastel's *Art et technique aux XIXe et XXe siècles* (1st ed. 1956) as no. 3, Sergei Eisenstein's avant-garde essays on film montage as no. 4, continuing with titles ranging from *Zen Buddhism and Psychoanalysis* (1st ed. 1960) by Fromm and Daisetz T. Suzuki as no. 8, to Norbert Wiener's *The Human Use of Human Beings* (1st ed. 1950, rev. 1954) as no. 9, all in the first year of edition; and, in the following decade, translation of works of works of authors such as Claude Lévi-Strauss (*La pensée sauvage* [1962] as book no. 12 in 1966), or Roger Caillois (10), Berthold Brecht (13), Roman Jacobson (16), Mikhail Bakhtin (17), Theodor Adorno (19), Jean Piaget (21), Ferdinand de Saussure (24), Louis Althusser (26), Thomas Kuhn (40) Walter Benjamin (41), Fredric Jameson (43), Henri Lefebvre (44), Jürgen Habermas (48), among many other most lustrous names.

Other publishing houses competed with early translations of key texts in theory and culture, such as, in Belgrade, Kultura bringing Rudolf

Arnheim's *Film als Kunst* (1st ed. 1932) in 1962, and Gaston Bachelard's *La Poétique de l'Espace* (1st ed. 1958) in 1969 that had left a lasting imprint in architectural imagination and writing. In 1975, key sources of phenomenology appeared: a collection of philosophical essays under the title *Phenomenology* in 'Sazvežđa 47', edited by Milan Damnjanović; Roman Ingarden's *Erlebnis, Kunstwerk und Wert. Vorträge zur Ästhetik 1937-1967*, (1st ed. 1969), translated and published by Nolit; and Edmund Husserl's *The Idea of Phenomenology – Five Lectures* (delivered in 1907 at the University of Göttingen) translated and published by BIGZ. A momentous event for the architectural discourse was publication in Serbo-Croatian of Heidegger's essays under the title *Thinking and Singing* in 1982, as 'Sazvežđa 79', which included two influential essays, namely 'Bauen Wohnen Denken' and '… dichterisch wohnet der Mensch …'. The essays would be amply cited by generations of Belgrade architects, in academic papers, lectures, and books and, also colloquially, by designers as points of inspiration for their projects. One might go as far as saying that Heidegger's lines reached veneration in architectural discourse of the 1970s and 1980s. As proposed by Jarzombek, after these essays by Heidegger, the 'philosophical project of architecture' took a decisive turn that in socialism can be observed as the turn from Marxism to phenomenology, producing a sort of a hybrid, Marxian phenomenology.[19]

In conclusion, it is quite interesting to note correspondence and parallelism in the same year of publication of translation of architectural versus theory books: Bachelard versus Giedion in 1969, *Phenomenology* (various authors) versus Norberg-Schulz in 1975, Derrida[20] versus Rudofsky in 1976; Heidegger versus Jencks in 1982; Jean-François Lyotard[21] versus Rowe and Koetter in 1988, and similar others.

Infusion of theory in architectural training

For our issue of sources, the main concern is the question of operative agency that might have brought to the fore Heidegger's essays or other phenomenological sources, into architectural theory, profession, and academia, that were nominally promoting socialist architecture, even if practising 'socialist aestheticism'.[22] One interpretation might have it that the impetus of change came through radical curriculum reform briefly implemented at the University of Belgrade Faculty of Architecture, termed 'The New School' in academic year 1970–1. The reform, led by Bogdan Bogdanović, was short-lived, constantly contested by factions within the Faculty and it ended in 1973. The reformist ideals continued in the coming decades as the teaching praxis of some of its proponents, such as Bogdanović himself, or Radović, who taught a much famed and popular survey lecture course 'Contemporary Architecture'. Yet, it might be argued,

it was the teaching syllabus of 'Architectural Analysis', a required first-year course conceived and practised by the architect and professor Branislav Milenković (1926) that most effectively infused theory into professional training of architects at the University of Belgrade. Introduced in 1971–2, the course presented freshmen with complex notions of contemporary architectural theory, combined with precedent studies of modern houses and interpretation of architectural space. It was often considered as somewhat incomprehensible, at first, but ultimately it had a lasting effect on future professionals. Milenković distributed his lectures internally as auxiliary teaching materials from 1969, and had his influential textbook *Introduction to Architectural Analysis I*, published by Građevinska knjiga in six editions until 2010.[23]

In the book's epigraph, the author cites a line by Merleau-Ponty from his essay on painting 'L'Œil et l'esprit' (1st ed. 1961), as translated into Serbo-Croatian and published in Belgrade in 1968. The book is infused by Heideggerian notions and the framework for the interpretation of space is set by key phenomenological notions of perception, experience, engagement, existence, and the like, that are, in the book, discussed against precedent analysis and what Milenković termed as the 'theory of place'. Bibliography includes references to texts by Henri Focillon, Gaston Bachelard, and Pierre Francastel, as well as to architectural phenomenology of authors such as Steen Eiler Rasmussen and, most notably, Christian Norberg-Schulz. In the coming years Milenković turned towards Henri Lefebvre's unitary theory of space that provided an underpinning to his PhD Thesis *Study of Architectural Program Principles in Relation to Other Disciplines of the Science of Space*, defended at the University of Belgrade in 1977. Lefebvre was available widely as numerous articles and essays and some fifteen books were translated, from 1957 when *Contribution à l'esthétique* (1st ed. 1953) appeared, to his influential *Critique of Everyday Life / Critique de la vie quotidienne*, vol. 1 (Introduction, 1947), translated in 1959, and, again, integral with vol. 2 (*Fondements d'une sociologie de la quotidienneté*, 1961) and vol. 3 (*De la modernité au modernisme: Pour une métaphilosophie du quotidien*, 1981) in 1988, as well as *La révolution urbaine* (1970) that was translated already in 1974. Excerpts of Lefebvre's *The Production of Space* (1st ed. in French 1974) were first translated and published in *Marksizam u svetu* in 1975, and broadcast on Radio Belgrade 3 theory reading program in 1980.

Lefebvre's remarks might serve here as appropriate summing up of relations between architectural discourse and phenomenology. He notes critically that highly esteemed authors in architectural theory such as Christopher Alexander or Christian Norberg-Schulz

> often seek ... authority either of philosophy in general or of particular philosophers [namely, Heidegger, Merleau-Ponty, Bachelard and Piaget].

What can be clearly seen by reading such authors is the way in which technicizing, psychologizing or phenomenologically oriented approaches displace the analysis of social space by immediately replacing it with a geometric – neutral, empty, blank – mental space. ... Thus objective space and the subjective image of space – the mental and the social – are simply identified.[24]

Milenković appreciated this and kept a critical distance through a dialectical method of analysing processes and changes of discourse over time, and discussing them through his teaching and later publications, such as in his sharp comments on the conference on postmodernism in philosophy and literary studies, which was held in Zagreb in 1986, with contributions from Jameson, Lyotard, Heinrich Paetzold, Gianni Vattimo, Maurizio Ferraris, Rada Iveković, and others.[25]

Concluding notes

The postmodernist turn significantly added a component of research and theory into architectural discourse that provided groundwork for analytical writing in several disciplinary directions that will be mentioned as way of concluding this chapter's discussion: historiography of modern architecture, interdisciplinary research of socio-spatial processes and urban study, and research-based urban design. In fact, I would go as far as to argue that research and critical reappraisal of the avant-gardes and the modern movement in art and architecture in Belgrade and Serbia came as part and parcel of postmodernist experimentation. For instance, the ground-breaking exhibition of international art collection *Zenit and the Avant-garde of the 1920s*, curated by Irina Subotić at the National Museum in March 1983, had an immediate effect on postmodernist architectural iconography, such as in the remarkable diploma project 'Bajloni Brewery', defended in June of the same year at the Faculty of Architecture in Belgrade, that was subsequently publicly exhibited in 1984 to great acclaim and formed the key part of its author's portfolio, that earned him admittance to continue studies in Zaha Hadid's unit at the Architectural Association in London.[26]

Interdisciplinary organizations such as JUGINUS, IAUS, or CEP instigated and fostered research into environment and design, minimum housing standards, housing for underprivileged social groups, socio-spatial processes of illegal urban sprawl, or problems of the so-called unhygienic settlements spreading on the city's periphery in the 1970s and 1980s.[27] Such research not only resulted in several significant publications, such as two thematic issues on slum of bulletin *Komunikacija*,[28] a book about illegal housing in Belgrade,[29] or an edited book on housing and poverty,[30] but had also permeated the praxis of urban planning through introduction of participation, environmentally conscious design, and the like.[31]

FIGURE 4.4 *Miloš R. Perović*, Iskustva prošlosti *(Belgrade: Zavod za planiranje grada, 1985), book cover.*

In urban studies, significant precedents were set by the 'Research into alternative urban models' and 'Study for the Reconstruction of the Central Part of New Belgrade and the Sava Amphitheatre' from the beginning of the 1980s, that came out in the bilingual book *Lessons of the Past* in 1985 (Figure 4.4).[32] Carried out in the Institute for Development Planning of the City of Belgrade (as the name of this professional and administrative institution was translated at the time), by a large research and design team, the studies comprised texts, immaculately precise drawings, and exquisite wood models. The resulting book was the pinnacle of architectural print of its period, with sharp black and white photography, sophisticated graphic design by Studio Strukture, and high-quality print by a printing house from Slovenia. Above all, studious methodology of design research by the studies' authors Branislav Stojanović (1950–2009) and, especially so, Miloš R. Perović (1939), who also edited the volume, provided some of the most articulate criticism of modernist planning and the functional city New Belgrade. Since 1977, Perović has widely exhibited his ideas and research by design, from galleries Emonska vrata in Ljubljana, Nova in Zagreb, Belgrade's Salon of the Museum of Contemporary Art to RIBA gallery in London, in turn,

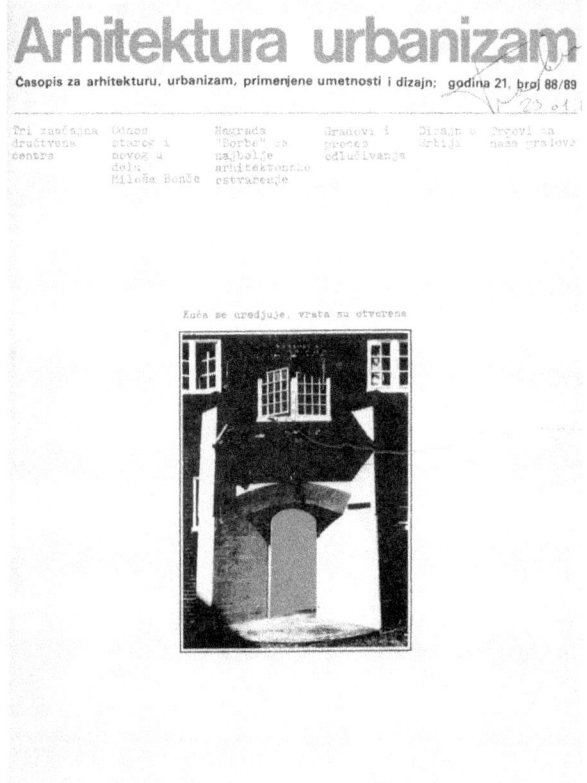

FIGURE 4.5 Arhitektura urbanizam *(Belgrade), no. 88–9 (1982), magazine cover.*

producing representative catalogues in collaboration with notable local and international critics and designed by Studio Strukture.[33] His publications, I would argue, epitomize the postmodernist turn in urban theory and set a precedent for post-socialist urban design. Criticized at the time of publication as elitist and oblivious of socio-spatial depravation,[34] in fact, they exposed the method of densification of a modern city, that addressed the very issues that will have arisen in the post-socialist period, thus, becoming, for better or worse, the print matter of current urban and architectural practices.

To conclude, focus on drawing, art objects installation, intensive exhibition activity, transdisciplinary approach, public exposure of architectural thinking and debate, erudite and critical writing and research, research by design, and, most importantly, nurturing regional and international collegial exchange and networks were the foundations for the rise of postmodernism in Belgrade as a vibrant force within the socialist architectural discourse of the 1980s. Moreover, I would argue, the same foundations might just still hold a promise for the rise of alternative architectural practices of today's post-socialist Serbia.

Notes

1. See previous research by the present author: Ljiljana Blagojević, 'Postmodernism in Belgrade Architecture: Between Cultural Modernity and Societal Modernisation', *Spatium International Review* 25 (2011): 23–9; and Ljiljana Blagojević, 'Sources of Postmodern Architecture in Late Socialist Belgrade', in Michela Rosso, ed., *Investigating and Writing Architectural History: Subjects, Methodologies and Frontiers. Papers from the Third EAHN International Meeting* (Torino: Politecnico di Torino, 2014), 736–46
2. Nikola Polak, 'Zlatno tele arhitekture', *Čovjek i prostor* 334 (1981): 10–13, citation, p. 10.
3. Cf. Jorge Otero-Pailos, *Architecture's Historical Turn: Phenomenology and the Rise of the Postmodern* (Minneapolis: University of Minnesota Press, 2010). On the subject, also see Ljiljana Blagojević, 'The Post-modernist Turn and Spectres of Criticality in Postsocialist Architecture: "One:Table" at the Venice Biennale 2012', *The Journal of Architecture* 18, no. 6 (2013): 761–80.
4. 'Postmodernism, or, the Cultural Logic of Late Capitalism' by Fredric Jameson, first published in the *New Left Review* in 1984, was translated into Serbo-Croatian and read on Radio Belgrade Program 3 in 1985; see Frederik Džejmson, 'Postmodernizam ili kulturna logika kasnog kapitalizma', translated by Slavica Miletić, *Treći program Radio Beograd*, 64 (1985): 181–228
5. *IRO Građevinska knjiga, bibliografija 1948–1988* (Belgrade: Građevinska knjiga, 1988).
6. For example Faculty of Architecture Postgraduate Housing Studies edition amounting seventy publications in the period 1975–83.
7. Cf. Blagojević, 'Postmodernism in Belgrade Architecture'; Ljiljana Blagojević, 'Raskršća savremene arhitekture: Ranko Radović i diskurs postmodernizma', *Kultura* 134 (2012): 182–99.
8. Reprinted in *Komunikacija*, 29 (1984).
9. *Polet*, est. 1967, revamped in 1976 and 1978 under the new editorial, journalists and designers crew that included 2,100 contributors over the course of fourteen years of weekly and, later, biweekly publication; see Željko Krušelj, *Igraonica za odrasle: Polet 1976–1990* (Rijeka: Adamić, 2015).
10. *Architectural Design*, 5–6, 1980, 1.
11. Dejan Ećimović, 'Novi Beograd', *Čovjek i prostor* 367 (1983): 26–8.
12. R(anko) R(adović), 'The House is Being Set in Order … the Door is Open', translated by Đ. Stanimirović, *Arhitektura urbanizam* 21, no. 88–9 (1982): 3–4, citation p. 3.
13. *Komunikacija,* 14 (1983).
14. *Komunikacija,* 3 (1981).
15. Dragoš Kalajić, *Antologija: post-moderna u Beogradu [Izložba teze Dragoša Kalajića]* (Belgrade: Salon Muzeja savremene umetnosti, 1982).
16. Blagojević, 'Sources of Postmodern Architecture in Late Socialist Belgrade', 741–2.

17 Bogdan Bogdanović, 'O Aaltou', *Alvar Aalto, 1898–1976* (Beograd: Muzej savremene umetnosti, 1987), 3–4.
18 *Komunikacija*, 27, 28 (1984).
19 Mark Jarzombek, 'The Cunning of Architecture's Reason', *Footprint* 1 (2007): 31–46, quote 31.
20 *De la grammatologie*, 1967.
21 *La condition postmoderne: rapport sur le savoir*, 1979.
22 As defined by the Belgrade literary critic Sveta Lukić in 1963, cf. Ljiljana Blagojević and Marija Milinković, 'The Beauty of Production: Module and its Social Significance', *arq: Architectural Research Quarterly* 17, no. 3–4 (2013): 253–68, quote 255.
23 Branislav Milenković, *Uvod u arhitektonsku analizu I* (Belgrade: Građevinska knjiga, 1972).
24 Henri Lefebvre, *The Production of Space*, translated by Donald Nicholson-Smith (Malden, MA: Blackwell Publishing, 1991), 298.
25 Branislav Milenković, *Uvod u arhitektonsku analizu II: Compendium* (Belgrade: Građevinska knjiga, 2009), 115. Cf. Milivoje Solar, Gvozden Flego, and Nadežda Čačinović-Puhovski, eds., *Postmoderna: nova epoha ili zabluda* (Zagreb: Naprijed, 1988).
26 Đorđe Dašić, 'Bajlonijeva pivara u Beogradu', *ČIP* 8, no. 365 (1983): 24–5.
27 See Aleksandar Kušić and Ljiljana Blagojević, 'Patterns of Everyday Spatiality: Belgrade in the 1980s and its Post-Socialist Outcome', *Český lid: Etnologický časopis* 100, no. 3 (2013): 281–303.
28 *Komunikacija* 30, 31 (1984).
29 Branislava Saveljić, *Beogradska favela* (Belgrade: Istraživačko-izdavački centar SSO Srbije, 1989).
30 Miloš Bobić and Sreten Vujović, eds., *Krov nad glavom. Ogledi o stambenoj bedi i siromaštvu* (Belgrade: Filip Višnjić, 1985).
31 *Resnik – linearni grad – Avala grad* (Belgrade: Kulturni centar, 1980).
32 Miloš Perović, ed., *Iskustva prošlosti* (Belgrade: Zavod za planiranje razvoja grada, 1985).
33 See bilingual (Serbo-Croatian and English) exhibition catalogues: *The Street of Encounters* (Belgrade, 1978); *Perović* (Belgrade, 1981); *With Man in Mind* (London, 1986), etc.
34 Milan Šćekić, 'Onda je pao sneg', *Arhitektura urbanizam* 97 (1986): 7.

PART TWO

Practices

5

Bogdan Bogdanović's surrealist postmodernism

Vladimir Kulić

In 1989, Italian architectural critic Mario Pisani published a book prophetically titled *Tendenze nell architettura degli anni '90*, which featured a roster of postmodernist celebrities, including Aldo Rossi, James Stirling, Robert Venturi, Paolo Portoghesi, Norman Foster, Jean Nouvel, and Frank O. Gehry.[1] Among the nineteen famous names, one stands out as largely unknown to today's English-speaking audience: Bogdan Bogdanović (1922–2010). The Yugoslavian architect had enjoyed sporadic international attention for more than twenty years – significantly, on both sides of the so-called Iron Curtain – but by the late 1980s, he was apparently poised to join the ranks of the world-famous. Indeed, by the following year, Bogdanović's work was featured on the cover of the London-based journal *World Architecture,* the short-lived publication of the International Academy of Architecture (of which he was a founding member); the same issue also reported on Gehry's new building in Paris and the inaugural conference of what would become Docomomo – an organization that definitively signalled the passing of modernism into history.[2] Only a few months later, however, Yugoslavia collapsed and Bogdanović's career took a sharp turn away from architectural stardom: as his country descended into chaos, the former mayor of Belgrade became a dissident opposed to hard-line nationalism of Slobodan Milošević's regime and was eventually forced into exile in Vienna. A new war completely overshadowed Bogdanović's career-long efforts to commemorate the previous, Second World War. He devoted his remaining years to writing, adding seven books to his already extensive literary output, most of them first published in German.[3] Yet, he never built again.

Failed though it was, the attempted induction of Bogdan Bogdanović into the pantheon of postmodernism points not only to the porous architectural borders of the waning Cold War – they were always more permeable than the conventional views would have it – but also to the possibility of opening up the historical formation of postmodernism to include properly Second World manifestations, not as second-hand appropriations, but as original positions of general relevance. However, such an opening poses all kinds of challenges to postmodernism's existing discursive elaborations: most fundamentally, in contrast to the West, where utopian impulses survived only as 'ghosts', as Reinhold Martin has argued, Bogdanović's oeuvre was devised in adamant support of an actual 'utopian' project – Yugoslavia's self-managing, non-aligned, multi-ethnic socialism.[4] To further confound the matter, Bogdanović himself was critical of utopian thinking understood as a prescriptive, fixed vision, even when he acknowledged its 'socially progressive' role.[5] Consequently, he opposed the 'high modernism' of socialist and capitalist states alike, and instead advocated an 'inner architecture' that would tie the scales of physical space to psychological and anthropological formations.[6] Nevertheless, such 'inner architecture' did not mean a retreat from politics: not only was Bogdanović active as a self-professed 'bad communist' for most of his career, but his 'inner architecture', based as it was on his surrealist upbringing, was inherently political, as it sought to achieve something akin to what Walter Benjamin called 'profane illumination' – a secular re-enchantment of the modern world as a precondition and an ingredient of revolutionary liberation.[7] Bogdanović's work thus struck at the very core of modernity as conceived through the lens of instrumental rationality, thus critiquing socialism's own uncritical espousing of capitalism's rationalist programs and methods.

What sort of postmodernism, then, was Bogdanović's, and was it a postmodernism at all? Rather than engaging in a futile attempt to answer that question by pinpointing some sort of postmodern 'essence' in his oeuvre, this chapter performs a theoretical *pas-de-deux* to demonstrate how Bogdanović's oeuvre stands simultaneously inside and outside of postmodernism's existing definitions, thus further challenging its already fuzzy boundaries. It focuses on some of the key tropes of postmodernist architecture, such as autonomy, criticality, and linguistics, to highlight Bogdanović's askew position in relation to the postmodernist mainstream and to point to its origins in surrealism.

Postmodernist or not?

In a recent article, architectural historian Ljiljana Blagojević designated Bogdan Bogdanović in no uncertain terms as 'one of the first postmoderns' in Belgrade.[8] Such perception is not unjustified, because Bogdanović was

entangled in some of the key events that led to the consolidation of postmodern architecture in Yugoslavia. For the generation of Belgrade's self-identified postmodernists, he was the spiritual father who supported their activities.[9] Even their conversion to postmodernism was purportedly sparked by the short-lived pedagogical reform he initiated at the Faculty of Architecture in Belgrade in the early 1970s.[10] When in 1980 the Zagreb journal *Arhitektura* launched a local discussion on postmodernism by dedicating an entire issue to the theme, Bogdanović was invited to contribute an essay.[11] Unlike other contributors, he never even mentioned the term, but his inventory of urban metaphors in early modern literature must have been read as a piece of postmodern theory in its own right. By the time postmodernism gained firmer foothold in the mid-1980s, his book *The Futile Trowel: The Doctrine and Practice of the Brotherhood of Golden (Black) Numbers* saw a renewed edition, no doubt as a home-grown precursor to current trends. Two decades after its original publication, this architectural phantasmagoria about the author's imagined initiation into an esoteric 'brotherhood' that included Bramante, Palladio, and Piranesi, among others, came to resonate not only with the ongoing fascination with classicism, but also with the popular literary genre of historiographic metafiction.[12] Finally, as mayor of Belgrade, Bogdanović presided over the 1986 international competition 'The Future of New Belgrade', which called for a radical reconfiguration of the key urban project of Yugoslavian socialist modernity. While the competition awarded one of the honourable mentions to Paolo Portoghesi, the top prizes went to entries from Czechoslovakia, Poland, and Yugoslavia, showcasing the extent to which postmodernist ideas became entrenched (and exchanged) across Eastern Europe.[13]

Much of Bogdanović's own oeuvre indeed supports the affiliation with postmodernism. On the theoretical level, he launched an early and persistent critique of modernism's overt rationality, especially on the urban scale, offering instead a vision of the city as deeply imbued with meaning.[14] His main architectural achievements, which include around twenty memorials dedicated to the victims of the Second World War, resonate with some of postmodernism's typical stylistic manifestations, as they all abound in ornament, vague historical references, and allusive shapes. A few of his built projects even anticipated specific postmodernist techniques: for example the Monument to the Jewish Victims of Fascism in Belgrade (1952), his first built work, incorporated fragments of buildings destroyed in the multiple wartime bombardments of Belgrade, thus prefiguring the postmodern taste for citationality – with a peculiar twist. His 1961 remodel of the late-nineteenth-century Villa of Queen Natalija in Smederevo into a residence for the guest of the first summit of the Non-Aligned Movement in Belgrade was an exercise in 'ironic' classicist revival, complete with skinny Ionic columns constructed out of plumbing pipes, topped by minuscule Ionic capitals (Figure 5.1).

FIGURE 5.1 *Bogdan Bogdanović, Remodel of Queen Natalija's Villa, Smederevo, Serbia, 1961. Photo by Bogdan Bogdanović.* © Architekturzentrum Wien, Vienna, Collection.

However, Bogdanović himself was not enthusiastic about being labelled postmodernist.[15] He probably disliked being lumped together with the latest stylistic fashion, with which he had less in common than would seem at first sight. At the most obvious level, in his built work he never resorted to the easy-to-mediatize surface effects that Fredrick Jameson found to be at the core of postmodernism; if anything, he tended to overemphasize the materiality of his projects. More importantly, as eruditely informed as he was, Bogdanović also must have been aware of the fundamental gaps in motivation that separated him from many of his contemporaries at the philosophical and methodological level. Despite his persistent preoccupation with the city, its history, and its meanings, his urban theory was in some important ways at odds with that of Aldo Rossi, Kevin Lynch, or Robert Venturi and Denise Scott Brown.[16] He was uninterested in discussing the mechanics of urban signification and decoding the city as a system of signs to be read; what interested him instead were the foundational urban metaphors, mutable, open-ended, and irreducible to explicit signification.[17] The pedagogical experiments he conducted at the 'summer school' at his studio in the village of Mali Popović outside of Belgrade in the late 1970s

were similarly ambiguous: they may have been postmodern in that students were led to simulate the cities of imaginary civilizations, but they hardly offered any immediately applicable instrumental knowledge or method, as did, for example Lynch or Venturi and Scott Brown.[18]

If Bogdanović ever identified with anything, it was with surrealism.[19] His writings are peppered with explicit clues in that respect, so much so that the title of his memoir, *The Accursed Builder,* directly refers to the nineteenth-century 'accursed poets' who inspired André Breton and his circle.[20] Surrealism was for Bogdanović much more than a style or a set of methods: it was a worldview. He literally grew up with it: his father Milan, a prominent literary critic, was in close contact with the prolific group of Belgrade surrealists, an early and in some ways self-sown formation that actively communicated with the Paris *Centrale* since 1923. Young Bogdan considered the group's leader Marko Ristić his intellectual father. The group's members were even more politically engaged on the left than their peers in Paris, to the point that they suffered censorship by the royal regime. But they were not always obedient followers of the party line either: in the late 1930s, Ristić famously participated in the so-called 'conflict on the literary left', opposing the Communist Party of Yugoslavia's sanctioning of socialist realism as the obligatory mode of leftist cultural production. Despite such confrontations, some of the prewar surrealists came to prominent positions in the new socialist state, especially after Yugoslavia was expelled from the Soviet bloc in 1948. Ristić was appointed Yugoslavian ambassador to France in 1951, whereas his one-time co-writer Koča Popović, a Parisian student and legendary Partisan commander during the war, became Yugoslavia's longest-serving foreign minister in 1953. Bogdanović's initiation into surrealism was thus early, thorough, and explicitly politicized, but it also provided him with an advantageous position in the new post-war society. Surrealism continued shaping his worldview for the rest of his life, even when his interests veered far beyond the movement's original historical contours.

Surrealism bears a tenuous connection with architectural postmodernism. There is indeed a line that connects Breton's circle, through Lacan, Bataille, Blanchot, and the *Collège de Sociologie,* to French philosophers like Foucault, and Derrida, but a similar link in architecture is much more difficult to draw.[21] The reason lies partly in the fact that there was hardly ever such a thing as surrealist architecture: surrealists were fascinated by some kinds of buildings (Art Nouveau, Gaudí, Facteur Cheval, etc.), they despised others (functionalism), and they sometimes engaged in spatial or proto-architectural practices (e.g. Kurt Schwitters's *Merzbau*), but very few architects ever attempted practising surrealism.[22] In turn, with all their focus on contradictions, ambiguity, and meaning, and all their references to the historical avant-garde, postmodernist architects hardly ever acknowledged any sustained interest in surrealism, save for a brief moment in 1978, when *Architectural Design* published a special issue on the topic.[23] It is hardly a coincidence that the editor was Dalibor Veselý, a phenomenologist and an

émigré from Czechoslovakia, where surrealism had had a strong base, but except for him, most other contributors, which included Kenneth Frampton, Rem Koolhaas, and Bernard Tschumi, demonstrated only an interest in surrealism's specific techniques, leaving its deeper motivations unaddressed.

In that sense, Bogdanović does stand apart from the common manifestations of postmodernism. In his drawings, one will not encounter figures in bowler hats à la Magritte (as in O. M. Ungers' work), or the 'metaphysical' cityscapes à la De Chirico (as in Aldo Rossi's). Instead, his surrealism ran deeper: together with the related interests in psychology, anthropology, the sacred, and the myth, it formed the bedrock of his architectural worldview in a myriad of ways, but most fundamentally through a rejection of any kind of fixity – whether linguistic, disciplinary, or political – that would constrain the 'actual functioning of thought', to use Breton's famous phrase.[24] It is his enthusiastic, optimistic embrace of the ever-mutable nature of living human thought that separates him from the often cynical worldview of his postmodernist peers, despite the fact – or perhaps precisely because of it – that he devoted most of his career to commemorating the victims of gruesome wartime atrocities.

Autonomy and criticality

In one of the first post-socialist attempts at historicizing the architecture of the socialist period in Serbia, architectural historian Miloš Perović designated Bogdanović as neither a postmodernist nor a surrealist, but as the most prominent representative of 'socialist aestheticism'.[25] This peculiar category, specific to the Yugoslavian context, originated in literary criticism in 1963 to describe the initial resurgence of modernism after the break with the Soviet Union, a 'Hegelian, first, abstract negation' of socialist realism, which manifested itself through the 'politically loyal and neutral' explorations of 'the purely "literary aspect" of literature'.[26] In the early 1980s, the phrase migrated into art criticism, where Miodrag Protić defined it as art's 'return to its neglected ontological structural and semantic material and reality', a definition distinctly reminiscent of Clement Greenberg's theorization of modernism as an autonomous media-specific art.[27] Around the same time, Protić's colleague Lazar Trifunović gave socialist aestheticism a negative slant, stressing its perceived disengagement from society and critiquing it as a conformist 'art for art's own sake' that 'did not disturb by asking enigmatic and inconvenient questions'.[28] Writing from an openly anti-communist perspective, Miloš Perović appropriated such critical position, but he pushed it even further to establish an imperative for architecture to serve as an agent of liberalism against the communist system. His sharpest criticism was reserved for Bogdanović, whose work he presented as mere 'aesthetic products in the service of the totalitarian communist regime'. In other words – summing up

the aforementioned key components of socialist aestheticism – he critiqued Bogdanović for pursuing an 'autonomous' architecture that did not fulfil a perceived ethical responsibility of being 'critical'.[29]

Autonomy and criticality are two of the core concepts in the theorization of architectural postmodernism. Both are politically deeply charged: in the West they were mobilized in order to save architecture from being devoured by late capitalism, effecting a retreat into alleged essence of the discipline. Whether through a revival of semiotics or through syntactic games with empty signifiers, that essence was found in the linguistic metaphor, which became the crux of critical resistance against architecture's total instrumentalization by 'the cheap politician and the commercial operator'.[30] But what do autonomy and criticality mean vis-à-vis the definition of postmodernism when applied not to late capitalism, but to an actual revolutionary society, such as Yugoslavia's? If Bogdanović's architecture qualifies as a conformist 'socialist aestheticism' for being allegedly autonomous *but not* critical, what would have it been if it were autonomous *and* critical? Postmodern? Would being critical of socialism qualify it as postmodern if postmodernism is already defined as being critical of capitalism?

Notwithstanding the many ironies arising from these questions, let alone the likely incommensurability of the two political systems, autonomy, criticality, and their manifestation in linguistic terms are still useful concepts to help us position Bogdanović vis-à-vis the main demarcation lines on the map of postmodernism. As I will try to show below, Bogdanović's work was precisely the opposite of how Perović sees it: rather than being *autonomous but not critical*, it was *critical but not autonomous*, which still puts it in an ambiguous position in relation to the common definitions of postmodernism, albeit in a rather different way. The question of architectural language will play an important role in the discussion, serving as it often did as the *differentia specifica* between postmodernism proper and the various other reactions to the impasses of waning modernism.

The politics of linguistics

Let us start at the end. In 1990, almost a decade after he had stopped building, Bogdanović published his last properly 'architectural' volume titled *The Book of Capitals*.[31] A collection of one hundred beautifully drafted variations on the theme of the Ionic capital, the book offered an imaginative – perhaps indeed surreal – reinterpretation of the classical tradition (Figure 5.2). The plates show uncanny combinations of the standard elements of the classical vocabulary – volutes (often turned upside down), flutings, acanthus leaves, egg-and-darts, cymae – with a range of anthropo- and zoomorphic motifs, such as eyes, breasts, horns, complete human (vaguely female) faces, and bovid skulls. Drafted entirely by hand, some are carefully shaded to produce

FIGURE 5.2 *Bogdan Bogdanović, Page 28 of* The Book of Capitals *(1990)*.
© *Architekturzentrum Wien, Vienna, Collection.*

a three-dimensional effect and some are left as linear drawings, but they all appear devoid of any attempt at geometrical conventinalization. The images are accompanied by text typical for Bogdanović's other publications: short stream-of-consciousness notes on the process of drawing, interspersed with quasi-scholarly comments complete with references to sources.

At first glance, here is postmodernism at its most linguistic: an entire book dedicated to the capital, the most important element in the classical vocabulary, the centre of architecture's linguistic metaphor. At a second look, however, one realizes that Bogdanović's explorations aim against postmodernism's typical concerns: rather than fortifying the language, they dissolve the linguistic consolidation that preoccupied postmodernists. What for most of them was a conventional architectural sign to be quoted or subjected to syntactic operations, for Bogdanović became just the starting

point for defamiliarizing the conventional meanings by relating the form back to its historical origins. Coincidentally, shortly before *The Book of Capitals* came out, art historian John Hersey published *The Lost Meaning of Classical Architecture*, which revealed the forgotten ritualistic, sacrificial purpose of the classical ornament.[32] Whether Bogdanović knew of Hersey's work or not, his motivation was similar: to inject meaning back into a form that had become so conventionalized that it no longer bore any relation to its sources. The method, however, was different: not through scholarly objectivity (despite the book's elaborate para-scholarly apparatus), but by activating fantasy and imagination. The epilogue makes that clear by bringing up Wendel Dietterlin, a sixteenth-century painter and theorist, whose *Architectvra* (1594) stands out among other renaissance treatises on architecture for its distinctly fantastical character. Replete with all kinds of mythical figures, Dietterlin's drawings served as an apparent inspiration for Bogdanović's own blending of scholarship and fantasy, which allowed him to reverse-engineer the capital back to its imagined figural origins, thus undoing the centuries of codification and liberating the form for free association. If there was anything postmodern about that operation, it was the deliberate relativization of history, reminiscent of the genre of metafiction; such a method, however, was fundamentally literary rather than linguistic.

Indeed, Bogdanović was adamant that architecture is not a language; as soon as linguistics began circulating in the architectural discourse with greater frequency, he rejected it as a mere metaphor, warning that, if understood too literally, it confuses and obscures, rather than reveals architecture's own epistemology.[33] Such a view is apparent in most of his built work, which defies any attempt at codified meaning and revels in deliberate polysemy.[34] That is not to say that Bogdanović considered language unimportant; on the contrary, he was extremely sensitive to it, to the point that he saw it as one of the central political questions of late socialist Yugoslavia. But what he saw as crucial in that respect – whether in architecture or in politics – was to maintain the openness and flexibility of language in the face of attempts to constrain it, a surrealist motivation par excellence in line with Breton's foundational dictum to expose 'the actual functioning of thought'.

It is difficult not to understand Bogdanović's thoughts on architectural language as inherently political when read side by side with another book he authored shortly before *The Book of Capitals*. *Dead Knots: The Mental Traps of Stalinism* (1988) was a vehement reaction to the nationalist coup that Slobodan Milošević engineered in the League of Communists of Serbia in the fall of 1987, an event that effectively set in motion the endgame of socialist Yugoslavia.[35] Remarkably, the volume centred on language as a key dimension of politics, analysing the reductive discourse of the coup as a symptom of the ongoing forced political homogenization. At stake was the relative freedom that had been cultivated in Yugoslavia since the 1948 break with Stalin, now endangered by the attempt to reinstate a 'postmodern Stalinism' through the witch-hunts conducted in the media

against the opponents of the coup, including the author himself. In no uncertain terms, Bogdanović warned that the quasi-religious imposition of a linguistic 'monophony' would not lead to a better understanding between Serbia and the rest of Yugoslavia, ending the book with a chilling prediction of the conflagration that was about to happen. In hindsight, the attempt was almost naïve in its belief that an intellectual argument on linguistics could steer the ship back to normalcy, but historical distance also makes it clear that the book was much more than a simple anti-nationalist statement: it was a desperate plea to save the project of socialist Yugoslavia, in whose construction Bogdanović participated almost his entire life.

With that in mind, it is a moot point that Bogdanović did not critique the 'totalitarian communist regime', as Miloš Perović demanded. Bogdanović was obviously willing to raise his voice against his own party when he thought it mattered, and much more openly than just through his buildings. But there is little doubt that for most of his career he also fought a similar campaign against the dogmatic closing up within architecture itself, whether demanded by instrumental rationality, by architecture's codified formal languages, or by its own traditional disciplinary limits. In that sense, it is difficult to see Bogdanović's career as nothing more than a vapid aesthetic exercise in conformism. His engagement against the established orthodoxies of the period cut across his many areas of creative output, from his writings on the city to his practice in the field of commemoration. At the same time, it also included an explicitly critical engagement in disciplinary terms. A case in point is the short-lived pedagogical reform he led as Dean of the Faculty of Architecture in Belgrade, which sought to democratize the architectural education and to rid it of its ossified, conservative mindset.[36] Even though it relied on a wide front of supporters, the reform became identified with Bogdanović, who was its driving force. The resulting 'New School' drew on the spirit of student protests that had shaken up the University of Belgrade in 1968, amplified by Bogdanović's subsequent one-year stay in the United States in 1970, where he witnessed first-hand a veritable revolution played out against the Vietnam War on university campuses.[37] Another source of inspiration was the recent push at American schools to dissolve architecture's specificity in the broader field of environmental design (one of Bogdanović's stops in the United States was Berkeley). The results were the New School's flexible ('differentiated') curriculum, toning down of the traditional hierarchies between faculty and students, and a novel emphasis on rigorous scholarship and multidisciplinary research, which were to replace the traditional professional education. In addition, the reformers sought to bring the discussion of architecture and its social purpose to the broad public; they published a regular bulletin of their efforts, in turn attracting unusual attention from the media across Yugoslavia. Despite such efforts, the New School proved to be short-lived: facing opposition from the more conservative cadre, Bogdanović was forced to step down as dean and, by 1973, the curriculum to a large degree reverted back to its old shape.

Bogdanović's 'critical' attempt to dissolve architecture's boundaries in multidisciplinarity was a symptom of his career-long defiance of autonomy, inspired in part by surrealism's own disdain for any kind of methodological purity. It manifested itself most conspicuously through his forays into other fields, such as anthropology, romanticist literature, and philosophy (again, all surrealist obsessions), best articulated in his redefinition of architecture as 'applied anthropology'.[38] Similar dissolution of autonomy can also be detected in his built work, which often confounded his peers as to its disciplinary basis, provoking them to wonder whether he was 'a sculptor or an architect'.[39] Indeed, Bogdanović's memorials emphatically blurred the boundary not only between architecture and sculpture, but also in relation to landscape architecture and urban design. Such an approach was especially characteristic for his large memorial parks of the 1960s, for example those at Jasenovac (Croatia), Mostar (Bosnia and Herzegovina), and Kruševac (Serbia), sprawling commemorative landscapes defined by extensive earthworks: mounds, craters, or terraces. Inextricably integrated into these landscapes are constructed objects that hover vaguely between categories: they are not traditional sculptures, because they invite intense physical interaction, and yet they are not quite buildings either, being too richly and evocatively shaped. From afar, the massive concrete 'flower' at Jasenovac appears like a giant statue, but at its core is an occupiable space, a crypt in which the commemorative procession culminates (Figure 5.3). From

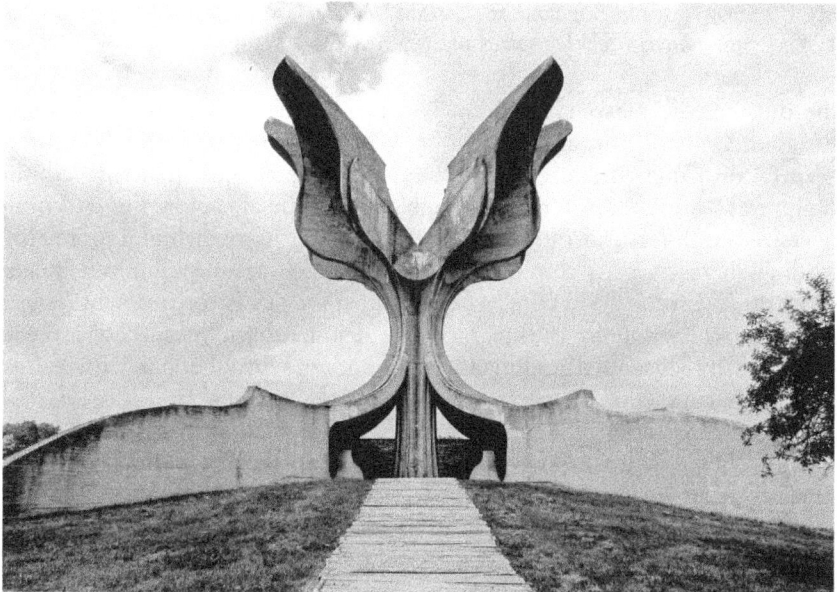

FIGURE 5.3 *Bogdan Bogdanović, Jasenovac Memorial Park, Jasenovac, Croatia 1966. Photo courtesy of Vladimir Kulić.*

FIGURE 5.4 *Bogdan Bogdanović, Partisan Cemetery, Mostar, Bosnia-Herzegovina 1965. Photo courtesy of Vladimir Kulić.*

the outside, the masonry walls in Mostar appear as a mere background for abundant stone ornaments, but between them they conceal labyrinthine 'streets' of a quasi-urban 'city of the dead' (Figure 5.4). In Kruševac, the sculptural 'horns' scattered through the artificial landscape resemble oversized architectural ornament liberated from its own building, in turn lending themselves to climbing or sitting, which visiting children indeed often do (Figure 5.5). In contrast to the post-war calls for the 'synthesis of the arts', which sought an integration of distinct disciplines, these projects emphatically expanded architecture's boundaries by dissolving them into larger 'environments' that defy traditional classifications.

Rosalind Krauss's influential theorization of land art necessarily comes to mind here, because Bogdanović's most important memorials occupied precisely that 'expanded field' that American sculpture would enter in the 1970s by reaching out towards landscape and architecture.[40] Krauss famously defined the 'expanded field' as postmodernist because it negated Greenberg's definition of modernism as a dogged search for 'medium specificity' (i.e. disciplinary autonomy). Bogdanović's defiance of autonomy thus places him in a paradoxical position in relation to postmodernism,

FIGURE 5.5 *Bogdan Bogdanović, Slobodište Memorial Park, Kruševac, Serbia 1965. Photo courtesy of Vladimir Kulić.*

at the same time inside and outside of it: according to Krauss, he would certainly be a postmodernist, but not according to architectural criteria, because postmodernist architects sought to reassert autonomy through their own disciplinary 'language'. This paradox certainly exposes the inherent contradictions within the broader formation of postmodernism, but it also highlights Bogdanović's own complicated position vis-à-vis postmodernism as defined so far.

Conclusion

Why is it so difficult to answer the question of whether Bogdanović was a postmodernist or not? Because it is like trying to fit a square peg into a hole that is not round, but rather rectangular: one that, at first glance, appears to match, but only ends up stubbornly frustrating the effort. Indeed, for many reasons, superficial or more profound, his oeuvre tempts comparisons with the accepted versions of postmodernism, but whatever definition one selects, a crucial component falls out of place. From some angles, it seems almost right: for example from the standpoint of literature or art, his oeuvre could be termed 'properly postmodernist', except that it doesn't quite belong to those fields. The reason for such mismatch is fundamentally geopolitical: Bogdanović proposed a novel position, one that was at odds with the theorizations developed in the First World for the First World. It opens the

possibility that the Second World may have produced original architectural visions relevant beyond its own borders, a feat that the rest of the world considered impossible ever since the demise of constructivism under Stalin.

With that in mind, it is important to reflect on Bogdanović's position in the broader picture of twentieth-century architecture. With his intellectual roots in surrealism, he opened a new branch in the architectural genealogy of the 1960s and 1970s, establishing a continuous, living connection to an important avant-garde movement that exerted paramount influence on many fields of contemporary culture, and yet had very limited impact in architecture. In that sense, his alleged postmodernism was not 'post' at all, as it did not come after the dominant functionalist modernism, but ran parallel and counter to it all along. With its impulse to dissolve any dead, ossified structures – whether of meaning, form, or professional organization – Bogdanović's work was analogous to surrealist-inspired, left-leaning postwar movements elsewhere, such as the Situationist International, but it was based on rather different methods and it produced different results. He was certainly aware of the techno-utopias of the period – for example he appreciated Archigram because he saw a spirit of surrealism in it – and he shared the enthusiasm for uninhibited play with the likes of Constant, but he never placed his trust in technology and its imagined potential to open up society to a utopian nomadic future.[41] Instead, he sought to open up architecture both as a physical bearer of social meaning and as a discipline, sharing with postmodernists their basic concern for meaning, but not their push for linguistic codification, nor their retreat into disciplinary autonomy. At a time when many of his peers in the West were ready to abdicate their social commitments in the face of the overwhelming forces of late capitalism, Bogdanović thus maintained the emancipatory, utopian spirit of the avant-garde alive, placing it in the service of a still functioning socialist society.

Notes

1 See Mario Pisani, *Tendenze nell architettura degli anni '90* (Bari: Edizioni Dedalo, 1989), 19–24.

2 See Slobodan Selinkić, 'Bogdan Bogdanović: The Poetry of Monuments', *World Architecture*, no. 9 (1990): 28–36.
 Bogdanović was a founding member of the International Academy of Architecture, which was founded in 1987 in Bulgaria in a belated attempt to cross over Cold War boundaries just before its passing.

3 For a detailed overview of Bogdanović's literary output, see Vladimir Vuković, *Bogdan Bogdanović: Das literarische Werk* (Vienna: Verlag Anton Pustet, 2009).

4 See Reinhold Martin, *Utopia's Ghost: Architecture and Postmodernism, Again* (Minneapolis: University of Minnesota Press, 2010).

5 See Bogdan Bogdanović, *Urbs & Logos* (Niš, Serbia: Gradina, 1976), 70–72.

6 For 'high modernism', see James C. Scott, *Seeing Like a State: How Certain Schemes to Improve the Human Condition Have Failed* (New Haven, CT and London: Yale University Press). For 'inner architecture', see Bogdan Bogdanović, *Zaludna mistrija: doktrina i praktika bratstva zlatnih (crnih) brojeva* (Belgrade: Nolit, 1963).

7 For profane illumination, see Walter Benjamin, 'Surrealism: The Last Snapshot of the European Intelligentsia', in Michael W. Jennings, Howard Eiland and Gary Smith, eds., *Walter Benjamin: Selected Writings, Volume 2 1927–1934* (Cambridge, MA and London: The Belknap Press, 1999), 207–21.

8 More specifically, referencing Jürgen Habermas, she describes him as an 'old conservative' seeking 'withdrawal to a position anterior to modernity'. See Ljiljana Blagojević, 'Postmodernism in Belgrade Architecture: Between Cultural Modernity and Societal Modernisation', *Spatium International Review*, no. 25 (September 2011): 23–9.

9 The case in point is MEČ, a group of young Belgrade architects who most consistently engaged with explicitly postmodernist themes and cultivated contacts with other self-identified postmodernists in Yugoslavia and Western Europe. Bogdanović wrote a foreword for the catalogue of MEČ's exhibition *Urbana kuća* (Belgrade: SKC, 1981), and he even exhibited with the group at the show *Three Generation of Belgrade Builders,* on display in Belgrade, Zagreb, and Kruševac in 1984. For a summary of these contacts and of the period, see the autobiographic note by one of the group's members, Slobodan Maldini, 'Arhitektura Novog pokreta u Beogradu u periodu 1970-ih in 1980-ih godina', available at http://maldinis.blogspot.com/2007/12/slobodan-maldini-arhitektura-novog.html (accessed 20 June 2017).

10 One of the members of MEČ, Slobodan Maldini, explicitly credits the so-called New School, initiated while Bogdanović was Dean at the Faculty of Architecture, as the beginning of the 'transformation of architectural thought' in Serbia; see ibid. For the New School, see my short article 'Bogdan Bogdanović: New School and Summer School', in 'Radical Pedagogies', special insert edited by Beatriz Colomina and Evangelos Kotsioris, *Volume* (Amsterdam), no. 45 (2015): 10–11.

11 See Bogdan Bogdanović, 'Grad stvarnost – grad metafora', *Arhitektura* (Zagreb), no. 172–3 (1980): 66–8.

12 According to Ljerka Mifka's postscript to the 1984 edition, the book was modelled on Pierre Louÿs's 'pseudotranslation' *The Songs of Bilitis* (1894), a collection of his own poems that poet tried to pass as the translation of an authentic ancient text. See Bogdan Bogdanović, *Zaludna mistrija: Doktrina i praktika bratstva zlatnih (crnih) brojeva,* 2nd edn (Zagreb: Grafički zavod Hrvatske, 1984), 178.

13 See Uglješa Bogunović, ed., *The Future of New Belgrade,* special issue of *Arhitektura Urbanizam* (1986).

14 For more, see my essay 'Bogdan Bogdanović and the Search for a Meaningful City', in Ákos Moravánskzky, Torsten Lange, Judith Hopfengärtner and Karl R. Kegler, ed., *East West Central: Re-Building Europe, 1950–1990,* vol. 1 (Basel: Birkhäuser-De Gruyter, 2016), 77–88.

15 Author's interview with Bogdanović, 20 May 2005.
16 See Kulić, 'Bogdan Bogdanović and the Search for a Meaningful City', 83–5.
17 Paradigmatic in this respect is his book *Urbs & logos*.
18 See Kulić, 'Bogdan Bogdanović: New School and Summer School'.
19 Ibid.
20 For Bogdanović's memoirs, including his obsession to produce '*l'architecture surréaliste*', see Bogdan Bogdanović, *Ukleti neimar* (Split: Feral Tribune, 2001), 69.
21 See Peter Bürger, *Ursprung des postmodernen Denkens,* 3rd edn (Metternich, Germany: Velbrück Wissenschaft, 2015). I thank Alla Vronskaya for this reference.
22 For the connections between surrealism and architecture, see Thomas Mical, ed., *Surrealism and Architecture* (Abingdon, UK: Routledge, 2004).
23 See *Architectural Design* 48, nos. 2–3 (1978).
24 See André Breton, *Manifestoes of Surrealism*, translated from the French by Richard Seaver and Helen R. Lane (Ann Arbor: The University of Michigan Press, 1969), 26.
25 See Miloš R. Perović, *Srpska arhitektura XX veka/Serbian 20th Century Architecture* (Belgrade: Arhitektonski fakultet, 2004), 148–209.
26 Sveta Lukić, *Savremena jugoslovenska literatura (1945–65)* (Belgrade: Prosveta, 1968), 201 and 49.
27 See Miodrag B. Protić, *Jugoslovensko slikarstvo šeste decenije – nove pojave*, exhibition catalogue (Belgrade: Muzej savremene umetnosti, 1980), 14. Greenberg's view on the topic is laid out in the different versions of his essay 'Modernist Painting'; see *Clement Greenberg: The Collected Essays and Criticism*, vol. 4, edited by John O'Brian (Chicago: University of Chicago Press, 1993), 85–93.
28 See Lazar Trifunović, *Studije, ogledi, kritike* (Belgrade: Muzej savremene umetnosti, 1990), 124.
29 Perović, *Serbian 20th Century Architecture*, 176.
30 See Colin Rowe, 'Introduction to Five Architects', reprinted in K. Michael Hays, ed., *Architecture Theory since 1968* (Cambridge, MA and London: The MIT Press, 1998), 75.
31 See Bogdan Bogdanović, *Knjiga kapitela* (Sarajevo: Svjetlost, 1990).
32 See John Hersey, *The Lost Meaning of Classical Architecture* (Cambridge, MA: The MIT Press, 1988).
33 See Bogdan Bogdanović, 'Predgovor', in *MEČ,* exhibition catalogue (Belgrade: Galerija SKC, 1981).
34 For an analysis of the polysemic character of the Slobodište Memorial Park in Kruševac, Serbia, see my article 'The Scope of Socialist Modernism: Architecture and State Representation in Postwar Yugoslavia', in Vladimir Kulić, Monica Penick, and Timothy Parker, eds., *Sanctioning Modernism:*

Architecture and the Making of Postwar Identities (Austin: University of Texas Press, 2014), 57–8.

35 See Bogdan Bogdanović, *Mrtvouzice: Mentalne zamke staljinizma* (Zagreb: August Cesarec, 1988).

36 For an overview of the New School, see Milorad Mladenović, 'Comments on ("Saopštenja") of the New School (of Architecture)', *SAJ*, no. 3 (2011): 37–8.

37 Author's interview with Bogdanović, 21 May 2005.

38 See Bogdan Bogdanović, 'Razgovor s autorom *Mrtvouzica*', Interview by Zoran Milović, *Start* (Zagreb), no. 518 (26 November 1988): 12–19.

39 See Zoran Manević, *Bogdanović* (Belgrade: Savez arhitekata Srbije, c. 1991).

40 See Rosalind Krauss, 'Sculpture in the Expanded Field', *October* 8 (Spring 1979): 30–44.

41 For Archigram, see author's interview with Bogdanović, 21 May 2005.

6

One size fits all:

Appropriating postmodernism in the architecture of late socialist Poland

Lidia Klein and Alicja Gzowska

If, following Robert Venturi, complexity and contradiction are the defining qualities of postmodernism, then Polish architecture in the years between 1970 and 2000 might be one of its finest examples. This complexity is especially visible in the period preceding the political transformation of 1989. At that time, postmodern tendencies in Poland not only were a manifestation of the logic of 'late socialism' rather than 'late capitalism' as per Fredric Jameson, but also were negotiated and appropriated by diverse groups of often diverging political interests – architects, the Catholic Church, and the state. Polish postmodernism during the 1970s and 1980s comprised a fragmented and dispersed set of ideas and practices, which did not form a coherent 'style', but rather served as a resonant tool for various actors and agendas. In late socialist Poland, postmodernism proved to be a versatile, 'one-size-fits-all tendency capable to accommodate often seemingly contradicting interests. This chapter analyses the complexities of Polish postmodern architecture by studying two typologies essential for Polish architectural landscape of the decades of 1970s and 1980s – mass housing and church architecture.

Postmodernism under late socialism

Since the 1970s, Polish architectural magazines as well as popular newspapers started to publish articles expressing growing dissatisfaction with an architecture dominated by dreary concrete subdivisions, faulting this trend for its uniformity, schematism, and monotony. Such critiques (mainly from anti-modernist stances, which are not always equivalent to deliberately postmodern stances) overlapped with an increasing interest in changes in architectural discourse taking place in the West, exemplified by the designs of Charles Moore, James Stirling, and Robert Venturi, and the writings of Christopher Alexander, Jane Jacobs, and Charles Jencks. Even though none of the works of these authors, except Jencks, were translated before 2000 (the Polish version of *Learning from Las Vegas* appeared only in 2013), they were amply quoted and paraphrased since the second half of the 1970s.[1]

One of the main difficulties faced by researchers attempting to map postmodernism in Polish architecture IS that it needs to be reconstructed from fragmented, inconsistent traces of inspirations and references. There was no coherent definition or common understanding of the term 'postmodernism'. Since it was first mentioned in 1979 in the state-sanctioned magazine *Architektura* (the leading Polish architectural magazine of that period) in an article describing 'New Trends in United States Architecture', it has been used freely, both by architects and critics, without a clear explanation as to which specific interpretation they are referring to.[2] Despite this inconsistency in defining postmodernism, the prevalent use echoes the Jencksian approach.

While Polish interest in postmodernism was rarely supported by careful analyses of its theoretical fundaments, architects eagerly studied Western architectural magazines, such as *Architectural Review*, *Bauwelt*, or *L'Architecture d'Aujourd'hui*.[3] They focused mainly on the reproductions of new designs and realizations published in these journals (as well as their reprints published in *Architektura*), readily indulging in the aesthetics of Venturi or Moore while often ignoring or not carefully studying their philosophical underpinnings. A limited circulation of foreign books imported or brought from travels abroad further constrained the level of knowledge about Western postmodernism. Furthermore, formal fascinations needed to confront the limited capacities of the Polish construction industry, so that one finds a significant gap between designs and realizations. During the time of the socialist Polish People's Republic (1952–89), architecture and urbanism were centrally managed by the Main Office of Urban Planning (Centralny Urzad Planowania Przestrzennego). Additionally, from 1957 to 1985, the building industry and the market of construction materials were controlled by the Ministry of Construction and Construction Materials Industry (Ministerstwo Budownictwa i Przemysłu Materiałów Budowlanych). The

design process was carried out within the rigid framework of plans issued by the office and the standardized system of prefabricated concrete – the dominant building technology. As in other countries of the Eastern bloc, the state prioritized mass housing estates over other building typologies. Mechanized construction, standardized building elements, and central management of the design process were all implemented to achieve the socialist goal of providing housing to every citizen. At the same time, such a model posed an obvious limitation for the designers increasingly interested in postmodern ideas permeating architectural discourse worldwide. The vision of the postmodern city as a human-scale settlement based on diversity and participation, which emerged from the writings of Jacobs or Venturi and Scott-Brown, contradicted the model of large-scale central planning and a homogenizing building method.

Making mass housing postmodern

In the 1970s and 1980s, this clash resulted in often idiosyncratic designs merging seemingly irreconcilable approaches to architecture. One of these cases is the Zielone Wzgórza housing complex near Poznań, designed in 1982 by a team led by Jerzy Buszkiewicz. Instead of the late modern ideal of an objective, impersonal 'machine for living', the designers proposed an intimate, picturesque estate with narrow streets, and piazzas encouraging social life beyond 'minimum existence'.[4] Diverse houses of different scales, often covered with mansard roofs, successfully created an impression of a small-scale, pre-modern town – a feeling almost convincing, but only for an inattentive visitor overseeing ill-fitting details, such as façades made from prefabricated slabs and concrete dormers. Such hybrids, merging late-modern industrialized technology and the ideology of concrete panel housing systems with postmodernist inclinations towards locality, historical allusions, and ideas of diversity against modern uniformity and totality, could be observed in many other Polish housing estates from the 1970s and the 1980s, such as the Radogoszcz-Wschód housing estate in Łódź, designed by Jakub Wujek and Zdzisław Lipski between 1979 and 1985 (Figure 6.1). In the latter case, instead of designing blocks of flats in an arrangement subordinated to the rules of the Athens Charter, architects created several small quarters – colonies organized around internal courtyards-gardens. Each colony was to be developed by a different architect, so the buildings and spaces between them would be diversified.[5] Ultimately, due to limited time and budget, as well as to the lack of support and understanding for the design principles shown by local authorities, the realization differs greatly from the initial project. The neighbourhood was eventually designed entirely by Wujek and Lipski, thus constituting a homogeneous, unified entity of buildings of similar volume constructed from concrete panel systems. Against such a background, repetitive, modest architectural details

FIGURE 6.1 *Zdzisław Lipski and Jakub Wujek, Radogoszcz-Wschód housing estate, Łódź, Poland, 1979–85. Photo courtesy of B. Ciarkowski.*

like pitched roofs not only appear absurdly misplaced, but also increase the impression of monotony rather than diversifying the complex.

It is tempting to interpret postmodernism appearing in socialist countries, such as Poland, in terms of longing for capitalist freedom, liberal ideals, and plurality as expressed in the architecture of Northern American and European provenience, juxtaposed with the obligatory Soviet model of mass-produced, standardized architecture.[6] However, the attitudes of both designers and the state towards postmodernism were more complex. Interest in postmodern theories and designs appeared in Poland at the auspicious political moment of liberalization under Edward Gierek's leadership as the First Secretary of the National Communist Party in 1970–80. Ideas interpreted as postmodern, such as freedom of expression and rejection of modern rigidity, became surprisingly useful tools for the state in its efforts to create a new image of progressive and open socialist country, and they were presented as a logical consequence of the development of socialism in Poland.[7] Such statements were purely declarative, and were not followed by any substantial moves to change the dominant approach to the urban environment. Nevertheless, they show that the State was eager to appropriate postmodernism for propagandistic purposes. For example, in an editor's foreword to Czesław Bielecki's 'Continuity in Architecture' ('Ciągłość w Architekturze'), an article that was published in *Architektura* in 1978 introducing postmodern ideas to Polish readers, we can read that 'under Polish conditions, it [postmodernism] is a consistently realized direction, arising from continuous improvements in how social democracy functions in every aspect, obviously including architecture'.[8]

Romuald Loegler (born in 1940), one of the most active architects during the 1970s and 1980s, accurately summed up this situation by pointing out that 'from one side architects were seeking new ways, and from another the Party eagerly used this occasion to build its image as caring and citizen-friendly'.[9]

The third way

The dynamics between the Party and architects summed up by Loegler is even more complicated. Although a majority of architects were rather supportive of the anti-government opposition, the State remained their main employer. What is more, since the 1970s postmodernist architects believed in the possibility to hybridize socialism and capitalism. Even when the Solidarity movement was established (1980), it was common to look for possible changes in the political and economic system that would have an evolutionary rather than a revolutionary character, and would incorporate (rather than unequivocally reject) socialist ideas.[10] One of the architects placing his hopes in the formulation of a 'third way' between socialism and capitalism was Marek Budzyński (born in 1939). For Budzyński, postmodern concepts were useful tools to create a bridge reconciling the contradicting systems of communism and capitalism, and the city served as a possible platform for their union. The most important realization of his theories was the North Ursynów estate in Warsaw, designed from 1970 (Figure 6.2). Although realized in obligatory prefabricated concrete panel system, Ursynów was planned as a social and urban experiment breaking with the model of loosely distributed, disconnected housing units. The main intention was to return to the ideals of traditional urban space, mainly the street, and recreate them within a socialist city. In Ursynów, the apartment blocks of various heights are situated along narrow streets. The ground level was planned for stores, restaurants, and services ensuring 'intricate minglings of different uses' as advocated, for example by Jane Jacobs.[11] The pedestrian traffic is privileged within the entire complex, as the project description reads,

> The individual character of the space plays the most important role in the identification of residents with 'spatial spheres' such as neighborhood, block, [or] street. Such identification is crucial for the residents' well-being.... The ground floor decides the character of the street ... it provides a natural terrain for human interactions.[12]

When completed, Ursynów was considered only a partial success. Only 20 per cent of the planned services were realized, and the streets were largely occupied by parked cars (as the planned two-floor parking garages were never built), and despite the designers' efforts to diversify the façades,

FIGURE 6.2 *Marek Budzyński, Andrzej Szkop, Jerzy Szczepanik-Dzikowski with team, North Ursynów estate, Warsaw, 1972–7. Photo courtesy of G. Rutowska.*

the monotony of the omnipresent grey prefabricated concrete slabs was difficult to offset.[13] Ursynow's project descriptions are saturated with the rhetoric known from works of such thinkers as Alexander and Jacobs, even though its planners never referred to their theories explicitly. As Budzyński admitted in an interview thirty years after designing Ursynów, Jacobs was an especially vital point of reference. 'When I was thirty years old', says the architect, 'Jane Jacobs was a crucial figure. Everyone involved in Ursynów knew who she was, we were reading and using her theories.'[14] 'She', says Budzyński, 'had a strong influence [on Polish architects in the 1970s]. Just as Christopher Alexander was [an important figure].'[15] Budzyński got to know Jacobs and Alexander's works while on internship in Denmark in 1969–70, but as for other Ursynów design team members, it is very hard to verify how those texts were circulating. Most likely, it was second-hand knowledge gained from the discussions with architects such as Budzyński or summaries and quotes published in *Architektura*.

The practices of Budzyński and other architects and urbanists of his generation clearly show that in many cases the interest in postmodern forms and notions in late socialist Poland should not be treated as a revolutionary gesture against the system, but as an attempt at reform from within.

Architecture, state and the Church

The Ursynów complex contains one more element that defies established preconceptions about late modern architecture in socialist countries. One of the settlement's most prominent spaces is a sculptural church facing a large square, both designed in 1980 by Zbigniew Badowski and Marek Budzyński (Figure 6.3). The building was intended to bring a sense of historical continuity into an estate erected from scratch, and the square was planned to recreate the role traditionally played by local town markets. Squat proportions, foundations made of stone, and low, simple portal columns recall examples from Romanesque architecture, while flowing curves of buttresses and façades recall both provincial baroque and gothic forms. Architects juxtaposed historical motifs with modern architectural language – the plain surface of the façade with an entrance shaped in the form of a cross, and the roof and exterior walls of the aisles covered with copper sheet or bijou precast detail of the portal. Avoiding both literal architectural quotations and ironic pastiche, the architects designed a massive temple in which numerous historical references and allusions served as a showcase for the solid tradition of Catholicism in Poland, attempting to portray its endurance even in the declaratively secular times of socialism.

The church in Ursynów is one among approximately 2,500 churches erected in Poland between 1979 and 1989, according to the data provided by Komisja Episkopatu Polski (The Commission of the Polish Episcopate).[16] Such a high number is striking not only given that churches were constructed under a socialist state, but also because it significantly exceeds church

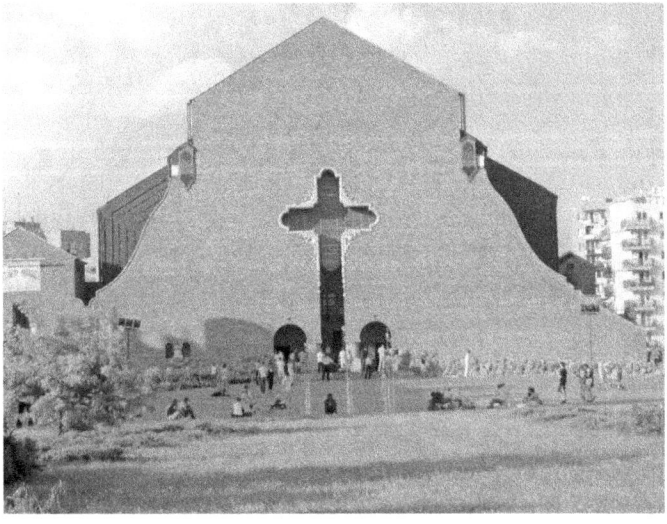

FIGURE 6.3 *Marek Budzyński, Zbigniew Badowski, Church of the Ascension of the Lord, Ursynów, Poland, since 1980. Photo courtesy of Marek Budzyński.*

realizations in any European country at that time.[17] The liberalization of the regime, visible especially under Gierek's leadership and in the decade of the 1980s, influenced also the party's attitude towards new church buildings. The state was willing to provide plots of land for the purpose of new church construction, given that the community will be responsible for the design, materials, and building. Church realizations in late socialist Poland were therefore bottom-up initiatives. They were executed thanks to the initiative and participation of church community members outside the system governed by the Main Office of Urban Planning, but with the approval of the state. A significant stimulus for the renewed interest in church architecture was brought by the Second Vatican Council (1962–5), which aimed to rethink the church's place in the contemporary world and adjust its practices accordingly. Mass was no longer conducted in Latin but in national languages and the priest would face the parishioners instead of the altar. During the Second Council, the Church declared also a strong interest in contemporary art and encouraged the artists' engagement in Catholic culture.[18] Those changes affected also the designs of new churches and opened a path for more bold designs, overlapping with the postmodern turn in architectural discourse worldwide.

The use of precast concrete was common in Polish church architecture of the late-socialist period. Often, like in Ursynów's church, it was combined with traditional techniques and materials, especially brick. Even though it was not always a deliberate aesthetic choice but to a large extent motivated by the availability of materials and technologies, it contributed to the particular boldness of Polish church architecture of the late socialist era. One such example is Mary Queen of Peace church in Wrocław-Popowice designed in 1980–95 by Wacław Hryniewicz, Wojciech Jarząbek, and Jan Matkowski. With its interior of deep-red painted walls juxtaposed with massive golden chandeliers and golden pillars supporting suspended arches, the space creates a Middle-Eastern ambience, which can be explained by architects' experience of work in Kuwait in the 1980s, at the same time allowing associations with the colourfulness of gothic architecture.[19] The influence of the latter can be observed particularly in the massive, vertical sculptural form with faceted elements resembling crystal. This gem-like effect was enhanced by the material used in the original design: highly polished granite. Due to financial limitations and time restrictions, lustrous stone was replaced with matt red brick (which the parish received as a gift from employees of local brick factory), just as the portals were executed in precast concrete instead of folded copper sheets. As much as being typical for Polish architects working in late-socialist reality, the design process was partially 'a play with prefabricated elements', as Jarząbek puts it.[20] This architectural game had of course very different constraints from the erudite yet witty amusements of Western postmodernists in the manner of Charles Moore or Ricardo Bofill. Polish architects expressed their creativity through their struggles with the material shortages and limitations of the state-controlled system of planning

and construction.[21] Similarly, the eclectic mélange of baroque and gothic references interwoven with Eastern inspirations at the same time matched postmodern postulates of unbound and often surprising associations and juxtapositions, and is evidence of the acquisition of knowledge of Western architecture through its Middle-Eastern translations.[22]

Another outstanding example of church architecture was Jerzy Gurawski's (born in 1935) church in Głogów, designed in late the 1970s (Figure 6.4). It was commissioned by the community resettled from the area of today's Ukraine and was intended not only to serve the religious needs of its members, but also as a symbol of their identity. For this reason, in addition to its modern construction and interior design following the resolutions of the Second Vatican Council, it also incorporates a panoply of elements referring to the stylistics of eastern wooden churches: roofing type, pear-shaped domes, and arcades surrounding the building. Gurawski's memories of his work at Głogów are very helpful for reconstructing the circumstances of church construction in late socialist Poland:

> The church [in the late socialist period] was above everything. Party officers were mostly simple people, secretly very religious and genuinely devoted to the church. Once, I witnessed when one of them went to the parish priest and asked him to secretly baptize his child. The priest responded: 'Sure, I can do that, but you'd need to get us 200 tons of concrete.' And he got it! In those days, the church was able to get building permission for every location. Also, during the martial law [1981–3], when the stores were practically empty, the priests always had food – from the farmers, but also received from abroad. People in Western Europe and the USA wanted to help the opposition so they were sending the churches, for example, turkeys for Thanksgiving or instant coffee – things that were impossible to get anywhere else. No wonder that people were coming to help build their churches in their free time, after work. They genuinely wanted to help and they were very passionate

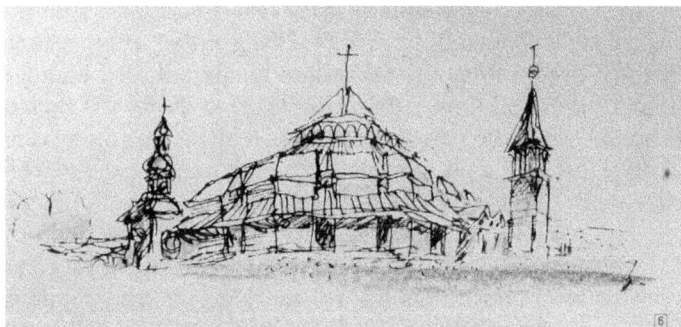

FIGURE 6.4 *Jerzy Gurawski, Drawing of the Church of the Blessed Virgin Mary Queen of Poland, Głogów, Poland, 1980s. Image courtesy of Jerzy Gurawski.*

about their new churches, but they also could get, for example, butter. I remember that once my car's trunk was filled with butter from priest Ryszard, parishioner in Głogów. It was so heavy that I worried if my car will make it with such a load![23]

Gurawski's story accurately captures some crucial points in the relation between architecture, state, and church in late socialist Poland. The Catholic Church was a strong centre for the anti-communist opposition. New churches were resonating symbols of the spirit of Polish religiousness despite proclaimed secularity of the socialist state, and thus an important tool of resistance against the communist system. This anti-systemic message was further strengthened by the emergence of the Solidarity movement and the election of the anti-communist Polish cardinal Karol Wojtyła as Pope in 1978. Postmodern forms – often historicizing and boldly sculptural – posed a strong contrast to the rigidity of late-socialist settlements and thus served as perfect vessels for oppositional messages. Both members of the Catholic community and the clergy were sceptical towards unfamiliar late-modern architectural forms too closely associated with omnipresent mass-produced housing, an expression of the socialist utopia of modernization. Instead, they preferred buildings resembling historical, traditional, and regional architecture, embodying the continuity of the Christian spirit in place of late-modern architecture, which recalled socialist attempts of secularization. In addition, church buildings served not only the religious purposes, – usually constructed with active participation from the community and through the engagement of local parishioners – but also as community cultural centres – an important place for discussions, meetings, film screenings, and exhibitions. At the same time, despite the link between opposition and the church, the state allowed (or even silently supported) new church realizations. There are two explanations of this conundrum. First, as Gurawski's account suggested, even under the socialist rule Poland was still a predominantly Catholic country and most of the party members were still personally tied to religious traditions. Secondly, facing the rise of the opposition led by the Solidarity movement, the party could not risk instigating more dissent. Prohibiting church realizations could easily work as a trigger for further protests.

The postmodern movement in architecture brought ideas that were broad and diverse enough to grow significant under the very complex social and political conditions of late-socialist Poland. Both churches and housing settlements from that period show that postmodern architecture was used as a convenient tool for often contradicting political agendas. On the one hand, both sculptural churches with multiple historical references and the return to traditional urban patterns and typologies in housing settlements

were easily interpreted as anti-systemic gestures by the communities of their users and by the architects. On the other hand, the Party, conscious of the subversive potential of such designs, had chosen to allow them, rather than to forbid and risk the rise of further tensions. Instead of identifying it as a pro-Western, alien threat to the socialist order, the Party presented postmodern notions as part of its efforts to improve the living conditions of the people. Rather than a hostile capitalist tendency imported from the imperialistic West, postmodernism was presented as a 'consistently realized direction, arising from continuous improvements in how social democracy function in every aspect'.[24] In this vein, postmodern efforts to 'humanize' urban space were seamlessly incorporated in mass-produced housing settlements. To further complicate this image, the architects not only were conscious of this appropriation (as Loegler's quote shows), but also (as in Budzyński's case) saw postmodern ideas as potentially capable of modifying, not overturning, the system.

Architecture in late socialist Poland complicates the established preconceptions of postmodern architecture as an utterly commercial style of 'late capitalism', usually identified with the lavish designs of Robert Stern or Charles Moore. Polish case studies from the 1970s and 1980s show how flexible and susceptible to differing ideological uses postmodernism was. Postmodern experiments were undertaken both in essentially socialist typology of mass housing estates and in abundantly emerging churches – types of buildings rather not expected to flourish in a socialist country. Postmodern forms and theories accommodated contradicting interests of the state and the opposition. The architects needed to navigate not only through this complexity of political and ideological agendas, but also through significant formal limitations. In this sense, postmodern architecture in late socialist Poland was a one-size-fits-all phenomenon, capable of reconciling seemingly mutually exclusive agendas.

Notes

1 The Polish translation of Charles Jencks's *The Language of Post-Modern Architecture* was published in 1987, and *Late-Modern Architecture* in 1989.

2 *Architektura*, 379–80 (1979). Short presentations of postmodern architects started to appear on its pages three years before.

3 *Polish Postmodernism: Architecture and Urbanism,* vol. 2, edited by Alicja Gzowska and Lidia Klein (Warsaw: 40000 Malarzy, 2013).

4 In this text, we use the term 'late modern' in reference to industrialized, prefabricated architecture emerging in Eastern bloc countries after 1954 (following Nikita Khrushchev's speech at the National Conference of Builders, Architects, Workers in the Construction Materials and Manufacture of Construction and Roads Machinery Industries, and Employees of Design and Research and Development organizations on 7 December 1954 and 1989).

5 The desire for diversification and flexibility cannot be unambiguously equated with postmodern inspirations. Almost every housing project in late socialist Poland was erected with prefabricated concrete panel systems. In spite of the fact that the latter were usually conceived as open and flexible, not a single factory ever launched full spectrum of components, limiting the production to the basic set of elements. As the market did not encourage competitiveness, the companies not only were uninterested in building innovatory projects, but also often forced architects to simplify the design.

6 In fact, in Czechoslovakia, for instance, Charles Jencks's *The Language of Post-Modern Architecture* was forbidden by the censors, and published as a samizdat only.

7 Between 1970 and 1980, the prevalent perception of modernism in Poland was dominated by late-modern prefabricated architecture, not its high-modern incarnations. In this sense, postmodernism was seen as a possible counter tendency, offering a liberal, democratic approach to architecture.

8 Andrzej Bruszewski, 'Editor's Afterword', *Architektura* 3–4 (1978): 77.

9 Romuald Loegler, 'Interview with Romuald Loegler', in *Polish Postmodernism*, 155.

10 See Marek Budzyński, 'Interview with Marek Budzyński', in *Polish Postmodernism,* 58.

11 Jane Jacobs, *The Death and Life of Great American Cities* (New York: Vintage Books, 1993), 222.

12 Andrzej Szkop, 'Rehabilitacja Ulicy', *Architektura* 326–7 (1975): 41.

13 A multi-level car parking according to another project by Budzyński was realized in Ursynów much later, in 2000.

14 Budzyński, 'Interview with Marek Budzyński', 20.

15 Ibid., 13–14.

16 This number does not include chapels and small branch churches (approximately 5,000). See *Komunikat nr 35 Komisji Episkopatu Polski ds. Budowy Kościołów* after: Andrzej Basista, *Betonowe dziedzictwo* (Warsaw and Kraków: Wydawnictwo Naukowe PWN, 2001), 156. See also Andrzej Majdowski, Piśmiennictwo do stanu badań nad architekturą sakralną w Polsce, 'Nasza Przeszłość' 106 (2006): 283–93 and Izabela Cichońska, Karolina Popera and, Kuba Snopek, *Architektura VII dnia* (Warsaw: Bęc Zmiana, 2016)..

17 Anna Tejszerska, 'Postmodernizm w polskiej architekturze sakralnej', in *Polish Postmodernism*, 218.

18 Mauro Mantovani, 'Church and Art: From the Second Vatican Council to Today', *Conservation Science in Cultural Heritage* 14 (2014): 127–43.

19 Since the mid-1970s a growing number of Polish architects were allowed by the government to work abroad in the Middle East and North Africa, where they got acquainted with postmodern ideas. The importance of this experience for the emergence of postmodernism in Poland is discussed by Łukasz Stanek, *Postmodernism is Almost All Right: Polish Architecture After Socialist Globalization* (Warsaw: Bęc Zmiana, 2012).

20 Wojciech Jarząbek, 'Interview with Wojciech Jarząbek', in *Polish Postmodernism*, 218.
21 A telling example showing the scale of material shortages is Kraków's *Na Skarpie* housing estate designed in 1985 by Romuald Loegler, Wojciech Dobrzański, and Michał Szymanow. According to Loegler, the facades were covered with white paint mixed with poster paint, as professional pigments for façade paints were an unreachable luxury, Loegler, *Polish Postmodernism*, 160.
22 For more, see Łukasz Stanek's chapter in this volume.
23 Jerzy Gurawski, Interview with Alicja Gzowska and Lidia Klein, 14 August 2013, unpublished.
24 Bruszewski, 'Editor's Afterword'.

7

Werewolves on Cattle Street:

Estonian collective farms and postmodern architecture*

Andres Kurg

Art historian Heie Treier, in her 1995 article on the use of the term 'postmodernism' in Estonia, wrote that 'recognition of the postmodern condition in Estonia almost coincided with that of the West. The first to consciously engage with the postmodern condition in their work were architects, ... the so-called Tallinn School, who were already producing postmodern works in the late 1970s, projects that were built in the early 1980s.'[1] According to Treier, postmodernism was understood in the modernist idiom as a progressive step forward in the development of art. In her view, the broader background and content of postmodernism as it had emerged in the West was not recognized in the Soviet context. Instead postmodernism was given a new and distinct content related to the local architectural reality – in opposition to mass housing and by formation of a new kind of relationship to the historic city. Treier added the following: 'In a confrontation between architectural generations, the word postmodernism had already become a pejorative term during the 1980s. ... Nevertheless, the architects unwittingly predicted the arrival of pluralism and the important breaks in society that would take place at the end of the 1980s.'[2]

*The research for this chapter was supported by Estonian Research Council (grant no. IUT32-1). I thank Justin Ions for the language editing of this chapter.

Treier's description of the rise and fall of postmodernism in Estonia is significant for two reasons. First, it situates the critical moment of postmodernism in the Soviet context in the late 1970s and early 1980s. Contrary to analyses that see postmodernism in the Eastern bloc as a cultural representation of Perestroika or even of post-socialism, Treier's analysis of postmodernism sees it as an architecture of the late-Brezhnev period – of 'developed socialism', as it was called officially. Secondly, rather than being essentially an imitation of developments in the West, postmodernism in the Soviet context is understood to be closely related to the local architectural situation – or rather, as I will argue below, postmodernism in this context grew out from the social and economic conditions of the period, particularly the peculiar economic advantage of the countryside over the town and the critical discourse that emerged at the time. In this way, a more precise investigation of postmodernism is possible, one that doesn't reduce it to, in Treier's words, 'copying the West without recognizing the context'. Finally, I engage with the idea that postmodernism anticipated the societal and political changes of the late 1980s: How did the postmodern architecture of the early 1980s relate to the emergence of the national liberation movements in the Eastern bloc and to the 'singing' revolutions in the Baltic countries?

'Developed socialism'

Since the years of Perestroika, it has become normal to describe the preceding Brezhnev era (1964–82) as a period of 'stagnation'. The label, however, is not well suited to the corresponding architectural output and it obfuscates the numerous economic and social changes that occurred over its length.[3] Until 1973, the economic growth was stable, with rising wages, increasing urbanization, and the emergence of the Soviet version of consumer society.[4] In the second half of the 1960s the central government made significant efforts to restructure the economic management and planning, with the hope to increase plummeting growth rates and make production more efficient. In the so-called Kosygin reforms, named after the prime minister of the Brezhnev era, an attempt was made to decentralize decision-making over production by delegating it from central planners to local producers and factories, and to motivate managers and workers with incentives from profits and sales, rather than solely by output.[5] The reform also proposed a stimulus system for innovation in order to encourage more efficient work practices and to generate new products. One of the long-term aims was to progress from single enterprises to multi-plant corporations that would plan their production and distribution in a coordinated way. A majority of these reforms were shelved in the early 1970s, but some initiatives were successful, leading to the adoption of several management innovations.[6] In 1974, the first agrarian-industrial complex in the Soviet Union was organized in the Viljandi region of Estonia. The idea was to

coordinate more efficiently the productive and processing industries, to provide additional incentives for economically weaker cooperative farms, and to manage agricultural production according to the logic of industrial production. The second agrarian-industrial complex in Estonia was formed in 1979, in the Pärnu region, and by 1981 similar reforms had been carried out in all of Estonia.[7]

Agricultural cooperatives, or kolkhozes, and the respective state farms, sovkhozes, were formed in the early Soviet years as part of the infamous project of forced collectivization.[8] However, from the late 1950s, de-Stalinization ended the terror and the gradual institutionalization of state and cooperative farms normalized the status of kolkhozes for a new generation of workers. Farm units pursued increased mechanization, leading to higher levels of production and profit.

The merging of the collective farms in Estonia intensified by the second half of the 1960s, resulting in larger production units with higher profitability. By the end of the 1960s, the sovkhozes, which had been less successful economically than the kolkhozes, went over to a system of self-management, which allowed them to retain profits and redirected them towards their own production and salaries.[9] One of the main problems for communal farms generally was the lack of skilled labour in rural areas. To fight the migration of workers to the cities, kolkhozes increased the salaries of their employees (by 1985 the average salary in an Estonian kolkhoz was 272 roubles, while the average in Estonia generally was only 153 roubles) and made significant efforts to improve living conditions in rural areas, offering not only better housing, but also more desirable leisure activities. Bank loans encouraged employees to build their own homes, which in the more prosperous kolkhozes could be compensated for skilled workers.[10] A large percentage of the profits were allocated to the construction of new cultural centres in the smaller towns, often with professional stage equipment for guest performances by theatre companies, a feature criticized by some reviewers as being too lavish.[11] Other programs included new multipurpose sports and leisure facilities, kindergartens, schools, and inter-farm sanatoria at seaside resorts. State resources were also directed to construction in the countryside: in 1984, these so-called rural sociocultural buildings and residential buildings were declared a funding priority and 15 per cent of the production of housing-construction factories was directed to the countryside.[12] Architecture in the 1970s and 1980s thus provided a means for communal farms to differentiate themselves, to present a distinct image reflecting their social values and individual success, such that some collective farms employed their own architects or even entire design offices.[13]

EKE Projekt and the KEK construction offices

The majority of collective farm structures were designed by the EKE Projekt cooperative office in Tallinn, established in 1966 on the initiative

of the inter-farm construction offices or KEK (Kolhooside ehituskontor). There were more than 20 KEK construction offices in Estonia in the 1970s, serving around 200 collective farms. By the end of the decade, the EKE Projekt office had grown considerably, employing more than a thousand people. Supported by clients that were independent of the state and having access to a broader range of building materials than contractors in the cities, EKE Projekt became the main initiator of change in Estonian architecture. From the late 1960s onwards a new generation of architects began work there, including Toomas Rein, Veljo Kaasik, and Harry Šein; they were later joined by Vilen Künnapu, Jüri Okas, and Marika Lõoke. All these architects graduated from the Faculty of Architecture at the State Art Institute in Tallinn, where they already critiqued the industrialization of building practice (including mass housing) and also the Soviet version of consumerism and its attendant 'parvenu' culture. For them, it was necessary for architecture to be related to other fields and especially to the visual arts, which since the 1960s had been revolutionized by Western pop art and minimalism. The younger generation, which retrospectively has been named the Tallinn School, also led the architectural discussions in the widely followed cultural media, on the topics such as the Soviet built environment, drawing attention to the forgotten heritage of the early twentieth century, and the current developments in world architecture.[14] They published several samizdat translations of works by contemporary Western architects, including Robert Venturi, Aldo Rossi, and Leon Krier, as well as those from nearby Finland.[15] Architectural discussions were brought to the centre of public attention through polemical exhibitions and seminars organized under the auspices of the Union of Architects Youth Section.[16]

The EKE Projekt architects of the late 1960s and early 1970s looked towards Scandinavian modernism, with its carefully staged relationship to nature, inside-out functionalism, and truth to materials. Two collective farm centres by Toomas Rein in Southern Estonia (in Tsooru and Kobela) exemplify this. In both instances, the architectural space gradually opens out to the surrounding nature: at Tsooru, the buildings face parkland, and at Kobela an artificial lake. Deep cornices dominate the exterior of both and the interiors comprise a continuously flowing space. Rein's design for Pärnu KEK in western Estonia (1970–7), a combined living and working complex, became one of the most significant architectural works of the decade. With its strict orthogonal layout and unusual housing typologies, the project ran contrary to the hierarchical zoning of the post-war decades. The complex was located on either side of the Tallinn-Riga highway, with its 700-metre-long, four-storey housing scheme, 'The Golden Home', forming an axis along one side of the road, and the office spaces and production facilities of the construction company (a metal workshop and a wood workshop) on the other side.

Vilen Künnapu and the turn towards postmodernism

In the second half of the 1970s, EKE Projekt's approach shifted away from functionalism to embrace classical order and historical references. This shift towards an approach that could be related to postmodernism is best represented by the career of a young architect, Vilen Künnapu. Künnapu started working at EKE Projekt after graduating from the State Art Institute in 1972 at the age of twenty-four. Previously he had already become one of the leading voices of his generation, writing for the popular press on recent developments in world architecture, including articles on Louis Kahn, Alison and Peter Smithson, and Robert Venturi, as well as on the NER group from Moscow and the revival of interest in Russian constructivism. His early projects conveyed his interest in neo-functionalism: in his 1974 winning submission for an internal EKE competition for a sanatorium in Pärnu, the large complex was broken down into smaller, functional units, connected on the second floor by a system of galleries. That same year, he built a group of five neo-modernist single-family dwellings for the administrative members of Aravete kolkhoz, placing each white house separately on the shore of an artificial lake on the outskirts of the farm complex. By the end of the decade, Künnapu's approach shifted towards historicist quotations and typologies. In August 1977, he published a polemical article, 'Environment Through A Myth', in the leading cultural newspaper *Sirp ja Vasar* (Hammer and Sickle), in which he praised the ideas of the machine age and use of technicist detail for organizing the new environment, as well as advocated poetic imagination when working for individual clients and single family dwellings. 'Houses contain thousands of associations', he argued, 'hidden and unconscious ones (memories, illusions), as well as public and conspicuous ones (advertisements, drying laundry on the roof, windows)'.[17] During the design process, the architect should produce 'a myth, a story' that 'would consist of the future user's illusions, their unconscious dreams'.[18]

The polemical article provoked a critical response in the same newspaper from architectural historian Leo Gens, who warned that in this way individual homes would ignore local traditions and become the plaything of fashion and irrationality: 'It is true that this kind of architecture began to spread in some Western European countries and in the USA as a manifestation of youth protest movements, of subculture. It is doubtful however, that we can bring this to our particular situation.' Gens interpreted Künnapu's 'myth' as enabling nouveau riche, social climbers to differentiate themselves, to show they were better than their neighbours: 'It is amusing to read Künnapu's Freudian ruminations. ... In reality this 'myth', or more precisely a dream, will not rise to the level of mythology. It signifies only conformity, manifested as petit-bourgeois individualism.'[19]

Other voices, nearer to the centre of power, proposed that the postmodern orientation towards the user offered possibilities for Soviet architecture. An article by leading Soviet architecture theorists Aleksandr Riabushin and Vladimir Khait, translated and published in *Sirp ja Vasar* in 1980, noted that, while one should consider postmodernism in the context of Western capitalism, some 'artistic takes and professional methods (while given new ideological content) offer practical interest also in the context of a different social system'. In its turn towards meaning and symbolism, the authors saw postmodernism's potential for addressing different groups of people and telling different stories. From the techno-utopian architecture that approached people always in the same way, there was a turn towards the ideals of the 'common man'. Meaningful architecture means 'turning towards the grand, centuries-old truth of human history and human culture'.[20]

One of Künnapu's most significant works from this period was a flower store on a narrow plot in Tallinn's medieval Old Town (1978–84). The laconic three-storey structure was screened from the street by a freestanding painted concrete façade, decorated with symmetrically placed arches and rectangles, and standing a metre away from the main body. Künnapu explained his work process: 'First, I drew the façades of all the houses on the street, then constructed in the empty space (replacing a decaying two-story dwelling) a façade that would correspond to the rise of the street-front and drew onto it an image that had architectural details from the neighboring houses mixed with free geometry.'[21] Demonstrating his knowledge of Robert Venturi and Denise Scott Brown's 'decorated shed' – that the façade of a house is an independent surface for symbolic meanings – the façade conveyed historicist and art-deco references with no relationship to the functional program of the flower store behind it.[22] The interior and the colour scheme, designed by Mari Kurismaa as her diploma project in interior design, projected additional layers of meaning within the tight, dramatic space. Most conspicuously, the upper corner of the courtyard façade was painted white to produce the illusion of a shadow cast by the roof of a neighbouring house. Inside, the spaces on the ground floor were organized around a circular staircase leading up to the workspaces. The circular shape was repeated in the third-floor guest apartment, where the kitchen and curving work surface were placed under a central skylight.

Several critics picked up the many narrative associations and ambiguities underlining the design, interpreting the building in an overtly poetic way. Prominent fiction writer Mati Unt explained in his article 'A Werewolf on Cattle Street' (referring to the actual street name) that, in dreams, buildings manifest the layers of the human psyche. Thus, the screen is a mask, a persona, and the functionalist volume concealed behind is the inescapable unconscious: 'Flowers symbolize life in the middle of the city, within a building with a modest façade, but a pretentious rear like a funeral parlour (the store

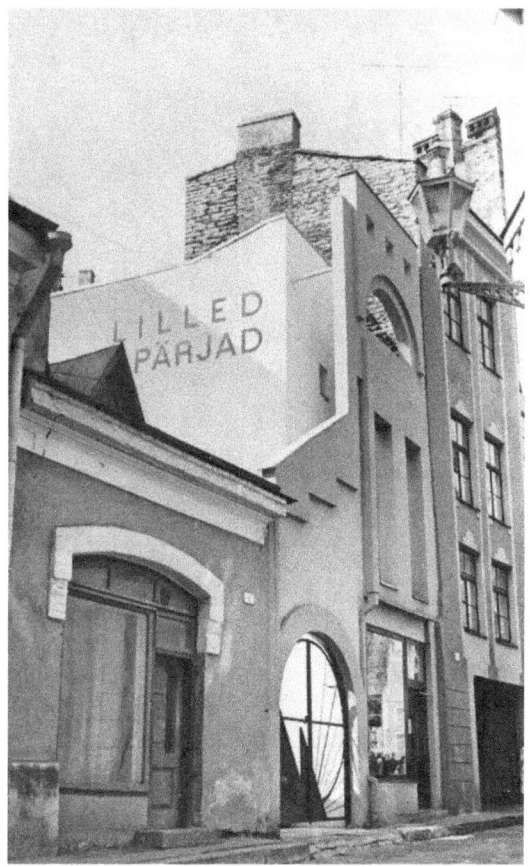

FIGURE 7.1a *Vilen Künnapu, Flower store in Tallinn, 1978–84. Photo courtesy of the Museum of Estonian Architecture.*

sign also reads "wreaths").'[23] The screen, rather than communicating the building's inner function, was for Unt a mask that concealed the shop and its 'inner life' from people passing in the street (Figure 7.1a and b).

The building was commissioned by a kolkhoz near Tallinn, named after Johannes Lauristin, the first secretary of the Estonian Communist Party Central Committee in the early 1940s. In 1975, the kolkhoz merged with the neighbouring collective farm 'Socialism's Way' and adopted several reforms, such as granting executive power to its chairman and separating economic and political decision-making.[24] In addition to pig and dairy farming, the kolkhoz enlarged its flower greenhouses and introduced souvenir production, which added considerably to its profits.[25] In this context, the flower store not only was a place to sell flowers from the new greenhouses, but also represented a shift towards finding new attractive ways of marketing its products.

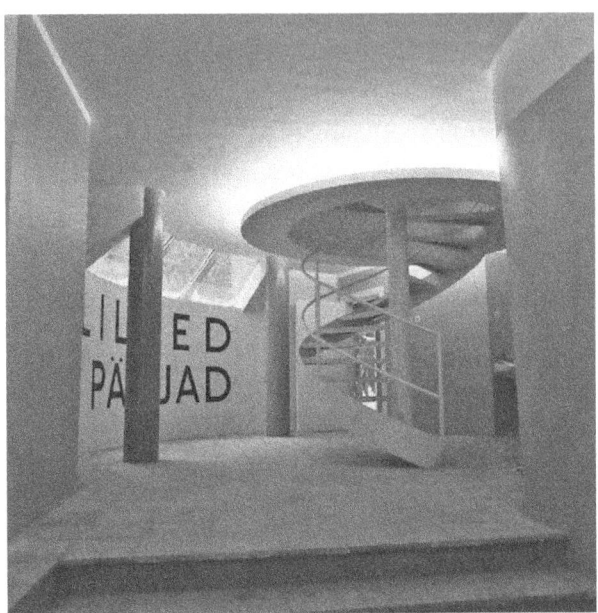

FIGURE 7.1b *Vilen Künnapu, architect, and Mari Kurismaa, interior designer, Flower store in Tallinn, 1978–84. Photo courtesy of the Museum of Estonian Architecture.*

The prosperous 'Kirov' fishery in Tallinn set up a similar structure combining a flower shop, café, gallery, and guest apartments (designed by Ado Eigi in 1979). Behind its modernist façade – it had horizontal windows and a large glass wall on the ground floor – was a double-height atrium for selling flowers and souvenirs, an upper floor gallery for displaying artworks, a basement bar with an aquarium, and, most importantly, a sauna with rooftop swimming pool and guest apartments.[26] The need for these spaces arose from the specifics of the Soviet economy, with its irregularities in planning and lack of reliable materials and supplies, leading to links between enterprises whereby personal relationships and nepotism helped secure the necessary products.[27] To impress potential industrial suppliers who could provide high-quality machinery or building materials, or the bureaucratic elite responsible for favourable planning decisions, meetings would be arranged in these new entertainment spaces. Bars, saunas, and swimming pools, often constructed using luxurious materials and with extravagant architectural designs, became a stage set for business. Although designed with typical modernist features, the façade of the Kirov building also functioned as a mask: its rooftop sauna was hidden behind a parapet, guarding the space from curious eyes on the street. In this way, the screens/masks of the flower stores represented not only the tectonic mythologies of their architects, but simultaneously both concealed and manifested the inconsistencies of the socialist system.

Postmodern collective farm centres

Künnapu's other influential postmodern works of the period were for collective farms in the countryside, where the architectural 'myth' was put to the service of new production units. In 1978, Künnapu was commissioned to design the administration building of the October Collective Farm in a small village in Peetri, in north-eastern Estonia (Figure 7.2a and b). In addition to the new administration building, the kolkhoz built ten new apartment buildings, a new central heating plant, a kindergarten, and a new canteen (previously workers and school children had shared a single canteen).[28]

Located in a large open field, the new administration building was a long, narrow two-storey rectangular structure in white brick. The simplicity of its exterior was broken only by the varying rhythms of apertures. Künnapu explained that the design was inspired by a 'classical Greek temple and had to form a horizontal counterpoint to the vertical Gothic church steeple nearby'.[29] It may also be seen to be in dialogue with an Italian neo-rationalist aesthetic: surrounded by the emptiness of the field, its monumental character echoed the functional ambivalence of many of Aldo Rossi's works. Künnapu imagined the building as a 'complex box', embodying an 'aesthetics of silence'. The building's interior in light blue and pink hues was dominated

FIGURE 7.2a *Vilen Künnapu, Collective farm administration building in Peetri, Estonia. 1978–84. Photo courtesy of the Museum of Estonian Architecture.*

FIGURE 7.2b *Vilen Künnapu, architect, and Mari Kurismaa, interior designer, Collective farm administration building in Peetri, Estonia. 1978–84. Photo courtesy of the Museum of Estonian Architecture.*

by a narrow, roof-lit, central atrium opening into office spaces and meeting rooms. At the far side of the building was a passageway, which bore little relationship to any existing road or pedestrian routes, but which, in the architect's words, was to have a poetic role – not only to connect two meadows, but also to evoke 'the paintings of Giorgio de Chirico'.[30]

In 1988, the October kolkhoz commissioned Künnapu to design a club (or 'culture house') and a sports hall to satisfy the needs of its rapidly growing population. The main auditorium, originally intended for 300 people, was now serving a village of around 450, and the population was expected to rise to 600 inhabitants over the next few years. Located a hundred metres from the new administration building, on the opposite side of a central square, the form of the new structure was to be radically different,

FIGURE 7.3 *Vilen Künnapu, Collective farm sports hall in Peetri, Estonia, 1988–92. Photo courtesy of the Museum of Estonian Architecture.*

contrasting the formal restraint of the earlier building with its abundance of narrative symbolism. The high gable roof over the sports hall, with a slanted skylight that ran along its apex, almost doubled the two-storey height of the rest of the building. In front were the entrance foyer, a cafe, and a winter garden, together creating a single continuous space, while on the second floor a library was placed in a separate, protruding volume (Figure 7.3). Unlike the 'classical temple' of the previous building, Künnapu relied instead on the archetype of the traditional Estonian farmhouse, manifesting the shift in his approach from mythology to *genius loci*, a concept he borrowed from Christian Norberg-Schulz. Künnapu wrote that the spirit of a place influences everything, from the behaviour of the people to their clothing and architecture, literature and art; and yet it was something that could not be fully attained by outsiders.[31] Nevertheless, it could be expressed by the use of certain details acting as universal archetypes: 'Long colonnades, simple vaults, ... walls covering the horizon, ... conic chimneys, ... water- and fire towers'.[32] The resulting structure was to be a catalogue of different geometries: a slanted skylight on the gable roof, a curved concrete screen at the main entrance, a screen with square openings in front of the smaller auditorium, and a huge decorative sphere in front of the main entrance (which remained unbuilt).[33] The formal difference between the two structures may be readily explained by the difference in their function – the severe administration building with its cool, poetic allusions, versus the exuberant culture house and sports hall, with its openly 'narrative' series

of spaces – but it should also be understood in the context of the political changes that occurred during that period. The administration building looks back to the late-Brezhnev era, coupling bureaucratic management initiatives with informal business networks and hidden, nepotistic deals, whereas the culture house and sports hall date already from the brief era of Perestroika, which brought about unanticipated changes in the economic domain and revolutionized public discourse. Thus, while the subtle irrationalities of the administration building still speak in ambiguous and sometimes ironic terms, the almost obligatory playfulness and excess of symbolism of the culture house and sports hall already manifest the new open discourse of *glasnost*, where everything is spoken out and nothing is taboo.

An alternative to that juxtaposition is evident in Künnapu's sovkhoz centre at Laekvere (1984–9), which replaced an old warehouse in the centre of a small village in north-eastern Estonia. Deriving its V-shaped plan from the existing street layout, the pastel-blue building combined a multifunctional cultural hall with 400 seats and a bar in its west wing with office spaces in the east wing (Figure 7.4). There was a public courtyard between the two parts, with a pergola and 'geometric composition of manicured trees inspired by Cezanne'.[34]

Like the kolkhoz in Peetri, Laekvere sovkhoz was formed in 1978 by the merger of two neighbouring farms, which in the early 1980s led to a program of major improvements to its workshops and machinery. To attract workers, the sovkhoz erected a kindergarten, new apartment buildings, and several new single-family dwellings; there was also a meat-processing factory for

FIGURE 7.4 *Vilen Künnapu, Laekvere sovkhoz administrative and cultural building, 1984–9. Photo courtesy of the Museum of Estonian Architecture.*

the autonomous supply of its employees, since the central distribution system was functioning poorly by the 1980s.[35] The new cultural and administrative centre was to be a landmark signifying these developments in the village. The architectural language, which Künnapu borrowed from the 'eclecticism of the village itself', also demonstrated his desire to convey the 'irrational' and 'mysterious' qualities of the site.[36] Situated at the intersection of two streets, the house became the dominant feature of the village centre. The unified façade with its high gable in the middle screened the two separate entrances to the administrative and cultural wings. This symmetry was disrupted by a glass tower to the right of the entrance and by an eccentric slanted window in the middle of the façade. Other openings referenced the nearby nineteenth-century storehouse. Characteristic of the ironies of the late-Soviet period, the first meeting held in the building when it was finally completed in 1992 was to discuss the 're-organization' of the sovkhoz – a euphemism for its closure.

In just ten years the architecture of cooperative farms in Estonia changed from modernist monumentality, with its carefully balanced relationship to the surrounding nature (as seen in the works of Toomas Rein), to a narrative postmodernism replete with ironic combinations of historical references and vernacular archetypes often better understood by the readers of professional magazines than by the buildings' actual users. Whereas Riabushin and Khait, in their 1980 overview of Western postmodernism, suggested that this approach could be of interest in the Soviet bloc, they also underscored the 'cultural and aesthetic' understanding of the built environment and respect towards architectural heritage that postmodernism could convey: by addressing the variety of groups of people and telling their different stories, it could be turned towards the ideals of the 'common man'.[37] By their account, postmodernism would succeed if it was given new ideological content, but only in the Soviet sense of ideology as the set of programmatic ideas of the Communist Party. Instead, the new collective farms built appear to indicate the opposite: a weakening of that ideological content, not only symbolically, but also literally, as the management reforms allowed the removal of the Communist-Party-appointed party organizers from local decision-making processes. Still, the ideal of the 'common man' persisted in many of the new programs, in public infrastructure, and in the care taken to provide common areas. On the other hand, it could be argued that a different kind of ideology was making itself manifest, not so much in the many 'myths' constructed about local culture and history, but in the ways in which these were coupled with a new understanding of architecture in the minds of the clients.

Conclusion

Later authors have argued that the building boom of the late 1970s and 1980s was an important event in the development of identity politics and

resistance to the Soviet regime in Estonia. Architect and artist Leonhard Lapin has argued that by commissioning projects from young architects, clients were protesting against the 'grey barracks of socialist realism'. According to Lapin, the construction of experimental villas should be distinguished from other, more nostalgic or kitsch houses that were constructed during what was a 'building revolution', nonetheless

> at a time when for example the Poles fought against Soviet occupation on the barricades, the moderate Estonians were busy on the scaffoldings of their private houses – both forms of resistance finally led to independence.[38]

Art historian Krista Kodres has related 'myth-making' more broadly to the mission of architecture during those years, such that the condition of being (post)modern was itself a symbol of resistance: 'achieving formal synchronicity with the rest of the world … was a way for self-affirmation, by which one would refuse to accept the surrounding social reality'.[39]

At the same time, the idea of a building as a medium for self-expression manifested the desire to consume and for an imaginary luxury lifestyle. New administrative and cultural buildings of collective farms, often the first public structures in the smaller villages, functioned as local landmarks with recognizable symbols and later also as the signature structures of cooperative enterprises which, towards the end of the Soviet era, began to behave more like private corporations. Architecture became a means for gaining advantage in the struggle to attract workers and resources, for monumentalizing the profits from their production, as well as a status symbol and a means for differentiation.

Towards the end of the 1980s, with its interest in historical symbols and reliance on national and regional archetypes, this postmodernism developed a particular relationship to Estonia's national independence movement. Often called the 'new era of awakening' (a reference to the so-called national awakening at the end of the nineteenth century), the independence movement was driven by an ideology of restoration and return: a return to democratic state organization, to national symbols and traditions, and to the restitution of pre-war property and hierarchies that had been confiscated or dismantled by occupation and annexation during the Second World War.[40] Jürgen Habermas called this process in Eastern Europe a 'rectifying revolution' and described it as a revolution that presents itself as if 'flowing backwards' – 'one that clears the ground in order to catch up with the developments previously missed out on'.[41] However, in instigating new values of ownership and profit, of competition, of difference, and of individualism, it could equally be argued that this 'revolution' was also flowing forward, towards the introduction of the neoliberal reforms of the 1990s, which aimed at catching up with the prosperity and values of the West. Architecture played an important role in this process, through which new attitudes began to take shape in the late 1980s and would eventually

become naturalized in the 1990s. The late-Soviet postmodern buildings of the collective farms became obsolete within just ten years, but the values they expressed and the processes they initiated paved the way for attitudes and practices actualized only during the 1990s.

Notes

1 Heie Treier, 'Postmodernismi mõiste Eesti kunstimaailmas', *Kunstiteaduslikke uurimusi*, no. 8 (1995): 249.
2 Treier, 'Postmodernismi mõiste Eesti kunstimaailmas'.
3 Mark A. Sandle, 'Triumph of Ideological Hairdressing? Intellectual Life in the Brezhnev Era Reconsidered', in E. Bacon and M. Sandle, eds., *Brezhnev Reconsidered* (Houndmills: Palgrave, 2002), 135–64.
4 Mark Harrison, 'Economic Growth and Slowdown', in E. Bacon and M. Sandle, eds., *Brezhnev Reconsidered* (Basingstoke: Palgrave Macmillan, 2002), 45.
5 Harrison, 'Economic Growth and Slowdown', p. 54.
6 Among other initiatives, heads of the collective farm could be given stronger executive power, including decisions which traditionally were controlled by the general meeting where the party bureaucrats had a strong voice. A direction was taken towards the separation of the economic sphere and the political sphere. See Vladimir Kontorovich, 'Lessons of the 1965 Soviet Economic Reform', *Soviet Studies* 40, no. 2 (1988): 308–16; Janos Kornai, *The Socialist System: The Political Economy of Communism* (Princeton: Princeton University Press, 1992), 124–5.
7 Heino Veldi, 'Vabariigi agrotööstuskompleks'. Eesti põllumajandus XX sajandil. II köide: Ülevaade põllumajanduse loost okupatsioonide ajal. Aastad 1940–1990. I osa: inimene ja ühiskond. Ed. A. Sirendi (Tallinn: Põllumajandusministeerium, 2007), p. 284.
8 Kornai, *The Socialist System*, 77–8.
9 Ants Laansalu, 'Majanduslikud valikud põllumajanduses', Eesti põllumajandus XX sajandil. II köide: Ülevaade põllumajanduse loost okupatsioonide ajal. Aastad 1940–1990. I osa: inimene ja ühiskond. Ed. A. Sirendi (Tallinn: Põllumajandusministeerium, 2007), 157–60.
10 Arvo Sirendi, 'Põllumajandusettevõtted', Eesti põllumajandus XX sajandil. II köide: Ülevaade põllumajanduse loost okupatsioonide ajal. Aastad 1940–1990. I osa: inimene ja ühiskond. Ed. A. Sirendi. (Tallinn: Põllumajandusministeerium, 2007), 193.
11 Vello Viirma, 'Keskusehooned ja klubid ainuprojektide järgi', *Sotsialistlik Põllumajandus* 22 (November 1983): 29.
12 Arvo Sirendi and Olev Joa, 'Maaehitus', Eesti põllumajandus XX sajandil. II köide: Ülevaade põllumajanduse loost okupatsioonide ajal. Aastad 1940–1990. I osa: inimene ja ühiskond. Ed. A. Sirendi. (Tallinn: Põllumajandusministeerium, 2007), 259.

13 An example is the design and construction of Kirov Experimental Fishery in Viimsi, near Tallinn. See Liina Jänes, Kolhoosikeskus Eesti NSV-s: arhitektuurne resistance sovetiseerimisele. BA Report. Tallinn: Estonian Academy of Arts, Institute of Art History, 2000.
14 Vilen Künnapu, 'Keeruline arhitektuur', *Sirp ja Vasar*, 5 May 1973.
15 'Soome ja Eesti arhitektide ühine sümpoosion "Kunst ja ehitamine"/"Taide ja rakennus"' (Common symposium of Finnish and Estonian architects 'Art and Construction', 14 October 1979. (Manuscript in Jüri Okas's collection)).
16 See Andres Kurg, 'The Turning Point in 1978: Architects of the Talllinn School and Their Late Socialist Public', in Ines Weizman, ed., *Architecture and the Paradox of Dissidence* (London: Routledge, 2013), 19–32
17 Vilen Künnapu. 'Keskkond läbi müüdi', *Sirp ja Vasar*, 12 August 1977.
18 Künnapu. 'Keskkond läbi müüdi'.
19 Leo Gens, 'Keskkonna müüt ja tegelikkus', *Sirp ja Vasar*, 2 September 1977.
20 Aleksandr Rjabušin and Vladimir Khait, 'Postmodernne arhitektuur', *Sirp ja Vasar*, 28 March 1980. Not surprisingly, the article was referenced by Künnapu in his own piece of writing in the same year, titled 'Towards closed space', which argued for the new tradition in urban planning.
21 Vilen Künnapu, 'Lillepood Väike-Karja tn. 6', *Ehituskunst*, no. 2–3 (1982–3), 72.
22 Künnapu had visited the United States towards the end of the 1970s; he drew parallels between the Soviet Estonian and US situation ('avantgarde is pushed to the peripheries of the cities … the settlement is spread out and there is much empty space between houses') in his article: Vilen Künnapu, 'Keerulise ja vastuolulise arhitektuuri probleeme', *Ehituskunst*, no. 1 (1981), 49.
23 Mati Unt, 'Libahunt karjatänaval', *Sirp ja Vasar*, 29 July 1983.
24 Julius Põldmäe, Joh. Lauristini nim. kolhoos. Manuscript in Tallinn University Library, 1984, 148p.
25 Põldmäe, Joh. Lauristini nim.
26 Ike Volkov, 'Kalurikolhoosi uusehitised', *Sirp ja Vasar*, 5 October 1979, 9.
27 Alec Nove, *The Economics of Feasible Socialism Revisited* (London: Routledge, 1992), 84.
28 Tiina Sarv, 'Pildid "Oktoobrist",' *Võitlev Sõna*, 23 April 1983, 2.
29 Vilen Künnapu, 'Kolhoosikeskus Ämbras', *Ehituskunst*, no. 4 (1984), 40.
30 Künnapu, 'Kolhoosikeskus Ämbras'.
31 Vilen Künnapu, 'Poeetilise ruumi mõistatus', *Ehituskunst*, no. 4 (1984), 52.
32 Vilen Künnapu, 'Mõistatuslikkuse aspekt traditsioonilises arhitektuuris', *Ehituskunst*, no. 2–3 (1982–3), 25.
33 Oleg Kotšenovski, *Arhitektuurikroonika* (Tallinn: Ehituse Teadusliku Uurimise Instituut, 1988), 189.
34 Vilen Künnapu, 'Sovhoosikeskus Laekveres', *Ehituskunst*, no. 4 (1984), 39.
35 Evi Kuht, 'Maaelu kolhoosiajal peitis endas võlu ja valu', *Virumaa teataja*, 1 March 2008.
36 Vilen Künnapu, 'Kolhoosikeskus Ämbras', *Ehituskunst*, no. 4 (1984), 40.

37 Rjabušin and Khait, 'Postmodernne arhitektuur'.
38 Leonhard Lapin, *Avangard. Tartu Ülikooli filosoofiateaduskonna vabade kunstide professori Leonhard Lapini loengud 2001. aastal* (Tartu: Tartu Ülikool, 2003).
39 Krista Kodres, 'Müüdiloojad ja teised', *Ehituskunst*, no. 5 (1990), 6.
40 See Marek Tamm, 'The republic of historians: historians as nation-builders in Estonia (late 1980s–early 1990s)', *Rethinking History* 20, no. 2 (2016), 154.
41 Jürgen Habermas, 'What Does Socialsim Mean Today? The Rectifying Revolution and the Need for New Thinking on the Left', *New Left Review*, September–October 1990, 4.

8

Incomplete postmodernism:

The rise and fall of Utopia in Cuba

Fredo Rivera

The fifteen-storey Hotel Santiago de Cuba looms above Cuba's second largest city with bright colours and reflective glass and metal surfaces (Figure 8.1). Completed in 1991 and adjacent to the historical core of the city, its form and colour refer to the region's industrial past, the local topography, and an aesthetic akin to contemporary Caribbean resorts. Designed by Santiago-born architect José Antonio Choy, the new hotel opened at the onset of the Special Period, an era of economic hardship caused by the fall of the Soviet Union and the strengthening of the US embargo. It was one of many projects completed at the close of the 1980s, which indicated that an embrace of global tourism no longer contradicted the ideological principles of the socialist state. The tower presents an unabashed postmodernism within the post-revolutionary terrain of eastern Cuba, one where form and colour are playfully integrated into the design of the edifice.

The Hotel Santiago de Cuba demonstrated the ambitions of a new generation of architects towards the end of the 1980s, which marked a significant shift in Cuban architecture. The two previous decades witnessed the rise of prefabricated architecture and the superblock. After 1980, ideological liberalization, a strong, Soviet-dependent economy, and an embrace of avant-gardism in the arts permitted an opening up, as

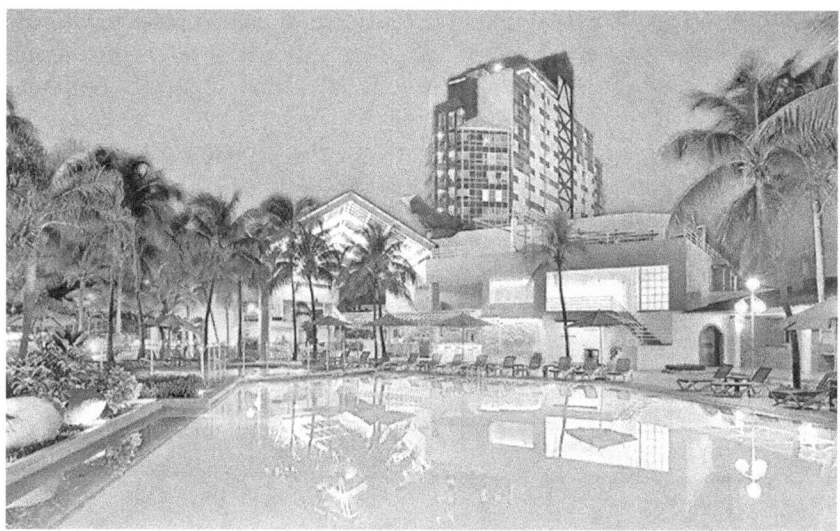

FIGURE 8.1 *Jose Antonio Choy, Pool deck and exterior of Hotel Melia Santiago de Cuba, 1991. Photo courtesy of Hotel Melia Santiago de Cuba, c. 2015.*

artists and architects began to respond to global trends. Such effects are visible in Choy's architecture, which employs a high-tech aesthetic while simultaneously referring to its locality. Choy's employment of primary colours and protruding, playful volumes is reminiscent of buildings from outside of the socialist context – Arquitectonica's famous 1982 Atlantis Condominium in Miami comes to mind, for example. However, while the undeniably postmodern building may appear new and extravagant within the contexts of a largely impoverished Santiago, for its architect the building also contained an undeniable *cubanidad* (Cuban-ness). Its scale resembles the prefabricated high rises in nearby central Santiago, while its colours are reminiscent of the graphic language of such buildings, transformed by deliberate colour schemes that localized their otherwise generic forms. The use of metal recalls the corrugated metal roofs of many homes in the region. Likewise, the fenestration brings attention to the reflecting sky and nearby Caribbean Sea.

Postmodernism in Cuba, this chapter argues, presents a case of what the Cuban anthropologist Fernando Ortiz has termed 'transculturation': adaptation of global trends and their hybridization with Cuba's economic realities and ideological programs.[1] While postmodernism played a more prominent role in the arts and literature of Cuba, architecture remained a venue where such hybrid expressions remained limited, or incomplete. The chapter traces the developments from the era of the 1970s into the 1990s, to explore how Cuban architects used the graphic and formal qualities of architecture to adapt the language of North American and Latin American commercial design and vanguardist art within post-revolutionary and

socialist contexts. Two particular periods are discussed: the *quinquenio gris,* or the 'gray period' of the 1970s, when semiotics developed alongside a period of rising repression; and the 'Special Period, a time of economic hardship following the collapse of the Soviet Union, resulting in the growth of tourism from Europe and Canada and the building of postmodern architecture. Following Ortiz, I also argue that Cuban postmodernism should be theorized alongside the dominating conceptual apparatus of the plantation. The tourist resort serves of a central contemporary example of the inherited plantation logic across the Caribbean, a racial economy itself apparent in the division of labour seen within Cuba's tourist economy today.[2]

Transculturation and power: Postmodernism in Cuba

Postmodernism in the Cuban context can only be understood against the ambitions and teleological metanarrative of modernity promoted by the Cuban government following the 1959 revolution. This narrative centred on father figures who fought valiantly and, as historian Lillian Guerra suggests, provided 'redemption' for the nation.[3] Visual media such as film and photography would play a central role in mythologizing the revolution and modelling the Cuban nation as an exemplar of a Third World modernism. Further, technological prowess became a dominant paradigm, as visual representations of scientific advances in construction engineering became common in popular media. Technology came to represent national aspirations within a larger global politics, with Cuba's national art museum hosting a large Soviet technology exhibition in 1961, and later sending participants to work in the Soviet Union's space program.

Cuba represented a peculiarity within Latin America given its longstanding antagonistic relationship with the United States at the height of the Cold War.[4] Its growing ties to the Soviet Union were made evident by the 1970s, with the continuation of the production of sugar as the backbone of Cuba's economy and its main contribution to Comecon, the Soviet-led economic alliance, into which the country was admitted in 1972. The growing Soviet influence became most overt the previous year, with the Declaration signed at the First National Congress of Education and Culture in April 1971. The document outlined pedagogical imperatives that would impact both architectural production and education, as new generations of artists and writers were to be educated 'in Marxist-Leninism, equipping with the ideas of the Revolution and their technical training'.[5] This congress marked the beginning of the *quinquenio gris*, where any resistance against the redemptive narrative of the revolution resulted in notable repression by state authorities.

The *quinquenio gris* was followed by a period of liberalization in the 1980s, marked by growing tourism arriving from the Soviet bloc and greater artistic exchanges with the developing world. Despite solidifying geopolitical allegiances, an awareness of Western postmodernism existed alongside a critique of architectural and urban planning practices of the United States and its capitalist allies. Prominent ideas from both capitalist and socialist countries in the postmodern era were evident in the scholarship and training of architects in the 1970s and 1980s. This is most evident in the writing of Roberto Segre, an architectural historian who taught at the Instituto Superior Politécnico 'Jose Antonio Echeverría' (CUJAE) in Havana throughout the 1970s and 1980s. His frequent publications explicated dominant trends and architectural theory of Europe and North America, providing a pointed critique of postmodernism. He identified Cuba's unique contribution as the bolstering of architecture through socialist ideology and the ambitions of the Third World. In his 1988 book *Arquitectura y Urbanismo Modernos: Capitalismo y Socialismo*, Segre dedicated two sections to recent trends in North American and Western European architecture, two geographies that for Segre exemplified architectural production within capitalism. He also identified the Third World as being outside the discourse of postmodernism, claiming its marginality an inheritance of its liminal position during the modern movement.[6] Segre's conflation of postmodern architecture with capitalism contributed to his critique of architectural production as broadening the divide between the First and Third Worlds. Cuba's contribution was advertised a utopic modernism that provided a model for the developing world.

Segre still defined architecture in Cuba as a utopian marriage between economic, artistic, and technological development.[7] It aligned with state propaganda and was a social mechanism for bringing people into the 'vanguard', as famously theorized by Ernesto Che Guevara.[8] From such a standpoint, postmodernism appears as an alternative to the vanguard, where architecture presents forms and symbols that undo the metanarrative of scientific, technological progress that became central to the Cuban Revolution. The playful architecture of the postmodern era thus suggested the death of modern architecture's ties to socialism. As the revolutionary ambitions of prefabricated architecture already began rotting in the humid, salty air of the tropics, they were replaced by the commercial large-scale hotels, resorts, and new transport infrastructure, built in response to the economic deprivation of the 1990s. Although criticized by the academic elites, postmodernism became prevalent in Cuban art and architecture of the latter twentieth century, as seen in the example of architect José Antonio Choy. Cuba's new economic relations with Western Europe and Canada became essential in this production of new architectures of leisure.

Historically, cultural production and the built environment within modern Cuba have been theorized within the dominating conceptual apparatus of

the plantation and its related economies. In his book *Cuban Counterpoint: Tobacco and Sugar*, anthropologist and leading Cuban intellectual Fernando Ortiz theorized Cuban culture through the history of sugar and tobacco commodities, defining the former 'as a question of power'.[9] Ortiz described how structures of economic and political power formed cultural imaginaries, extending his analysis to the visual worlds around the two commodities. The logic of the plantation persisted into the Republican and Revolutionary eras, as sugar and tobacco remained dominant exports from the island nation. The plantation as a utopia of order and surveillance is emulated in the organization of labour throughout the revolutionary period. The microbrigades described below employed prefabricated architectures for the masses and by the masses, with their plans recalling the site plans of the modern sugar mills of the nineteenth century. This is also seen in the spatial logic of the resort, which extracts labour in a programmatic, ordered manner.

Ortiz's theory of 'transculturation' presented a hybridization that accounted for the loss of African and indigenous culture and the creation of a new one within changing political and economic contexts. It also challenged previous assumptions that African cultural traits were entirely erased through the process of colonization. 'The real history of Cuba is the history of its intermeshed transculturations', Ortiz claimed.[10] Transculturation serves as a useful model for thinking about postmodernism and its uneven entrance into Cuba. Both the utopian endeavours following the 1959 revolution and the subsequent postmodern era presented interfaces with the colonial past and its intermeshing with socialist ideologies. This is especially seen in the burgeoning field of research regarding art and culture following the fall of the Soviet Union, when Cuban scholars and artists began to explore the legacy of utopia and revolutionary ideals in the face of economic hardship and globalization.[11]

Revolution and semiotics: Transforming prefabricated architectures

The 1969 graphic campaign for the *zafra*, or second harvest of sugar cane, contained a bedazzling counting of numbers. Individual posters spelled out the progress of the harvest – *un millon, y van 2, 3 , ya son 4, la mitad, seis, el 7 , ya van 8, falta uno* – with text and numbers protruding from their backgrounds in multiple and dynamic perspectives and vivid, tropical hues, until finally the series reached ¡*diez!* – a sign of the new goal of the revolution to produce 10 million tons of sugar for the Soviet Union and satellite states. The ecstatic campaign advertised the economic imperative under which the backbreaking labour of the sugar harvest took place. The *zafra* had a history that dated back to Cuba's colonial era, when a

plantation-slave-based economy brought the island great wealth and misery. Antonio Benitez-Rojo, the foremost theorist of Cuban postmodernism, invoked the plantation both as analogous to expressive and creative transculturations within authoritarian spaces, and as an ever-persisting conceptual and spatial apparatus determining power relations within the island.[12] The drama of the plantation, once realized by the capitalist exploits of the past, thus became recreated in a communist context to remain a site of cultural exchange and lived experience.

The campaign for the *zafra* was among the earliest expressions of postmodernism in the built environment of Cuba, presenting a transculturation between North American popular culture and Cuban design. It was the penultimate expression of progressive optimism in the high modernity of the socialist state, and an early example of semiotic wordplay of Cuba's late modern era, where the graphic impulse of the city reached the built environments of agrarian reform. For the workers returning from the field each evening during harvest, the billboards and graphic signs visualized their progress in vivid, seemingly psychedelic colours. Designed by Olivio Martínez under the auspices of the COR (Commission for Revolutionary Orientation), the graphic campaign employed pop and op art trends from the United States, repurposing their irony and playfulness to represent the devotional, redemptive modernity of the Revolutionary vanguard.[13] This expression of a revolutionary modernity promoted labour and power relations rooted in Cuba's colonial past, and hence highlighted the solidification of communist ideology and authoritarian, patriarchal rule in a manner that imbued works of art and architectural and visual culture with an ironic, subversive tint.[14]

It is almost uncanny how explicitly some of the roadside billboards from the 1970 *zafra* recalled the aesthetic of commercial advertising (Figure 8.2). Combining a vibrant graphic appeal with a familiar message as a form of branding, their comic book-like aesthetic was strikingly akin to the work of US pop artist Roy Lichtenstein. Workers transported to the sugar cane fields would regularly encounter such advertisements. The goal was to impact the psyche at a communal and societal level, to obfuscate the intense physical labour of the plantation with new technologies of communication. The extensive use of graphic images – photographs, painted surfaces, typeface, and other visual elements – also heavily affected architecture, which provided blank surfaces for propaganda. Roberto Segre has suggested that the graphic arts played a dominating role in Cuban architecture of the 1970s as a form of mediation between rational architecture and the everyday.[15] Together with photography and film, they began to visually reframe the new technologies of concrete, becoming additional means to construct and represent the utopic endeavours of the socialist government.

The logic of the plantation would make itself obvious in Cuba in the 1970s in two predominant manners. First, the introduction of labour camps as

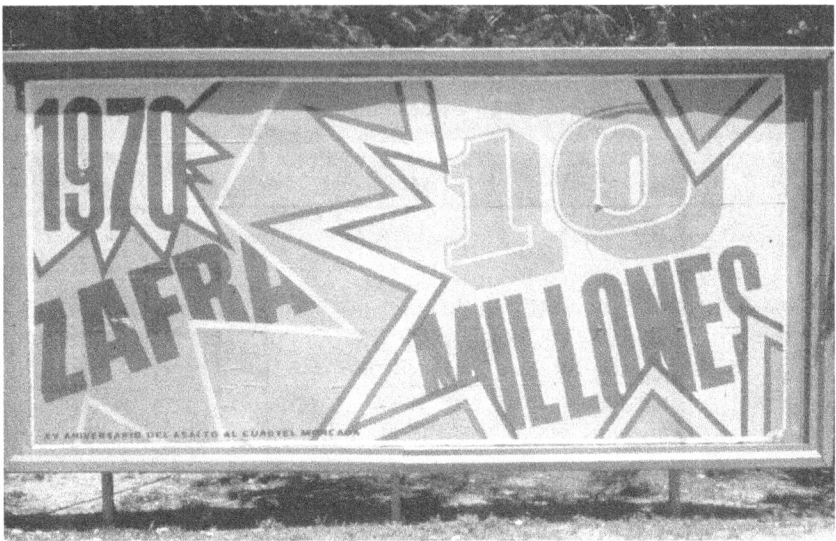

FIGURE 8.2 *Billboard for La Zafra, c. 1970. Photo courtesy of Roberto Segre.*

a revolutionary action and as punishment (or reorientation) for citizens who did not fit within the revolutionary ideology (be it through appearance or actions) constituted labour as an oppressive or vindictive force. Second, the productive force of labour also came to be seen as a means of liberation, conceived of as labour by the people for the people. In the realm of architecture no better example exists than the microbrigades, an idea introduced by Fidel Castro in 1970 that encouraged workers to build communal, prefabricated housing for themselves and others.[16] Excused from normal work duties, citizens formed brigades and worked together to build their own housing, with the state continuing their salary and providing materials. Apartments were distributed based on the decisions of communal assemblies.[17] Microbrigades contributed to the needs of the people in an economy based on the order and ethos of the plantation, but entirely reconfigured it through to emphasize community.

The largest and most significant microbrigade project, Alamar, was in many ways an icon of post-revolutionary architecture. Initiated in December 1970, the neighbourhood within Habana del Este was the first major endeavour to employ microbrigades on a large scale, attempting to alleviate Havana's continual housing shortage as well as the limited availability of materials.[18] Alamar expanded upon the use of prefabricated architecture to create a massive suburb, with a population totalling over 100,000. It also demonstrated the graphic possibilities of prefabricated architecture. Its buildings differed in construction type and orientation but provided a multitude of blank surfaces for integrating graphic images that

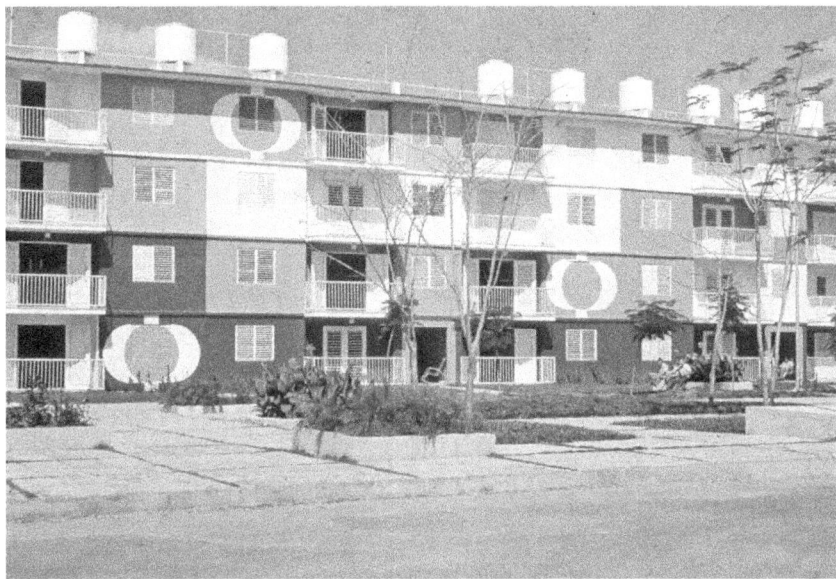

FIGURE 8.3 *Exterior façade of Bloque GP-IV housing, Camagüey, Cuba, c. 1975. Photo courtesy of Roberto Segre.*

contributed to architecture's *cubanidad*. Some edifices featured the simple placement of a large star – the symbol of the republic – thus referring to the nation state. Other buildings applied more abstract, non-linear, and geometric patterns, incorporating the aesthetic of prominent artists of the Cuban *vanguardia*, which also had associations with nationalism in the Revolutionary period. Sometimes this aesthetic was simplified by the employment of colour blocking with simple geometric forms, as seen in an example of prefabricated housing in the Camagüey province from the 1970s (Figure 8.3). Few examples remain intact today.

The graphic aesthetic of the 1960s marked the creation of a *ciudad gráfica*, or graphic city, which redefined the traditional image of Havana as a 'city of columns', known from Alejo Carpientier's poetic 1963 photo essay.[19] Large-scale painting and photographic prints transformed the surfaces of prefabricated buildings, interrupting the logic of science and technology with that of symbols and experiences. The ability of architecture to provide a surface for visual signs reflective of a political expression is seen in the example of the draping of the iconic image of Che Guevara over the Ministry of the Interior for his 1967 eulogy, or the placement of Lenin on the Cinema Yara on La Rampa (Figure 8.4). The iconic, heroic figure of Che became a dominating trope of *cubanidad*, while the image of Lenin reflected Cuba's realignment with the Soviet Union. Abstraction in visual culture, however, also revealed itself in more subtle ways, exhibiting patterns and rhythms outside the scope of figureheads. In Heriberto

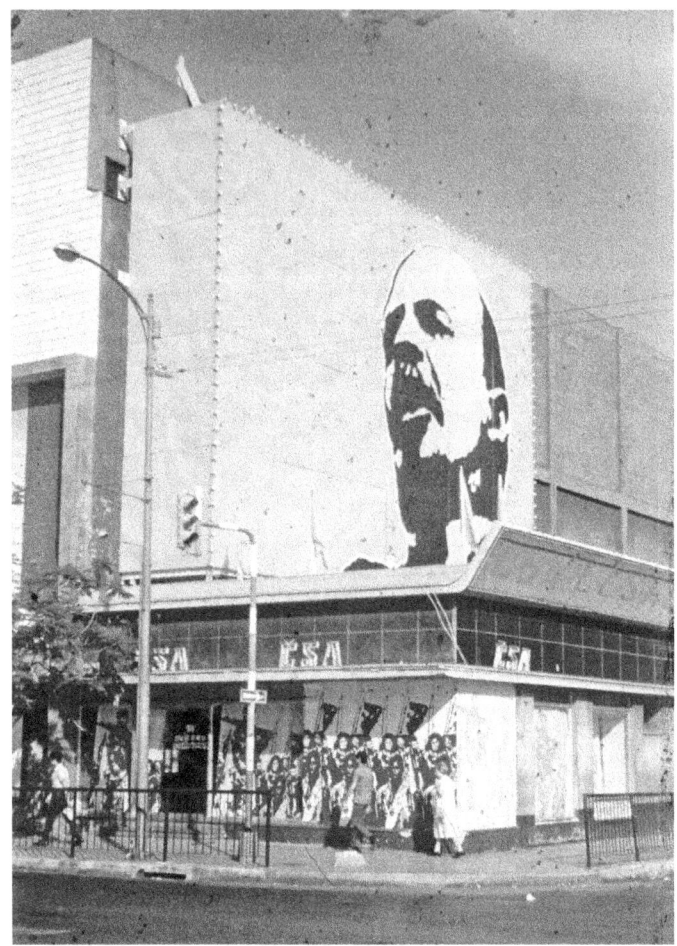

FIGURE 8.4 *Billboard of Vladimir Lenin, La Rampa and Calle L, Havana, c. 1971. Photo courtesy of Roberto Segre.*

Duverger's Escuela Primaria Volodia of 1977 (Figure 8.5), graphic arts and architectural space come together to represent the ethos of revolution and its mythologized stature. The elementary school combined painted surfaces and sculpture to create a sense of whimsy and exploration. Colourful, rainbow-like stripes form pipes along the balconies and their overhangs, pouring stars and water onto the painted concrete surface. A nearby plaza utilizes metal circles and concrete bench-like platforms that correspond to the mural. The visual sense of abundance suggested the influences of a seemingly psychedelic pop art much like that of the billboard of the *zafra* (Figure 8.2), though the knowledge of trends from the United States and Mexico remained unaccounted for.

FIGURE 8.5 *Exterior of Escuela Primaria Volodia, Havana, c. 1977. Photo courtesy of Roberto Segre.*

Tropical socialism: Fragments of the postmodern

Contemporary developments in postmodern architecture informed Cuban architects during the 1980s, though their adaptation was piecemeal. The two primary journals of Cuba – *Arquitectura Cuba* and *Arquitectura y Urbanismo* – often covered trends in North American architecture and urban development, always including a pointed critique of capitalism. In a 1981 article exploring architecture in the United States, Roberto Segre provided a summary of the recent advent of postmodernism, identifying Cuba's independence from the political and economic contexts of capitalist development and proclaiming their revolutionary approach to architecture – one that emphasized Cuba's socialist leanings and a dedication to Third World solidarity.[20] At the same time, the influence of architectural theory from North America and Europe was prevalent, as the work of Choy demonstrated by the close of the decade. In February 1980 Havana hosted a national symposium of graphic divulgation, to explore enhancing the graphic ambience of the built environment. In their lecture presented at the symposium, architects Luis Lápidel Mandel, Isabel Rigol Savio, and Sergio Ferro Cisneros claimed that consumerism produces visual chaos and degradation of the city in the capitalist North. Their investigation seemed to be informed by recent publications such as *Learning from Las Vegas*, as made evident in their critique of advertising in the United States.[21] What remains unclear is how the growing field of semiotics in Cuba

provided any semblance of critique regarding the role of graphic arts within Cuba. The commitment to a revolutionary ideology was made explicit in the essay's bibliography, which cited only Marx, Lenin, and the Cuban art historian Jorge Rigol.

The revival of tourism in Cuba started well before the onset of the 'Special Period' in 1989. In the early 1960s, Cuba had abandoned international tourism of the 1950s era and its reliance on casinos as the main attraction, only to return to tourism for economic motives in the early 1980s, paralleling the rapid expansion of the tourism sector in Mexico and neighbouring Caribbean islands. In a 1982 speech Fidel Castro cited the natural elements of the tropics as a prime resource for Cuba's wealth within a more mobile world.[22] Cuba began to envision itself as a site for Soviet and international tourism, refocusing its housing campaign to create new infrastructure for foreign pleasure seekers.

The development of tourism from within the Soviet bloc necessitated similar amenities to the more global, expanded tourism experienced today in Cuba. The island nation was envisioned as a tropical playground for foreign masses, and this resulted in the construction of behemoth hotels at the end of the 1980s, such as the aforementioned Hotel Santiago de Cuba. By the 1990s multiple hotels were built to fit the expectations of well-to-do tourists, often in collaboration with Western European and Canadian companies. These hotels, especially those built along the coast in the resort town of Varadero, began to play with a postmodern architectural vocabulary through the tropes of tropicality, or 'the complex visual systems through which islands were imaged for tourist consumption'.[23] Many hotels, for example, the Gran Hotel de Varadero, even incorporated military encampments from the revolutionary period. Originally built as an encampment for the military brigade Pioneros de Varadero through the locally designed Girón system of prefabrication, the former dormitories were retrofitted with high-end amenities, a new glass façade, and a vibrant colour scheme. An element of nature-based kitsch was introduced through massive rocks that rose up the four-storey high open lobby, contrasting the original modernist concrete pillars.[24]

The rise of tourism also resulted in significant investments in transport infrastructures. In the 1990s airports were rebuilt to accommodate larger flows of tourists, as were other transport centres. One prominent example is the 1997 Railway Terminal in Santiago de Cuba, designed by María Quintana and José Antonio Choy in a style akin to Choy's Hotel Santiago de Cuba. Tropical hues of yellow, blue, and green form playful geometric entities, all under a tall metal shed. While the shed brings to mind the grandiose spaciousness of the plantation, the playful waiting areas and platforms establish postmodern forums for consumption by tourists.

The 'Special Period' in Cuba is popularly thought of as an era of economic desperation, one when existing infrastructure seemed to melt under the oppressive sun and salty air. Indeed, Cuba encountered a housing crisis, with many dilapidated buildings teetering into a precarious state. Architecture in

this era focused around the tourist, rather than the resident, and the ideal of housing for the masses was largely abandoned. Even the last major example of mass housing, the complex known as the Villa Panamericana, was developed as a sports village for Cuba's hosting of the 1991 Panamerican Games in East Havana (Figure 8.6). With the country vying to also host the Olympic Games, the Villa Panamericana was a prime example of innovative economic mechanisms in architecture. Located in East Havana within the close vicinity of Alamar, the new suburb consisted of fifty-five buildings with 1,468 apartments for visiting athletes, intended to be turned into homes in order to alleviate the housing crisis.[25] Comprised of varied prefabricated elements, each housing unit employed different elements within the same scale, creating a varied aesthetic among neighbouring units. While the overall ethos of the project is modern, playful experimentation and differentiation present a postmodern gesture. This experiment with typologies could not undo the economic hardship of the 1990s, nor did it completely rid itself of the repetitive monotony associated with the Ministry of Construction's post-revolutionary projects. But it did predicate the tourism-based architecture to follow, with its employment of whimsy alongside functionalism.

The Villa Panamericana was perhaps the last gasp of utopia, or of modernity's ideological purity and push for social and spatial order. The Special Period of the 1990s would change architectural production prominently, as Cuba developed its tourist sector broadly. The introduction of all-inclusive resorts and high-rise hotels would not only challenge previous

FIGURE 8.6 *Streetside facades of Villa Panamericana housing units, Havana, 1991. Photo courtesy of Roberto Segre.*

state imperatives, but also bring an element of postmodern kitsch to the island. Contemporary architecture today appears even more aimed at tourists and foreigners, to the creation of hotels and resorts and ports for large cruise ships – themselves neoliberal apparitions of the plantation being implanted upon the seashores of the socialist island nation.

Conclusion

The contradictions between the ideological imperatives of the Cuban Revolution, its economic hardships and former dependence on the Soviet Union, and the ever-burgeoning influence of capitalist designs suggest a postmodern era where utopia reached its climax and then became hollowed. Frederic Jameson cites postmodernity as being associated with the demise of the utopic, a rupture from high modernity related to the 'end of ideology'.[26] The ideological aversion to postmodernism articulated by Cuban architects and scholars of the 1980s remains pertinent today, when the socialist imperative of the revolution provides a political façade to the tourism-dependent economy and encroaching globalization. Further, one may question whether the ruins of modernist structures in Cuba are themselves postmodern, as representations of how the dreams of utopia have gone awry. There is a certain allure to the 'ruin porn' prevalent among foreigners documenting Cuba since the onset of the Special Period era, as photographers spectacularize and capitalize upon the decay of Cuba's modern architectures.

To claim that postmodernism is incomplete in Cuba is perhaps unfair, as the language of postmodernism was never permitted by prominent scholars on the island and authorities in the Ministry of Construction. Nonetheless, time impacts our understanding of socialist architectures, and we can today account for the spatial and visual references designers and architects were making with global trends. Much like Ortiz accounted for African elements of Cuban culture in the 1940s that were previously denied in the official discourse of the nineteenth-century colony, contemporary scholarship on Cuba is questioning the solidity of the Revolutionary era's modernist ethos. By deconstructing the modern, the postmodern qualities of whimsy, kitsch, and diversity may emerge, be it in the graphic presentations on architectural surfaces from the 1970s or the new architectures of consumerism produced in the 1990s.

Notes

1. See Fernando Ortiz, *Cuban Counterpoint: Tobacco and Sugar* (Durham: Duke University Press, 1991), 103.
2. As Katherine McKittrick writes, 'The plantation thesis uncovers the interlocking workings of modernity and blackness, which culminate in long-standing, uneven racial geographies while also centralizing that the *idea* of the

plantation is migratory. Thus, in agriculture, banking, and mining, in trade and tourism, and across other colonial and postcolonial spaces – the prison, the city, the resort – a plantation logic characteristic of (but not identical to) slavery emerges in the present both ideologically and materially. With this, differential modes of survival emerge – creolization, the blues, maroonage, revolution, and more – revealing that the plantation, in both slave and postslave contexts, must be understood alongside complex negotiations of time, space, and terror.' Cited from 'Plantation Futures', *Small Axe* 17, no. 3 (November 2014): 3.

3 *Visions of Power in Cuba: Revolution, Redemption, and Resistance, 1959–1971* (Chapel Hill: University of North Carolina Press, 2012), 13.

4 This became especially poignant when Cuba was to host the World Congress of Architecture in 1963, where changing economic allegiances and the socialist direction of Cuba became clearly articulated among the architecture profession. Glendinning, 'The Architect as Cold War Mediator: The UIA Congress of 1963, Havana', *Docomomo Journal* 37 (September 2007): 32–3.

5 'Declaración del Primer Congreso Nacional de Educación y Cultura (Fragmento)', *Revista Casa de las Américas*, Mayo-Junio 1971, 111.

6 Roberto Segre, *Arquitectura y Urbanismo Modernos: Capitalismo y Socialismo* (Havana: Editorial Arte y Literatura, 1988), 396.

7 Segre, *Arquitectura y Urbanismo Modernos*, 499.

8 Che Guevara's theory of the vanguard is proclaimed in his regarded essay 'Socialism and the New Man' (1965), a published letter to Uruguayan writer and politician Carlos Quijano. For Che, the *vanguardia* moves from an artistic and intellectual movement to a political one, where the primary goal is education in order to incorporate the masses into the 'vanguard'. *Che Guevara Reader: Writings on Politics & Revolution* (Melbourne: Ocean Press, 2003), 222.

9 Ortiz, *Cuban Counterpoint*, 56.

10 Ibid., p. 98.

11 Artists of the 1980s and 1990s often responded both to the legacy of modernization in Cuba and recent trends in postmodernism, offering a critique of nationalism and the state in their expressions regarding contemporary Cuba. See Rachel Weiss, *To and From Utopia in the New Cuban Art* (Minneapolis: University of Minnesota Press, 2011), and Luis Camnitzer, *New Art of Cuba* (Austin: University of Texas Press, 2003).

12 Antonio Benítez-Rojo, *The Repeating Island: The Caribbean and the Postmodern Perspective* (Durham: Duke University Presss, 1992), 36.

13 Historian Lillian Guerra refers to the 1959 revolution as containing a dynamic of resistance and redemption, with the male leaders of the Revolution figured as martyrs of the state, *Visions of Power in Cuba: Revolution, Redemption, and Resistance, 1959–1971* (Chapel Hill: University of North Carolina Press, 2012), 13.

14 Jorge R. Bermúdez. *La Imagen Constante: El Cartel Cubano de Siglo XX* (Havana: Editorial Letras Cubanas, 2000), 167.

15 Interview with Roberto Segre, 21 March 2012.

16 See Kosta Mathéy, 'Recent Trends in Cuban Housing Policies and the Revival of the Microbrigade Movement', *Bulletin of Latin American Research* 8 (1989): 67–81.

17 This is expertly highlighted in interviews with architects Mario Coyula and Daniel Bejerano in the film *Microbrigades – Variations of a Story*. Directors Florian Zeyfang, Alex Schmoeger, Lisa Schmidt-Colinet, 2013. The short, thirty-one-minute film is accessible at http://www.florian-zeyfang.de/microbrigades-variations/movie/ (accessed 1 October 2014).

18 Mario Coyula, 'La Lección de Alamar' *Espacio Laical*, April 2011, 56.

19 Alejo Carpientier's photo essay 'Ciudad de las Columnas' reflects upon Havana's dominant urban imaginary and related rhythms, creating a visual and poetic language to understand the tropic, neoclassical city. The removal of advertising and the emphasis on propaganda help transform the modern Cuban city throughout the island nation. Alejo Carpentier and Paolo Gasparini, *La ciudad de las columnas* (Barcelona: Editorial Lumen, 1970).

20 Roberto Segre, 'A problemática urbanistica Y arquitectura en Estados Unidos en la decada del 70', *Arquitectura y Urbanismo* 2.1 (April 1981): 22–6.

21 The lecture was published as an article in *Arquitectura y Urbanismo*. Luis Lápidel Mandel, Isabel Rigol Savio and Sergio Ferro Cisneros, 'La propaganda graphic a escala urbana', *Arquitectura y Urbanismo* 1.2 (December 1980): 80–100.

22 Rosalie Schwartz, *Pleasure Island: Tourism & Temptation in Cuba* (Lincoln: University of Nebraska Press, 1997), 205.

23 Krista Thompson, *An Eye for the Tropics: Tourism, Photography and Framing the Caribbean Picturesque* (Durham: Duke University Press, 2006), 5.

24 Juan de las Cuevas Toraya, *500 Años de Construcciones en Cuba* (Madrid: D. V. Chavín, 2001), 352–3.

25 Cuevas Toraya, *500 Años de Construcciones en Cuba*, 358.

26 Frederic Jameson, *Postmodernism: The Cultural Logic of Late Capitalism* (Durham: Duke University Press, 1991), 158.

9

Anti-architectures of self-incurred immaturity:

A house-spirit in a *Plattenbau*

Alla Vronskaya

Little House-Sprit Kuzia, a popular Soviet children's animation from 1984, opens with a heart-breaking scene of a wrecking ball demolishing an old peasant house – a victim of city growth and modernization.[1] Kuzia (diminutive from old-Russian name Kuz'ma), a little house-sprit boy who had lived in this house for centuries, is left homeless and has to resettle himself in a nearby apartment block. He is discovered by a little girl Natasha, with whom he becomes friends, remaining invisible to adults. Their adventures begin amid bare concrete walls and modern appliances of a brand-new apartment: a garbage chute, an electric stove, a ventilating shaft, and radiators. Although at first sight this story might seem a mere animation director's whim, in what follows, I will argue that it bespoke of more – of a longing for openness and fantasy of a child's worldview, which was lost in the world of adults. It reflected the lack of the magical, the poetic, and the sacral, which was acutely perceived in a modernized, bureaucratized, rationalized, and urbanized society – and the late-socialist USSR was such a society par excellence.

Kuzia was only one among many apparitions, vengeful spirits, poltergeists, and other ghosts – former gods repressed from modern consciousness by the new secular culture – that have haunted the modern world since the times of Romanticism.[2] They were, in other words, products of the disenchantment of the world (*Entzauberung der Welt*). A concept introduced by Max Weber,

it referred to the loss of the magical and the sacral in modern rationalized culture; accordingly, re-enchantment emerged as a burning psychological need of a modern man:

> Increased intellectualization and rationalization do not bring with them a general increase in our knowledge of the conditions under which we live our lives. What they bring with them is something else: the knowledge, or the belief, that if we wished to, we could at any time learn about [the conditions of our life]; in other words: that, in principle, no mysterious and unpredictable forces play a role in that respect. ... And that, in its turn, means that the world has lost its magic. Unlike the savage, for whom those forces existed, we no longer need to resort to magical means in order to dominate or solicit the spirits. That can be done by technology and calculation.[3]

Weber believed that the ethical core of the modern social condition emerged in Judaism and was subsequently concentrated in Protestantism, which expelled the mystical, prioritizing, instead, the worldly everyday life. This life was based on productive and organizational work, and Protestant ethics, consequently, focused on professional values, creating a subjectivity that Weber characterized as vocational and a society that he called vocational civilization.

Although later interpretations of disenchantment addressed primarily the social role of religion, this concept can refer to a broader characteristic of the modern worldview that includes but is not limited to religiosity – a characteristic that Siegfried Giedion defined as a split between thought and feeling.[4] Weber, too, believed that disenchantment could be compensated with a variety of secular conscious and unconscious strategies, ranging from the fetishization of 'quantitative bigness' peculiar to the stereotypical American businessman to fascination with extramarital eroticism, which gave an escape from the rationalization of sexual life.[5] Likewise, the modern man in the Soviet Union located the problem not in the loss of religiosity, but in the hyper-rationalization of the work-centred everyday.

As early as the nineteenth century, Russian culture stigmatized the everyday (*byt*) as the opposite of true being (*bytie*). Scores of writers, poets, and artists – academic, realist, symbolist, and the avant-garde alike – agreed on the corrupting effects of *byt* for the spiritual well-being of the human: for instance, Vladimir Mayakovsky's suicide note, poem 'The Unfinished', explained that 'the love boat smashed up on the dreary routine [*byt*]'.[6] The everyday, Russian culture concluded, replaced feeling with habit, spontaneity with predictability, and idealism with pragmatism. Among the routines of the everyday, regular, paid work was seen as one of the most debilitating and disdained. 'It's not for the gods to bake bricks' says a Russian proverb, evoked by nihilist Bazarov, the protagonist of Ivan Turgenev's *Fathers and Sons* (1862).[7] In *The Human Condition* (1958),

Hannah Arendt distinguished between creative and fruitful work, which produced eternal outcomes, and dull and repetitive labour, necessary for the maintenance of biological existence. Arendt critiqued Marx for failing to make the distinction, noting that his replacement of skill with labour power 'indicates that the distinction between labor and work has been abolished in favor of labor'.[8] Indeed, universal labour, rather than individualized work, lies at the core of Marxist visions of modernity, including its bureaucratized Soviet version. The Soviet productivist ethos of modernization was based on an exaltation of proletarian labour and economic reliance on heavy industry and use value. In response, Soviet cultural elite of varied political convictions (dissidents and the non-conformists as well as all those who simply wanted to avoid the ennui of officialdom) viewed paid productive activity as a useless and meaningless time-spending.

Among others, Aleksandr Brodsky, the most celebrated of Soviet architects who came of professional age in the late 1970s, tried to replace the routine of work with the ritual of festivity. Recalling his years of collaboration with Il'ia Utkin, the most productive and successful time of his life, he argued that to work collaboratively, for them meant

> Vodka, beer, port, sometimes – dry vine. Of course *Led Zeppelin*, sometimes – *Black Sabbath*. This was a continuous, non-stop celebration, which started wherever we sat down to work. In the 1980s we were taken by a strong wave of moonshine production. Il'ia was a great specialist, I – just temping. Although with time I also learned it. His dacha was the center; I secretly opened my little branch in Moscow. ... Of course, we drew, even drafted, sometimes thought and talked about architecture, that also happened. But all that [happened] in snatches, under the roar of toasts and various jokes. Thanks God, we could not really concentrate.[9]

Alcohol, in this context, became a quasi-religious medium of spiritual transformation in an altered state of consciousness, while architecture dematerialized and turned into performative act. According to Brodsky, the best of what he and Utkin created ('a true art for art's sake') were presents for their colleagues at the Central Scientific-Research Institute of Experimental Design of Spectacle Buildings and Sport Constructions (note the long and bureaucratized title of this institution) – or rather, one might suggest, the feelings of comradeship and festivity that these presents evoked. As Brodsky revealed, most of their working time was occupied by making these small gifts, which replaced standardized consumer products. In Weber's words, art 'takes over the function of a this-worldly salvation, no matter how this may be interpreted. It provides a salvation from the routines of everyday life, and especially from the increasing pressures of theoretical and practical rationalism.'[10]

Brodsky and Utkin belonged to a cohort of co-thinkers and collaborators whose utopian drawings produced for foreign competitions and exhibitions during the 1980s came to be known as 'paper architecture'. Not unlike

children's animation, this genre at the crossroads of architecture, philosophy, literature, drawing, and graphic design responded to the condition of hyper-rationalization, aspiring to re-enchant both the world and the discipline. In its deliberate un-seriousness, paper architecture came close to Western postmodernism, especially in its 'deconstructivist' version, betraying, nevertheless, an important difference – unlike its Western counterparts, it strove for re-enchantment. Examining how paper architecture aimed to achieve this goal, below, I will assess two of its frequent strategies, personalization and absurdism, and two typologies, the house and the theatre.

Late socialism and paper (anti-)architecture

The term 'paper architecture' was a marketing trick invented by Vigdaria Khazanova, a scholar of the Soviet avant-garde and the mother of one of the participants of the movement, as the title for its first exhibition in the office of magazine *Iunost'* (*Youth*) in 1984.[11] A pejorative nickname given to the interwar modernists by their critics, it provokingly asserted unproductivity as the new architectural value, simultaneously referring to the tradition of French 'revolutionary architecture'. As a conscious abstinence from building, and thus work, paper architecture evolved in response to the reduction of the discipline to standardized construction that took place during the 1960s and 1970s – similar to Brodsky, many of the participating architects described their motivation as a desire to do something 'meaningful' to compensate for the dullness of work in state-run construction offices.[12]

Most of early paper architects studied with a professor of Moscow Architectural Institute (MARKhI) Ili'a Lezhava, famous for his 1960s' utopian urbanist model *The New Element of Settlement* (NER). The most celebrated victory of Lezhava's students was *Theater for Future Generations*, which won the first prize at OISTAT (The International Organization of Scenographers, Theatre Architects, and Technicians) competition in Paris in 1976.[13] Several other MARKhI students were awarded prizes in this competition, including the team of Brodsky, Utkin, and Egor Solopov, who received a second prize. An opportunity for further participation presented itself in Japan. Inviting visionary projects from young architects, the journal *Japan Architect* (JA) hosted two recurring competitions: Shinkenchiku Residential Design and Central Glass. Conducted since the mid-1960s, these competitions became international in the 1970s, juried by Japanese and International stars, including Richard Meyer (1976), Peter Cook (1977), Charles Moore (1978), James Stirling (1979), Kisho Kurokawa (1980), and Fumihiko Maki (1981), and attracted submissions from some of future architecture luminaries, such as Stan Allen, and Elizabeth Diller and Ricardo Scofidio, among other entries by young architects from all continents of the inhabited world.

There are at least two versions of how the first Soviet project, *An Exhibition House on the Grounds of the Museum of the Twentieth Century* by Mikhail

Belov (a member of Lezhava's team in the OISTAT competition) and his own student Maksim Kharitonov, was submitted to *JA* in 1981. According to Belov, the brother of one of their friends, a diplomat, was leaving for Japan, and unaware of the risks of such a request, the youths asked him to deliver a project to a Japanese post office.[14] According to another former paper architect Yuri Avvakumov, the project was sent via *Soviet Woman* magazine, where a friend of one of the architects' mother worked.[15] In any case, the project won the first prize in the Shinkenchiku competition, leaving Soviet officials to legitimate its participation post factum. The fame of Belov and Kharitonov spread in MARKhI and beyond. Now everyone wanted to submit. The Union of Soviet Architects undertook the initiative of sending subsequent Soviet entries abroad. According to Belov, the number of Soviet submissions to each *JA* competition reached 20, then 30, then 300, and ultimately 500, quickly outnumbering the entries from the rest of the world altogether.[16] The reality was somewhat more prosaic: as a remarkable attempt at achieving a global significance, beginning in 1980, *JA* solicited submissions from socialist and non-aligned countries, and until the end of the 1980s maintained a geopolitical balance in the distribution of prizes. The success inspired more submissions, and at the peak of this competition activity the amount of entries from the Socialist Bloc indeed outnumbered those from the United States and Western Europe, although the number of Soviet submissions to one competition never went beyond forty-two. Between 1981 and 1988 Soviet architects created over two thousand 'paper' projects.[17] In spite of their stylistic heterogeneity – historic references ranged from Piranesi (Brodsky and Utkin) to Symbolism (Mikhail Filippov) to the Soviet avant-garde (Avvakumov) – these projects were unified by their literary and often poetic character.

After 1988, the wave of submissions receded. Against all expectations, the warming of the political climate did not stimulate, but rather eliminated paper architecture: when individualized architectural work again became possible, the position of radical unproductivity lost its justification. Paper architecture's next, posthumous phase was shaped by Avvakumov, who became its ardent collector and chief curator. It turned into a sought-after market object, entering museum collections and featured at nearly fifty exhibitions around the globe. Somewhat misleadingly, curators often paired it with *sotsart*, a sarcastic and highly politicized type of Soviet non-conformism, which bridged pop and conceptual art.[18] Although irony and narrativity were indeed pertinent to paper architecture, what it in fact proposed was not a rebellion but a withdrawal from social life and an escape into the world of the oneiric.

Bastions of intimacy

Anthony Vidler remarked that functionalist modern architecture expelled Romantic ghosts haunting nineteenth-century houses only to become

haunted by its own ghost – the nostalgic ghost of the house.[19] The rationalization (or, one could say, disenchantment) of the modern dwelling led to the mystification of the notion of the house in the post-war period in the works of Gaston Bachelard, Martin Heidegger, and others who saw home as a secure, womb-like shelter. Paper architects absorbed and embraced this nostalgia, asserting the house as the bastion of enchantment in the hostile world.

According to architectural critic Gregory Revzin, the difference between paper and socialist architecture (early- and late-modernist alike) lies in the type of subjectivity that it asserted: whereas the modernists designed for a mass subject, paper architects addressed a subject that was individual and psychological.[20] Yet, the individuality that paper architects affirmed was far from solitude, misanthropy, or selfishness: it was precisely the social sphere that it wanted to protect from corruption by modernist urbanization – but instead of an abstraction (such as a society or a class), they suggested a personal vision, addressing their architecture to an exclusive circle of friends. Most paper architecture projects were produced as collaborations between two or three architects, which transformed design work, as many later recalled, into an opportunity for enjoying each other's company. Two of the most successful and long-term collaborators, Brodsky and Utkin, commemorated their friendship in 'The House of Winnie-the-Pooh', a 'paper' project in which they depicted themselves – and, of course, a bottle – in the living room of the house (Figure 9.1).[21] The project was awarded a third prize in the 1983 *JA* competition 'A Dwelling with Historicism and Localism', judged by Yoshinobu Ashihara, Masato Otaka, Charles Correa, Michael Graves, and Atsushi Shimokobe.

The supplementary text articulated universal problems with urbanized modernity – 'nostalgia for a house of one's own' and the impersonal character of urban apartment blocks – to propose a small, one-family house nestled within the city just as the magic house of *Baba-yaga*, the witch of Russian fairy tales, was nestled within a forest. Modernity was a necessary milieu that allowed the project to exist: 'Our house is almost independent one', the architects explained. It is not connected with city's communications. Instead of them (except electricity) there is 'Very Modern Machine Block'. It supplies the house with all that necessary and takes all superfluous. It must be changed from time to time. We think that it will be done by the same company that produce these houses. So you can choose the place for your house following your own taste only.[22]

Two further illustrations supported this intention, comparing the house to a medieval tower and a space rocket, making the former recognizable within the latter.

ANTI-ARCHITECTURES OF SELF-INCURRED IMMATURITY 149

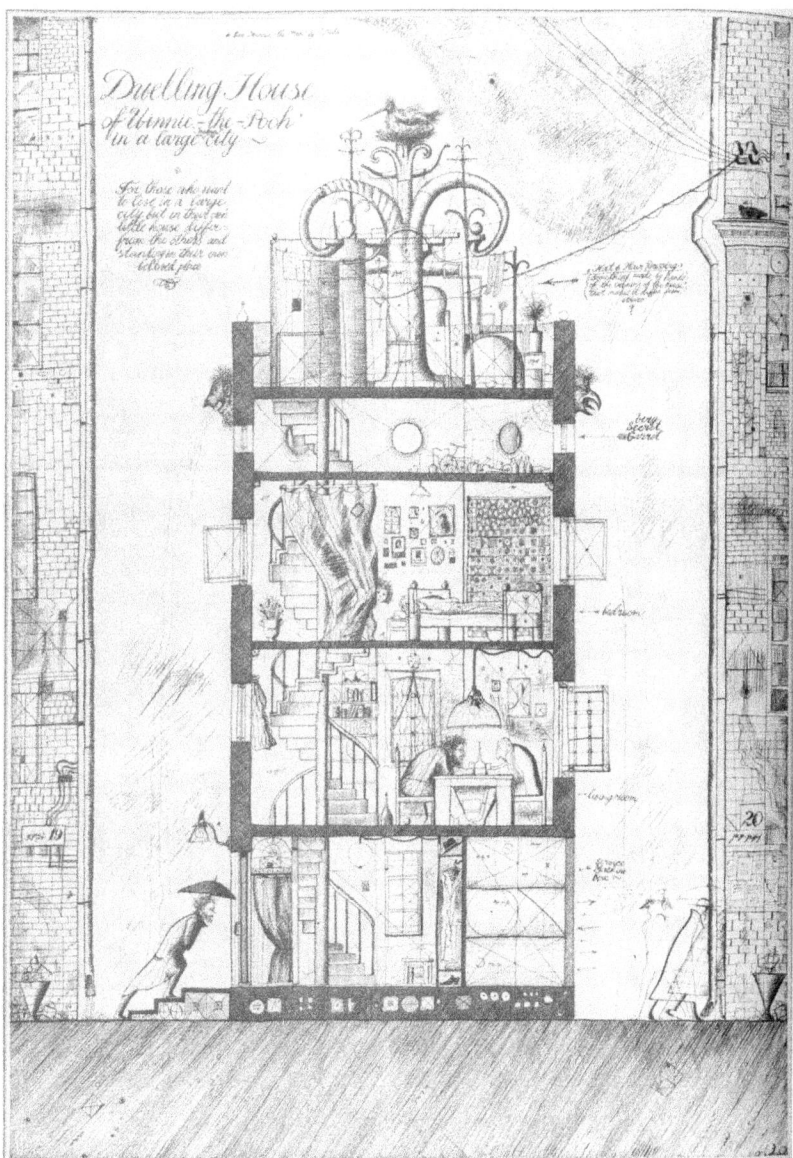

FIGURE 9.1a–b Brodsky&Utkin, *The House of Winnie-the-Pooh*.
Source: Japan Architect 8402, pp. 30–31. [Courtesy of Aleksandr Brodsky].

The personal character of the house was asserted by visual allusions to eighteenth-century artificial-ruin pavilion in Desert de Retz near Paris (particularly in the shape of the windows) and to the Moscow house of Konstantin Mel'nikov, the only private residence constructed in the city during the Soviet period. 'The House of Winnie-the-Pooh' and its several counterparts

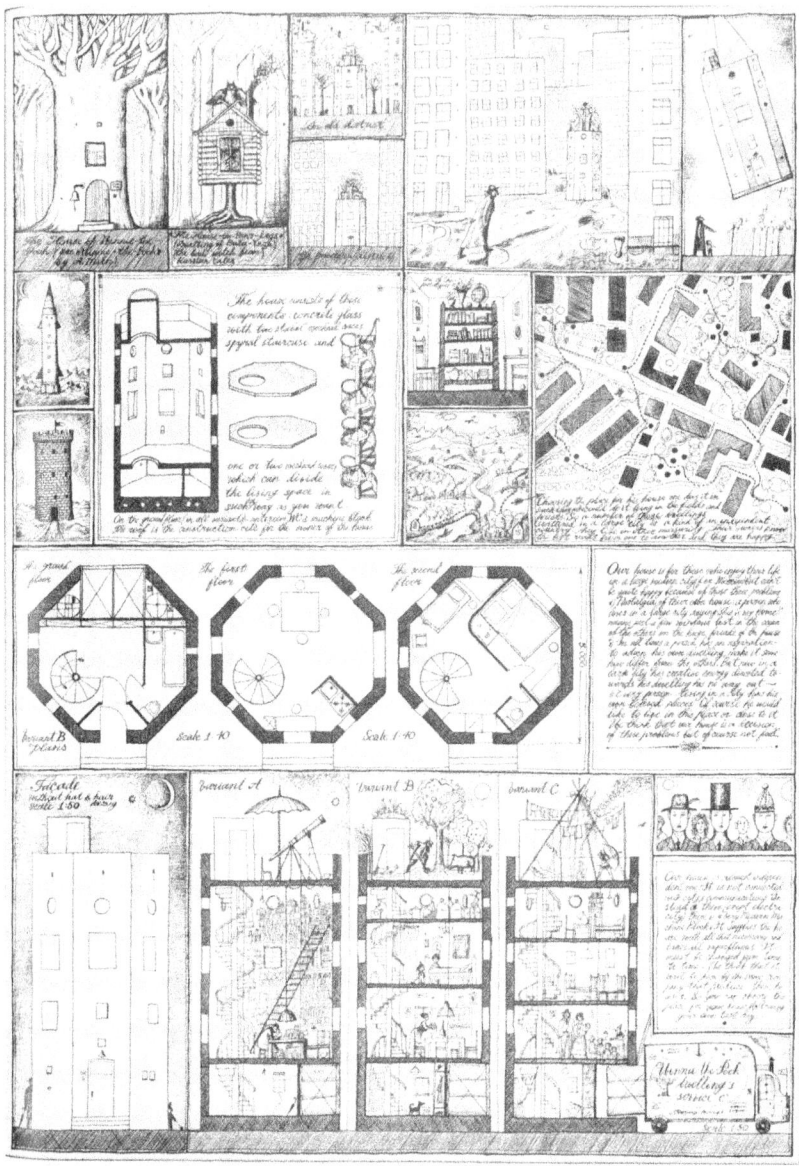

FIGURE 9.1a–b *(Continued)*

formed a parallel universe – that of happiness and friendship – invisible to the rest of the world:

> Choosing the place for his house one does it in such a way as he could do it being in the fields and forests. So a number of these dwellings, scattered in a large city is a kind of an independent country. They live in other

measuring [dimension – *A.V.*]. Their owners know the best routes from one to another and they are happy.

Little wonder that the users of this highly individualized architecture could be none other than its architects. A section depicted their private world: a child (perhaps one of Utkin's children born during that period) hiding behind a curtain of the bedroom, a friend stepping on the porch, and the 'very secret garret' storing memorabilia. Meanwhile, the roof projected their individuality to the outside world: comparing it to 'hat and hair dressing (something made by hands of the owners of the house that makes it differ from others)', Brodsky and Utkin proposed that, depending on the owner, it could be used as an astronomical observatory, a garden, a tent, or, in their own case, an horn-shaped column topped with a bird's nest.

Winnie the Pooh and Piglet, known to Soviet audience as protagonists of the beloved Soviet cartoon based on the tale by A. A. Milne and directed by Fedor Khitruk in 1969–72, were charming in their unpracticality and guilelessness intertwined with cheerfulness and childish hedonism. Consequently, the project of Utkin and Brodsky, like many other paper architecture projects, resembled children book illustration, animation, and filmstrips.[23] Moreover, several paper architects specifically devoted themselves to work with or for children.[24] A return to the world of childhood was a way out of Kant's famous definition of the Enlightenment as an overcoming of humanity's self-incurred immaturity. According to Bachelard, childhood played a central role in the formation of architectural experience: childhood home was the *Urhaus*, the ideal of domesticity that one was to carry through their later life. But children's universe was broader than the spatial reality surrounding them: it merged reality and day-dreaming. Thus, a home was, first and foremost, an oneiric space, a space where one could return to one's own, true, self, masked in the modern world and visible only to soulmates – to one's own childhood.

The theatre of the absurd

Whereas home was seen as the space of authenticity, and, consequently, that of children, modern public sphere was the space of adults. It acted as a theatre, where people were forced to play their social roles, performing the rituals of the everyday. Modern culture constructed an opposition of theatre and home, which paper architects interpreted as a conflict of the false and the true, the public and the private, the impersonal and the personal, the meaningless and the meaningful. The affirmation of home was one strategy with which they responded to this conflict. Appropriating theatre for the case of the private was another one.

What allowed for such an appropriation was engagement with children's theatre, which, unlike traditional theatre for adults, aspired to create not an illusion of reality but a world of the magic and the fairy tale. Revzin distinguished between the theatricality of the projects of Lezhava and those of his student Mikhail Belov. The older architect, he argued, understood theatre as activity, whereas for Belov theatre was 'form, formal structure, space, in which nothing is to be done, in which one can only behold'. This allowed him to transform architecture into an 'expression of self-perception of a person who does not have a place in the real world', into an expression of solitude, melancholy, and the existential dimension. In other words, as Revzin noted, paper architecture expressed the 'worldview of a late-Soviet person – non-inclusion into the real space. It is a view of a stranger, who does not have a place anywhere'.[25] A home turned into an inhabited stage-set – and it is precisely the theatrical, surreal quality of this home that re-enchanted it.

Take, for instance, the first successful paper architecture project, Belov and Kharitonov's *Exhibition House* (Figure 9.2). The competition brief, composed by Fumihiko Maki, asked to design a house in the corner of the grounds of a twentieth-century museum. 'What does a house mean to us?' was the question that the projects had to address.[26] Belov and Kharitonov responded by designing a labyrinth that puzzled and disoriented its visitors but served as a comfortable dwelling for those who inhabited it. Presented as two sets of drawings, architecturally, the project combined a theatre stage portal, a perspectival street borrowed from Vincenzo Scamozzi's decoration of Palladio's Teatro Olimpico in Vicenza, and a lower level sequence of internal spaces. 'The Visitor's World' described the journey of a bewildered guest:

> Having left the museum, I found myself in front of the House in frame. I entered the House through the frame, but it turned out that I had left it. I was standing in an empty street at the end of which there was the House I had just entered. I ran to the House, but as I ran I became so tall that I could hardly get into the house which became dwarfish. Having gone down a spiral staircase, I found myself in a giant nursery. Now I became a dwarf and could hardly climb over the bridge I found there. Huge prints showing the House were on the walls. The mysterious House twinkled in the grotto-like fireplace. I went through an open door inside the House and ran down a long corridor which ended in a rise. I found myself in the same place from which I had begun my trip into the House that I had entered but not visited.

The second set of drawings demonstrated the world of the house's inhabitants who were aware of its strangeness but accustomed to it. They enjoyed a Corbusian, hygienic modern lifestyle swimming in the pool,

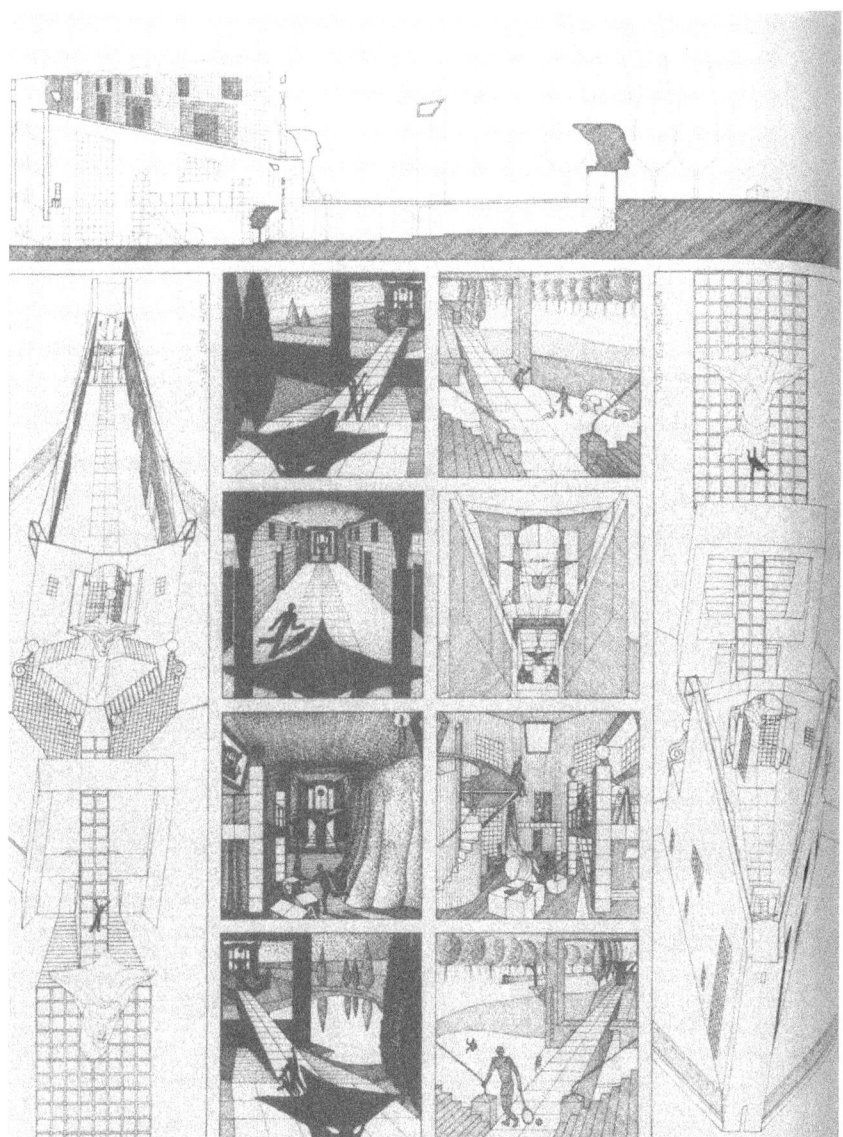

FIGURE 9.2a–b *Belov&Kharitonov, Exhibition House.*
Source: Japan Architect 8202, pp. 12–13. *[Courtesy of Mikhail Belov].*

watching movies, and playing with children on the flat roof. For them, the very absurdity of the modern house became a source of a special pleasure:

> Our House is an exhibit for visitors to the museum but just Our House to us. We return here everyday and have got used to it. On the roof of Our House are a cinema and an open-air kindergarten for our son and his

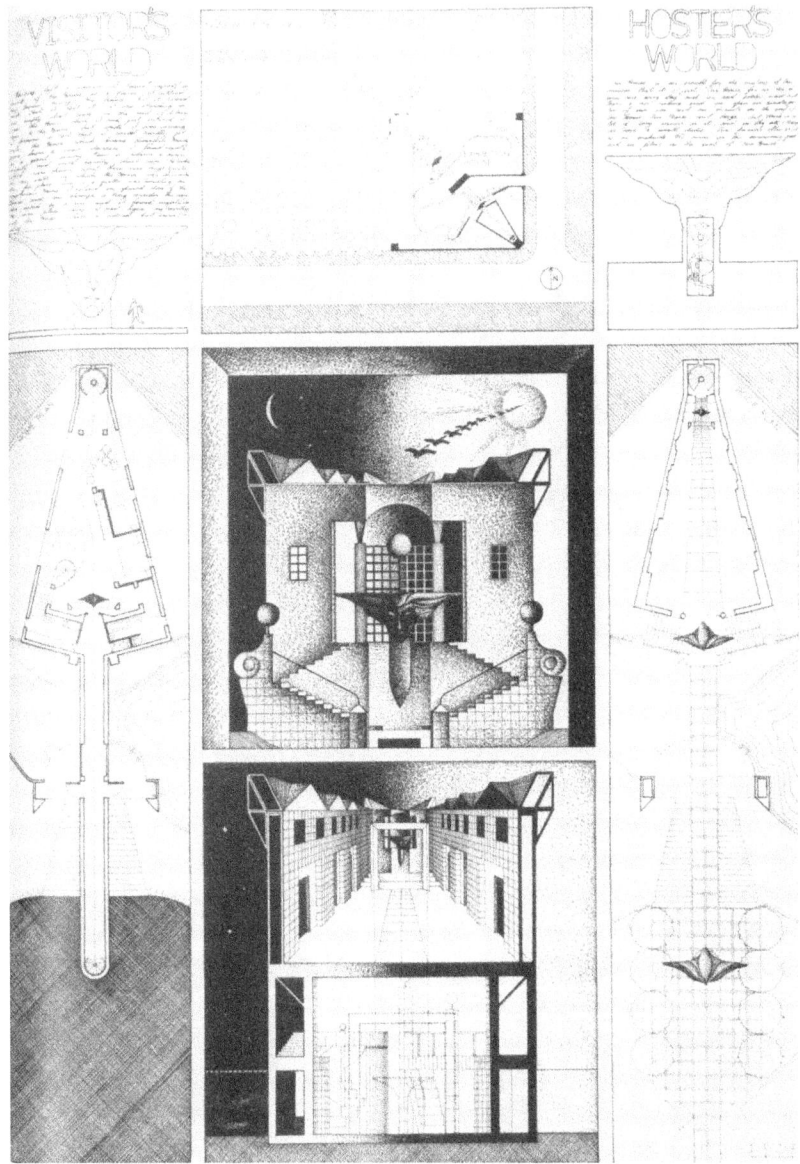

FIGURE 9.2a–b *(Continued)*

friends. Our House is not large but has many cozy corners. In the attic, we have a small studio. Our friends often visit us on weekends. We swim in the swimming pool and watch films on the roof of Our House.

The phantasmagorias and metamorphoses of Belov's and Kharitonov's project referred to Lewis Carroll's *Alice's Adventures in Wonderland* and

Through the Looking-Glass, and What Alice Found There. Important for Russian culture (*Alice in Wonderland*, for instance, was translated by Vladimir Nabokov in 1922), both novels were particularly popular in the late Soviet Union. Artist Gennadii Kalinovskii illustrated a new Russian translation of *Alice in Wonderland* in 1979 and *Through the Looking-Glass* in 1980, and Kiev animation studio produced cartoons based on the two books in 1981 and 1982 (Figure 9.3). In this light, the *Exhibition House* could be viewed as an attempt to architecturalize Carroll's magical world: to make the guests believe that they had left the house while entering it (an episode from *Through the Looking-Glass*), the architects designed a two-dimensional portal, while a Scamozzian perspective decoration with progressively diminishing size of houses created the illusion of an empty city street, at the end of which the guest turned into a giant, resembling the permutations that happened in *Alice in Wonderland*; likewise, the lower level dwarfed the guest because of the colossal scale of the space and the objects.

Carroll's novels lie at the origin of a new literary tradition: absurdism. It was later explored by Franz Kafka and the Surrealists, forming a significant topic of existentialist philosophy and post-war drama, the so-called theatre of the absurd. Defined as unreasonable, illogical, or transgressing the limits of rationality, the absurd acted as the Other of the rationalizing impetus of modernity. In Russia, absurdism was famously represented by OBERIU, a late 1920s' group of writers and performers. It returned as a recurrent theme of Soviet 1970s' conceptual art, literature, and animation, from artist Ilya Kabakov to writer Sergei Dovlatov and animation director Juri Norstein. This tradition emphasized the irrationality of the Soviet everyday, saturating, as in the case of Dovlatov, autobiographical prose with invented

FIGURE 9.3 *Gennadii Kalinovskii, Illustration of Lewis Carroll's* Through the Looking-Glass, 1980. *Image courtesy of Raisa Kalinovskaya.*

absurdities that made reality indistinguishable from fiction: not unlike the myths that surrounded paper architecture, his novels presented the USSR as an enchanted world where the very rationalization of life, driven to absurd, opened possibilities for the impossible and the magic (Figure 9.4).

The absurd, of course, was not endemic for Soviet architecture. It attracted postmodernist architects, particularly those associated with the so-called deconstructivist movement. Projects of Coop Himmelblau, Daniel Liebeskind, Peter Eisenman, or Frank Gerry that were exhibited at the *Deconstructivist Architecture* exhibition at MoMA in 1988, or Rem Koolhaas's *Delirious New York* (1978), were equally relying on an aestheticization of the absurd. The absurd was, indeed, intrinsic to the theory of postmodernism, whose roots, as Peter Bürger has recently demonstrated, go back to Surrealism.[27] Thus, the

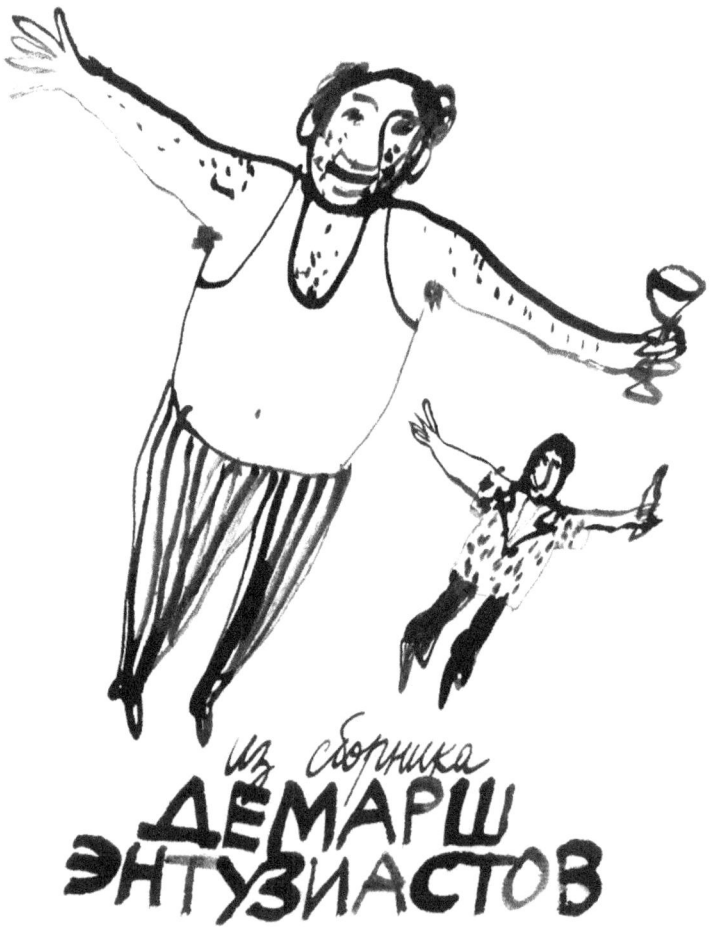

FIGURE 9.4 *Aleksandr Florenskii, Illustration of Sergei Dovlatov, Enthusiasts' Demarche (1985). Image courtesy Aleksandr Florenskii.*

absurdism of paper architecture was interpreted by many as a parallel to that of 'the deconstructivists': Deutsches Architekturmuseum published the major Western catalogue of paper architecture with the preface by the museum's founder, the advocate of postmodernism Heinrich Klotz, and when invited to submit a project for the 1995 world exposition in Vienna (the expo was later cancelled), Belov found himself among an exclusive group of postmodernist celebrities: Jacques Herzog, Pierre de Meuron, Bernard Tschumi, Norman Foster, Hans Kollhof, Richard Rogers, and Renzo Piano.

However, the absurdism of paper architecture was in many ways different from that of deconstructivism. In his *Logic of Sense,* Giles Deleuze differentiated between absurdity and nonsense. Whereas absurdity was characterized by a lack of sense, nonsense originated from its overabundance: it was, in a way, a producer of sense. Absurdity was represented by Surrealism and post-war philosophy and literature; nonsense – by Lewis Carroll. Deleuze quotes a letter of Antonin Artaud, who complained about being unable to translate Carroll's 'Jabberwocky': 'I tried to translate a fragment of it, but it bored me. I never liked this poem, which always struck me as an affected infantilism.' According to Deleuze, Artaud was a poet of depth, whose works revealed the cruelty of reality; unlike them, Carroll's novels slid on the surface – but it was precisely on the surface where sense dwelt.

If deconstructivist architecture followed the tradition of the absurd, paper architecture relied on nonsense. Returning to the starting point of modernity, it suggested to dream about possible worlds rather than to lament the irreversibility of history. Its playfulness betrayed the seriousness of a child who forgets about the difference between a game and reality – in contrast to the playfulness of deconstructivism – a sophisticated gesture of an adult. Japanese architects, who in the 1970s and 1980s embarked on a similar search of a more poetic way of overcoming functionalism, understood this intentional naivety of paper architecture better than Western curators, who strove to present it as an underground postmodernism.

The wisdom that paper architecture suggested to seek – not in reading but in play, not outside but inside, not in work but in enjoyment, not in use but in uselessness – liberated architecture without entering into a political confrontation with the regime. It offered spectacles that allowed seeing the world with the eyes of a child. The estrangement effect that these spectacles created empowered one to see the absurdity of the logic of modernity, seeking for the magic within one's own, suppressed, childhood self. Unlike the deconstructivist projects, which, eccentric as they were, proved to be realizable, paper architecture was too poetic to be translated into built form. When during the 1990s paper architects, including Belov and Kharitonov, started professional careers, their buildings turned to be far less successful than early visionary projects, whereas Brodsky's international success was that of a conceptual, rather than a practising, architect. A child cannot build a house. The architecture of re-enchantment could be constructed within but not outside oneself.

Notes

I am thankful to Ana Miljački for once drawing my attention to paper architecture; to Edward Dimendberg and Steven Jacobs for enabling me to discuss this work at CAA conference; to Vladimir Kulić for inviting me to contribute to this volume and for commenting on a draft of the essay; and to Aleksandr Brodsky, Mikhail Belov, Aleksandr Florensky, and Raisa Kalinovskaya for kindly allowing me to reproduce the images.

1. The cartoon was directed by Aida Ziablikova and based on a 1977 book by Tatiana Aleksandrova.
2. David Morgan, 'Enchantment, Disenchantment, Re-Enchantment', in James Elkins and David Morgan, eds., *Re-Enchantment* (New York: Routledge, 2009), 9.
3. Max Weber, 'Science as a Profession and Vocation', in Hans Henrik Bruun and Sam Whimster, eds., *Max Weber: Collected Methodological Writings* (London: Routledge, 2012), 335–54 (342).
4. Siegfriend Giedion, *Space, Time and Architecture: The Growth of a New Tradition* (Cambridge, MA: Harvard University Press, 1941), 13. For contemporary discussions of disenchantment, see Marcel Gauchet, *The Disenchantment of the World: A Political History of Religion* [1985] (Princeton: Princeton University Press, 1997), and James Elkins and David Morgan, eds., *Re-Enchantment*.
5. Weber, 'Religious Rejections of the World and Their Directions', *Essays on Sociology*. Transl. and edit. by H. H. Gerth and C. Wright Mills (New York: Oxford University Press, 1946), 346–7; see also Weber, *The Protestant Ethic and the Spirit of Capitalism* [1930] (London: Routledge, 1992), 32.
6. See Svetlana Boym, *Common Places: Mythologies of Everyday Life in Russia* (Cambridge, MA: Harvard University Press, 1994).
7. Ivan Turgenev, *Fathers and Sons* (New York: The Modern Library, 1950), 126.
8. Hannah Arendt, *The Human Condition* (Chicago: The University of Chicago Press, 1958), 90.
9. Interview published online at: http://azbuka.gif.ru/critics/b-u
10. Weber, *Essays on Sociology*, 342.
11. See interview of Mikhail Belov in *Proekt Klassika*, no. 6 (2003): 16–23, and interview with Juri Avvakumov by Mikhail Bode, 'The History of Paper Architecture' (in Russian), *Iskusstvo* [*Art*], no. 4 (July) 2004 (available online at http://archi.ru/press/russia/32425/istoriya-bumazhnoi-arhitektury-mihail-bode). On paper architecture, see Andres Kurg, 'Towards Paper Architecture: Tallinn and Moscow', in Eeva-Liisa Pelkonen, Carson Chan and David Andrew Tasman, eds., *Exhibiting Architecture: A Paradox?* (New Haven, CT: Yale School of Architecture, 2015), 119–29.
12. See series of interviews 'For the Twentieth Anniversary of Paper Architecture' conducted by *Proekt Klassika* in 2004.
13. The team included Mikhail Belov, Mikhail Khazanov, Tat'iana Arzamasova, Vladimir Lomakin, and Viacheslav Ovsiannikov.

14 Belov, interview in *Proekt Klassika*.
15 Avvakumov, interview in *Iskusstvo*.
16 Belov, interview in *Proekt Klassika*.
17 Avvakumov, interview in *Iskusstvo*.
18 Both, however, could be seen as responses to the dullness of the Soviet everyday. The link between conceptualism and Soviet standardization of urban environment has been noticed by Kuba Snopek in *Belyayevo Forever: A Soviet Microrayon on Its Way to the Unesco List* (Berlin: DOM, 2015).
19 Anthony Vidler, *The Architectural Uncanny: Essays in the Modern Unhomely* (Cambridge, MA: MIT Press, 1999), 63–6.
20 Gregory Revzin, '20 Years After' [in Russian], *Proekt Klassika*, no. 12 (2004): 24–31.
21 The two restaged this scene as a photograph in 1995, after their collaboration had ended (published in *Proekt Klassika*, no. 8 (2003)).
22 Here and below, the quotations follow the text of the original project.
23 Alexander Brodsky's father, Savva Brodsky (1923–82), was an architect-turned book illustrator (although illustrating primarily adult literature). I am thankful to Nicholas Drofiak for informing me about this.
24 Vladislav Kirpichov and Mikhail Labazov run renowned children design studious; Nadezhda Bronzova became a children book illustrator; Sergey Barkhin became a stage-set designer actively engaged with children's theatre. This link is not coincidental, since in the late Soviet Union, state-funded and little-controlled children book illustration, animation, and film formed one of the most dynamic spheres of culture.
25 Grigory Revzin, 'Homeless Architect' [in Russian], special issue of *Proekt Klassika,* no. 19 (2006).
26 *JA*, no. 298 (February 1982): 9–11.
27 Peter Bürger, *Ursprung des postmodernen Denkens* (Weilerswist: Velbrück Verlag, 2000). I am thankful to Anne Kockelkorn for this reference.

PART THREE

Exchanges

10

Cultural feedback loops of late socialism:

Appropriation and transformation of postmodern tropes for Uran and Crystal in Česká Lípa

Ana Miljački

IBA, Berlin, 1978–87

On 24 and 25 October 1980, an international jury, which included Kenneth Frampton, Richard Meier, and Rem Koolhaas, reviewed proposals for Berlin's Tegel district. They were judging one of the twenty-one competitions organized by the *Internationale Bauausstellung Berlin* (International Building Exhibition), IBA '87, in the period between 1978 and 1987.[1] This particular jury, which reviewed projects for a recreational centre and the urban concept for the neighbourhood, awarded the already well-known international figures: the first prize went to Charles Moore with John Ruble and Buzz Yudell, the second to the British-Swedish architect Ralph Erskine, and the third to Arata Isozaki. Erskine, however,

FIGURE 10.1 *Perspective drawing of the Stavoprojekt proposal for Tegel Harbor in Berlin. Drawing by Michal Brix, 1980.*
Source: *Internationale Bausausstellung Berlin 1984, Sie Neubaugebiete, Dokumente – Projekte,* 1984: 141. *[Courtesy of Michal Brix].*

shared his second place with a Czech team from Liberec, simply referred to as 'Stavoprojekt' in the IBA exhibition catalogues.[2] The Czech sources claim that the jury had encouraged Moore to work with the Stavoprojekt team, but that did not go over well, and while Moore got the Tegel site, the Stavoprojekt team received a smaller commission for an apartment complex in the Friedrichstadt quarter, which they completed in 1985.[3] Though their requisite hand rendering of the Tegel area sports a lighter touch than those of other competitors, it would be hard to distinguish the Czech contribution from the rest (Figure 10.1).

The name of the Czech team in the catalogues signalled a different form of authorship than most included in the IBA competitions, which relied on the name of the principal author-architect: James Stirling, Aldo Rossi, Leon Krier, and eventually Peter Eisenman, John Hejduk, and other postmodernist celebrities. In its own national context, Stavoprojekt referred to an entire network of architectural organizations, produced through a single sweep of nationalization only a few months after the communist regime came to power in Czechoslovakia in 1948. From that point on, the Czechoslovak Building Works and its design arm, Stavoprojekt, employed all practising architects in the country. Although the local offices of Stavoprojekt were eventually renamed 'design institutes', and the body in charge of them also changed a number of times over the years, the imperative for central planning and the mandate for an industrially minded and economically socialist organization remained central from 1948 to 1989. Five architects comprising the 'Stavoprojekt' team in Berlin – Emil Přikryl, Jiří Suchomel, Martin Rajniš, John Eisler, and Dalibor Vokač – were all part of Atelier 2 in the Liberec office at the time of the competition in 1980.

The IBA exhibition – officially intended to 'elevate the image of Berlin', 'critically' recover its city centre, solve a housing problem, and set a new foundation for plurality – has gone down in history books as a demonstration project for international postmodernism, far more architecturally concrete than earlier such events, including the 1973 fifteenth Milan Triennale curated be Aldo Rossi, or the famous *Strada Novissima* at the centre of the first Venice Architectural Biennale curated by Paolo Portoghesi. Indeed, there was enough consensus among the contemporary critics that the 'specter of postmodernism was haunting Europe', as Portoghesi had suggested in 1982, that in 1987 critics in the *Architectural Review* could simply describe Moore's Tegel project as 'classically postmodern'.[4] There has been historically little agreement on what that exactly meant. By the time Portoghesi offered his particularly historicist definition at the beginning of the 1980s, contextualized within a cultural and technological framework, many productive definitions were already in circulation.[5] They ranged from Charles Jencks's double, and multiple semantic coding and mischief, with its capacity to simultaneously mount a disciplinarily autonomous and populist address, through various forms of anti-modernism, to Fredric Jamesons's periodizing and geopolitically specific view of postmodernism as an inevitable 'cultural turn of late capitalism'.[6] The Czechoslovak architects' participation in IBA could be explained simply as a token Eastern European project that concretized the idea of plurality celebrated by the organizers, but both its inclusion here and its architectural language challenge us to think about the performative and inevitably political dimension of postmodernism's jumping the wall. Czech architects unusual participation in the 'critically re-building' of West Berlin highlights the economic and geopolitical complexity of this moment, but it also has bearing on the proper characterization and understanding of the work they produced simultaneously in Czechoslovakia. When it comes to theorizing postmodernism, this small fact of Czechoslovak participation in IBA suggests a way of understanding the much larger question about the circulation of postmodern discourse and its constitutive entanglement with the Cold War in its various dimensions, through a set of feedback loops, that happened to criss-cross and undermine 'the wall' and its epistemological divide.

This essay takes a position that postmodernism is a historically situated discursive formation, first and foremost (including here various statements in writing and in architecture), and not a set of essential qualities. While in some ways most sympathetic to Jameson's formulation, in which postmodernism is a periodizing concept corresponding with a complex set of political, economic, and cultural circumstances, it precisely seeks to challenge the geopolitical premise at the base of his definition of postmodernism, in order to re-theorize it to include 'Second World's' production. Czechoslovak architects' participation in IBA points to the possibility of arguing that architects who were involved in SIAL's Školka and from 1972 on, its

successor Atelier 2 of Stavoprojekt Liberec, produced their work in 'imaginary' conversation with the contemporary developments in the West. Even if one-sided, this conversation across geopolitical contexts resulted in very real adaptations of various architectural 'sources' to the socialist reality and ideals of the Czechoslovak context, as well as in a form of dissident defiance of the discursive barriers erected by Czechoslovak normalization and the Cold War more generally.

SIAL, Liberec, 1965–82[7]

Out of five Czech architects who participated in IBA's Tegel competition, three – Přikryl, Suchomel, and Eisler – ended up working on the Wohnpark Victoria apartment block for the IBA exhibition, 1983–5. All of them belonged to the youngest in the 'extraordinary three generational constellation' that comprised the legendary SIAL (Liberec Association of Engineers and Architects) group of architects.[8] During the late 1960s' experimentation in all spheres of Czechoslovak culture, which included the establishment of bottom-up organizations in the field of architecture, Stavoprojekt Liberec spawned two successive offshoots. With the help of Liberec's mayor, the Czech architect Karel Hubáček opened Studio S12 in 1965, which dedicated itself to the construction of the hi-tech, futuristic Ještěd tower. In 1968, with an influx of additional Stavoprojekt Liberec architects and again, with the help of Liberec's mayor, S12 was transformed into the SIAL office. Equally outside of the purview of Stavoprojekt Liberec, though it included many of its former members, SIAL in its turn sponsored an incubator studio, Školka (kindergarten). Hubáček and Školka's mastermind Miroslav Masák hoped that ambitious and talented young architecture graduates with fresh ideas and still limited professional experience, would help the studio win competitions, as they learnt the craft competing with each other for small commissions and their mentors' attention. For the first four years of its existence, Školka was supported by (and ostensibly contributed to) the independent studio SIAL. Following the Warsaw Pact intervention in Prague in the summer of 1968, Stavoprojekt was restructured again with SIAL folding back into Stavoprojekt Liberec. Although the reverberations of the era of normalization resulted in ever greater financial and organizational insecurity, Hubáček and Masák managed Školka's continued operation on the spatial and organizational fringes of the state-subsidized system, in the space of an old inn, Na Jedlově (At Jedlová).[9]

The young Školka architects spent a large part of the decade living and working at Jedlová. They participated in the incubator's early internal competitions, and joined in the atmosphere of play, rivalry, and discussion, as well as self-education about architecture outside of Czechoslovakia, mostly through access to their half-British colleague John Eisler's

architectural magazine subscriptions.[10] These young architects' orientation towards each other and the collective insistence on dealing with concrete commissions placed disciplinary issues at the centre of their conversations, which stood in stark political contrast to Czechoslovak normalization, and almost any other Stavoprojekt office.[11] Over the course of the 1970s the Školka architects were absorbed into the mainstream production of the Stavoprojekt Atelier 2 through ever more robust architectural commissions, including the Berlin project.

Školka, Berlin, 1980–5

The idea that they might participate in a competition that was taking place on the occasion of the IBA exhibition in Berlin and the opportunity to do so were both presented by Mirko Baum, who while at Jedlová held the room between Přikryl's and Suchomel's. Having left the country a bit earlier, he found himself working at the time in the Berlin architectural office of Joseph Paul Kleihues.[12] Kleihues was in turn the key voice and organizer of the IBA exhibition, and eventually both IBA GmbH's director and the key proponent of the need for supporting 'typical Berlin forms', 'the image of the city', and 'the art of building', in the process of 'critically redeveloping' West Berlin's identity and architectural cohesion.[13] Many of these terms already coincided with the Školka architects' concerns. Though they entertained their mentors' hi-tech (Hubáček) as well as humanist interests (Masák), many members of this youngest generation were interested in communication and image-making early on.[14] Their references and their politics were a bit different than their mentors', but they were all cultivated at Jedlová to value concrete architectural proposals, over and above the era's visionary architecture that reached them via foreign magazines.

Přikryl, Suchomel, and Eisler's Wohnpark Victoria was presented at IBA, 1987 (Figure 10.2). Its street façade included a dramatic half-circle balcony supported by a massive cantilever that signalled the building's axis of symmetry, and it was clad in the obligatory brick. The interior of the housing block, however, was rendered in a more muted white and punctured by carefully figured rectangular and circular windows. The window arrangement as well as the horizontal brick striping that accentuated the structure of floors may have been distant echoes of Loos's work in Prague (Villa Müller) and Vienna (Red Vienna being of particular interest at this time for its iconographic and communicative content). A Czech historian Vendula Hnídková also suggested that 'although the designers renounced any conscious "quotation", it is impossible not to see that some aspects betray a subconscious inspiration from the work of James Stirling'.[15] Its own architects recently characterized Wohnpark Victoria housing as postmodern and even historians Rostislav Švácha and

FIGURE 10.2 *SIAL, IBA apartment block, Berlin, 1985.*
Source: *Rostislav Švácha (ed.),* SIAL Liberec Association of Engineers and Architects, 1958–90: Czech Architecture Against the Stream *(Prague: Arbor Vitae, and Olomouc: Museum umění, 2012): 184. [Courtesy of Jiří Suchomel].*

Jakub Potůček, more cautious than most about using the label, dubbed it 'SIAL's foremost Post-Modern built project'.[16] And indeed to most historians of IBA, these characterizations could hardly seem contentious. This building competently deploys some of the formal signifiers of the postmodern style: platonic shapes, central symmetry around the key features of the façade, a mixture of classicism and modernism in the massing, granted without relying on historicist ornamentation. Furthermore, given that its Berlin context was defined complexly enough already by its own symbolic and real Cold War constraints, the fact that Wohnpark Victoria was conceived of by the 'builders of socialism' did not register as a conundrum to 'First world' or Czech critics.[17] If anything, it was a perfect rebuff to the veteran critic Otakar Nový's 1984 assertion that Czech architects

> play quite comfortably only on home playgrounds with domestic league and division rivals, but we forfeit international matches in our industry both at home and abroad – which might be a useful tactic from the point of view of eliminating risks of loss, but from the point of view of the socialist cultural offensive, it is ineffective and morally and politically deficient.[18]

This commission was crucial for the three architects who had worked on it in Berlin. First of all, it confirmed that their ideas worked in translation, or that their work fit in the context of the architectural discourse represented by the Berlin context. Secondly, it exposed them to the system of architectural production in which profit mattered more than the ideological content of buildings, even though their own project was but a minor example of that.[19] The connections they made while working on their project resulted in John Eisler emigrating to the United States in order to work for Richard Meier, while others were encouraged by the successful outcome of their participation in the IBA competition to try their luck on other foreign competitions, often in conjunction with colleagues who had emigrated and established a base somewhere across the wall. They also lead to a few opportunities to publish their Czechoslovak work in foreign journals. Shortly after their Berlin project was launched, Přikryl's shopping centre in Česká Lípa Uran appeared in full colour in an issue of *Casabella*.[20]

Uran and Crystal, Česká Lípa, 1975–92

In parallel to their work in Berlin, Přikryl and Suchomel worked on two major projects in the north Bohemian town of Česká Lípa: Uran and Crystal. By the mid-1970s, the previous decade's democratization had fully morphed into its de facto opposite project known as normalization – a return to an older version of normal: top-down socialism, free of the democratic ideals articulated in this context during the 1960s. Historian Paulina Bren termed the normalization period in Czechoslovakia as the era of 'late socialism' when 'nothing happened' by design: no new mock trials, no hard core propaganda, and definitely no democratization.[21] Late socialism, periodized this way, not only in terms of its nearing 1989 (its putative end in the bloc) but in terms of the evacuation of any emotional investment in it by its key producers, thus coincides with Fredric Jameson's 'late capitalism'.[22]

Normalization's effects on the architectural field had left SIAL's key figures outside of the reconfigured professional leadership, and stigmatized for their reformism and other forms of non-party compliance. But the upgrading of Česká Lípa's status to a regional centre of uranium production in 1974 and the concomitant urban development required these architects' services regardless of their political standing. So, in 1975, SIAL, and eventual Atelier 2's, leader Hubáček assigned the design of a shopping and a cultural centre in Česká Lípa to Přikryl and Suchomel, respectively.[23] The architects began with an urban plan that set their buildings in a conversation across an open space, with the two buildings formally reinforcing each other's horizontality and colour palette (Figure 10.3).[24] Uran shopping centre opened its glazed doors in 1984, a year before their IBA apartment building was finished. Its stylized, mostly opaque volumes punctured by large circular windows were

FIGURE 10.3 *Emil Přikryl, Axonometric drawing of the urban plan of the southern periphery of Česká Lípa including both Uran and Crystal and projecting a number of architectural elements that would complete this edge of town, 1985. Image courtesy of Emil Přikryl.*

formally reinforced and compositionally balanced by many smaller circular vents protruding from its ceramic tile façade. The Crystal culture house would be constructed across the street six years later (opening in 1992); in addition, Uran, the Berlin project, and the reconstruction of the Trade Fair Palace in Prague represented an embrace of the 'the new wave in architecture' (Figures 10.4, 10.5).[25]

Přikryl made two proposals for Uran; the first one in 1975 included a dramatic central double-height space cutting the building into two parts longitudinally, producing symmetry in both directions of the plan, and filling the shopping interior with large graphic splashes. As new urban plans were produced for the southern edge of town in 1978, Přikryl produced another scheme, simplifying the formal palette of the building, eliminating gable roof motifs of the earlier scheme, as well as the symmetry in the short section. A feat of architecture, it also transcended its mandatory – state-stipulated – prefabricated system, MS 71, to send a signal of 'medieval monumentality' to its contemporary architectural critics.[26] Its brick coloured tiles covered up the seams of the MS 71 prefab system allowing the building to appear more massive and archaic.

In developing the Crystal culture house across the street, Suchomel stated that 'the idea of the tilted façade was based on Stirling's competition entry for the Derby civic center from 1970'.[27] He was also especially taken by Stirling's Staatsgalerie in Stuttgart, as well as Přikryl's recent and ultimately unbuilt project for a museum in Most, which Přikryl in turn linked to Venturi and Scott Brown's National Football Hall of Fame (Figure 10.6).[28] Přikryl's project for Most took cues from the rounded roof of the latter (the shed)

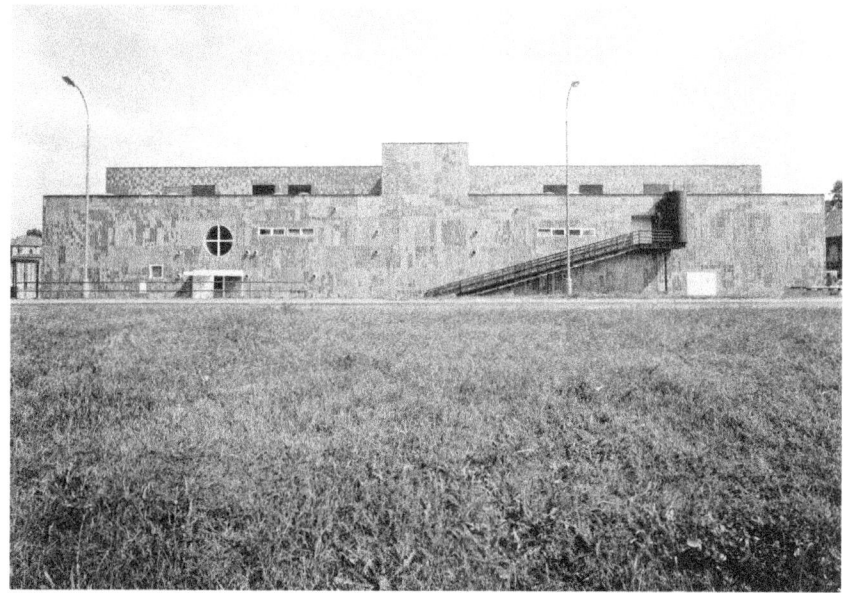

FIGURE 10.4 *Emil Přikril, Long back façade of the Uran shopping centre, 1980–4.*
Photo courtesy of Emil Přikryl.

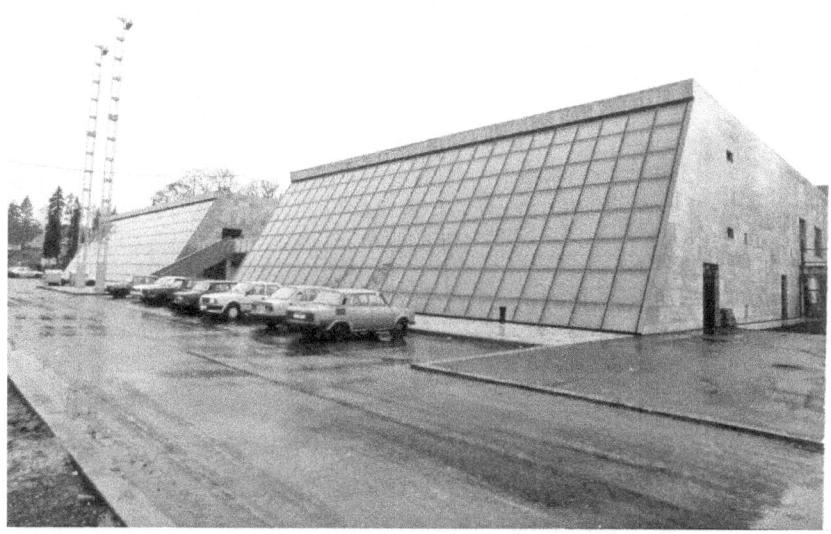

FIGURE 10.5 *Jiří Suchomel, Photograph of Crystal culture house, 1976–90.*
Photo courtesy of Jiří Suchomel.

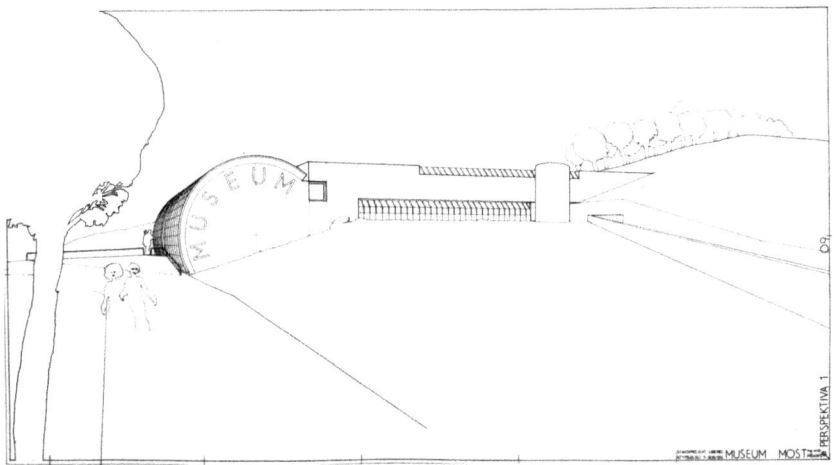

FIGURE 10.6 *Perspective of the Museum and Archive in Most, Emil Přikryl, 1975.*
Source: Emil Přikryl.

as well as its parti logic, but not its paradigmatic billboard (decoration). Suchomel was himself working through ideas about solar architecture at the time, and the culture house included many passive solar strategies, insofar as those could be executed in the local construction terms. In order to test some of these ideas, Suchomel had set out to build a smaller solar home, whose form in many ways followed through on the logic of Venturi and Scott Brown's decorated shed, except that the concept had little to do with advertising and everything to do with passive solar performance. Crystal's section and central symmetry around the entry door were indebted to a series of earlier Školka explorations in sectional extrusion.[29] The culture house is dimensioned as a true civic venue, with two theatres, a regional library, a restaurant, workshops, shops, and a set of passages carved into the hill in the back of the building, rendered in platonic concrete shapes and arrayed with a nod to the disposition of elements in the neighbouring baroque monastery. The path to Crystal's construction was more arduous than to Uran's, plagued with interruptions and uncertainties, and on top of those, in the midst of working on the project, Hubáček named Suchomel his successor as the leader of the studio numbering upwards of sixty-five members.

Postmodernism, Czechoslovakia

Czech architectural historians as well as architects have insisted that Uran's platonic shapes and elevational symmetry, as well as Crystal's ramps, slanted entry hall, 'baroque' figuration of the park in the back, and its acid green railings and mullions, resonate with some of the key architectural elements

of postmodernism in Western Europe and America. The architects have themselves over the years become ever more definitive about their interest (at the time) in the architecture of Louis Kahn and James Stirling, as well as Charles Moore, Robert Venturi, and a few others.[30] Czech historian Rostislav Švácha has written on numerous occasions of Přikryl's interest in Kahn, offering in the mid-1990s that he 'tried to achieve a deeper understanding of the ideas and concepts behind the work of the American architect – without being properly prepared for this task'. When it came to solutions for specific problems, Švácha argued that Přikryl 'found his model in James Stirling in whose glass-and-steel brutalism of the 1960s, inspired by Victorian engineering architecture, Přikryl and other SIAL members sensed a link between their machinism and Kahn's spiritual concept of architecture'.[31] But Švácha also cautioned that historians should perhaps refrain from calling this work postmodernism, as it did not, in his estimation, properly produce effects of humour and irony within its own context.[32]

To anyone who lingers long enough on Přikryl's 1985 axonometric drawings of the urban plans of the lower level of Česká Lípa – whose representational signals and additional semi-circular and square building forms launch one into hallucinating this project's place in Heinrich Klotz's vividly illustrated *Postmodern Visions* – Švácha's caution about applying the label too quickly must be understood as an invitation to contextualize the nature of the formal allusions at play, and consider the relationship between the aesthetic production of 'late capitalism' and 'late socialism'. 'The mechanics of usage' – as Boris Groys has termed the specific Second World deployment of its First World appropriations – of both postmodern discourse and quotation or allusion in architecture possibly undertaken in this context, already embody specific and politically sophisticated mechanics of relation[33] The very claim of relation across the Iron Curtain – such as Přykril's 'I am a Kahnist', or another of his colleagues Mirko Baum's proposal that all the early work of their studio could be divided into the Archigram-inspired 'machinist' and the 'Venturiesque' strands, or the historians who speak of yet another member of the same studio producing the 'first properly postmodern house' – has to be read as political. But same is true of the production of history and discourse. When Švácha cautions us about the label, he too is signalling his participation in and expertise about the discussion beyond the Czech borders, even as he relies only on one of the many definitions of postmodernism available.

Although the postmodernism of these specific works has been contested as often as it has been asserted, the ultimate construction of Uran and Crystal coincided with important debates on postmodernism in the local context. In 1978, architects Bořislav Babáček, Jiří Kučera, and Jaroslav Ourecký translated and published excerpts from Charles Jencks's *The Language of Postmodern Architecture* in the most important Czechoslovak architectural journal of the period, *Architektura ČSR*. In a series of defining texts on the topic published in *Umění a řemesla* and *Architektura ČSR*, the key

writers on postmodernism in the context of Czech architectural discourse, Jiří and Jana Ševčikovi, most often rely on Charles Jencks, Robert Venturi, and C. Ray Smith to frame the local scene.[34] Excerpts from *The Language of Postmodern Architecture* and *Complexity and Contradiction* were presented in Czechoslovak architectural journals and both were translated in their entirety, illustrated by hand, and published through samizdat channels in Czechoslovakia in 1979. They circulated as precious samples of radical Western discourse, under the radar of Czechoslovak normalization. That is not to say that they were gobbled up uncritically, but that they entered Czechoslovak discourse without being officially sanctioned, at least until the mid-1980s.[35] As architectural historian Maroš Krivý has suggested recently, forms of socialist realism and postmodernism coexisted in this period (sometimes indeed dovetailing together), and were certainly intertwined through their shared emphasis on the psychological dimension of the built environment and insistence on the communicative function of architecture.[36]

In this period when 'design of residential buildings practically stopped being architecture' due to various policies on deploying prefabrication and typification, these architects set their sights on the 'imagined community' of world architects and on the architectural developments beyond their context.[37] Jiřina Loudová captured this sentiment in 1984: 'We are receiving news from abroad about the developments of contemporary world architecture – both enthusiastic and critical. We do not want to and cannot stand outside world development' ignoring its progress.[38] I use Benedict Anderson's famous concept 'imagined communities' against the grain of its end-point on the construction and logic of nationalism, but in line with him insofar as he insists on 'imagined communities' being quite literally imagined. The style of imagining this community of world architects, traversing the Iron Curtain, was cosmopolitan in nature; it relied on the conceptual possibility of communicating, or what Esra Akcan has referred to as translatability.[39] As the feedback loops from Liberec to Berlin, and back to Česká Lípa, suggest, the communication was for the most part one-directional, and in this context necessitated by the very fact of its relative invisibility in the West. It is important to recover the Czech architects 'need to demonstrate membership in the Western cultural groups' as more than a trivial impulse, which might have resulted in the simplification of postmodernism in the Czechoslovak context, but instead as precisely what makes the work produced in this imaginary dialogue locally specific.[40]

In their attempt at a typology of contemporary architectural production in 1987 Czechoslovakia, the Ševčikovi couple read Uran and Crystal as products of a particular kind of tendency towards abstraction that for these veterans of Školka involved refocusing their efforts from earlier interests in technological innovation to spatial disposition, always keeping the historicizing project of postmodernism at a distance.[41] And still, somehow, postmodern tropes in Berlin have been easier to pronounce as postmodernism than those in Czechoslovakia, and for some important reasons. The critics in

Czechoslovakia were fully aware that the First World and the Second World contexts were not commensurate, certainly not in terms of the economies and technologies of architectural production, just as they were intensely aware of the one directionality of their own interpretations and contribution to the postmodern discourse. It was, and still is far less complicated to describe the relationship of Uran and Crystal (and many other Czech) buildings, as well as all the Czech writing on postmodern architecture, with their Western 'sources' as allusion, inspiration, and quote, than to decipher the specific boundaries of some properly First, Second, or Third World form of postmodernism. And yet what makes this Czechoslovak postmodern discourse specific, on top of the way in which it wields the histories of its own architectural avant-garde, or uses its prefab building technologies to its own ends, is precisely its extensive knowledge and constant translation of First World concepts to fit its own needs.

The cultural turn, one world

Each of these terms – allusion, inspiration, quote – indeed evidences the kind of agency and activity that British art historian Michael Baxandall used precisely to expand the vocabulary describing and the imagination regarding the correlation between 'source material' and the new work produced in relation to it.[42] He proposed in 1985 that thinking in terms of influence was the curse of art (and architecture) history, because of its 'wrongheaded grammatical prejudice about who is the agent and who the patient': for when we say that X influenced Y, or First World influenced the Second, this assumes some form of action on the part of the First World. Baxandall proposed that instead historians should understand Y, in this case Second World architects, as 'the actor'. The evidence of agency and of the productivity of the imaginary and real conversations the Second World architects and intellectuals conducted with their First World counterparts – the simultaneity of late socialism and late capitalism and the logic of their cultural exchange – begins to challenge the model of discourse, and more broadly, the model of history, in which the Second World is seen as failing to catch up to the First, or conversely as its exotic other, far out in the future.

All of Jameson's examples of literary, architectural, or theoretical postmodernism were drawn from the First World, for in his conception of the tripartite global, the First World was where capitalist relations of production were determining culture even while acknowledging the power of 'the cultural turn' to seep into those relations; he hoped the Second World – because of its socialist constitution – would eventually intimate 'some far future of human history the rest of us are not in a position to anticipate', while the Third World was where (presumably pre-capitalist) allegories of nationhood were 'necessarily' being produced.[43] For all his hope (granted, pre-1989) that the Second World might offer ways to imagine something other than the status

quo, Jameson's willingness to accept the three-world model short-circuited the interpretive power of his own theory of entanglements between cultural, political, and economic developments. Though he attempted to freeze the ordinal numbers describing different geopolitical regions, they stubbornly continued to correspond to Marx's and – as Dipesh Chakraborty showed – to the European historicist developmental paradigm more generally, with entire regions relegated to the 'imaginary waiting room of history' on their way to becoming advanced, or included, or 'first'.[44] Though it may not adequately describe the real feedback loops of global cultural production, the three-world model certainly adequately accounts for 'asymmetrical ignorance', for which it is also partly responsible.[45] While the discursive hegemony of Western European scholarship still guides the discussion on the period coinciding with the futurologically dubbed 'late capitalism', in the 1980s its discussion on postmodernism provided a productive register for Czechoslovak architects, critics, and historians. They recognized in some of the West European and American discourse on postmodernism not only the contours of their own critiques of state proffered modernism, but also a way to participate in a debate and a community beyond their own intensely impermeable national borders. Though postmodernism's 'cultural turn' may have been enabled by Cold War's borders – insofar as 'late capitalism' may have been enabled by the same – the fact that it managed to course through the Czechoslovak architectural discourse reminds us that we do not live (and have never lived) in three worlds, but in a connected one.[46]

Notes

This is a substantially expanded and transformed version of an earlier text on the topic, 'Cold War Adaptations: Školka SIAL's Real and Imaginary Architectural Dialogues with the West'.

1 'The Competitions', *Architectural Review* 181, no. 1082 (1987): 46.
2 *IBA '84 '87: Projektübersicht Stadterneuetung und Stadtneubau* (Berlin: Internationale Bauausstellung Berlin, 1982); Josef Paul Kleihues, ed., *Internationale Bauausstellung Berlin 1984 Die Neubaugebiete, Dokumente – Projekte* (Berlin: Quadriga GmbH Verlagsbuchhandlung KG, 1981).
3 Vendula Hnídková, 'IBA apartment block, John Eisler, Emil Přikryl, Jiří Suchomel, 1983–1985', in Švácha, ed., *SIAL, Liberec Association of Engineers and Architects, 1958–1990: Czech Architecture Against the Stream* (Prague and Olomouc: Arbor vitae and Muzeum umění Olomouc, 2010; English edition, 2012): 182–5.
4 Paolo Portoghesi, *Postmodern, The Architecture of the Postindustrial Society* (New York: Rizzoli, 1983, originally published by Electa Editrice in Italian in 1982); Douglas Clelland, 'Berlin, Origins to IBA', *Architectural Review* 181, no. 1082 (1987): 25.
5 Martin, *Utopia's Ghost*.

6 To list just a few key ones in the order I invoke their authors, Charles Jencks, *The Language of Postmodern Architecture* (London: Academy Editions, 1977); Jean-Francois Lyotard, *The Postmodern Condition: A Report on Knowledge* (Minneapolis: University of Minnesota Press, 1984); Fredric Jameson, *Postmodernism, Or, The Cultural Logic of Late Capitalism* (Durham, NC: Duke University Press, 1991).

7 Masák suggested, and has been followed by a number of Školka veterans in this, that the Školka experiment definitively ended with the loss of their space on Jedlová. See Ana Miljački, *The Optimum Imperative: Czech Architecture for the Socialist Lifestyle* (New York: Routledge, 2017), 258.

8 Jiří Ševčík, 'Aktuální tendence v České architektuře 70.-80. Let', lecture from 13 March 1985, printed in *Jana Ševčíková and Jiří Ševčík, Texty* (Prague: Tranzit.cz and VVP AVU, 2010), 111–21.

9 Suchomel suggested that among the members of this group 'Školka' had less purchase than Jedlová.

10 John Eisler's magazines consistently come up as the description of these architects' key sources in Western architectural development. See, for example, interviews included in Miroslav Masák, ed., *Architekti SIAL* (Prague: Kant, 2008).

11 But even here, the lines between 'official' and 'unofficial' are exceedingly hard to draw, for Školka emerged in opposition to the practices of the day but was eventually supported logistically and financially by them.

12 According to Jiří Suchomel, a wave of emigration from the studio stated in 1978 and lasted until 1983. Email exchange with author, 6 July 2016.

13 These are all terms quoted from an editorial that Kleihues and his colleague Woold Jobst Sidler advocated in their series of articles: 'Models of the City', in *Berliner Morgenpost*. Quoted and discussed in Wallis Miller, '"Models for a City:" Housing and the Image of Cold War Berlin', *Journal of Architectural Education* 46, no. 4 (May 1993): 205.

14 Famously many of them were gathered already in the 1967 exhibition *Apelace* (The Call) organized by their colleague Petr Vad'ura (also an early member of Školka) at the Czech Technical University in Prague. Having attended briefly a university in Ottawa, between 1968 and 1969 Vad'ura also introduced Marshall McLuhan's ideas about media and messages, building on the already indigenous – Czech structuralism's – interest in architectural communication via his writings in *Architecktura ČSR*, *Výtvarna práce*, and *Estetika*. It is also useful to consider the early and mid-1970s' work of the members of SIAL and Školka, the work, after the Ještěd teletower, most often referred to as 'machinist', as representing a highly stylized and image conscious version of high-tech architecture. See Mirko Baum, 'Nikoli asociace a metafora, nýbrž podstata a účel', in Miroslav Masák, ed., *Architekti SIAL* (Prague: Kant, 2008), 31; see Jakub Potůček and Rostislav Švácha, 'Between Environmentalism, Post-Modernism and the New Modernity', in Rostislav Švácha, ed., *SIAL, Liberec Association of Engineers and Architects, 1958–1990: Czech Architecture Against the Stream*, 142–69, and also Dita Dvořáková, 'Petr Vad'ura', in Švácha, ed., *SIAL, Liberec Association of Engineers and Architects, 1958–1990: Czech Architecture Against the Stream*, 276–9.

15 Vendula Hnídková, 'IBA apartment block, John Eisler, Emil Přikryl, Jiří Suchomel, 1983–1985', in Švácha, ed., *SIAL, Liberec Association of Engineers and Architects, 1958–1990: Czech Architecture Against the Stream*, 185.

16 Potůček and Švácha, 'Between Environmentalism, Post-Modernism and the New Modernity'.

17 Vladimir Kulić, 'The Builders of Socialism: Eastern Europe's Cities in Recent Historiography', *Contemporary European History* 26, no. 3 (2017): 545–60. Doi:10.1017/S0960777316000497.

18 Otakar Nový, 'Moderní a postmoderní architecktura', *Architektura ČSR* XLIII (1984): 157.

19 The architects' friend Mirko Baum would describe his time in Kleihous's office as sobering in that sense; Baum, 'Nikoli asociace a metafora, nýbrž podstata a účel'.

20 'Centro commerciale a Česká Lípa 1978–1983', *Casabella* 512 (April 1985): 12–13.

21 Bren, *The Greengrocer and His TV*.

22 Fredric Jameson, *Postmodernism, or, The Cultural Logic of Late Capitalism* (Durham: Duke University Press, 1990).

23 Crystal's narrative is a bit more complicated, as the very first solution for the building was provided by a different architect from the same group, Václav Králiček who had to abandon the project in 1974. Jitka Kubištová, 'SIAL v České Lípě', *Umění* LIX, no. 1 (2011): 59–95.

24 It took a decade for one and a decade and a half for the other building to be executed on the site, with some of the urban fabric in the area changing fundamentally in the interim.

25 Kubištová, 'SIAL v České Lípě', 65.

26 Jan Sapák, 'Obchodní dům Uran', *Československý architekt* XXXI, no. 23 (1985): 3.

27 Email exchange with Suchomel, 6 July 2016.

28 Email exchange with Suchomel, 6 July 2016, and Přikryl's exchange with author, 23 July 2016.

29 What the architects themselves and local historians have lovingly referred to as 'sausage buildings'.

30 Other sources come up in writing and conversations, as well. Most notably, Přikryl brings up Charles Moore's Sea Ranch, but also Aldo Van Eyck, the Amsterdam School, Frank Lloyd Wright, Plečnik and Venturi and Scott Brown, most recently in an email exchange with the author, 23 July 2016.

31 Rostislav Švácha, 'The Energy of Geometry', in Sona Ryndová and Rostislav Švácha, eds., *Emil Přikryl a jeho škola* (Prague: Galeria Jaroslava Fragnera, 1995), 43.

32 Rostislav Švácha, 'Czech Architecture 1989–2007', in Ján Stempel, ed., *Architecture V4 1990–2008; Czech Republic, Slovakia, Hungary, Poland* (Prague: Kant, 20090), 13.

33 Boris Groys, *Total Art of Stalinism: Avant-Garde, Aesthetic Dictatorship, and Beyond* (Princeton, NJ: Princeton University Press, 1992).

34 They also invoke Christian Norberg Schultz's theories and C. Ray Smith's *Supermannerism*. See for example, Jana and Jiří Ševčikovi, 'Postmodernismus a my I: Nabídka postmodernismy v krizi soudobé světové architektury', *Umění a řemesla* 4 (1987): 20–2; Jana and Jiří Ševčikovi, 'Postmodernismus a my II: Situace doma-pokus o typologii', *Umění a řemesla* 4 (1987): 61–6.

35 There are at least two key articles by veteran contributors to architectural journals that weigh in on the topic from the point of view of 'realistic and socialist direction'. Both Zdeněk Kostka and Otakar Nový found merit in the Czech postmodern turn in architecture and called for a deeper understanding and engagement with it. Zdeněk Kostka, 'Kam bude směřovat architektura', *Výtvrná kultura* 4 (1984): 11–17; Otakar Nový, 'Moderní a postmoderní architecktura', *Architektura ČSR* XLIII (1984): 157–64.

36 Krivý, 'Postmodernism or Socialist Realism?', 74–101.

37 Benedict Anderson, *Imagined Communities: Reflections on the Origin and Spread of Nationalism* (London: Verso, 1983).

38 Jiřina Loudová, 'Postmodernismus, skutečnost a mýtus', *Architektura ČSR* XLII (1984): 155.

39 Esra Akcan, *Architecture in Translation: Germany, Turkey, and the Modern House* (Durham and London: Duke University Press, 2012).

40 Potůček and Švácha, 'Between Environmentalism, Post-Modernism and the New Modernity', 156.

41 Jana and Ševčikovi, 'Postmodernismus a my II', 61–6.

42 Michael Baxandall, *Patterns of Intention: On the Historical Explanation of Pictures* (New Haven: Yale University Press, 1985).

43 Fredric Jameson, 'Third-World Literature in the Era of Multinational Capital', *Social Text* #15 (Fall 1986): 65–88.

44 Dipesh Chakrabarty, *Provincializing Europe: Postcolonial Thought and Historical Difference* (Princeton and London: Princeton University Press, 2000).

45 Chakrabarty, *Provincializing Europe*, 28.

46 Aijaz Ahmad, 'Jameson's Rhetoric of Otherness and the "National Allegory",' *Social Text*, no. 17 (Autumn 1987): 3–25.

11

Mobilities of architecture in the late Cold War:

From socialist Poland to Kuwait, and back

Łukasz Stanek

In February 2015 a development project called Aladdin City was launched in Dubai. The project was presented as drawing 'upon a deep reverence for the region's history' with legends of Aladdin and Sinbad as the 'driving force' of the design, including buildings resembling exotic marine life, fantasy animals, and towers formed as Aladdin's lamp.[1] Such a parade of 'ducks', in Denise Scott-Brown and Robert Venturi's terms, shaped according to forms associated with the region, is hardly new to the Gulf.[2] It was already during the 1970s that the requirement of referencing 'local tradition' was introduced in briefs of architectural competitions and building regulations in response to the dissatisfaction of the Gulf elites with the first two decades of post-oil urbanization. As these earlier processes had been largely informed by modern architecture and CIAM urbanism, architects, both expats and local, searched for alternative approaches and they often turned to postmodern strategies, from ducks and 'decorated sheds' to typo-morphological research. Sometimes applied by luminaries of postmodern architecture themselves, who were occasionally invited to work in the region, these architectural practices could be seen as yet another emanation of the New York-Venice axis – and the numerous professional

and educational links between Gulf actors and Western European and North American institutions would support such an argument.³

However, in this chapter I will focus on a different geography of architectural mobilities by following actors who, until recently, have not been present in architectural historiography of the Gulf: architects and other professionals from socialist countries in Eastern Europe. During the last decade of the Cold War, much of the architectural production in Kuwait, the UAE, and elsewhere in the region was carried out by architects from socialist Bulgaria, Hungary, Poland, and Yugoslavia. In difference to their earlier engagements abroad, by the late 1970s the leadership of these states paid lip service at best to the ideas of socialist internationalism, and privileged commercial interests instead. By focusing on Kuwait, which was the first in the Gulf to experience the consequences of post-oil urbanization, and by discussing the work of Polish professionals, a particularly large group among architects from socialist countries in the city state, I will argue that their work in the Gulf needs to be seen as part of what I have called elsewhere the worldmaking (mondialization) of architecture.⁴ Against the reduction of architecture's global mobility to 'Westernisation' or 'Americanisation', I argue that architecture as a techno-cultural apparatus of world-wide urbanization emerged in the course of the twentieth century from within competing visions of global solidarity and cooperation. Yet rather than adding Moscow, Warsaw, or Belgrade to Western centres of architectural diffusion, the worldmaking hypothesis disposes of the diffusionist framework altogether and, instead, focuses on specific transactions across various networks intersecting at a variety of scales.⁵

In this perspective, and in the context of this volume, the focus on the group of Polish professionals in Kuwait offers more than just a narrative about a replacement of modern architecture by postmodernism as the (Western) model of architectural production in late 1970s' and 1980s' Gulf. The protagonists of this chapter were aware of and, sometimes, inspired by both the pioneers of postmodernism as identified by its performative historiographers such as Charles Jencks, and the appropriations of postmodern forms by the increasingly globalized corporate architecture, which had a highly visible presence in Kuwait.⁶ But at least equally important for the work of Polish architects in the Gulf was their disenchantment with what remained from the modernist project in socialist Poland. This sentiment tuned into the change of the climate of opinion in Kuwait where clients and commissioners expected an architecture that reflected the identity of the place and the people. In what follows I will show how Polish architects responded to this expectation not only by studying vernacular typologies and ornaments, but also by making an extensive use of cutting-edge technological expertise which entered Kuwait from the West, including new technologies of construction, building management, and design. In this way, their work allows to rethink the relationship between technological and cultural expertise beyond the modernist model of 'adaptation' of a

(metropolitan) technological expertise to the cultural conditions of the peripheries. In retrospect, the renegotiation of this relationship appears as a crucial shift in the architectural culture of the late 1970s and 1980s – and I will argue that the specific position of architects from socialist countries on the labour market in Kuwait offers a privileged vantage point to describe this shift.

From Socialist Poland to Kuwait

In simpler terms, this is a story about a group of friends. Andrzej Bohdanowicz, Ryszard Daczkowski, Wojciech Jarząbek, Edward Lach, Krzysztof Wiśnowski, and many other protagonists of this chapter graduated from the architectural school of Wrocław Polytechnic in the late 1960s. Some of them were invited to join the Chair of History of Urbanism at the Institute of History of Architecture, Art and Technology,[7] where their research focused on regional architecture in Silesia, from urban ensembles to details and materials. This experience informed designs which they submitted, composing various teams, to numerous competitions, including the 1974 winning entry for the Kozanów neighbourhood in Wrocław, designed by Bohdanowicz, Daczkowski, Lach, and Wiśnowski.[8]

In spite of this success, these architects became disillusioned with the conditions of work in Poland, which was characterized by the submission of architecture to the state building industry, the domination of planning over architecture, and the increasingly apparent economic and political crisis of the 1970s. Their competition entry for Kozanów is a case in point. Breaking with the 'real existing modernism'[9] of undifferentiated, homogenous apartment blocks being constructed in Poland since the early 1960s, Kozanów was a topographically sensitive composition of diverse housing typologies, linked by a cluster of low pavilions with social facilities. In spite of the fact that the project won the first prize in a national competition, it was rejected by the Ministry of Construction, which did not accept the flexible prefabrication system proposed by the architects.

In this context, the invitation abroad was a welcomed change. The circumstances of the travels of the Wrocław group to Kuwait differed from most of the arlier engagements of Polish architects in Iraq, Syria, and elsewhere in the Middle East, which had resulted from intergovernmental agreements of economic and technical cooperation in the framework of socialist solidarity. Since the late 1950s, these agreements provided entrance points for Polish architects to the Middle East, but also included provisions for Arabs to study at Polish universities.[10] It was one among such educational provisions that led to the first trip of Wrocław architects to Kuwait, who were invited by a Palestinian alumnus of the Wrocław Polytechnic. The first group to come to Kuwait in 1976 included Lach and Daczkowski, who were employed in the Gulf Engineering Office (GEO), and later co-opted

others. Wiśniowski and Bohdanowicz were employed in 1977 by Shiber Consultants, headed by Victor Shiber, brother of the renowned Palestinian architect and urban planner Saba George Shiber who worked in Kuwait from 1960 until his death in 1968.[11] In 1978, Jan Urbanowicz, Jacek Chryniewicz, and Jarząbek replaced Wiśniowski and Bohdanowicz in Shiber's office, where they cooperated with the Industrial & Engineering Consulting Office (INCO). INCO's director, Mohammad Al-Sanan, recalls the group's successful competition entries for Site C of the Sabah Al-Salem district (designed in 1977, constructed in 1982) and for the Kuwaiti National Theatre (designed in 1978, unrealized).[12]

While these competition entries were drawn on tourist visas, in their wake architects from Wrocław signed contracts with Foreign Trade Organization (FTO) Polservice. Polservice was founded in 1961 and put in charge of the export of labour from socialist Poland, which included architectural labour, based on the well-publicized experiences of post-war reconstruction, modernization, and urbanization of the country. While Polservice's contracts since the 1960s displayed an ambiguous relationship between technical assistance and commercial activities which was typical for socialist foreign trade, by the end of the 1970s the latter started to dominate the former in order to satisfy the demand for foreign currency needed to finance the Polish regime's modernization efforts and, later, to pay off its debts.[13] A Polservice contract with an individual expert consisted of three separate but interdependent agreements: first, an employment contract with the foreign employer; second, a contract with Polservice which was paid a share of the expert's foreign salary and in return transferred a fixed fee to their bank account in Poland and covered their social expenses (health insurance, pension fund); and, third, the agreement with the employer in Poland to grant the expert an unpaid leave and the right to return to the same or equal position after the termination of the foreign contract.[14] Similar agreements were signed by architects from other socialist countries working in Kuwait, including Czechoslovak and Yugoslavian professionals.[15]

Polish architects coming to Kuwait recommended others, including their wives and partners: Danuta Bohdanowicz, Zdzisława Daczkowska, Anna Wiśniowska. Architects from other Polish cities were arriving as well, including Janusz Krawecki and Włodzimierz Gleń, who contributed to the first high-rise buildings in Kuwait.[16] They and others found employment in various Kuwaiti offices: INCO, SSH, the SOOR Engineering Bureau, the Arabi Engineer Office, the Kuwait Engineering Office (later the Kuwait Engineering Group, or KEG), and GEO (later Gulf Consult).[17] The professional links with Poland were rarely severed and Jarząbek, for example, sent plans for the church of St Mary Queen of Peace in Wrocław-Popowice (1994) from Kuwait, the details of which resemble those of the Al-Othman Centre he co-designed in Hawally (with Lach for KEG, 1995).[18] After the declaration of martial law in Poland (1981) most of them decided

not to return and the monthly fee imposed on them by Polservice was one more incentive to break with the state-socialist system.[19]

Labour conditions for the Wrocław architects in Kuwait on Polservice contracts were different from those of Western 'consultants' in the Gulf, such as Constantinos Doxiadis or Michel Ecochard, and from employees of large state-socialist companies working in the region, such as Bulgaria's Technoexportstroy. The daily routine of the Polish architects was characterized by their intense engagements with clients and contractors, and direct supervision of the building sites, where many details were drawn when needed.[20] They cooperated with Kuwaiti professionals, mainly educated in the United Kingdom and the United States, and with architects from Arab countries active in Kuwait, in particular Egyptian, Iraqi, Lebanese, and Palestinian professionals, as well as with architects and engineers from India and Pakistan. Exchanges were intense with British professionals in Kuwait, present in the Gulf since the period of the protectorate, as were exchanges with offices from the United States.[21] These collaborations often resulted from joint-venture agreements between Kuwaiti and foreign firms which were increasingly required for larger projects by the authorities and private clients alike.[22]

Kuwaiti urbanities

The Kuwait that confronted the architects from Wrocław was the result of three decades of rapid urbanization, financed by the state's oil revenues, and defined by state policy of land acquisition and resettlement.[23] The first master plan of Kuwait by the British planners Minoprio, Spencely, and MacFarlane, in 1951, had envisaged a transformation of what was then a settlement of courtyard houses into a commercial and business 'city centre', separated by a Green Belt from new residential suburbs. While much of the urban fabric of Kuwait was erased, only a few urban projects were realized. Hence visitors arriving to Kuwait City in the early 1980s admired new buildings by 'world's architectural prima donnas', including Arne Jacobsen, Jørn Utzon, Reima and Raili Pietilä, The Architects Collaborative (TAC) and Skidmore, Owings and Merrill (SOM); and they yet deplored that these structures stood 'among parked cars [and] the ruins of what remains of Kuwait's stock of single-storey courtyard family houses'.[24]

The subsequent master plan, commissioned in 1968 from the British consultants Buchanan and Partners, tried to remedy this condition. Besides shifting the scale of intervention by envisaging a linear development following the coast, Buchanan suggested a renewal of the city centre by stimulation of commercial and government programs, filling the gap in the urban fabric and laying out pedestrian zones.[25] Subsequent revisions of the plan (1981) declared several conservation areas within the Green Belt and designated several historical structures for preservation.[26] These decisions responded

to the calls to preserve the little that was left of the old Kuwait, which were followed by first renovations of historical building by the municipality (starting with Old Kuwait Courts, supervised by Ghazi Sultan, 1987).[27]

This interest in preservation was accompanied by a critique of two decades of post-oil urbanization, considered alien and alienating in its forms, uses, and typologies such as apartment blocks, sometimes explicitly linked by critics to the tradition of modern architecture and CIAM urbanism.[28] In response, by the late 1970s calls for references to 'Arab' and 'Islamic' architecture abounded in professional and popular debates. Many impulses were coming from Baghdad, with a prominent school of architecture shaped by the teachings of Mohamed Makiya, and numerous development projects under Saddam Hussein headed by Rifat Chadirji, who solicited contributions from Arthur Erickson, Venturi and Scott-Brown, Ricardo Bofill, and other luminaries of postmodern architecture.[29] Elsewhere in the Gulf, too, reference to an often-unspecified 'Islamic tradition' was becoming a standard requirement in governmental commissions, and foreign designers needed to comply.[30] For instance, the design of the Kuwait Law Courts by Basil Spence Partnership evolved in order to accommodate the recommendation that the building 'follows Islamic tradition' (1983).[31] In the years to come, such a requirement became part not only of competition briefs in the region, but also of the building codes. This was the case in the Abu Dhabi Emirate, where buildings which did not 'reflect the Arab, Islamic character and the history of the civilization of the region' were denied building permits.[32]

If the general interest in contextual visions of urbanity explored by the Wrocław group back in Poland tuned into this new climate in the Gulf, the sources that allowed them to explore local architectural traditions were limited, and included few available publications, among them Saba Shiber's *Kuwait Urbanization* (1964), and debates in professional journals in the region, such as *Middle East Construction*.[33] In Kuwait, these architects also got an easy access to Western journals and magazines. As Wojciech Jarząbek recalled, it was by reading *The Architectural Review* in Kuwait that he discovered the work of James Stirling, his ferryman to postmodern architecture, which then reverberated not only in his Kuwaiti designs, but also in those he drew in Poland upon his return in the 1990s.

Like earlier in Poland, upon their arrival to Kuwait, the Wrocław architects learnt from vernacular typologies of urban spaces and negotiated their ways of use with the conditions of post-oil Gulf. For instance, the project for senior housing in Sharkh by Jarząbek and Lach referenced the scale, disposition, sequence of spaces, materials, and details of the disappearing courtyard houses in this area.[34] By contrast, direct quotations of historic buildings were avoided in the design of the site 'C' in the Sabah Al-Salem neighbourhood (Wiśniowski, Bohdanowicz, Jarząbek for Shiber Consult, 1982). Sabah Al-Salem was one of the biggest neighbourhoods planned in Kuwait in the 1970s as part of the broad program of distribution of housing among Kuwaiti citizens.[35] The competition brief by Kuwait's

National Housing Authority (NHA) requested an 'Arab design' and floor plans that sustained Kuwaiti customs.

The designers responded with an interpretation of the vernacular courtyard typology, developed by means of a split-level disposition, with the day area below and the night area above.[36] The day area included two larger rooms, one of which could be separated from the rest of the apartment and used as a *diwaniyya* (semi-public/ semi-private room for male visitors) while the night area could be used as a living room for the entire family. This differentiation of privacy in the apartment followed the recommendations of the NHA, as did the possibility of transforming the terrace into an additional bedroom.[37] Another key attempt to respond to the 'local tradition' was, in the words of the architects, the careful design of external spaces, topography, and greenery. Inspired by the quickly disappearing urban fabric of Sharkh, Site C was furnished with a network of narrow, shaded, pedestrian-only pathways that linked the houses to the local community centre with its mosque, kindergarten, and shops. Perpendicular to the pedestrian paths, a grid of roads was introduced for vehicle traffic (Figure 11.1).[38]

The negotiation between car accessibility and pedestrian movement was recognized in Kuwait as a key challenge for an intended 'Arab urbanism'.[39] A contribution to this debate was Suq Dawliyah, combining a multi-storey parking garage with an atrium and an office block (Daczkowski and Lach for GEO, 1978), and imagined as a nodal point within the new pedestrian zones of the master plan for Kuwait City. Yet this negotiation sometimes

FIGURE 11.1 *A. Bohdanowicz, W. Jarząbek, K. Wiśniowski for Shiber Consult/ INCO, Site C, Sabah Al Salem, Kuwait, 1982, general plan. K. Wiśniowski archive, Kuwait City.*

brought to the fore contradictions inherent to the social production of space in post-oil Kuwait.[40] A case in point is the Al-Othman Centre, a commercial and residential complex in Hawally, where the rhetoric of the arcade open to the street is contradicted by its internal layout and its uses, which are fully dependent on the car (Figure 11.2). Similarly, in three apartment buildings

FIGURE 11.2 *E. Lach, W. Jarząbek for KEG, Al Othman Center, Hawally, Kuwait, 1995. Photo courtesy of Ł. Stanek (2014).*

constructed in Salmiya (Andrzej Bogdanowicz for Shiber Consult, 1978) the careful sequencing of transition spaces between the apartment and the street contrasts with the surrounding, poorly cared-for streets with dilapidated or no sidewalks. These apartments were rented out to immigrant workers (which in 1980 were more than 59 per cent of the population in Kuwait and three-fourths of its labour force),[41] who had few instruments to put pressure on the authorities and landlords to maintain the streets – as the architects would know from their own experience as expat tenants.

If the design of spaces with an appearance at odds with their uses indicates formal fascinations of Wrocław architects, these spaces also reflected the programmatic decisions of the commissioners. A case in point is the Baloush bus station, resulting from a competition won by INCO (Leopold Chyczewski, Wiśniowska and Wiśniowski, 1986). After the competition, the Kuwait Public Transport Company changed the program and replaced the commercial functions the architects had proposed with publicly accessible spaces with no commercial use.[42] Yet the program of a bus station implied that the building was to be frequented mainly by low-income, non-Kuwaiti residents, the primary users of public transportation in Kuwait.[43] In spite of the station's multiple gestures towards public space – pronounced eaves, two open-entrance pavilions, and the basilica section of the main hall – it could not have become a space where people of different backgrounds meet, as it was unable to fill the gap of such spaces left in a city centre that had been severely depleted during the process of post-oil urbanization (Figure 11.3).[44]

FIGURE 11.3 *Chyczewski, A. Wiśniowska, K. Wiśniowski for INCO, Baloush Bus Terminal, Kuwait City, 1986. Photo courtesy of Ł. Stanek (2014).*

These examples show that the Wrocław architects responded to the climate of opinion in Kuwait in the 1980s by re-imagining the pre-oil urban fabric (Sabah Al-Salem), by alluding to images acculturated in the Middle East by colonial urbanism (Al-Othman Centre, the Baloush bus station), or by reinterpreting the suq typology (Suq Dawliyah). These buildings engaged the voices in Kuwait that demanded putting an end to the architectural and planning patterns of the two post-oil decades, patterns widely considered to be alien and alienating. However, it was against the background of these more familiar images that the 'other within' appeared: immigrants and other non-citizens.

Technologies in context

The projects of the Wrocław group that were discussed above might appear to confirm the modernist narrative of architecture's role as a cultural 'mediator' of modern technology, as developed in the post-war period from 'tropical architecture' to 'critical regionalism'.[45] In this view, the core of architectural labour is the 'labour of adaptation', that of adjusting the metropolitan (Western) technology to the cultural (non-Western) context. The technologies of the car, the escalator, the elevator, the highway, and prefabricated construction systems appear to be integrated into floor plans inspired by courtyard houses, arranged according to morphologies derived from vernacular urbanization patterns, and decorated with details abstracted from pre-oil monuments in Kuwait. In the final part of this chapter, however, I will argue that the specific position of Polish architects in Kuwait facilitated a renegotiation of the relationship between cultural and technological expertise beyond the modernist discourse of 'adaptation'.

Much of the disappointment with the buildings in Kuwait of the 1950s' and 1960s' stemmed from the rapid pace of their deterioration, and this concerned, in particular, the one material most strongly associated with the modern movement: reinforced concrete. While most concrete structures in Kuwait were less than thirty years old, they quickly deteriorated in the hot, humid, dust-laden climate of the Gulf. Expatriate architects were sometimes accused of specifying building materials that proved unsuitable, especially in light of the fast pace of construction during the boom period and the fact that maintenance protocols were often not adhered to.[46] In response, private investors and government agencies introduced a number of control measures and encouraged the use of prevention techniques (coated rebar, dense concrete, and pulverized fuel ash as an alternative to cement).[47] This was supported by the emerging Kuwaiti and Saudi building industries, which were increasingly able to supply materials produced on foreign licences that accounted for the aesthetic proclivities of the clients, with ornamental rubber moulding for prefabricated concrete elements, cladding panels with openings in the shape of ogee arches, and glass reinforced concrete (GRC) used by Wrocław architects for their *mashrabiyyas* and *muqarnases*.

More generally, the shift beyond the townscape of post-oil urbanization in Kuwait was facilitated by innovations in the building industry. These included the organization of building sites, and over the course of the 1970s the NHA limited the size of housing projects to 500 units. The reason was to prevent delays and to support local contractors, but this regulation also brought to an end the large, uniform housing projects of the 1960s and early 1970s.[48] During the same period, the NHA introduced the requirement of computerization of the design and construction process in order to accelerate information flow between all actors involved, facilitate communication between them, and ensure their accountability.[49] For many Western firms, in particular from the United States and the United Kingdom, the Middle East became one of the first places to employ CAD on a commercial scale, including the designs of Kuwait's Stock Exchange (John S. Bonnington, 1984) and the Salhia Complex (Arup, 1979). CAD was particularly useful for managing commissions within the 'design and build' procedure that was favoured in the Middle East, when contractors were expected to submit design proposals together with building cost estimates.[50] CAD became necessary in view of fast-moving contract programs in Kuwait, while the use of dynamic databases allowed for a quick response time to contract programs updates and forecasts.[51]

Salah Salama, the head engineer of KEG, recalled that this office bought the General Drafting System (GDS) in the early 1980s for the working drawings of the Fintas Centre project, because of its size, complexity, and the particularly short timing of the commission.[52] For this project, Erickson delivered the general design, possibly learning from his research on the traditional urbanity of Baghdad's Abu Nuwaz area; and Wrocław architects at KEG produced the execution drawings. In the wake of the unrealized Fintas Centre, CAD technology was used in other KEG projects,[53] including the Audit Bureau, designed by Jarząbek and Lach before the invasion, and then completed in 1996 (Figure 11.4). Within the narrative sensitivity developed in their Kuwaiti projects, Jarząbek and Lach designed a complex, ornamental *mashrabiyas*, themselves drawn in CAD. The technology was also used in the design of the Al-Othman Centre, which, as with the Audit Bureau, was only finished after the Iraqi invasion. Jarząbek argued that the building's careful details, including the decorative geometry of the tiles, would not have been possible without CAD.[54]

In this way, the implementation of CAD and other building and design technologies in Kuwait through the 1980s displays the processes of de-territorialization and re-territorialization of expert systems across diverse social and cultural situations, which have been described by Science and Technology Studies scholars in their work on global knowledge transfer. Accordingly, the implementation of computerized management systems at construction sites in Kuwait could be analysed as unstable 'global assemblages', as studied by Stephen J. Collier and Aihwa Ong, in which impersonal forms of techno-science are assimilated and contested within

specific, situated arrangements.⁵⁵ Similarly, the Kuwaiti offices which implemented CAD in order to cooperate with Western architects and construction firms could be seen as 'technological zones', discussed by Andrew Barry as sites where differences between technical practices, procedures, and forms are reduced and common standards are established.⁵⁶

FIGURE 11.4 *W. Jarząbek, E. Lach for KEG, Audit Bureau Headquarters Building, Kuwait City, 1996. Photo courtesy of Ł. Stanek (2014).*

Barry, Collier, and Ong stress that such 'technological zones' and 'global assemblages' forge a separation between 'global/Western' and 'local' regimes (political, economic, social, and ethical). By contrast, several of the expert systems discussed above bridged this separation and facilitated a 'contextual' response, in line with the new architectural climate of opinion in Kuwait in the 1980s. In particular, the prefabricated systems and CAD software accommodated the demand for a visual environment into which collective identities could be projected. This shift, from the self-assigned mediation between 'technology' and 'context' (as postulated by various regionalisms, 'critical' and otherwise), towards their conflation testified to a reshuffling of architectural culture in the Gulf, to which architects from Wrocław contributed.

If their work is a privileged vantage point to study this dynamics, it was because of their specific position on Kuwaiti market of architectural labour. Architects from Wrocław neither were local experts nor, unlike many among earlier generations of Polish architects working abroad, transferred building technologies that had been earlier employed in Poland. By the time they worked in Kuwait, Polish construction technology was increasingly outdated and rarely marketable in the competitive Gulf market. Accordingly, by 1986 a representative of the Polish government was forced to admit, in a public debate, that what was formerly called 'building export', 'verges on being not much more than the export of labour power'.[57] The collective 'profile' of 'specialists abroad' as characterized by Polservice in a 1972 publication can be read as a reflection of this condition, with the stress on flexibility, efficiency, dedication, and ability to learn.[58] In Polservice's recruitment procedures during the final decades of the Cold War, such transportable profile this took precedence over specific experience with post-war reconstruction which had legitimized earlier Polish master plans for cities in Algeria, Libya, Syria, and Iraq.[59] Aspects of this profile had been provided by the typically Central European training of the Wrocław architects, straddling engineering, architecture, and urban planning, which was valued in Kuwaiti offices, often headed by civil engineers – all the more so as it came with a modest price tag.[60] Such training furnished them with a broad set of portable rather than localized skills which were advantageous within the expanding global market of architectural services: a market which, as this chapter demonstrated, Polservice not only took advantage of but also helped to define.[61]

Afterword: From Kuwait to Poland

The 1990 Iraqi invasion resulted in damaging several buildings in Kuwait, as well as in the closure of several Kuwaiti architectural offices, and in foreign professionals leaving, some of whom moved to Dubai and Abu Dhabi in the years that followed.[62] The invasion coincided with the end of socialism

in Eastern Europe, and most architects of the Wrocław group who were leaving Kuwait decided to return to Poland. Upon their arrivals there, they became known by the nickname 'Kuwaitis', and they helped shape the urban landscape of post-socialist Wrocław. Jarząbek used CAD technology, for example, which he had previously utilized in Kuwait, to design the Solpol department store (1993), the first in the Wrocław city centre after 1989. Lach was responsible for the Dominikańska department store alongside the medieval town (1999), among other projects.[63] In 1994, when the construction of the church in Popowice was completed, the cardinal who consecrated the building associated its interior with Islamic architecture – and went on to jokingly thank Jarząbek for designing 'such a beautiful mosque'.[64]

Beyond anecdotal references, the experience of working in the Gulf, the Middle East, and North Africa in the 1980s was a decisive career step that prepared architects from Poland and other then-socialist countries for practising architecture after the political transformations. They distinguished themselves by their professional knowledge and familiarity with programs with which architects that had remained practising in state socialism had little experience, such as middle-class housing, office parks, shopping malls, and modern department stores.[65] They benefited from the experience with current building processes, from CAD through construction technologies and advanced materials, the organization of the office, and the construction site, to contacts with international developers and construction firms. No less important was the acquaintance with postmodernism, embraced by investors and the public alike. While postmodern tendencies were present in Polish architecture since the 1970s, it was only after the end of socialism that they were turned into a new mainstream, facilitated by imported programs, materials, building technologies, and capital.[66] Yet while boosting individual careers, the work on export contracts often came with a sympathetic association with developers and construction firms, reinforced by the experience of a 'public' deemed too fragmented and contingent to become an obligation for an architectural project, and an architectural culture valorizing the detachment of architectural images from broader processes of space production. These experiences dovetailed with the new professional habitus in the Eastern Europe of the 1990s' and the conditions of architectural labour in post-socialist Poland.

Notes

1 'Aladdin City: Sailing Into Dubai's Future', www.clapway.com (accessed 30 December 2016). This chapter develops my paper 'Mobilities of Architecture in the Global Cold War: From Socialist Poland to Kuwait and Back', *International Journal of Islamic Architecture* 4, no. 2 (2015): 365–98. See also Łukasz Stanek, *Socialist Worldmaking. Architecture and Urbanization in the Global Cold War* (Princeton NJ: Princeton University Press, forthcoming in 2019).

2. Robert Venturi, Denise Scott-Brown and Steven Izenour, *Learning from Las Vegas: The Forgotten Symbolism of Architectural Form* (London: The MIT Press, 1972).

3. For discussion of globalization processes in the Gulf, see Murray Fraser and Nasser Golzari, eds., *Architecture and Globalisation in the Persian Gulf Region* (Farnham, Surrey: Ashgate, 2013); Yasser Elsheshtawy, ed., *The Evolving Arab City: Tradition, Modernity and Urban Development* (London and New York: Routledge, 2008). On the New York-Venice connection, see Joan Ockman, 'Venice and New York', *Casabella* 619–20 (1995): 56–73.

4. Łukasz Stanek, 'Architects from Socialist Countries in Ghana (1957–1967): Modern Architecture and Mondialisation,' *Journal of the Society of Architectural Historians* 74, no. 4 (December 2015), 416–42; see also Łukasz Stanek, 'Miastoprojekt Goes Abroad: Transfer of Architectural Labor from Socialist Poland to Iraq (1958–1989)', *The Journal of Architecture* 17, no. 3 (2012): 361–86; Stanek, *Socialist Worldmaking*.

5. For a critique of the diffusionist model, see Jane M. Jacobs, 'A Geography of Big Things', *Cultural Geographies* 13, no. 1 (2006): 1–27.

6. Charles Jencks, *The Language of Post-Modern Architecture* (London: Academy Editions, 1991); Fredric Jameson, *Postmodernism or, the Cultural Logic of Late Capitalism* (London: Verso, 1991).

7. They included Krzysztof Wiśnowski, Andrzej Bohdanowicz and Ryszard Daczkowski.

8. *Krzysztof Wiśniowski, Anna Wiśniowska, Magdalena Wiśniowska, Jan Wiśniowski: 1969–2006* (Wrocław: Muzeum Architektury, 2006).

9. For the discussion of 'real existing modernism' in Eastern European state socialism (often called 'real existing socialism'), and the responses to it in Czechoslovakia, Hungary, Poland, and Yugoslavia, see Łukasz Stanek, ed., *Team 10 East: Revisionist Architecture in Real Existing Modernism* (Warsaw: Museum of Modern Art/Chicago, IL: University of Chicago Press, 2014).

10. Stanek, 'Miastoprojekt'.

11. Joe Nasr, 'Saba Shiber, "Mr. Arab Planner": Parcours professionnel d'un urbaniste au Moyen-Orient', *Géocarrefour* 80, no. 3 (2005): 197–206; Saba George Shiber, *Kuwait Urbanization: Documentation, Analysis, Critique* (Kuwait: **Kuwait** Government Printing Press, 1964).

12. Interview with Krzysztof Wiśniowski, Kuwait City, 12 January 2014; interview with Mohammad Al-Sanan, Kuwait City, 13 January 2014.

13. See also, Stanek, 'Miastoprojekt'.

14. Stanisław Grzywnowicz and Jerzy Kiedrzyński, *Prawa i obowiązki specjalisty* (Warszawa: Wydawnictwa UW, 1972), 26, 49–50.

15. Interview with Stojan and Mirjana Maksimović, 14 September 2014, Nahant, MA.

16. They included the Al-Fintas towers (Gleń, J. Damija, N. Fatteh for Arabi Engineer Office, 1984) and the Al-Qibla tower (Krawecki for Gulf Consult, 1988), SARP Archive, Warsaw, 1091; Janusz Krawecki archive, Kraków. See also the following personal dossiers in SARP Archive: 279, 351, 353, 363, 480, 533, 983, 1138, 1218.

17 For the work of these offices, see Jacek Wozniak, *Contemporary Architecture in Kuwait* (no date), 282–93; Roberto Fabbri, Sara Saragoca and Ricardo Camacho, *Modern Architecture Kuwait: 1949–1989* (Zurich: Niggli, 2016).

18 Here and in what follows, unless otherwise specified, the dates indicate the construction year of the building in question.

19 Interview with Andrzej Bohdanowicz, Kuwait City, 15 January 2014.

20 Interview with Krzysztof Wiśniowski.

21 Tanis Hinchcliffe, 'British Architects in the Gulf, 1950–1980', in Fraser and Golzari, eds., *Architecture and Globalisation*, 23–36.

22 Telephone interview with Janusz Krawecki, March 2014.

23 Asseel Al-Ragam, 'The Destruction of Modernist Heritage: The Myth of Al-Sawaber', *Journal of Architectural Education* 67, no. 2 (2013): 243–52; Farah Al-Nakib, *Kuwait Transformed: A History of Oil and Urban Life* (Stanford, CA: Stanford University Press, 2016).

24 Neil Parkyn, 'Kuwait Revisited', *Middle East Construction* (hereafter *MEC*) 9 (1983): 39; Stephen Gardiner, *Kuwait: The Making of a City* (London: Longman, 1983); Lawrence Vale, *Architecture, Power, and National Identity* (New Haven, CT: Yale University Press, 1992), 248–78; Udo Kultermann, *Contemporary Architecture in the Arab States: Renaissance of a Region* (New York: McGraw-Hill, 1999), 167–78.

25 Gardiner, *Kuwait*; Shankland/ Cox Partnership, 'Master Plan of Kuwait: City Centre', Library of Congress, Geography and *Map* Reading Room, Washington, DC, G7604.K9G45 1977.S5.

26 'A Master Plan to Reshape the City Centre', *Kuwait Times*, 8 November 1981, 19.

27 'The Changing Suq', *MEC* 11 (1982): 14; 'Purposive Architecture for the Urban Development of Kuwait', *Kuwait Times*, 10 May 1978, 5; 'An Architect from Kuwait', *Albenaa* 7, no. 38 (1987/1988): 10–11.

28 Ahmed Farid Moustapha, 'Islamic Values in Contemporary Urbanism (1)', *Albenaa* 7, no. 41 (1988): 18–24, 26–33.

29 'Architect of Baghdad', *MEC* 1 (1984), 12–13.

30 'Sunshine and the Rule of Law: Kuwaiti Law Courts Scheme', *Building Design* 501 (20 June 1980): 24.

31 'Sunshine and the Rule of Law', 25.

32 'Mura'at Al Tabe' Al Hadari wal Islami lel manteqa fe tasameem almabani al jadedah', (Complying with the Islamic identity and culture of the region in designing new buildings), *Al-Ittihad*, 17 June 1984.

33 Shiber, *Kuwait Urbanization*.

34 Edward Lach archive, Wrocław.

35 'Housing the Arab Population', *MEC* 1 (1983): 27–34; 'A Road Network Sized for the Products of Detroit', *Construction Today – Middle East* 3 (1979): 30–1.

36 Interview with Wiśniowski.

37 'Household Interviews', vol. 4 of National Housing Authority (Kuwait), *National Housing Programme* (London: Buchanan, 1976), 5 vols.
38 Krzysztof Wiśniowski archive, Kuwait City.
39 'Safat Square – Kuwait', *Albenaa* 3, no. 17–18 (n.d.): 60–1.
40 Al-Nakib, *Kuwait*.
41 Abdulrasool A. Al-Moosa, 'Kuwait: Changing Environment in a Geographical Perspective', *British Society for Middle Eastern Studies: Bulletin* 11, no. 1 (1984): 45–57.
42 Interview with Wiśniowski.
43 Bruce G. Hutchinson and Galal M. Said, 'Spatial Differentiation, Transport Demands and Transport Model Design in Kuwait', *Transport Reviews: A Transnational Transdisciplinary Journal* 10, no. 2 (1990): 91–110.
44 Al-Nakib, *Kuwait*.
45 Jane Drew, Maxwell Fry, *Tropical Architecture in the Humid Zone* (New York: Reinhold, 1956); Kenneth Frampton, 'Towards a Critical Regionalism: Six Points for an Architecture of Resistance', in Hal Foster, ed., *The Anti-aesthetic: Essays on Postmodern Culture* (Port Townsend, WA: Bay Press, 1983), 16–30.
46 'Facing Facts', *MEC* 3, no. 4 (1987): 19–20.
47 'As Solid as Concrete?', *MEC* 4, no. 5 (1987): 20–1.
48 Simon Dunkley, 'Housing Project Runs into Difficulties', *MEC* 12 (1980): 11; 'Ambitious Housing Projects Keep the Market Buoyant', *Kuwait Times*, 8 November 1981.
49 'Ambitious Housing Projects'.
50 'Design and Build', *MEC* 5 (1984): 29; 'Number One for Jubail', *MEC* 5 (1985): 21–3; 'Dynamic Management', *MEC* 4 (1986): 32–3.
51 John A. Davison, 'Computer Aids in Modern Architectural Practice', *Albenaa* 2, no. 9 (1981): 52–4; 'Salhia Complex Kuwait', *Arup Journal* 14, no. 2 (July 1979): 2–5.
52 Interview with Salah Salama, Kuwait City, 16 January 2014.
53 KEG Archive, Kuwait City.
54 Interview with Wojciech Jarząbek.
55 Ong Collier, 'Global Assemblages'.
56 Barry, 'Technological Zones'.
57 'Konferencja w PIHZ', *Rynki zagraniczne* 52–3 (1986): 11.
58 Grzywnowicz and Kiedrzyński, *Prawa i obowiązki specjalisty*, 26, 49–50.
59 Stanek, 'Miastoprojekt'; Łukasz Stanek, 'PRL™ Export Architecture and Urbanism from Socialist Poland', *Piktogram: Talking Pictures Magazine* 15 (2011): 1–54.
60 Interview with Al-Sanan.
61 See also: Donna C. Mehos and Suzanne M. Moon, 'The Uses of Portability: Circulating Experts in the Technopolitics of Cold War and Decolonization', in

Gabrielle Hecht, ed., *Entangled Geographies: Empire and Technopolitics in the Global Cold War* (Cambridge, MA: MIT Press, 2011), 43–74.

62 Muhannad A. Albaqshi, 'The Social Production of Space: Kuwait's Spatial History' (Ph.D. diss., IIT, 2010); Yasser Mahgoub, 'Kuwait: Learning from a Globalized City', in Elsheshtawy (ed.), *The Evolving Arab City*, 170.

63 Stanek, *Postmodernism Is Almost All Right. Polish Architecture after Socialist Globalisation* (Warsaw: Fundacja Bęc-Zmiana, 2012).

64 Interview with Wojciech Jarząbek.

65 See also Stanek, *Postmodernism*.

66 Alicja Gzowska and Lidia Klein, eds., *Postmodernizm polski*.

12

East-east architectural transfers and the afterlife of socialist postmodernism in Japan

Max Hirsh

In the early 1980s, the East German government commissioned the Japanese construction firm Kajima to build two luxury hotels in Dresden and East Berlin.[1] The hotels were part of a broader urban renewal program that deployed postmodern design in order to counter widespread dissatisfaction with the dilapidated condition of East Germany's inner cities, and to convert them into attractive destinations for foreign tourists and businessmen. Against the backdrop of intensified economic relations between the Eastern bloc and Japan – a largely overlooked facet of the late socialist period – the GDR entered into trade agreements with Japanese corporations, who promised to upgrade the country's international business and hospitality infrastructure.

For the design practitioners involved, the hotels served as a crucial platform for the cross-cultural exchange of knowledge: introducing East German planners to more advanced Japanese construction and project management techniques while exposing Japanese architects to postmodern design theories and architectural research methods that were being used in Europe. This essay, which is part of a larger research project on architectural exchanges between Japan and the GDR, traces the encounter between these design professionals at the Hotel Bellevue in Dresden and the Grand Hotel in East Berlin. Drawing upon archival research and interviews conducted in both countries, it argues that these projects represented a back-door conduit for the transfer of architectural knowledge that circumvented conventional channels of transnational exchange. I begin by situating the interaction between these designers within the broader context of economic relations

between Japan and the GDR, and against the backdrop of a renewed interest in history among East German architects and planners. I then investigate the use of historicist and contextual design approaches in Dresden and East Berlin, and finish by studying the unintended transfer of these architectural ideas back to Japan. In the conclusion, I argue that the interpenetration of East German and Japanese design techniques demands a re-evaluation of the dominant history of postmodernism, and of the globalization of architectural practice: one that transcends reductive divisions into East and West, and into capitalist and socialist modes of production. By highlighting alternative pathways of architectural knowledge and practice that connected a socialist country in Central Europe to a capitalist one in East Asia, the essay points to the critical role played by architects and design firms from outside of North America and Western Europe in the globalization of architectural practice. Far from a simple transfer of services from Japan to the GDR, these projects abetted the multinational exchange of architectural knowledge, engineering technology, building materials, and labour between more than a dozen countries in Europe and Asia. East German cities like Dresden and East Berlin thus operated as loci of syncretic architectural experiments that recombined the aesthetic, technical, and managerial precepts emerging from very different cultural and ideological systems.

In 1975, Günter Mittag – the economic secretary of East Germany's politburo and the chief architect of its planned economy – travelled to Japan in order to study the country's rapid post-war development. Impressed by what he saw, Mittag proposed a comprehensive trade agreement under which the East German government contracted Japanese conglomerates such as Mazda, Mitsubishi, and Nippon Steel to boost the GDR's output of high-value industrial products and consumer goods such as petrol, cars, and colour TVs.[2] These projects were administered by a parastatal body known as the Japan-GDR Project Committee (JGPC), through which the East German government also contracted Kajima, one of Japan's largest construction firms, to build trade centres and luxury hotels in East Berlin, Dresden, and Leipzig. Though unusual within the larger geopolitical context of the Cold War, these contracts were part of the GDR regime's strategy to stimulate business with the so-called *nichtsozialistisches Ausland*, or 'non-socialist foreign countries', in order to strengthen East Germany's hard currency reserves and reduce the crushing foreign debts that ultimately led to the regime's demise.[3] Moreover, government planners were keen to learn about Japanese advancements in building technology and project management in order to upgrade the overall quality of the GDR's construction industry without abandoning its reliance on a large-scale prefabrication.[4]

Founded in Edo in 1840, Kajima had made a name for itself in post-war Japan as an efficient builder of heavy infrastructure and high-rise modernist office buildings such as the Kasumigaseki Building (1968), the country's first 'super-tall' skyscraper. By cooperating with Kajima, East Germany's economic planners hoped to sidestep three obstacles that hampered the

growth of foreign trade: the absence of modern office facilities featuring basic amenities such as telex machines; the low standards of East German hotels, which were poorly designed and apathetically staffed; and the export restrictions of the West German government, which actively obstructed the transfer of engineering technology and building materials to the GDR.[5]

Cooperation with Kajima addressed all three of these challenges. The company's first project, the twenty-five-storey International Trade Center (1978) in East Berlin, aimed to stimulate foreign investment by providing high-quality office and meeting facilities for international firms. The second project, a modernist skyscraper in Leipzig called the Hotel Merkur (1981), was intended to facilitate deal-making during the annual *Leipziger Messe*, East Germany's most important trade fair. To ensure the rapid completion of these projections, Kajima helped to establish a subsidiary office in Vienna, which functioned as a transshipment centre for technical drawings and building materials that were sent from West Germany to Austria and then redirected to the GDR. Significantly, the Vienna office also supplied these projects with foreign construction workers, mainly from Greece and Yugoslavia, who could be deployed more cheaply and flexibly than their counterparts in East Germany's state-run construction combines.[6]

The Japanese architects encountered numerous hurdles, ranging from the intercultural to the logistical. Few of Kajima's employees had ever been outside Japan, and many were distressed by the prospect of working in a distant, isolated country. Moreover, they faced significant challenges to deeply held aesthetic and operational assumptions, and were perplexed by the vagaries of East Germany's planned economy, where systemic shortages often produced unexpected delays. As the GDR's economic crisis deepened, their East German clients increasingly resorted to high-end forms of barter, offering to exchange materials, technical services, and labour in the absence of a convertible currency.[7] Moreover, it was in East Germany where Kajima's architects were first exposed to the tenets of postmodernism: in particular historicism and contextualism which, under various socialist pseudonyms, became hallmarks of large-scale inner-city urban renewal plans throughout the country, including in Dresden and East Berlin.[8] These redevelopment projects aimed to bridge the gap between the 'old' pre-war urban landscape and the 'new' post-war city of socialist modernism by combining historicizing architectural elements with industrial construction methods.[9] Kajima's hotels for these cities – originally planned as modernist skyscrapers, the firm's area of specialization – were engulfed by this peculiar brand of socialist postmodernism, becoming show projects of both economic modernization and prefabricated neo-historicism.

The lead architect for the two projects was Takeshi Inoue, a lifelong employee of Kajima who lived in the GDR for nearly a decade. When Inoue made his first visit to Dresden to survey the site of the future Hotel Bellevue, he was dismayed to find a windswept terrain that had been neglected for decades and was dotted with derelict pre-war structures. He soon learnt that the hotel lay at the heart of an urban renewal scheme that focused on the reconstruction of the Saxon state opera house, or Semperoper. According to

this larger plan, the hotel was to be sited on the northern banks of the Elbe, at a bend in the river whose sweeping vistas of Dresden's skyline had been captured in a painting by Canaletto. Working together with the chief architect of Dresden, the director of the city's department for historic preservation, and the lead architect of the state-run hospitality chain Interhotel, Inoue, and his team – which included fifteen Japanese architects, engineers, and interior designers – were charged with building a hotel that would pay tribute to the so-called *Canalettoblick* by providing a space where well-to-do foreign visitors could enjoy the view of Dresden's reconstructed inner city (Figure 12.1).

The Bellevue's architectural brief foregrounded its role within that larger renewal scheme. It also pointed to a specific constraint – a baroque townhouse sat at the centre of the site – yet it did not provide any guidance on whether, or how, the townhouse should be preserved. The Kajima team prepared two design schemes: one incorporated the existing structure, which would lead to a longer and more expensive construction process, while the other projected the building's removal. Despite the protests of local preservationists, who had petitioned for the townhouse's restoration, Interhotel chose the cheaper scheme and instructed Inoue to plan for the building's demolition.[10]

None of this was out of the ordinary in the East German context, where the razing of pre-war structures was a routine phase of many new building endeavours. But what distinguished this particular project was its location within an area destroyed during the 1945 bombing of Dresden, which was recalled as an episode of severe national trauma by a large portion of the adult population in both German states. Dresden occupied a central position

FIGURE 12.1 *Perspective drawing of the Hotel Bellevue, Dresden. Image courtesy of Takeshi Inoue.*

in national discourses on the history of the Second World War and more broadly on the savagery of war. In late 1981, the demolition plans were leaked to a journalist at the West German *Frankfurter Allgemeine Zeitung*.[11] In an editorial entitled 'A piece of old Dresden is about to be torn down', the newspaper railed against the planned destruction of what it called 'the last remaining example of what was once one of Dresden's most precious Baroque thoroughfares'.[12] It noted that the destruction would come at the hands of 'a Japanese company, from whom one can hardly expect any understanding for the significance of *la vieille Saxe*'.

The article elicited a swift response on the other side of the border. Within days, Inoue was informed that his East German clients had changed their mind, and told to incorporate the baroque structure into the central façade of the building (Figure 12.2).[13] This proved to be difficult for the Japanese designers, none of whom had any experience working with traditional European construction techniques, and whose portfolio of post-war projects in Japan took a *tabula rasa* site as a given. Reared in a culture where it is common practice to demolish buildings after a few decades – and which assigns importance to the spiritual preservation of an historic site rather than to the literal continuity of its material composition – the Japanese architects were fascinated by the importance that their German clients placed on the physical preservation of historic building materials.

The attention that the hotel received in the West German press unleashed a hypersensitivity to history among Kajima's East German partners, who supplied them with pre-war maps, photographs, and site plans, as well as scholarly articles on the architectural history of Dresden. The city's chief architect also asked Inoue to familiarize himself with the history of Saxon baroque townhouses, along with their constitutive spatial and structural elements, such as interior courtyards and barrel vaulted ceilings. He also instructed the Kajima team to meet regularly with Wolfgang Hänsch – a prominent local architect who was leading the reconstruction of the Semper

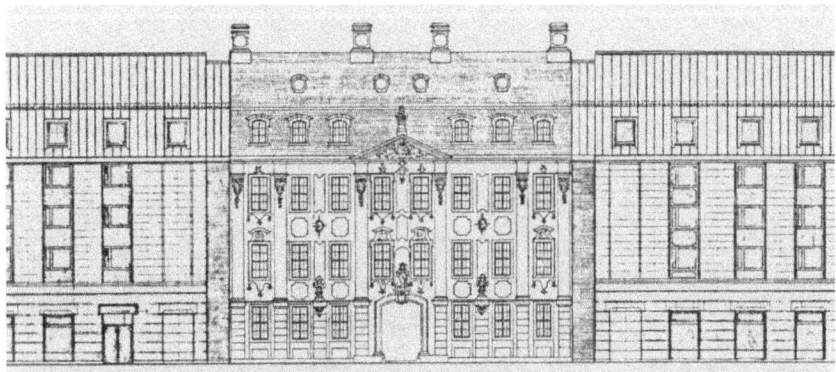

FIGURE 12.2 *The Hotel Bellevue, Dresden, with a Baroque townhouse incorporated into the building's central façade. Image courtesy of Takeshi Inoue.*

opera – in order to learn the basic principles of historic preservation, and to coordinate with a team of craftsmen who had been trained in traditional construction and ornamentation techniques. Finally, Interhotel asked Inoue to conduct a study tour of exemplary instances of contextual and neo-historical design in both Eastern and Western Europe, including Budapest's Hilton Hotel (1977), designed by the Hungarian architect Béla Pintér.

In effect, Inoue and his colleagues were given a crash course in how to conduct historically informed design research. For the Japanese architects, trained in the strictly modernist ethos of post-war architectural pedagogy, this approach seemed both retrograde and ill-advised. Several of the architects whom I interviewed noted that they had learnt, both at university and afterwards in professional practice, that it was 'forbidden' to use historical styles and motifs.[14] Yet Kajima's clients asked them to base their design process on a rigorous interrogation of archival materials that documented the historic urban fabric of Dresden. This entailed not just developing an appreciation for the aesthetic vocabulary of baroque, romantic, and *Gründerzeit* architecture, but also acquiring a working knowledge of its structural and technical underpinnings. The resulting hotel was invested with a heavy-handed dose of contextualism and labour-intensive restoration, efforts that were designed to demonstrate the ability of Dresden's architects and urban planners to adapt the historic inner city to contemporary technical demands and economic functions. The building's proportions acknowledged both the baroque townhouse and the modernist apartment blocks across the street, juxtaposing eighteenth-century height restrictions and angled mansard roofs with the jagged allotment plan of post-war prefabricated housing blocks located across the street. The façade foregrounded the use of locally produced sandstone. In keeping with historic conventions, the roof was clad in copper, while the vertical window treatments were intended as a reference to the Japanese Palais, commissioned by the Saxon king August the Strong to house his porcelain collection (Figure 12.3).[15]

The Hotel Bellevue and the restored opera house were inaugurated simultaneously on 13 February 1985, which marked the fortieth anniversary of the bombing of Dresden. Two hundred thousand people – nearly half of Dresden's population – flocked to the inner city to witness the premiere of Weber's *Der Freischütz*: the last piece that had been performed before the opera shut down at the end of the Second World War.[16] In the first media event of its kind, the premiere was broadcast simultaneously on both East and West German television. As the performance drew to a close, foreign dignitaries and tourists retired to the Bellevue, which afforded views of the opera house across the river Elbe.

Kajima's successful contribution to what was not just a complex urban renewal project, but also an elaborate multimedia *mise en scène* of Dresden's belated rise from the post-war ashes, led to the company's participation in another one of the GDR's showcase urban renewal projects: the restoration of East Berlin's centre, which was redeveloped in the run-up to the 750th anniversary of the city's founding that was celebrated in 1987.

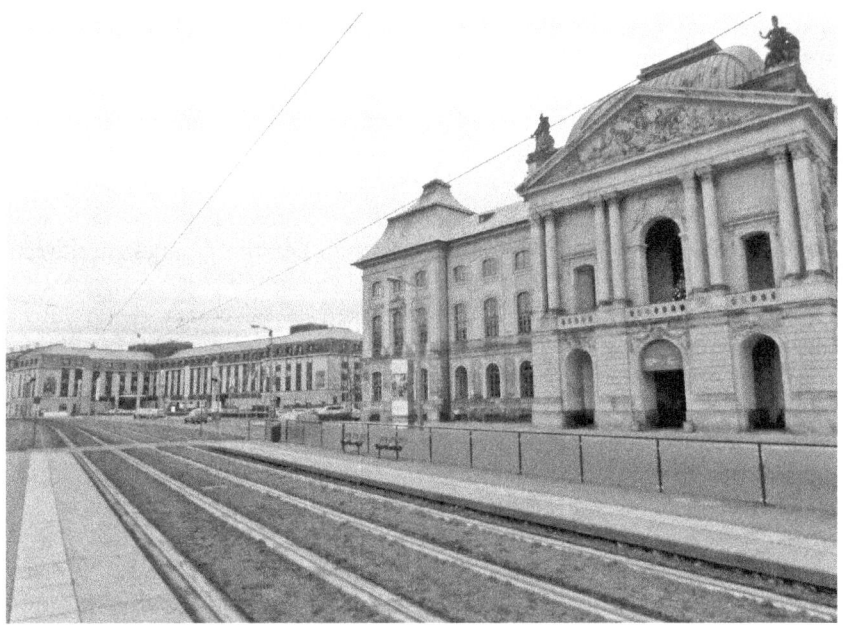

FIGURE 12.3 *The Hotel Bellevue (left), sharing the copper cladding and vertical window treatments with the adjacent Japanisches Palais (right). Photo courtesy of Max Hirsh.*

A key component of this urban renewal scheme was the reconstruction of Friedrichstrasse, downtown East Berlin's most important – and long neglected – central avenue. Within a fifty-block zone, more than hundred shops and high-end boutiques, fifty bars and restaurants, and a dozen luxury apartment buildings were to be erected.[17] The plan's ultimate goal was to turn Friedrichstrasse into an 'attractive socialist world city boulevard': one that heralded the conversion of East Berlin's run-down inner city into an attractive destination for both East German citizens and foreign visitors.

The Grand Hotel, a luxury property designed for the needs of foreign tourists and businessmen, was one of the showpiece projects of the new and improved Friedrichstrasse (Figure 12.4). Under the tutelage of Erhard Gißke, the director of the construction ministry's influential Special Projects Division, Inoue designed an historically accurate amalgamation of two pre-war structures: the Kaisergalerie, a neo-Renaissance shopping arcade built on the site of the future hotel in 1873; and the Hotel Adlon, pre-war Berlin's most famous luxury hotel, which was erected next to the Brandenburg Gate in 1907. To assist him, Gißke provided Inoue with a chronicle of the Adlon, published shortly before the outbreak of the First World War.[18] He encouraged Inoue to use the chronicle, which featured photos of lavish interiors interspersed with portraits of the royal family, as a template for designing the new hotel as well as a street-level arcade filled with reproductions of historic restaurants, cafés, and nightclubs. In essence, Gißke requested a faithful

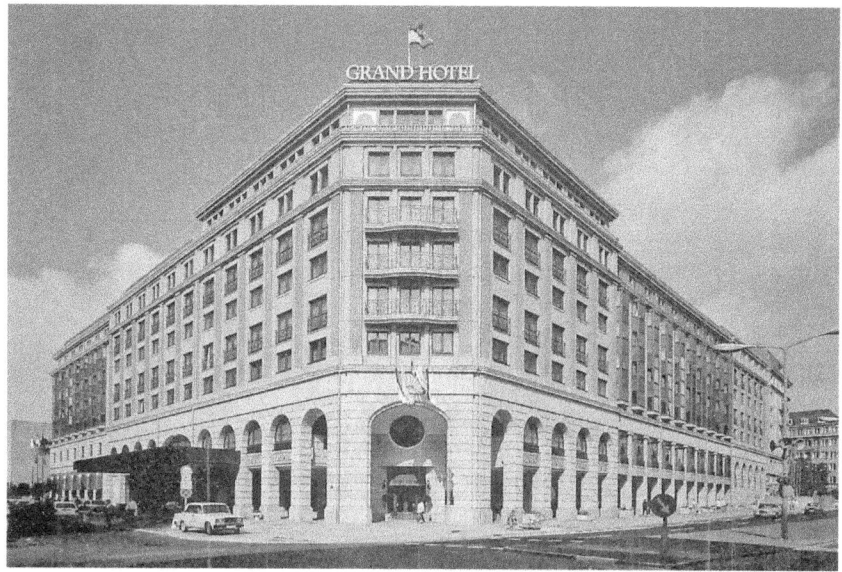

FIGURE 12.4 *The Grand Hotel, Berlin. Photo courtesy of Kajima Corporation.*

reproduction of Wilhelmine architecture – with one large caveat. Instead of using traditional stonemasonry techniques, the Kajima team would need to rely on pre-cast concrete panels: the dominant building material deployed by the GDR's state-run construction combines, to which Gißke and his colleagues attached tremendous aesthetic and ideological importance. In order to grasp the formal potential of prefabricated historicism, Gißke invited Inoue to join him on a trip to the suburbs of Paris, where they toured several postmodern housing estates designed by Ricardo Bofill.[19]

The hotel consisted of a monolithic steel frame covered in pre-cast panels. Through the panels' clever deployment and the selective use of more expensive finishes such as sandstone cladding and granite plinths, the hotel appeared to be composed of six separate buildings, differentiated through the strategic use of fascia, setbacks, and jetties (Figure 12.5).[20] Considered one of the crowning achievements of neo-historical prefabrication in the GDR, the Grand Hotel's subdivided façade thus paid tribute to Friedrichstrasse's pre-war allotment plan. Meanwhile, the hotel's interior, designed by the architect Kazuo Yamane, relied on the work of skilled East German craftsmen, who produced handmade reproductions of Biedermaier and 'rococo-style' furniture, light fixtures, and finishes made of wood, brass, and stucco.[21]

In both Berlin and Dresden, the Kajima team took an autodidactic approach to a postmodern design methodology that rested on the reproduction of individual reference cases and the careful study of local history and building traditions, coupled with an attempt to combine those traditions with modern construction techniques and building materials.

FIGURE 12.5 *The façade of the Grand Hotel, Berlin. Photo courtesy of Max Hirsh.*

This particularly conservative brand of postmodern design enjoyed an unacknowledged afterlife in Japan. As the GDR teetered on the brink of collapse, Kajima reassigned several architects who had worked in East Germany to produce a chain of 'European' hotels in Japanese cities such as Kobe, Nagasaki, and Sapporo.[22] The choice of these locations was not accidental: due to a history of contact with European merchants and architects, they all contain an unusually large collection of both Western and 'Western-style' (*giyofu*) architecture. From the late 1980s onwards, the 'exotic' architectural legacy of these foreign encounters came to be viewed as a vehicle for stimulating domestic tourism. Working with the hotel operator Monterey, Kajima developed a series of European-themed leisure environments that drew extensively on the urban research skills and design techniques that the firm's architects had acquired in the GDR.

The parallels are perhaps most evident at the Hotel Monterey Sapporo (1994), whose façade represents an elaboration of Inoue's design for the Grand Hotel, adapted to the narrower plot sizes and high-rise proportions of Japanese cities (Figure 12.6). A close inspection reveals a high degree of continuity between the two hotels' vertical façade treatments, use of fake setbacks and ornamental balconies, and distinctive roof-level signage. Design features deployed by Yamane in the Grand Hotel's interior and landscaping, such as a palm garden and pavilion, are likewise reproduced. Meanwhile, at the Hotel Monterey Kobe – opened in 1989, one month before the collapse of the GDR – the formal similarities to the Hotel Bellevue's Saxon courtyard are underscored by the use of prefabricated granite panels in the arches and pillars, echoing the emphasis on industrially assembled historicity applied in Dresden and East Berlin. The baroque-era proportions of the Saxon merchant's house likewise extend to the barrel vaulted ceilings in the hotel's reception and lounge areas. Echoes of the Hotel Bellevue are also evident at the Hotel Monterey Kyoto, where Kajima's architects drew

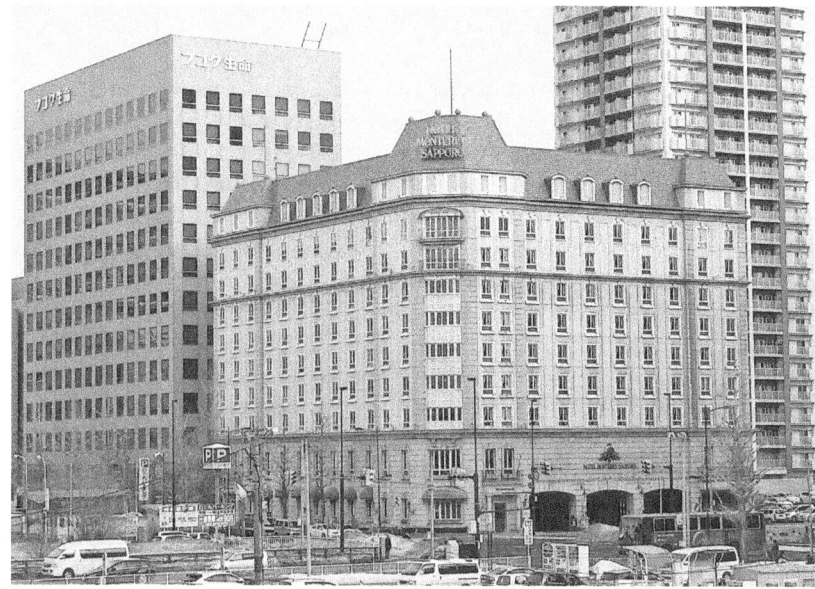

FIGURE 12.6 *Hotel Monterey, Sapporo. Photo courtesy of Max Hirsh.*

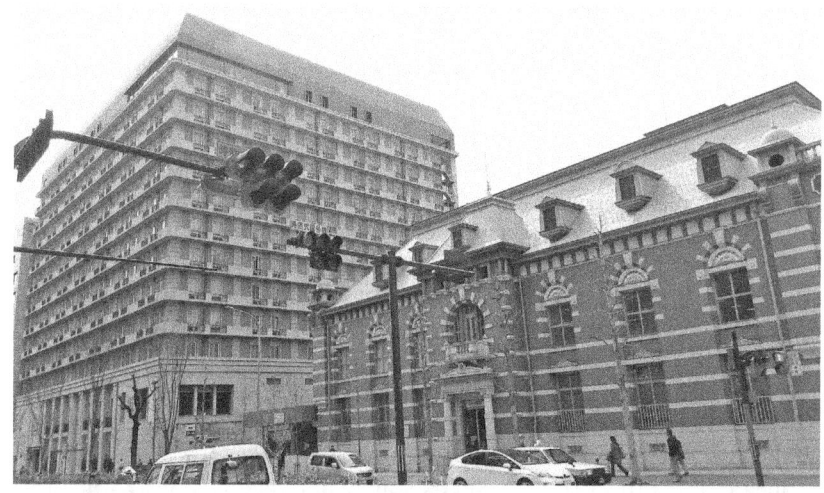

FIGURE 12.7 *The Hotel Monterey, Kyoto, deploys contextual strategies, similar to those used by Kajima's architects in Dresden, in order to reference an adjacent building designed by Kingo Tatsuno, one of Japan's first Western-educated architects. Photo courtesy of Max Hirsh.*

upon strategies devised to link the Hotel Bellevue to the adjacent *palais*, such as the use of horizontal strips and window treatments, as a means of referencing a nearby bank building, designed in 1906 by the architect Tatsuno Kingo (Figure 12.7).

Conclusion

The accelerated circulation of images and styles, and their sometimes peculiar recombination, is a defining facet of both postmodern aesthetics and the globalization of architectural practice. Berlin's Grand Hotel physicalizes their intersection: for while the facade represented a sanitized rendition of Wilhelminian architectural aesthetics, the hotel's massing, structural design, and perspectival orientation towards the street corner rehearsed the basic features of Kajima's standard perimeter-block office typology, which the firm developed in Japan from the 1950s onwards. Inoue had become familiar with that building type while designing a department store in Hiroshima in the early 1970s. In essence, then, the Grand Hotel combines the underlying structure of a Japanese commercial typology with a prefabricated historicist facade typical of East German postmodern urban renewal projects. The duplication of the Grand Hotel in Sapporo can thus be read as an act of typological re-import, enabled by the increasing global mobility of Japanese architects and the attendant exposure that working abroad gave them to postmodern design methods.

In the final years of the GDR, architects experimented with postmodern design techniques in order to instil a sense of patriotism – or what was called *Heimatgefühle* – in a population that was deeply critical of the regime's mismanagement of the economy, and was alienated by the practical and aesthetic shortcomings of the urban landscape. In response, architects and urban planners deployed neo-historicism in order to promote civic pride and an appreciation for local traditions, as well as contextualism, in order to enact a sense of continuity between these cities' disjointed pre- and post-war urban development. Yet while projects like the Bellevue in Dresden and the Grand Hotel in Berlin were motivated by a desire to return to regional styles and local traditions, the means by which they were produced portended a fundamental shift away from national building cultures and towards the globalization of architectural practice. Beneath the neo-Wilhelmine façade of the Grand Hotel and the baroque fixtures of the Bellevue lay design, engineering, and construction processes that incorporated goods, people, and ideas from Japan, Sweden, Yugoslavia, Austria, Hungary, Switzerland, West Germany, France, the United Kingdom, and Greece. In that sense, the two hotels can be read as the loci of a nascent European integration: coordinated, somewhat incongruously, by design professionals from Japan.

Contemporary publications about these hotels tended to elide the transnational dimensions of their production. One women's magazine, for example, published a full-colour spread of the Grand Hotel, accompanied by a text that suggested that its superior design was the product of fruitful collaboration between workers hailing from all over the GDR – Berlin, Schwerin, Cottbus, Karl-Marx-Stadt, Erfurt – who had come

together to harness the collective strength of the entire republic in order to rebuild the national capital.[23] Grand Hotel certainly hosted an unusual confluence of architects, engineers, and construction workers – but they weren't just from Cottbus and Karl-Marx-Stadt, but also from Tokyo and Thessaloniki. Indeed, the patriotic discourse that surrounded historicist renewal projects is rendered problematic when one considers the syncretic conditions surrounding the genesis of these hotels, which were designed by Japanese and East German architects, and which relied on construction workers from the Balkans to assemble West German technical equipment and prefabricated panels from Scandinavia. Moreover, the hotels catered primarily to foreign tourists and investors. After all, these were so-called *Devisenhotels*: where payment could only be made in hard currency, and which remained beyond the grasp of the average East German. In effect, the visual language of contextualism and the political discourse of national solidarity masked the incipient globalization of East Germany's construction industry. Both projects were built with the publicly averred commitment to the preservation of national culture and local identity – yet their ultimate effect was to accelerate the influx of global capital, migrant labor, and foreign visitors into East German cities.

Notes

1 The author would like to thank Kohei Kitayama, Setsuo Maruyama, Tadao Nodeki, Ken Tadashi Oshima, Hiroki Sugiyama, Takeshi Inoue, and Osamu Ueno for their critical support during the fieldwork stage of this project. He also thanks Kirsten Angermann, Regina Bittner, Eve Blau, Bruno Flierl, Seng Kuan, Vladimir Kulić, Alexander Rehding, Tanja Scheffler, Thomas Topfstedt, Daniel Trambaiolo, Manfred Zache, and Jun Zhang for their helpful comments and suggestions, as well as Sayuri Kakiuchi and Anri Maruyama for their research assistance. The project was funded through the generous support of the Hang Seng Bank Golden Jubilee Education Fund for Research.
2 Hans Modrow, et al., *Die DDR und Japan* (East Berlin: Dietz Verlag, 1983), 101–2.
3 On the GDR's debt problem, see Charles Maier, *Dissolution: The Crisis of Communism and the End of East Germany* (Princeton, NJ: Princeton University Press, 1997).
4 Hans-Christian Herrmann, 'Japan—ein kapitalistisches Vorbild für die DDR?' *Deutschland Archiv* 39, no. 6 (2006): 1033, 1041.
5 Kazuo Sasagawa, 'Vier große Bauprojekte in der ehemaligen DDR. Die schlüsselfertigen Bauprojekte durch [sic] Bauunternehmer Kajima, Tokio, Japan'. Lecture at Brandenburg Technical University of Cottbus, June 1999. See also 'Cocom: Ein "Relikt des Kalten Krieges",' *Der Spiegel* 34 (1988): 80–3.
6 *Fußspur. Kajima DDR Projects, 1985–1987* (Tokyo: Kajima, 2002), 38–9.
7 *Fußspur. Kajima DDR Projects, 1985–1987*, 68–70.

8 On the reception of postmodernism in the GDR, see Bruno Flierl and Heinz Hirdina, *Postmoderne und Funktionalismus: Sechs Vorträge* (East Berlin: Verband Bildender Künstler, 1985). See also Klaus Andrä and Wolfgang Weigel, 'Tendenzen der städtebaulichen Entwicklung von Stadtzentren in sozialistischen Ländern', *Architektur der DDR* 37, no. 8 (August 1988), 54–6. Ule Lammert, ed., *Städtebau. Grundsätze, Methoden, Beispiele, Richtwerte* (East Berlin: VEB Verlag für Bauwesen, 1979). Torsten Lange, 'Haus der heiteren Muse. Der Friedrichstadtpalast und die Kritik des "Postmodernismus" in der DDR', trans. 26 (March 2015): 128–37.

9 For more on postmodern urban renewal in East Germany, see Max Hirsh, 'Intelligentsia Design and the Postmodern *Plattenbau*', in Kenny Cupers, ed., *Use Matters: An Alternative History of Architecture* (London: Routledge, 2013), 169–82.

10 *Fußspur. Kajima DDR Projects, 1985–1987*, 17.

11 Takeshi Inoue, Interview with the author at Inoue's home in Higashimatsubara, Tokyo, 28 February 2015.

12 'Ein altes Stück Dresden vor dem Abriß', *Frankfurter Allgemeine Zeitung* 22 (December 1981): 7.

13 *Fußspur. Kajima DDR Projects, 1985–1987*, 59.

14 Tadao Nodeki, Interview with the author at Kajima KI Building, Akasaka, Tokyo, 2 March 2015.

15 w*Fußspur. Kajima DDR Projects, 1985–1987*, 84–5.

16 'Der Freischütz mit der Wunderharfe', *Der Spiegel* 7 (1985): 176–80.

17 On the reconstruction of Friedrichstraße, see Urban, *Neo-Historical East Berlin*.

18 Takeshi Inoue, Interview with the author at Inoue's home, Higashimatsubara, Tokyo, 2 March 2015.

19 Ibid.

20 Roland Korn, 'Schöpferische Beiträge der Architekten für die Beschleunigung des Wohnungsbaus und die weitere Ausgestaltung unserer Hauptstadt Berlin', *Architektur der DDR* 5, no. 85 (May 1985): 263.

21 Takeshi Inoue, Interview with the author at Inoue's home, Higashimatsubara, Tokyo, 2 March 2015.

22 Ibid. Also Osamu Ueno, Interview with the author at Kajima KI Building, Akasaka, Tokyo, 2 March 2015.

23 Conrad Tenner, 'Jungbrunnen für eine alte Straße', *Für Dich. Illustrierte Wochenzeitung für die Frau* 37, no. 86 (September 1986): 12.

13

Expanding architectural discourse in early reform-era China, 1978–89

Cole Roskam

The term 'postmodernism' was first publically introduced to China's architectural community in January 1980 through an article published in *Architectural Journal* by Yang Yun, a member of the China Academy of Building Research.[1] In the piece, Yang provided a survey of recent and contemporary foreign scholarship on the term, with references to the work of figures like *The New York Times's* critics Paul Goldberger, Robert Stern, and Charles Jencks, among others. The article also featured a jumble of visual references, including the Vanna Venturi house (1964) by Robert Venturi, the Yoyogi National Gymnasium by Kenzo Tange, completed in anticipation of the 1964 Olympic Games in Tokyo, and Charles Moore's faculty lounge for the University of California at Santa Barbara (1968), among others. Although Yang was quick to dismiss postmodernism's direct relevance to socialist China, particularly given the theory's association with capitalism, Yang saw two potential lessons for Chinese architects. The first concerned the value of architectural form in inspiring people and serving vital social and cultural functions. The second related to closing the developmental and conceptual gap that had long separated China's architects from other, more capitalistically inclined parts of the world.

The publication of Yang's essay occurred as Deng Xiaoping and other reform-minded party leaders had just begun the difficult process of reforming China's state-run economy. Deng assumed power over the party in 1978, and he quickly launched the 'Four Modernizations' campaign in an effort to

spur the country's agriculture, industry, science and technology, and defence sectors forward in an effort to join the world's most industrialized nations by the year 2000. Foremost among Deng's challenges was how to overcome Mao-era policy that the party control all aspects of China's economic production.² 'Readjustment, consolidation, restructuring, and improvement of the economy' became the party's new mantra, and a series of new policies was launched that aimed to improve the productive capability of China's state-run economy through the introduction of more market-friendly approaches.

These changes did more than simply transform the nature of economic production in China; they also redefined the role of architecture in socialist Chinese society. Under Mao, architectural production was designed to promote collectivity and social revolution through class struggle. With reform, new kinds of architecture were sought – projects capable of mediating China's nascent relationship to international capital without completely discrediting the Chinese Communist Party's (CCP) ideological raison d'etre. Over the course of the 1980s, the country's architectural establishment struggled to synchronize competing visions within the party and project them into a definitive set of aesthetic, discursive, and formal terms that would inspire the general populace while mitigating the risks of destabilization posed by China's economic restructuring and intensified international interactivity. Architectural ideas from around the world were imported into China in an effort to encourage its architectural community to rapidly improve both the quality and quantity of its physical and theoretical production.

One of the most influential ideas to take root in early, reform-era Chinese architectural discourse was the notion of postmodernism. Postmodernism's influence upon reform-era Chinese art, literature, and film has received significant scholarly attention, but the term has been generally dismissed in relation to China's reform-era architectural discourse on the grounds that it constituted little more than a 'superficial' and confused engagement with a foreign importation.³ Some have omitted it from the recent history of Chinese architecture altogether.⁴ Nevertheless, the history of postmodernism in reform-era China remains relevant for several reasons.

China's architectural trajectory over the course of the 1980s was obviously distinctive from other parts of the world. For one, China lacked the economic and political conditions for the kinds of criticality historically understood as vital to postmodern discourse as it developed in the United States and Europe, and many of China's architectural establishment quickly came to understand the limitations of postmodern theory in relation to China. Nevertheless, and as this chapter argues, postmodernism offered a vital, new mode of expression for a Chinese architectural community actively seeking new theoretical purchase following the rigid orthodoxy of Mao-era design methodology.

On the one hand, China's efforts to define and understand postmodernism in relation to its own architectural development signified nothing more

than a superficial engagement with a foreign discourse that did not have any relation to the transformative economic and cultural changes taking place in China at the time. At the same time, however, China's shift away from Maoist positivism and towards the uncertain abstractions of the market triggered self-critical reassessments within China's state-run architectural industry that seemed to resonate with the so-called postmodern experiences in other parts of the world, even if the catalysts for and motives behind such introspection may have been unique to the post-Mao China milieu. As this chapter argues, the very presence of postmodern discourse in early reform-era China was productive insofar as it provided architects and intellectuals with an opportunity to expand the terms of China's own architectural conversation. The selective borrowing and, at times, misappropriation of foreign theory that accompanied China's architectural development contributed to broader conceptual rationalizations taking shape in relation to the country's rapidly changing economic and political landscape.

Defining a post-revolutionary architecture

The 1978 launching of groundbreaking economic reforms in post-Mao China posed challenges for socialist Chinese architectural production and theory that were distinct from late Maoist problems of architectural discourse and representation. Naturalizing the reformations of power taking shape in China through architecture, and rendering them both physical and palatable to the broader Chinese architectural community and the public at large, was paramount. How to do so remained unclear, however. Of primary concern to officials and designers alike was the question of terminology to describe post-Mao China's uncertain economic condition. Periodization, and specifically Marx's universal stages of historical development, remained vital to socialist Chinese ideology. One of the most consequential intra-party debates to take shape over the course of 1977 and 1978 concerned the language needed to convey the extraordinary scale of national economic development still to be achieved throughout the country without denying the achievements of Mao-era governance or the broader superstructure of Marxist thought considered imperative to the CCP's legitimacy.[5]

Ultimately, officials settled on the notion of an 'undeveloped socialism' (*bufada de shehui zhuyi*) and the proposed addition of two sub-periods between traditional historical moments in China's interpretation of Marxist evolution – the first extending from the initial victory of the proletariat to the socialist transformation of the ownership of the means of production, and the second extending from that point to the moment when full socialism is reached.[6] This distinctive theorization was unique from the so-called developed socialist state imagined by Marx and Lenin, insofar as it suggested a political revolution still in process, and not yet achieved. It was also a risky reconceptualization, coming after years of state-sanctioned

propaganda designed to reassure the Chinese public of the country's unwavering advancement towards communism vis-à-vis all other capitalist and socialist rivals.[7]

Adapting China's political history to the urgency for economic change required contribution from numerous forms of cultural production, in particular architecture. During the Cultural Revolution, imperial-era art and architecture were literally and figuratively attacked as an inconvenient reminder of the country's feudal past – indeed, the physical destruction of such monuments was justified on the grounds that it liberated the people from the vestiges of imperialism while redirecting the constructive energy of cultural producers towards the urgency of social revolution.[8] Reform constituted a different and complex ideological configuration – one that acknowledged both the limitations of China's state-planned economy and the benefits of less-controlled international exchange. Through these shifts in policy, new discursive spheres were allowed to develop. In architecture, designers could begin to test the teleological stability of the country's so-called modern condition in aesthetic and formal terms.

Beginning in 1979, and following a national conference for China's building industry organized around architecture's participation in the Four Modernizations campaign, *Architectural Journal* published a series of articles exhorting the country's architectural establishment to embrace the new reformist spirit in socialist Chinese architectural design. Provocatively titled 'Break up the Old and Establish the New to Further Raise the Design Level', 'Emancipate the Mind, Endeavor to Do the Design Work Still Better', and 'Crush the Mental Fetters and Raise the Design Level', these articles identified the major obstacles impeding Chinese architects from fully realizing their potential as designers during the Cultural Revolution.[9] They were followed, in January 1980, by Yang's piece on postmodernism and its potential lessons for China.

Importantly, Yang's essay begins with what, at first glance, appears to be a mistranslation of the term – *houxiandai zhuyi* in Chinese – as *xinxiandai zhuyi*, or neomodernism.[10] The malapropism seemed to reveal the challenges posed by the rapid influx of foreign architectural discourse into a country ill-equipped to contextualize them.[11] Such misunderstandings were not only due to a lack of familiarity with the term, however. Confusion surrounding postmodernism's translation into Chinese revealed an abstruseness endemic to the original discourse itself. As numerous other scholars have pointed out, the very notion of postmodernity was ill-defined from its inception.[12] Over the course of the late 1960s and early 1970s, the published work of figures like Paul Goldberger, Robert A. Stern, and Charles Jencks refined their respective understandings of the term, its alternatives, and its potential meaning in relationship to architectural modernism.[13] It was Goldberger, for example, who initially used the term 'ultra-modern' in reference to what would later be more specifically identified as postmodernism.[14] The second edition of Stern's *New Directions in American Architecture* (1977) includes

the author's acknowledgement that his reassessment of the work of figures like Venturi and Moore necessitated their re-categorization from some late stage of modernism to 'post-modern'.[15] Jencks was famously known for dating the death of modernism to the demolition of Pruitt Igoe housing complex in 1972, only to retroactively attribute its demise to the 1961 publication of Jane Jacobs's *The Death and Life of American Cities*.[16]

These debates, succinctly noted by Yang in his own essay, posed additional challenges when translated both into a foreign language and a vastly different socioeconomic and cultural context such as early reform-era China. Following years of America's vilification by the party, Chinese architects struggled to react to the government's decree that designers now learn from foreign, particularly American, architectural discourse.[17] Moreover, and as Yang admitted, 'assessing the state of Western architecture is incredibly complex'.[18] Following years of isolation from Western European and North American design and discourse, however, Yang's efforts were notable for their responsiveness. Although China's architectural elite had access to foreign journals and were likely aware of the term, many within the country's architectural and construction industry may have been introduced to the term for the first time through Yang's article. In this respect, the essay gestured towards the acceptability of exposure to capitalist-fuelled design and, by extension, the value of international architectural exchange regardless of its ideological origins or intent. Yang's piece made brief reference to a dizzying array of topics and projects, from the work of Team X to the Parthenon to post-war Japan. Yang saw important lessons for China in post-war Japanese architecture, and he applauded the country's shrewd domestication of foreign technology into internationally recognized form through projects such as the International Conference Center in Kyoto (1964) by Sachio Otani. Intertwining several Chinese projects, including the Sirimavo Bandaranaike Memorial International Conference Hall in Colombo, Sri Lanka, begun in 1963 and eventually completed in 1973 by the Chinese Academy of Building Research under the supervision of Yang and Dai Nianci, with contemporaneous foreign examples also helped to resituate China within a broader, global architectural narrative (Figure 13.1). Through the essay, readers could see a new, more expressive Chinese architectural language emerging in parallel to, but not necessarily in direct connection with, postmodern theory in the West.

These new relativities, coming years after state-supported absolutism forbidding contact with non-socialist swathes of the world, represented unprecedented and intoxicating moments of proximity and simultaneity for China's architectural elite. Numerous foreign designers and theorists visited post-Mao China over the course of the 1980s, and few completely understood or appreciated the depth of China's intellectual thirst for discourse and history of any kind. For example, Japanese architect Yoshinobu Ashihara (1913–2008) was shocked to learn of Chinese audience members' interest in postmodernism following his public lecture at Tianjin University's

FIGURE 13.1 Yang Yun, "Some Ideas Connected with New Trends in Western Contemporary Architecture," Architectural Journal, no. 1 (1980): 26–27.

Architecture Department in 1981.[19] Among Yang's most obvious influences was Jencks, who was married to Maggie Keswick, daughter of Sir John Keswick, head of the Scottish trading conglomerate Jardine Matheson, who returned to business in mainland China in 1979. Jencks had the opportunity to travel to China with his father-in-law at the time and delivered what is believed to be the first lecture on postmodernism in China, to faculty at Tsinghua University – a lecture that, in part, may have prompted Yang's article.[20] Jencks subsequently expressed surprise at the speed with which unauthorized translations of his own book, The Language of Post-Modern Architecture, appeared in 1986.[21]

Officially, China was in the midst of a national modernization effort that precluded any discussion of a distinctly Chinese postmodernism. Yet party representatives were aware of the variegated forms of cultural expression beginning to emerge around the country, if not necessarily the implications they presented for a Chinese society in dramatic and unsteady flux, and they saw the intellectual and economic benefits of such engagement. In particular, Deng Xiaoping, later dubbed 'The Chief Designer' for his far-reaching reformist vision, understood that overly strict enforcement of party rules would suffocate the country's nascent economic liberalization.[22] Only by providing architects unfettered access to international ideas and information such as postmodernism could they begin to move beyond the horrors of the Cultural Revolution and help begin to redefine the limits of creative cultural production in China.

At the same time, however, CCP leaders were unsure of exactly how to encourage architects to pursue innovation when, just years prior, people had been severely punished, even jailed, for promoting such beliefs. In this respect, it was through Chinese debate over postmodernism and its exact meaning that the term's discursive value to the Chinese state presented itself. Postmodernism's pliancy, to quote Johann P. Arnason, made it 'adaptable to the most diverse ideological positions'.[23] Charles Jencks has traced such confusion to the kind of 'double-coding' taking place in postmodern design, which was based on 'the combination of modern techniques with something else (usually traditional building) in order for architecture to communicate with the public'.[24] Such mutability, or double-coding, had distinctive political advantages in China, where the government's new economic agenda demanded an architectural expression capable of satisfying reform-inclined officials, comforting their more conservative counterparts, accommodating sudden shifts in party doctrine, and re-engaging a disaffected Chinese public.

Debating a post-revolutionary architecture

In January 1983, a public event devoted to the relationship between architecture, governance, and technology convened at the Great Hall of the People in Beijing underscored the challenges of concealing the country's recent past through the production of a new architectural present.[25] Co-organized by the Architectural Society of China and the China Association for Science and Technology, the symposium was designed to clarify the role of the architect in post-Mao China, particularly the designer's responsibility in harnessing of technological innovation to the broader interests of the state. Chen Zhanxiang (1916–2001), also known as Charles Chen, a University of Liverpool graduate, former assistant to Sir Patrick Abercrombie (1879–1957), and member of China's Urban Planning Bureau, argued for greater autonomy to produce quality work and avoid the homogeneity rampant in socialist Chinese architectural production.[26] Discussion also included broader questions concerning the ideological role of architectural production in a reforming China. Xiao Tong, vice minister of the Ministry of Urban and Rural Construction and Environmental Protection, noted that 'we talk about architectural style, but what do we call the new socialist style? What, exactly, we call a socialist style affects what we call a capitalist style, meaning that these can easily be confused.'[27] Dai Nianci (1920–91), one of China's most prolific architects, reiterated these concerns. 'When we say a "city modernized through socialism with Chinese characteristics", what kinds of conditions does this exactly describe?'[28]

Such questions help to illuminate the value of postmodern theory in early reform-era China. If reform presented the political and economic justification for Chinese designers to rehabilitate earlier paradigms of

Chinese architectural production for a political party eager to re-legitimize itself domestically, postmodernism – and foreign theory in general – thus helped China to reframe its economic liberalization as a temporary step in the country's continued development towards communism, and, more generally, at a time in which broader, international architectural zeitgeist seemed to revolve around questions directly relevant to China's post-Revolution condition, including the revival of historicism and the need for more inclusivity and variety in China's architectural expression. The very indeterminacy of postmodernism aided China's architectural community in broadening the conceptual spectrum for a new, reform-inspired discourse that acknowledged China's undeveloped socialism in material terms and offered theoretical proposals to address it.

Engagement did not come without the risk of repercussion, however, particularly as heated ideological disputes over the degree of reform necessary to improve China's economy continued to reverberate throughout the country's political sphere. In January 1983, Alvin Toffler was invited to China to discuss his international bestsellers *The Third Wave* and *Future Shock*, both of which theorized the impact of a new, information-based industrial revolution and the unsettling cultural effects of rapid, global technological change. Reform-minded officials were intrigued by the possibility that China could somehow skip specific stages of development – that, for example, and in accordance with Toffler's theory, a country could have characteristics of preindustrial and postindustrial development at the same time.[29] Importantly, an information revolution was also, in theory, both class neutral and based on models easily transferred from abroad.[30] Yet Toffler's theories also prompted strenuous objection by conservatives to any talk of a postindustrial society, which they felt challenged core party orthodoxy regarding the belief that China's proletarian socialist revolution represented the final act of its own political and economic making. In October 1983, the government's leftists launched a campaign against 'spiritual pollution', or what was seen as Western-influenced principles believed to have infiltrated the Chinese psyche.

The campaign was quickly put down by Deng and other reform-inclined representatives, but it illuminated the sensitivities at work in challenging the established teleology of the country's political economy. The CCP's tolerance for criticality had limits, and any imported, untested theory carried the potential to destabilize the intellectual public sphere. Despite the relative freedoms necessitated by reform, architecture remained a key contributor of significant representational and practical value to socialism, and designers remained public servants beholden to meeting the needs of the people.[31] The state's relationship to its physical environment was an important component of its authority, and one not taken lightly.

One foreign visitor who theoretically understood such ideological delicateness was Fredric Jameson, who spent the fall of 1985 at Beijing University as a visiting scholar sharpening his own postulations on postmodernism. Over the course of several months, Jameson conducted several

lectures to packed audience halls of eager students at Beijing University and Shenzhen University. However, there is no evidence that he engaged with China's architectural community during his time in China, and he did not believe that China's new landscape was postmodern.[32] Following his stay, Jameson famously allegorized China as 'an unfinished social experiment' exhibiting 'the freshness of a whole new object world produced by human beings in some new control over their collective destiny'.[33] In reality, however, the new object world taking shape in China was very much the product of more substantive Chinese engagement with international capital and the new architectural forms and theories it fuelled – a concerted and official move beyond Maoist notions of modernity through class struggle in favour of some new, state-sanctioned politics and economy of culture. The very possibility of a postmodern era helped to prompt a reassessment of the meaning of the modern in China. Indeed, and as Wang Chaohua has noted, the Chinese translation of Jameson's lectures, published in 1986 as *Postmodernism and Cultural Theory*, notably removed the term 'late capitalism' from Jameson's original title, effectively allowing China's intelligentsia to subsequently interpret and promote mass culture and consumerism as a new realm for individual liberty.[34]

Meanwhile, the materialization of hundreds of new hotels, museums, cultural centres, government offices, and schools around the country, each engaging with a variety of aesthetic, discursive, and programmatic influences, began to evince the results of an expanded Chinese architectural field. Projects such as the Shaanxi Museum of History, completed in Xi'an between 1985 and 1991 by Zhang Jinqiu of the Northwest Institute of Architectural Design and Research, were hailed as evidence of the country's recommitment to its own past following the destructive anti-historicist dogma of the Mao era, and the violence such doctrine had incited upon the country's architectural heritage and, more generally, its people (Figure 13.2). Wang Shu's Youth Recreation Centre (1989–91) reveals obvious interest in the work of figures like Aldo Rossi and Peter Eisenman (Figure 13.3). A traditional Beijing Opera theatre and office complex completed between 1993 and 1996 emphasizes both the cultural uniqueness of Chinese drama and the improving efficiency of China's reform-era economy (Figure 13.4).

It is important to emphasize that neither the designers of these projects nor the Chinese government understood or promoted these projects as postmodern in any way. 'Advocates of postmodernism may pursue their own intellectual agendas', reasoned Xu Shangzhi (1915–2007), a Chongqing University Professor and active member of the Sichuan province's leadership, in 1984. 'Protecting national culture and the identity of place is a goal that everyone can embrace, however.'[35] To be postmodern, however, posed questions as to what it meant to be modern – a pressing issue in early reform Chinese architecture and Chinese society more generally. In remarking on designs for a proposed market in Beijing that assumed the guise of a Tibetan Lama temple, Zeng Zhaofen, editor of *World Architecture* and architecture professor at Tsinghua University, acknowledged that there was

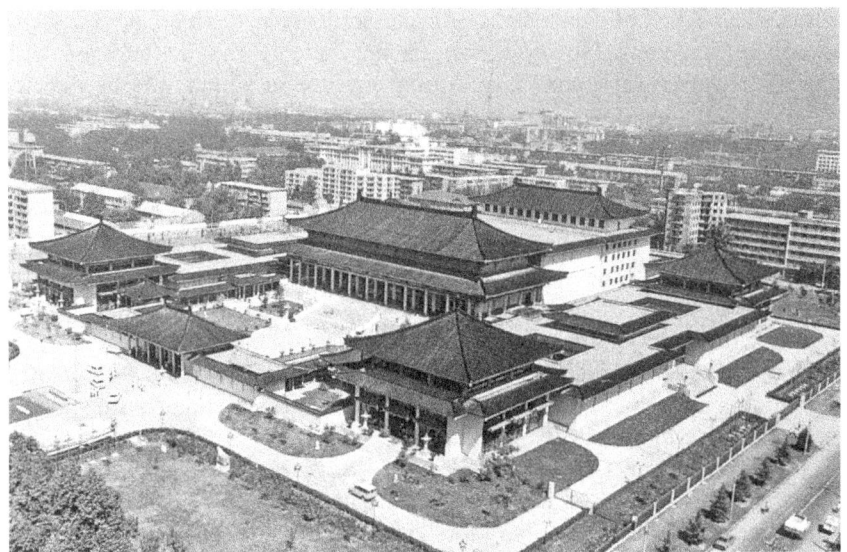

FIGURE 13.2 *Zhang Jinqiu, Northwest Institute of Architectural Design and Research, Shaan'xi Museum of History, Xi'an, Sha'anxi, 1985–91.*
Source: Chinese Architecture Since 1980 *(Zhongguo dangdai zhuming jianzhushi zuopin xuan)*, 1998.

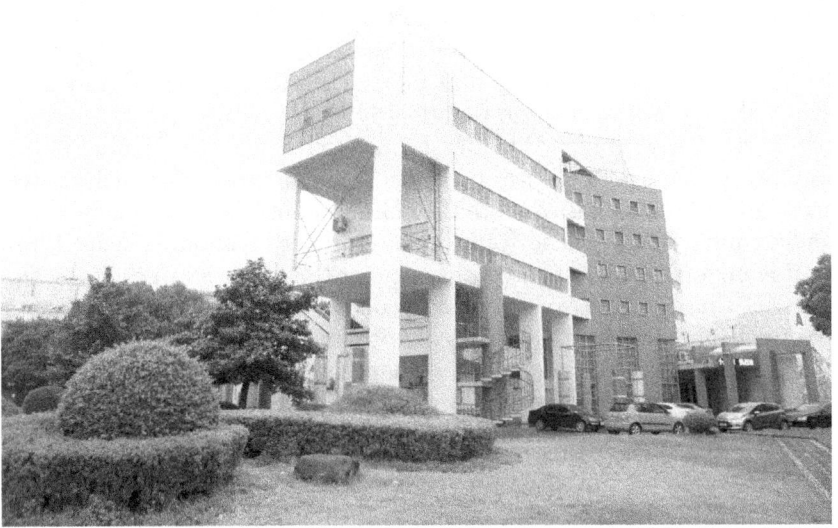

FIGURE 13.3 *Wang Shu, Youth Recreation Center, Haining, Zhejiang, 1989–91.*
Photo courtesy of Cole Roskam.

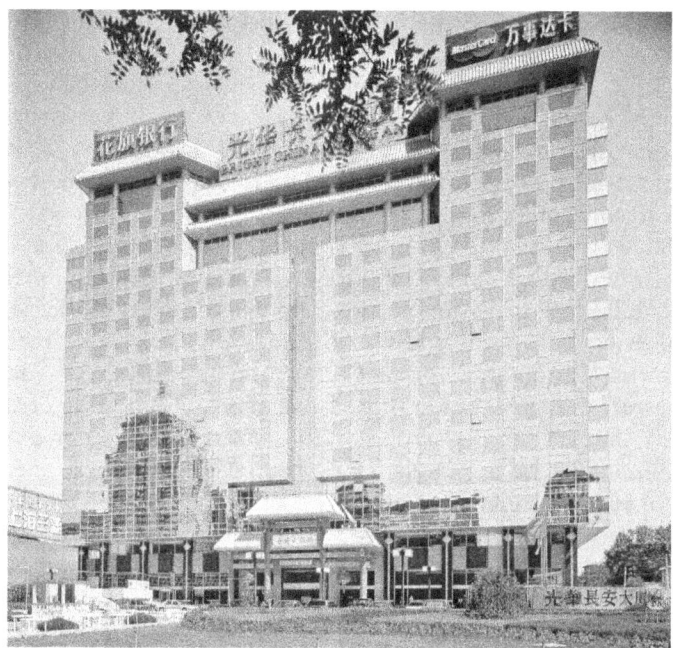

FIGURE 13.4 *Wei Dazhong, Beijing Institute of Architectural Design and Research. Guanghua Chang'an Building, Beijing, 1993–6.*
Source: Chinese Architecture Since 1980 *(Zhongguo dangdai zhuming jianzhushi zuopin xuan)*, 1998.

no theoretical reason why a market or office tower couldn't take formal inspiration from a Lamaist temple.[36] Zeng feared an overabundance of pastiche could ultimately subvert the era's progressive objectives, however. 'In ten or twenty years, if we architects are still relying on vaulted domes and pointed arches to distinguish our work, no one will consider us a progressive or creative generation of designers', he warned.[37] Meanwhile, student protests in 1986 and 1987 registered growing discontent with the party's reform agenda regardless of what architectural form it took, particularly the ways in which certain economic and political privileges were being provided to some citizens at the expense of others. Such unrest reached a crescendo during the violence perpetrated on 4 June 1989, which revealed both the commitment of certain members of the Chinese public to change, and the government's steadfast belief that it could not survive such dissent.

After postmodernism

As the Chinese government struggled to retain control over increasingly fractious public dissent, postmodern theory lost its political currency.

In November 1989, less than six months following the violence of 4 June, architect and historian Zou Denong published an essay titled 'The Lessons of Twice Importing Architectural Theory: From National Form to Postmodernism.'[38] In it, Zou drew several parallels between what he saw as the careless borrowing of postmodern design theory by China's architectural elite in the 1980s and that in the 1950s, another era of widespread conceptual adoption from abroad, specifically, the Soviet Union. Just as Soviet advisers had exerted unchecked sway over China's nascent communist leadership in the promotion of a socialist realist architecture for China, so did Zou perceive undue foreign influence as part of what he termed 'postmodernism's theory of addition: the addition of big roofs, the addition of ornament, the addition of fake structural members, the addition of certain tastes, and most importantly, the unavoidable addition of capital'.[39] In Zou's mind, such excess spoke to an architectural discourse unhinged from the fundamental economic issues Zou considered so pertinent to the survival of socialist Chinese society. Whether the party controlling socialist Chinese society would have survived without the addition of foreign capital in the first place remained an unaddressed question.

Zou's article may have dimmed the influence of postmodernism in Chinese architectural theory, but postmodern theory was essential to the project of reform, insofar as it helped to justify China's designers' engagement with new forms of architectural discourse and production that expanded the country's own architectural field. Such language, in turn, accommodated the party's changeable economic and political agenda over time. Postmodernism's discursive displacement in China may have signalled a jarring and cryptic communiqué from another economic reality, but it proved crucial in helping Chinese designers imagine new ways of conceptualizing China's own architectural history and development relative to forces beyond their control. In broadening and popularizing notions of the cultural and political value to be found in architectural design, theory, and history, postmodernism also aided the re-legitimization of the party itself. The revival of imperial-era architectural motifs – once forbidden symbols now embraced by a government torn between catalysing its own reinvention and retaining its grip on power – allowed the CCP to reconstruct for itself and its people a more easily recognizable and nationalistic architectural aesthetic rooted in China's cultural past that remains influential if increasingly controversial today.[40] Equally importantly, the opportunity to engage internationally through the medium of architectural discourse and form was also in part a legacy of postmodernism in China. It presented a sudden and unprecedented yet seemingly attainable proximity to the capitalist world through image and meaning that helped to delineate the new discursive parameters within which a post-Mao architectural culture began to materialize.

Notes

1. Yang Yun, 'You xifang xiandai jianzhu xin sichao yinqi de lianxiang', *Jianzhu xuebao*, no. 1 (1980): 26.
2. Donald Hay, Derek Morris, Guy Liu and Shujie Yao, *Economic Reform and State-Owned Enterprises in China, 1979–1987* (Oxford: Clarendon Press, 1994), 20.
3. See, for example, Zhang Xudong, *Chinese Modernism in the Era of Reforms*; Wang Jing, *High Culture Fever: Politics, Aesthetics, and Ideology in Deng's China* (Berkeley: University of California Press, 1996); Gao Minglu, *Total Modernity and the Avant-Garde in Twentieth-Century Chinese Art* (Cambridge, MA: MIT Press, 2011), 9–23. For a discussion of postmodernism in relationship to architecture, see Xuefei Ren, *Building Globalization: Transnational Architecture Production in Urban China* (Chicago: University of Chicago Press, 2007), 48; Peter G. Rowe and Seng Kuan, *Architectural Encounters with Essence and Form in Modern China* (Cambridge, MA: MIT Press, 2002), 186: Yu Shuishan, *Chang'an Avenue and the Modernization of Chinese Architecture* (Seattle: University of Washington Press, 2012), 173–7, 194–5, 225–6.
4. Gong Deshun, Zou Denong and Dou Yide, *Zhongguo xiandai jianzhu shigang* (Tianjin: Tianjin kexue jishu chubanshe, 1989).
5. See Lu Zhenmao, 'A Summary of Discussions over the Past Three Years on the Problems of Planned Economy and Regulation by Market Mechanism', *Guangming ribao*, 29 May 1982 (translation from *FBIS Daily Report*, 8 June 1982, K6–K9; 'Appropriate Development of Individual Economy is a Necessity of the Social Economic Life', *Renmin ribao*, 9 January 1983, 1. Translation from *FBIS Daily Report*, 11 January 1983, K1–K2).
6. Joseph Fewsmith, *Dilemmas of Reform in China: Political Conflict and Economic Debate*, Socialism and Social Movements (Armonk, NY: M.E. Sharpe, 1994), 69.
7. Fewsmith, *Dilemmas of Reform in China*, 70.
8. Jane Debevoise, *Between State and Market: Chinese Contemporary Art in the Post-Mao Era* (Leiden: Brill, 2014), 21.
9. Xiao Tong, 'Jiefang sixiang, kaidong jiqi, ba kancha sheji gongzuo tigao dao yi ge xin de shuiping', *Jianzhu xuebao*, no. 6 (1979): 1–2; Yan Zixiang, 'Jiefang sixiang, jiao ta shidi, nuli zuo hao kancha sheji gongzuo', Ibid., 3–7, Gong Deshun, 'Dapo jingshen jiasuo, tigao sheji shuiping', Ibid., 8–10.
10. Yang Yun, 'You xifang xiandai jianzhu', 26.
11. Yu, *Chang'an Avenue and the Modernization of Chinese Architecture*, 173.
12. Hans Bertens, *The Idea of the Postmodern: A History* (London: Routledge, 2005); *Zeitgeist in Babel: The Postmodernist Controversy*, Ingeborg Hoesterey, ed. (Bloomington: Indiana University Press, 1991).
13. See Ingeborg Hoesterey, *Zeitgeist in Babel: The Postmodernist Controversy* (Bloomington: Indiana University Press, 1991), 2–21.
14. Bertens, *The Idea of the Postmodern*, 61.

15 Robert A. M. Stern, *New Directions in American Architecture* (New York: George Braziller, 1977), 117.

16 Wu Huanjia, 'Lun jianzhuzhong de xiandaizhuiy yu houxiandaizhuyi', *Shijie jianzhu*, no. 2 (1983): 19; Bertens, *The Idea of the Postmodern*, 60–1, 80 n6; Interview, Charles Jencks, 11 February 2014.

17 See Arindam Dutta, 'No Duchamps in Delhi', in Glenn Adamson and Jane Pavitt, eds., *Postmodernism: Style and Subversion, 1970–1990* (London: V&A Publishing, 2011), 271–2.

18 Yang, 'You xifang xiandai jianzhu', 28.

19 Yoshinobu Ashihara and Terunobu Fujimori, 'Yougan yu Zhongguo guanyu "Houxiandai jianzhu" de taolun', (originally published in Japan Architect (November 1985)), in Gu Mengzhao and Zhang Zaiyuan, eds., *Zhongguo jianzhu: Pingxi yu zhanwang* (Tianjin: Tianjin kexue jishu chubanshe, 1989), 24–6.

20 Interview, Charles Jencks, 11 February 2014. For information about the Jardine Matheson's reengagement with socialist China, see Maggie Keswick, ed., *The Thistle and the Jade: A Celebration of 175 Years of Jardine Matheson* (London: Francis Lincoln Limited, 2008), 254–5, 274.

21 Interview, Charles Jencks, 11 February 2014. See also Jencks, *Houxiandai jianzhu yuyan*, trans. Li Daxia (Beijing: Zhongguo jianzhu gongye chubanshe, 1986).

22 Ezra Vogel, *Deng Xiaoping and the Transformation of China* (Cambridge, MA: The Belknap Press of Harvard University Press), 707. See also Daniel Benjamin Abramson, 'A Trans-Pacific Planning Education in Reverse', in Patsy Healey and Robert Upton, eds., *Crossing Borders: International Exchange and Planning Practices* (London: Routledge, 2010), 290.

23 Johann P. Arnason, 'Modernity, Postmodernity, and the Japanese Experience', in Johann P. Arnason and Yoshio Sugimoto, eds., *Japanese Encounters with Postmodernity* (London and New York: Kegan Paul International, 1995), 23.

24 Charles Jencks, 'Postmodern vs. Late-Modern', in Ingeborg Hoesterey, ed., *Zeitgeist in Babel: The Postmodernist Controversy* (Bloomington: Indiana University Press), 4.

25 'Zhongguo jianzhu xuehui yijiubasan nian chunji xueshu zuotanhui jiyao', *Jianzhu xuebao*, no. 3 (1983): 3.

26 Ibid.

27 Ibid.

28 Ibid.

29 Andre Mendelsohn, 'Alvin Toffler in China: Deng's Big Bang', *New Republic*, 4 April 1988, 15–17.

30 Richard Baum, *Burying Mao: Chinese Politics in the Age of Deng Xiaoping* (Princeton: Princeton University Press, 1994), 166.

31 'Jianzhu yu guojia de fazhan: Guojia jianxie di shisan jie guoji huiyi zong baogao', *Jianzhushi*, no. 2 (1980): 199–203.

32 Interview, Fredric Jameson, 4 February 2014.

33 Fredric Jameson, 'Postmodernism, Or, the Cultural Logic of Late Capitalism', *New Left Review*, no. 146 (July–August 1984): 74. Although Jameson's work was enormously influential within the field of comparative literature, it had a limited impact on Chinese architectural discourse. In fact, Jameson had little to no contact with architects during his time in Beijing, though he did visit Shenzhen and had some idea of the transformative economic changes taking place there. Interview, 7 February 2014.

34 Wang Chaohua, ed., *One China, Many Paths* (London: Verso, 2003), 21. See also Fredric Jameson, *Houxiandai zhuyi yu wenhua lilun*, trans. Tang Xiaobin (Xi'an: Shaanxi shifan daxue chubanshe, 1986).

35 Xu Shangzhi, 'Wo guo jianzhu xiandaihua yu jianzhu chuanzuo wenti', *Jianzhu xuebao*, no. 9 (1984): 12.

36 Zeng Zhaofen, 'Houxiandai zhuyi yi lai dao Zhongguo', *Shijie jianzhu*, no. 2 (1987): 59–65.

37 Ibid., 61.

38 Zou Denong, 'Liang ci yinjin waiguo jianzhu lilun de jiaoxun: cong "minzu xingshi" dao "hou xiandai jianzhu",' *Jianzhu xuebao*, no. 11 (1989): 47–50.

39 Ibid., 50

40 Cao Li, 'China Moves to Halt Weird Architecture', *The New York Times*, 22 February 2016. https://www.nytimes.com/2016/02/23/world/asia/china-weird-architecture.html (accessed 23 March 2017).

Postscript:

A postmodernist international?

Reinhold Martin

As the term suggests, 'postmodernism' conventionally begins and ends with dates. Not without controversy, these dates usually assume that whatever it is or was, postmodernism comes after something else. Less controversially, and whether we are speaking about architecture, the visual arts, literature, music, or any other area of culture, that 'something else' is usually modernism. And yet, at least as it was defined in Western Europe and North America around 1980, postmodernism was widely construed as a multiplication, a breaking up of big stories, or master narratives, into little ones. That included the monolithic narrative of 'modernism' itself, which some historians now prefer to render in the plural, as 'modernisms'. Correspondingly, according to now widely accepted philosophies of difference (which were much less canonical and much more controversial, *c.* 1980) the rendering plural of the term – postmodernisms – may seem either just right or just a little redundant.

From the start, opponents of the concept on all sides took pains to point out the contradiction: Was this story about the end of big stories not just another big story? To which some of the moment's most astute thinkers replied pre-emptively: No, because it is not a question of chronology, of teleology, or even of the particularization of alleged universals per se. Postmodernity, they said, though usually not in quite these words, was a revolutionary concept. Albeit a little more tentatively than its overconfident predecessors, postmodernity was the very embodiment of rupture, of the event, of an indeterminate opening to what may or may not happen next. However complacent it may seem to those accustomed to the big stories, in this account postmodernism is more like a disposition, a recalibration of the instruments of culture that sensitizes them to the slightest and most incongruous historical tremor.

I am alluding of course to the work of French philosopher Jean-François Lyotard, author of *The Postmodern Condition* (1978). Quite scandalously for historians of art and architecture, it was Lyotard who suggested that postmodernism comes 'before' modernism, as a perpetual experiment that constantly rewrites the rules of the game. Rather than signal the exhaustion of the modernist avant-gardes, postmodernism enlivens them. Interestingly for us here, among Lyotard's examples is one drawn from the Soviet sphere: to his eyes, where Kazimir Malevich was a modernist, El Lissitzky was a postmodernist. Lyotard intimates that Malevich's underlying nostalgia for myth committed him to historical teleology, while Lissitzky, in his Proun paintings and constructions, played with indeterminacy and by extension with historical open-endedness. Contrary to modernist orthodoxy this play, in Lyotard's view, does not betray the revolution. Rather, it prolongs the revolutionary moment of rupture, of breaking with convention and with an oppressive past, drawing the rupture deeper down into the artwork, while profaning the myth of progress (a master narrative par excellence) in a Dadaistic orgy of carefully calculated and quite paradoxical dead ends.

So, to the extent that we retain the concept at all, let us stipulate that postmodernism is not a stylistic or strictly chronological category; it is an untimely discursive one. One way to reflect, then, on the contributions to this volume is to ask how their subject matter permits or even compels different types of statements, and different thoughts, than the usual ones regarding modernisms (plural), east or west. Is there a different before-and-after at work in the self-described 'Second World'? Does or did history proceed differently there? Again the reference term is suggestive, but again we might hesitate just a little. After all, is not what makes this world 'secondary' also a big story – 'the' big story – of movement through developmental stages, from third to first? This frame differs a little from the revolutionary, neo-Hegelian master narratives Lyotard mainly had in mind, writing from a 'First World' perspective ten years after the inconclusive events of 1968. Rather more dryly, it speaks the language of development, of the United Nations and the World Bank. But 'Second World' also speaks the language of the Cold War; as Vladimir Kulić points out in the Introduction, it is a term that rhetorically subordinates the socialist world to the capitalist one. Hence its utility as a term of art favoured by Western technocrats to differentiate enemy from friend that relegates everyone else to the status of colony or client, past or future.

On this most basic level, the term 'Second World' reminds us that postmodernism in its traditional usage is itself a product of the Cold War. To test this, think of the terminological reflex that codes contemporaneous and quite related architectural works located in the 'Third' world, such as those that speak the figurative language of recently acquired nationhood during the 1970s and 1980s, as 'regionalist' rather than postmodernist. Like

their Western counterparts, some Eastern bloc postmodernisms adopted a nationalist idiom that included appeals to 'local' materials and vernaculars, none of which properly qualify as regionalist in this postcolonial sense. That is because tacitly all postmodernisms played a latter day Great Game, even when they dissented. This was the game of 'First' versus 'Second' worlds, of which the 'Third' world was, more often than not, collateral damage.

My second stipulation, then, is that this Cold War frame is more than mere context; it is epistemic. To the extent that the postmodernist game is a game of signifiers and signifieds – a 'language game', as Lyotard says – every detail of every building considered in this book may be considered to inhabit the Cold War's semantic field, even at some distance, and even from within a 'third way' or 'non-aligned' political orientation. To be sure, the diverse architectural signifiers floating on these pages through Eastern Europe, Cuba, and (a little incongruously) China cannot simply be flattened into a this-versus-that syntax of political systems, whether as expressions or subversions thereof. Still, it remains edifying to cast all of those architectural postmodernisms crisscrossing the Atlantic, including the ones discussed here, as Cold War ideologemes. In the West, for the most part they indicated a resigned (or delirious) acceptance not only of capital's triumph but of a this-versus-that order of things that falsely consigned socialism safely to somebody else's history. Whereas, in the East of actually existing socialisms, the newly floating signifiers seem to have indicated something more ambiguous, more Lissitzkian: an opening up of closed systems.

To proceed, I suggest putting these two points together in order to reset our timelines and refocus our ideologically tinted lenses: postmodernism as untimely discourse and as epistemic system. Staying on one side of the Berlin Wall for just a moment longer, let us therefore split the difference between Lyotard and Charles Jencks, postmodern architecture's most official apologist, and suggest that if it began at all, postmodernism – architectural and otherwise – began on 24 October 1945, with the ratification of the United Nations Charter and with it, the founding of the United Nations Security Council, the five permanent members of which were the United States, the Soviet Union, the United Kingdom, France, and (pre-Communist) China.

The architectural consequences of this moment are well known. The United Nations resurrected the feeble interwar League of Nations and with it, memories of the competition for that organization's headquarters on Lake Geneva, won by a consortium of Beaux-Arts style academicians including the Hungarian Joseph Vago. Two decades later, the design for the new headquarters in New York brought together what remained of the modernist international, translating its most poignant, vexed statement – Le Corbusier's competition entry for the Palace of the Soviets in Moscow – into a placid bureaucratic enclave. Their collective utopianism, led by the ageing messiah, clashed with the new world order. The two declining empires (Britain and France) and the three rising ones (the United States, the USSR, and China) that dominated the Security Council and hence the institution

were rapidly bound together in an antagonistic thermonuclear brotherhood. Wallace Harrison's architectural synthesis, which wishfully subordinated the Council's star chamber to the quixotic General Assembly, with both overseen by the great, crystalline bureaucracy of the Secretariat, epitomized modernism's eloquent 'new monumentality' in a cosmopolitan civic centre for the world.

In that sense, the United Nations complex seems a perfect bearer of the modernist master narrative of unity under the sign of capital, which was only confirmed by the Soviet (and later Chinese-PRC) presence: a shining, geometrically absolute Malevich-like *arkhitekton* that consigned Lissitzkian ambiguity to the back stairs, hallways, and airport lounges of the post-war diplomatic order. Internationalist melancholy pervades the entire complex, showcasing the capacity of trim, materially subdued detailing to absorb occasional outbursts of national or subnational 'culture' in the form of donated paintings, sculptures, or other artworks that dress the interiors. The canonical image, made for television, is not the Dr Strangelove-like Security Council, but the General Assembly podium. Its prismatic, marble-clad form has served as an unforgettable stage for countless speeches expressing solidarity, disdain, resolve, or menace, from countless political representatives, some of whose names the history books repeat more often than others.

From the beginning this architectural Esperanto also absorbed the United Nation's (originally) five official languages, and numerous unofficial ones, into a technological matrix of translator's booths and audio headsets. The ensuing theatre of translation, utopian in its own way, punctuated the ideally universal 'communicative public sphere' with the stuttering untranslatability of the real. Whereas the very fact that the complex's simple architectonic forms seem to say anything at all about world unity locates them on the precipice of a renewed 'architecture parlante', or speaking architecture, that would become a postmodernist hallmark. Before Lincoln Center's 'ballet school' modernism and its many civic brutalist relatives East and West, a late 1940s' governmental monumentality, incubated in the cauldron of post-war European reconstruction and relocated to the banks of New York's East River, laid the groundwork for postmodernism proper by refunctioning functionalism into a living, speaking language, in response to the internationalist call for civic meaning.

The dream of a modernist international was of course an old one. Despite his artistic commitment to incommensurable viewpoints, Lissitzky was among that international's earliest, most idealistic citizens. In conjuring the dream again, albeit in weakened form, the United Nations and the world to which it belonged set the stage for an enigmatic and potentially contradictory postmodernist international. The Berlin Wall and the 'iron curtain' did not so much divide this world as unify it within a common structure, to which cultural producers like architects and urbanists responded. Their responses were not limited to surreptitious contacts across the Cold War's battle lines,

or improbable samizdat publications of Western postmodernism's instant, dubious classics. For if there is anything postmodern about the works and texts surveyed here, it is to be found in a vague yet consistent dissatisfaction with the world as given by the United Nations Security Council and its managers, East and West, first and second, with the third as remainder.

If this vague feeling can be translated into a formal hypothesis, it would be this seeming tautology: what joins the various 'postmodernisms' is their modernity. By this I mean a shared sense that the point is to comprehend the world in order to change it. The Berlin Wall reified the deadly contradictions that this sometimes entailed. Well before 1989, when the walls began to fall, the spectre haunting Europe was the recognition that historical change could no longer be called 'revolution' in the older sense, nor its telos, a self-evident 'communism'. Hence the detached irony, the uncertainty with which the postmodernist international faced the future, beginning in 1945. Hence also, the unmistakable pathos borne by its most incongruous landmark, the United Nations Headquarters. Despite its melancholy, and despite the technocracy to which it so firmly belonged, the United Nations called forth a new Babel. The future that it heralded would only be called 'postmodern' thirty years later.

By accepting Lyotard's anachronism, the historian's heresy that I am proposing puts Wallace Harrison, architect to the Rockefellers as well as leader of the UN design team, in the position of El Lissitzky, who expected nothing more of art than to 'Beat the Whites with the Red Wedge', a title he gave to one of his most programmatic graphic works. If anything, Harrison's cause was capitalist, not communist, revolution. So how could the resolutely modernist United Nations possibly stand for a postmodernism of the disarmingly revolutionary 'event' *avant la lettre*? To answer this question we must set aside simplistic, hardly disinterested stories of vanquished anti-capitalist ideologies. Work backwards instead from the case studies and national contexts treated in these essays and you will find the ambivalent but for that very reason, real, ghosts of the socialist utopias they seem to have left behind. Ghosts are anachronistic things. They return, unexpectedly and inappropriately.

In all likelihood, none of the works explored in this book were directly affected by decisions made in the United Nations Security Council, though some reflected (or resisted) the larger body's development policies, post-Bretton Woods. All, however, presupposed the same world that the United Nations presupposed. Not in the trivial sense that all belonged to the long 'post-war' experience, but much more specifically, in that the problems on which they worked only made sense in a world where the United Nation's agonistic political theatre made sense. By 1960 if not earlier, architectural efforts to communicate from Beijing to Berlin, with all their semantic ambiguities, were only truly legible within the same signifying environment as Khrushchev's (alleged) shoe-slamming. In the same way that the United Nations was quite visibly built on disunity, think of the dissonant

postmodernist international as implying, dialectically, the possibility of an impossible, cacophonous unity.

Suggesting that all postmodernisms belong basically to the same order of legibility, the same semantic field, raises a number of thorny questions. Most obviously, it risks stretching the already-suspect term 'postmodernism' beyond recognition. More interestingly, it implies something like a cultural or even political-economic 'totality', the very thing that postmodernism was supposed to make unthinkable. Fredric Jameson has been unfailingly eloquent on this topic, and I will not rehearse his arguments here. Differently from Jameson, who wishes to think postmodernism primarily from within the political-economic totality of the world system of capital as its 'cultural logic', I suggest only that we think of the postmodernist international as a discursive formation committed to unity in difference.

That is, rather than aim only to decode postmodernism's contradictory architectural representations – the historical quotations, the intermixed vernaculars, the national and tribal symbols – we might look to their 'enunciative function' (to use the Foucauldian expression), or the conditions under which an architectural statement becomes legible as a statement in the first place. You might say that, when presented with such a statement, we want to consider its 'architecture', meaning the ordering principles that make it appear as it appears: the architecture of the architecture.

So what is the architecture of postmodern architecture, in the Second World? Quite evidently from the essays here, it is first the printed matter – books, magazines, pamphlets – that accumulated in architects' offices and personal libraries, translated or not, in fairly predictable patterns but with some intriguing surprises (Blagojević). But before that, one must have had access to this printed matter through physical channels, as well as through the ability to translate or read the English, French, or Italian in which it was written. The fact that by and large this ability did not extend in the other direction (few Western architects read the Eastern European languages) already hints at a one-way street indifferent to countervailing sources and reference points such as the discursive networks of socialist realism. This street leads in turn to a diffusionist model of discourse, analogous to the First-to-Second-to-Third-World model of 'development' still current at the time, in which ideologemes press on, from west to east, perhaps altering their meaning as they go, but – unlike real printed matter – always arriving at their destination. In what amounts to the same story, the one-way street also shows up as a channel for technology transfer, moving in one case from Tokyo to Dresden, offset to some extent by the reverse transfer of design techniques (Hirsch), at a time when Japan was still subject to US hegemony (and a hotbed of 'postmodernist' ennui) in the aftermath of the Marshall Plan.

Something comparable can be said about the 'logic of late socialism' invoked by several of the essays (Klein and Gzowska, Miljački), with the difference that its actual 'lateness' seems to be confirmed by the events of 1989, an observation that cannot be made of Ernst Mandel's (and Jameson's)

'late capitalism'. If anything, 'late socialist' postmodernisms may have more of a claim on the chronology implied by both terms, in the sense of decline but also of a kind of belatedness in which actually existing socialism's dialectical complexity only comes into full view after the fact (Krivy, Kurg). In a related spirit, non-ironic, utterly real exercises in utopian architectural practice in Yugoslavia (Kulić) seem directly to contravene the prevailing claim, in the west, that such exercises were not only obsolete but dangerous.

These external contradictions, as well as the internal ones – an endgame of productive uncertainty versus 'bad' infinity (Krivy), or, intriguingly, the collective farm as para-corporation (Kurg) – are different from attempts to replace one myth with another, whether the myths are Volkisch or satirical in character (Molnár, Vronskaya). They also differ significantly from an antimodernist ideological cleansing oriented towards nationalism emanating from the state or from some other specific hegemony (Anderson). Moreover, the complex and contradictory postmodernisms of Eastern Europe seem especially to differ, in their pronounced 'lateness', from the sequential or progressivist thinking of Deng's 'Four Modernizations' (Roskam) or Cuba's 'three periods' (Rivera).

Any incipient postmodernist international may indeed have gained technical support from the movements of Eastern European professionals in and out of an oil-rich Middle East (Stanek). As much as these back-and-forth movements refute the diffusionist model, however, they operate mainly at the level of socialist or post-socialist praxis seemingly uncontaminated by the intersecting discourse networks we are citing. Consider, for example, that for over a decade, Lyotard was a member of the Socialisme ou Barbarie group in Paris, led by the Greek political philosopher Cornelius Castoriadis. Committed to socialist ideals, the group, which closely monitored developments in Eastern Europe, the Soviet Union, and China, centred its critique on capitalist technocracy, like that within which Polish engineers and architects worked in Dubai. Though Lyotard did not fully share Castoriadis's anarchist commitments, we can see traces of this experience in his later rejection of the 'grand narratives' including – but not limited to – the grand narrative of the vanguard party and its technical apparatus. Though it may be true that 'late socialist' architects and engineers, like other modern technocrats, lived most of their professional lives well away from that apparatus, especially as expert consultants abroad, its stories travelled as modernization metanarratives, in the techniques and ideologies of the neo-liberal Chicago School economists as well as of the Polish Ministry of Construction. As a pattern of antithetical statements made legible by the same semantic field, this repetition is the work of discourse.

Another of Euro-American postmodernism's avowed attributes is the notorious 'death of the author'. As background systems for generating paperwork (or, as in Warsaw-Dubai, CAD files) the bureaucracies within which many 'late socialist' architects worked were in certain ways authorless. With its profusion of proper names unfamiliar to Anglophone readers, the

scholarly recovery of 'Second World postmodernisms' may therefore entail something like the 'birth', or rebirth, of the author. For historians, the first task may then seem to be deciding whether those names deserve the same recognition as those of their generational peers elsewhere. This task, however, is illusory. Pluralizing postmodernisms gets us half way out of the dilemma by allowing each set of names to occupy its own geocultural sphere, perhaps arranged by language group. But if we accept the periodization I have suggested and with it, a historico-theoretical problem of the one versus the many, we must address the question of whether to name names at all.

The 'death of the author' ascribed to textual proliferation by theorists like Roland Barthes is not the same as the subordination of individual artistic authorship to the collective programs of the Czechoslovak Stavoprojekt, the Estonian Kolhooside ehituskontor (KEK), or the Cuban microbrigade Alamar. But neither does recovering and circulating the names of individual architects like Bogdan Bogdanović, Vilen Künnapu, or Imre Makovecz, or of critics like Bohuslav Dvořák, Aleksandr Riabushin and Vladimir Khait, or Yang Yun automatically mean embracing the larger value-generating program of what the Soviet tradition regarded as bourgeois art history. The fact that many of the Second World's architectural protagonists spent at least their early careers working in collective professional agencies or institutions binds their authorial names to a complex and highly variegated system of production. Though this system overlapped and interacted with western consumerism, it made different claims on individual agency. Among the challenges to historians, then, will be to decide how those claims differed from, say, the relative anonymity of American-style corporate practice and its obverse, the accrual of cultural celebrity, and how they did not.

One way to think about the question of authorship and agency is from the perspective of the object. All of the many buildings inventoried here are useful things, and so the role of architects can be (and has been) productively considered in terms of the delivery of professional services. The design and construction of hotels in East Germany by a Japanese conglomerate or Polish technical assistance in Kuwait illuminate larger trends in this area. Remember, too, however, that Western controversies over postmodernism and postmodernity often turned on the alleged arrival of a 'post-industrial' society, centred not only on a service economy, including professional services and the goods they delivered, but also on the semiotics of consumerism. Is something like this discernible, for example, in the Hungarian 'tulip debate', which turned on an effort to attach a new and playful 'meaning' to drab social housing? Or, flowers being something of a sub-theme here, does the emphasis on the architectural object not shift slightly from function to form, when the architecture (and ideology) of collective farms in Estonia is subordinated to the architecture (and ideology) of the flower shop marketing their products? Or, for that matter, are not the ironically modernist graphics of 1980s' propaganda in Cuba, or even 'doubly coded' Chinese 'characteristics', evidence of a differential reorientation of

architecture, if not necessarily towards exchange value, then away from use value as traditionally considered (the useful object) and towards an ambiguous, dissonant semantics that, in a period of severe ideological and cultural flux, had a certain instrumental value – a utility – of its own?

Finally, Barthes derives another, related coinage, the 'empire of signs', from post-war Japan, an emerging consumer society slightly askew from Western powers but dependent on them. These few examples, above, and many others explored or alluded to by the authors in this volume, suggest an intriguing alternative possibility. Beyond merely representing the tip of a second postmodernist iceberg floating beside the better-known Euro-American (and Japanese) one, they potentially shed light on the larger ocean in which these two icebergs float. For what is this 'ocean of signs' if not a treacherous, stormy substrate that has in the past half-century rearranged global relations of production, circulation, and consumption, such that floating signifiers – 'doubly coded' pastiche, Volkisch vernaculars, and post-industrial flowers – are all that we can see?

This ocean of icebergs returns us to 1945, and to the possible, unnoticed emergence of a postmodernist international out of the ruins of the modernist one presided over by the UN Security Council and its antagonisms. Each of the figures named in this book had their own reasons for seeking theoretical and practical routes out of the particular corner of modernity in which they came of age. Just as every one of the 'third world' countries that gained independence after 1945 did so amid a bipolar Cold War hegemony, these figures – imaginative artists and professionals mostly, with a few genuine intellectuals mixed in – had no choice but to acknowledge its terms, which they did mostly by reversing them, subverting them, or, occasionally, modifying them to suit new needs and new desires. Think for a moment about the career of Yugoslavian architect Bogdan Bogdanović, inventoried by Kulić: a committed socialist and designer of eccentric, memorial landscapes commemorating anti-fascist partisans and concentration camp victims (including the formidable concrete 'flower' of Jasenovac), who became an outspoken and ultimately exiled anti-nationalist. Running in the background – East and West, North and South – was and remains the aftermath of the Second World War, the shifting orientation of political parties, the nationalization and de-nationalization of industries, the reorganization of the international division of labour, and the long shadow of nativism and nationalism. This is the landscape to which the term 'postmodernism' belongs and from which it derives its vocabulary, however we choose to apply it.

To a degree, such irruptions as the 1955 Bandung Conference and with it, the non-aligned movement, which refused the bipolarity without substituting an internally coherent third way, provincialized the Cold War hegemony. As did other, related efforts at transnational solidarity in the wake of decolonization, like Pan-Africanism. Architectural analysis has for the most part yet to absorb their perspective and their terminology, and has only

occasionally addressed their subject matter. Hence the current, slow-but-sure turn towards critical histories of modernization and development, often (though not always) with acute sensitivity towards the epistemic and physical violence that these terms and their accompanying policies and practices enacted and continued to enact. Hence also, the slower, equally critical but sometimes just a little patronizing admission of the global subaltern into the archive of architectural and art history, if not into the curriculum. Despite or perhaps because of this apparent opening up, what remains striking is how many postmodern suspicions persist, especially the suspicion of big stories.

As a result, it has become commonplace to note with some regret the proliferation of particularlisms across today's intellectual landscape, with no small hint of nostalgia for the universalisms of earlier days. A newly discovered 'Second World postmodernism' may, of course, simply add to that particularism, perhaps with some nostalgia, like the German *Ostalgie*. But it also affords an opportunity to re-examine postmodernism's common sense, starting with the rejection of big stories. Many here note the predominance of a neo-liberal imagination among their subjects. In this, they repeat the biggest story of them all: the story of capital's ultimate, worldwide triumph, and of its insinuation into the tiniest crevices of culture. But they also show the distorted, damaged persistence of the very thing that neo-liberal ideology has ranged itself against, most spectacularly, perhaps, in the post-Soviet sphere: the anti-capitalist past in all its complexity. Beginning with the haunted, technocratic internationalism of the United Nations, from Manhattan to Moscow, it is the presence of this past (to re-use an old postmodernist expression) that makes all postmodernisms modern.

INDEX

Aalto, Alvar 57, 70
Abercrombie, Sir Patrick 217
absurdity versus nonsense 157
Abu Dhabi Emirate 185
Academy of Fine Arts of the USSR 23–26
Accursed Builder, The 85
Adorno, Theodor 71
Aeroflot Headquarters 22
aesthetics 35, 39–40, 43, 48, 54, 99
 architectural 7, 208
 Marxist 37
 postmodern 208
 of silence 119
 translation of texts 70–2
'After the Post-Modern' 66
agency 6, 10, 62, 72, 175, 189, 233
Akcan, Esra 174
Aladdin City 180
Alamar 134
alcohol 145
Aleksandrova, Tatiana 158 n.1
Alexander, Christopher 73–4, 99, 103
Algeria 192
Alice's Adventures in Wonderland (Lewis Carroll) 154, 155
Allen, Stan 146
Al Othman Center, Hawally, Kuwait 183, 187, 189, 190
Althusser, Louis 71
Alvar Aalto exhibition 70
Anderson, Benedict 174
Anderson, Richard 8–9, 17, 232
Anlselmi, Alessandro 70
anthroposophy 55
anti-modernism 165
Apelace (The Call) exhibition 177 n.14
applied anthropology 91

Arabi Engineer Office 183
Archigram 5
Archipress 66
architect's library 63–70
'Architectural Analysis' 73
architectural aesthetics 7, 208
Architectural Association 74
Architectural Atelier of Miskolc 58
Architectural Design 67, 85
architectural humanization 35
Architectural industrialization 38, 41, 42, 53
Architectural Journal 211, 214
architectural modernism 47, 52, 54, 214
architectural phenomenology 8, 36–7, 63, 70, 73–4
Architectural Review, The 99, 165, 185
architectural training, infusion of theory in 72–4
architecture
 autonomy of 86–7, 91, 93, 21
 mobilities of, in Cold War 180–97
 organic 54–9
 spontaneous 50–1
 tropical 189
 vernacular 9, 42, 43, 48–51, 57, 59, 123, 181, 185, 186, 189, 228, 231, 234
 see also individual entries
Architectvra (Wendel Dietterlin) 89
Architektura (Poland) 99, 101, 103
Architektura ČSR (Czechoslovakia), 173, 174 n.14
Arendt, Hannah
 Human Condition, The 144–5
arhitektov bilten (ab, Ljubljana, Yugoslavia) 67

Arhitektura (Zagreb, Yugoslavia) 1, 67, 83
Arhitektura urbanizam (Belgrade, Yugoslavia) 67, 76, 68
Arkhitektura SShA (Architecture of the USA) (Andrei Ikonnikov) 21
Arkhitektura zapada (Architecture of the West) 29
Arnason, Johann P. 217
Arnheim, Rudolf 71–2
 Film als Kunst 72
Arquitectura Cuba (Cuba) 137
Arquitectura y Urbanismo 137
Arquitectura y Urbanismo Modernos: Capitalismo y Socialismo (Roberto Segre) 131, 137, 142 n.21
Art, translation of texts in 70–2
Artaud, Antonin 157
Art et technique aux XIXe et XXe siècles (Pierre Francastel) 71
Art Nouveau 53, 55, 85
Arts and Crafts Movement 55
Arzamasova, Tat'iana 158 n.13
asceticism 27
Ashihara, Yoshinobu 148, 215–16
Asse, Eugene 21, 22
Association of Belgrade Architects 70
Association of Hungarian Architects 57
asymmetrical ignorance 176
Athens Charter 100
Atlantis Condominium, Miami 129
Audit Bureau Headquarters Building, Kuwait City 190, 191
Austria 200
autonomy 86–7
 of architecture 86–7, 91, 93, 217
 disciplinary 92, 94
avant-garde 8, 35, 68, 74, 85, 94, 144, 146, 147, 175, 227
'Avant-Garde and Continuity' (Giorgio Grassi) 66
Avvakumov, Yuri 147

Babáček, Bořislav 173
Bachelard, Gaston 72, 73, 148
 La Poétique de l'Espace 72
Badowski, Zbigniew 104

'Bajloni Brewery' 74
Bakhtin, Mikhail 71
Baloush Bus Terminal, Kuwait City 188
Bán, Ferenc 59
Bandung Conference (1955) 234
Barbara, Santa 211
Barkhin, Sergey 159 n.24
Barry, Andrew 191, 192
Bartók, Béla 53
Basil Spence Partnership 185
bastions of intimacy 147–51
Baum, Mirko 167, 173
Bauwelt 99
Bedford, Joseph 37
Beijing Institute of Architectural Design and Research, Guanghua Chang'an Building, Beijing 221
Bejerano, Daniel 142 n.17
Belgrade 9, 62–78, 81–5, 90, 95 n.9, 181
 publication production in 64
Belopol'skii, Iakov 24
Belov, Mikhail 146–7, 152, 157, 158 n.13
 Exhibition House 152–5
Belyayevo Forever: A Soviet Microrayon on Its Way to the Unesco List (Kuba Snopek) 159 n.18
Beneš, Michal 40–1
Benitez-Rojo, Antonio 133
Benjamin, Walter 71, 82
Bielecki, Czesław
 'Continuity in Architecture' ('Ciągłość w Architekturze') 101
BIGZ 72
Blagojević, Ljiljana 9, 62
Blazsek, Gyöngyvér D. 52
Bloque GP-IV housing, Camagüey, Cuba 135
Bobić, Miloš 69
Bodonyi, Csaba 58–9
Bofill, Ricardo 105, 185
Bogdanović, Bogdan 62, 64, 69, 70, 72, 85, 233, 234
 Knjiga kapitela (The Book of Capitals) 87–8, 89

Mali urbanizam (Small
 Urbanism) 64
 as postmodernist 82–6
 surrealist postmodernism 81–97
 *Zaludna mistrija: doktrina i
 praktika bratstva zlatnih (crnih)
 brojeva* (The Futile Trowel: The
 Doctrine and Practice of the
 Brotherhood of Golden (Black)
 Numbers) 83
Bohdanowicz, Andrzej 182, 183
Book of Capitals, The (Bogdan
 Bogdanović) 87–8, 89
Borba 64
bourgeois functionalism 35
Brazil 18
Brecht, Berthold 71
Bren, Paulina 169
Breton, André 85
Brezhnev, Leonid 17, 112
Brodsky, Aleksandr 145–8, 151, 157
 'The House of Winnie-the-
 Pooh' 148–50
Brodsky, Savva 159 n.23
Bronzova, Nadezhda 159 n.24
Budapest 59, 203
Budapest Technical University 56
Budzyński, Marek 102, 104, 108
Bulgaria 181
 Technoexportstroy 184
bureaucratic dictatorship 62
Buszkiewicz, Jerzy 100

CAD 190–3
Caillois, Roger 71
Canaletto 200
Canalettoblick 201
capitalist modernity 52
capitalist urbanization 40
Caribbean 3
Carpientier, Alejo 135, 142 n.19
Carroll, Lewis 157
 *Alice's Adventures in
 Wonderland* 154
 *Through the Looking-Glass and
 What Alice Found There* 155
Casabella 67
Castoriadis, Cornelius 232
Castro, Fidel 134

Catholic Church 9, 98, 107
Catholicism 104
Čehovin, Marjan 62
Central Asia
 prefabricated housing 3, 7
Central Europe 33, 199
Central Glass (architectural
 competition) 146
Central Scientific-Research Institute
 for the Theory and History
 of Architecture
 Arkhitektura zapada (Architecture
 of the West) 29
Central Scientific-Research Institute
 of Experimental Design of
 Spectacle Buildings and Sport
 Constructions 145
Centre for Urban Development
 Planning (CEP) 68, 69, 74
Centre of the Anthroposophical
 Society 55
Chadirji, Rifat 185
Chakraborty, Dipesh 176
Chaohua, Wang 219
Chechulin, Dmitrii 22
Che Guevara, Ernesto 131, 135
 theory of the vanguard 141 n.8
Chen Zhanxiang (Charles Chen)
 217
China 1, 6, 10
 architectural discourse in early
 reform-era (1978–99) 211–25
 Architectural Society of China 217
 China Association for Science and
 Technology 217
 late socialism 4
 after postmodernism 221–2
 post-revolutionary
 architecture 213–21
 Urban Planning Bureau 217
Chinese Academy of Building
 Research 215
Chinese Communist Party
 (CCP) 212, 213, 217, 218, 222
Choy, José Antonio 128–9, 131,
 137, 138
Chryniewicz, Jacek 183
church architecture, role of state
 in 104–8

Church of the Ascension of the Lord, Ursynów, Poland 104
Church of the Blessed Virgin Mary Queen of Poland, Głogów, Poland (1980s) 106
Chyczewski, Leopold 188
CIAM 54, 185
Cipriani, Felice 70
Cisneros, Sergio Ferro 137
cities
 Beijing 217, 219, 221, 225 n.33, 230
 Belgrade 9, 62–78, 81–5, 90, 95 n.9, 181
 Berlin 8, 10, 163–70, 174, 198–200, 203–6, 208, 230
 Camagüey 135
 Česká Lípa 169–72, 174, 175
 Cottbus 208, 209
 Dresden 198–203, 205–8, 231
 Erfurt 208
 Głogów 106, 107
 Jasenovac 91, 234
 Karl-Marx-Stadt 208, 209
 Kruševac 91–3, 95 n.9, 96 n.34
 Kuwait City 184, 186, 188, 191
 Kyoto 206, 207, 215
 Liberec 164, 166–7. 174
 Łódź 100, 101
 Moscow 7, 10, 21–3, 41, 115, 145, 149, 181, 228, 235
 Mostar 91, 92
 Pécs 52, 58
 Peetri 119–22
 Schwerin 208
 Smederevo 83, 84
 Tallinn 113, 114, 116–18, 126 n.13
 Thessaloniki 209
 Tokyo 209, 211, 231
 Ursynów 102–5, 109 n.13
Civilization at the Crossroads (Zdeněk Lakomý) 36
classicism 24, 43, 83, 168
Cold War 3, 5–7, 10, 11, 52, 82, 94 n.2, 130, 165, 166, 168, 176, 199, 227–9, 234
 mobilities of architecture in 180–97
collective farms 2, 3, 9, 111–27, 232, 233

Collective farm sports hall, Peetri, Estonia 120–2
Collège de Sociologie 85
Collier, Stephen J. 190, 192
colour 1, 7, 105, 116, 128, 129, 133, 135, 136, 138, 169, 170, 199
Commission for Revolutionary Orientation (COR) 133
Communist Party 36, 38, 54, 85, 123
Complexity and Contradiction in Architecture (Robert Venturi) 21, 174
constructivism 30 n.19, 94, 115
'Contemporary Architecture' 72–3
Contemporary Architecture in Eastern Europe (Udo Kultermann) 3
'Continuity in Architecture' ('Ciągłość w Architekturze') (Czesław Bielecki) 101
Contribution à l'esthétique (Henri Lefebvre) 73
Cook, Peter 146
Cooke, Catherine 26, 39
Coop Himmelblau 156
Correa, Charles 148
Čovjek i prostor (ČIP, Zagreb, Yugoslavia) 67
Coyula, Mario 142 n.17
craftsmanship 55
criticality 86–7, 212, 218
critical regionalism 54–9, 189
Critique of Everyday Life/Critique de la vie quotidienne (Henri Lefebvre) 73
Crnković, Ivan 70
Crystal, Česká Lípa, 1975–92 169–72, 174, 175
Crystal culture house 171
Csete, György 52
Cuba 1, 10, 128–42, 228
 First National Congress of Education and Culture 130
 gray period (*quinquenio gris*) 130, 131
 late socialism 4
 Ministry of Construction 139, 140
 Ministry of the Interior 135
 Non-Aligned Movement 6
 prefabricated housing 3, 132–6

semiotics 132–7
Special Period 4, 10, 128, 130, 138–40
transculturation 129–32
tropical socialism 137–40
Cuban Counterpoint: Tobacco and Sugar (Fernando Ortiz) 132
cubanidad 129, 135
Cuban Revolution 131, 140
Cullen, Gordon 64
Cultural Revolution 214, 216
cultural turn 175–6
cybernetics 9, 36, 39, 44
Czechoslovak Building Works 164
Czechoslovakia 1, 7–9, 33–46, 163–79
 Czechoslovak Academy of Sciences' Institute of Theory and History of Art 35
 Czechoslovak Ministry of Construction 35
 institutionalization of architectural theory 35
 late socialism 4
 post-war history of housing design 33
 Stavoprojekt 33

Daczkowska, Zdzisława 183
Daczkowski, Ryszard 182
Dai Nianci 217
Damnjanović, Milan 72
Dašić, Đorđe 62
Death and Life of American Cities, The (Jane Jacobs) 215
death of the author 232, 233
deconstructivism 157
Deconstructivist Architecture exhibition, MoMA 156
decorated shed (*zdanie-sarai*) 21, 116, 172, 180
decorativism 24–26
Dekorativnoe iskusstvo SSSR (Decorative Art of the USSR) 18
De la modernité au modernisme: Pour une métaphilosophie du quotidien (Henri Lefebvre) 73
Deleuze, Giles
 Logic of Sense 157

Delirious New York (Rem Koolhaas) 156
Delo 71
Deng Xiaoping 216
 'Four Modernizations' campaign 211–12, 214
Department of Architectural Theory (*Kabinet teorie architektury*, KTA) 35, 37–8, 43
Department of Architectural Theory and the Living Environment (*Kabinet teorie architektury a životního prostředí*, KTAŽP) 35–7, 43
Der Freischütz (Max Weber) 203
Deroko, Aleksandar 62
Derrida, Jacques 72, 85
'Der Ursprung des Kunstwerkes' (Martin Heidegger) 71
Deutsches Architekturmuseum 157
developed socialism 19, 112–13
Dévényi, Sándo 58
Devisenhotels 209
dialectical interpretation 34
dialectical materialism 34, 35, 37
'dialectic of negation' (*dialektika otritsanniia*) 27, 28
Dietterlin, Wendel
 Architectvra 89
Diller, Elizabeth 146
disciplinary autonomy 92, 94
disenchantment 143, 144, 148, 181
Disney Land 54
diwaniyya 186
Dobogókő 57
Dobrzański, Wojciech 110 n.21
Docomomo 81
Dominikańska department store 193
Domus 67
double-coding 217, 233, 234
Dovlatov, Sergei 155
Doxiadis, Constantinos 184
duck 180
Dulánszky, Jenő 52
Duverger, Heriberto 135–6
Dvořák, Bohuslav 39–40, 233

'Earth Architecture' 69
East Asia 3

Eastern Europe 7, 83, 181, 228
 late socialism 4, 5
East Germany 198, 199
Ećimović, Dejan 62
Ecochard, Michel 184
Edinburgh 58
Eisenman, Peter 156
Eisenstein, Sergei 71
Eisler, John 164, 166, 169, 177 n.10
EKE Projekt 113–14, 115
Ekler, Dezső 58
Élet és Irodalom 54
'Emonska vrata' 74
environment 6, 19, 51, 74, 92, 114, 115, 123, 131, 133, 137, 174, 230
 human 44 n.1
 living, humanizing 9, 33–46
 man-made 44 n.1
 natural 37, 44 n.1
 physical 44 n.1, 218
 psychological 44 n.1
 social 25
 urban 101, 159 n.18
 visual 192
environmental monotony 40
environmental psychology 39
'Environment Through A Myth' (Vilen Künnapu) 115
Erickson, Arthur 185
Erlebnis, Kunstwerk und Wert. Vorträge zur Ästhetik 1937–1967 (Roman Ingarden) 72
Erskine, Ralph 163–4
Escape from Freedom (Erich Fromm) 71
Escuela Primaria Volodia, Havana 135–7
Estetika 177 n.14
Estonia 7, 111–27
 collective farms 2, 3, 9, 111–27, 232, 233
 EKE Projekt 113–14, 115
 KEK construction offices 113–14
 late socialism 4
 postmodern architecture 111–27
Étienne-Louis Boullée 68

Exhibition House on the Grounds of the Museum of the Twentieth Century, An (Belov and Kharitonov) 146–7, 152–5

Facteur Cheval 85
Faculty of Architecture 67
 Belgrade 62, 67, 72, 74, 83, 90, 95 n.10
 Postgraduate Housing Studies 77 n.6
 Tallinn 114
Fathers and Sons (Ivan Turgenev) 144
Federal Committee for International Cultural Exchange (Yugoslavia) 69
Ferraris, Maurizio 74
Fiatalok (Youngsters) 53, 58
Fidel Castro 138
Filippov, Mikhail 147
Film als Kunst (Rudolf Arnheim)
fine arts 31 n.34
Finnish National Romantic movement 57
Fintas Centre 190
First World 3, 5–7, 10, 11, 93, 131, 168, 173, 175, 204, 227
Flower store, Tallinn, Estonia 116–18
Focillon, Henri 73
Folk art camp house, Nagykálló 58, 59
Fondements d'une sociologie de la quotidienneté (Henri Lefebvre) 73
Foreign Trade Organization (FTO) Polservice 183
Foster, Norman 81, 157
Foucault, Michel 85
'Four Modernizations' campaign 211–12, 214
Frampton, Kenneth 86, 163
Francastel, Pierre 73
 Art et technique aux XIXe et XXe siècles 71
Frankfurter Allgemeine Zeitung 202
freedom of expression 101
Fromm, Erich
 Escape from Freedom 7

functionalism 19, 20, 36, 41–3, 50, 85, 114
 architectural standardization 40
 bourgeois 35
 neo-functionalism 115
 pseudo-functionalism 38, 42
 Riabushin's critique of 27–8
 scientific-technological rationality of 33
functionalist modernism 94
Funeral home, Farkasrét, Budapest 56
Futile Trowel: The Doctrine and Practice of the Brotherhood of Golden (Black) Numbers, The (Bogdan Bogdanović) 83
'Future of New Belgrade, The' 83
Future Shock (Alvin Toffler) 217

Gaudí, Antoni 61 n.28, 85
Gehry, Frank O. 81
General Drafting System (GDS) 190
'Genesis of the Architecture of Postmodernism in the USSR, The' (Mikhail Tumarkin) 29
genius loci 121
Gens, Leo 115
GEO (later Gulf Consult) 183
German Democratic Republic (GDR, East Germany) 8, 10, 198–210, 233
Gerry, Frank 156
Gesamtkunstwerk 55
Ghazi Sultan 185
Giedion, Sigfried 72, 144
Gierek, Edward 101, 105
Girón system of prefabrication 138
Glancey, Jonathan 58
glass reinforced concrete (GRC) 189
Glazychev, Viacheslav 23, 24, 29
Gleń, Włodzimierz 183
global interconnectedness 7
Gnedovskii, Iurii 25
Goetheanum 55
Goldberger, Paul 19, 211, 214
'Golden Home, The' 114
Gorbachev, Mikhail 17
Government House of the Russian Soviet Federative Socialist Republic 22
Građevinska knjiga 64
Grand Hotel, East Berlin 198, 204–6, 208–9
Gran Hotel de Varadero 138
graphic city (*ciudad gráfica*) 135
Grassi, Giorgio
 'Avant-Garde and Continuity' 66
Graves, Michael 148
gray period (*quinquenio gris*) 130, 131
Graz Steirischer Herbst festival 63
Greece 200
Greenberg, Clement 86
Grlić, Danko 71
Groys, Boris 173
Gründerzeit 203
Guardian, The 58
Guerra, Lillian 130, 141 n.13
Gulf Engineering Office (GEO) 182
Gumanizm sovetskoi arkhitektury (The Humanism of Soviet Architecture) (Aleksandr Riabushin) 27
Gurawski, Jerzy 107
Gzowska, Alicja 9, 98

Habana del Este 134
Hansen, Oskar
 Linear Continuous System 5
Hansen, Zofia
 Linear Continuous System 5
Harrison, Wallace 229, 230
Heidegger, Martin 37, 70, 72, 148
 'Der Ursprung des Kunstwerkes' 71
 'Wozu Dichter?' 71
Heimatgefühle 208
Hejduk, John 164
Helsinki 57
Hersey, John
 Lost Meaning of Classical Architecture, The 89
Herzog, Jacques 157
high modernism 2, 11 n.1, 82, 95 n.6
Hilton Hotel, Budapest 203
Hiroshima 208
Hirsh, Max 10, 198
Hnídková, Vendula 167
Holzwege 71
Honzík, Karel 35

Hotel Bellevue, Dresden 198, 200, 202–4, 206, 207
Hotel Melia Santiago de Cuba 128–9, 138
Hotel Merkur, Leipzig 199
Hotel Monterey Kobe 206–7
house factory technology 50
'House of Winnie-the-Pooh, The' (Brodsky and Utkin) 148–51
housing diversity 41
'Housing Problems' (Iľja Skoček) 34
Hryniewicz, Wacław 105
Hubáček, Karel 166, 169, 172
Human Condition, The (Hannah Arendt) 144–5
human environment 44 n.1
Human Use of Human Beings, The (Norbert Wiener)
Hungary 47–61, 181
 critical regionalism 54–9, 189
 folk culture 47, 48
 organic architecture 54–9
 prefabricated housing 3, 7, 9
 spontaneous architecture (*spontán építészet*) 50–1
 Strip House 5
 Tulip Debate 48–54
Hussein, Saddam 185
Husserl, Edmund 36, 37
 Idea of Phenomenology – Five Lectures, The 72

IBA apartment block, Berlin 163–6
idealism 55, 144
 transcendental 36
Idea of Phenomenology – Five Lectures, The (Edmund Husserl) 72
ideological efficacy (*ideovost*) 38–40, 42
Ikonnikov, Andrei
 Arkhitektura SShA (Architecture of the USA) 21
India 184
Industrial & Engineering Consulting Office (INCO) 183, 188
influence 7, 33, 36, 42, 44, 55, 57–9, 94, 103, 105, 121, 130, 136, 137, 140, 175, 212, 216, 218, 219, 222

Ingarden, Roman
 Erlebnis, Kunstwerk und Wert. Vorträge zur Ästhetik 1937– 1967 72
Inoue, Takeshi 200
Institute for Development Planning of the City of Belgrade 75
Institute of Architecture and Urbanism of Serbia (IAUS) 67, 74
Instituto Superior Politécnico 'Jose Antonio Echeverría' (CUJAE) 131
instrumental rationality 82, 90
intellectual pluralism 47
International Academy of Architecture 81, 94 n.2
International Conference Center, Kyoto 215
Internationale Bauausstellung-Berlin (IBA), Berlin 1978–87 10, 163–6
International Trade Center, East Berlin 199
International Union of Architects 42
Introduction to Architectural Analysis I (Branislav Milenković) 73
Iraq 192
irrationality 155
Iskustva prošlosti (Miloš R. Perović) 75
Isola Tiberina 'La Nave di Pietra' 70
Isozaki, Arata 163
Iunost' (*Youth*) 146
Iveković, Rada 74
Izgled 66

Jacobs, Jane 99, 102, 103
 Death and Life of American Cities, The 215
Jacobsen, Arne 184
Jacobson, Roman 71
Jameson, Fredric 2, 3, 71, 74, 98, 169, 175, 165, 218–19, 231
 Postmodernism and Cultural Theory 219
Jankovics, Tibor 52
Janson, H. W. 64

Japan 2, 7, 30 n.7
 afterlife of socialist postmodernism in 198–210
 architectural exchanges with GDR 198–210
Japan Architect (JA) 10, 146, 147
Japanese Palais 203
Japan-GDR Project Committee (JGPC) 199
Jarząbek, Wojciech 105, 182, 183, 185, 190, 191, 193
Jasenovac Memorial Park, Jasenovac, Croatia 91
Jencks, Charles 2, 67, 72, 99, 165, 181, 211, 214, 217, 228
 Language of Post-Modern Architecture, The 19, 28, 173, 174, 216
 'Post Modern History' 69
Jinqiu, Zhang 219, 220
Johnson, Philip 29
Judaism 144
JUGINUS (Yugoslav Institute for Urbanism and Housing) 66–7, 74
Jugoslavija 64
Junior Studio 52
Jürgen Habermas 71
 'Modern and Postmodern Architecture' 69

Kaasik, Veljo 114
Kabakov, Ilya 155
Kádár, János 51
Kádár Cube 51
Kafka, Franz 155
Kahn, Louis 115, 172
Kajima 199–206, 208
Kalajić, Dragoš 69
Kalinovskii, Gennadii 155
Kant, Immanuel 151
Kasumigaseki Building, Tokyo 199–200
Kazakhstan 43
KEK (Kolhooside ehituskontor) construction offices 113–14
Keswick, Maggie 216
Keswick, Sir John 216
Khait, Vladimir 7, 18–21, 23, 28, 29, 116, 123, 233

'Post-Contemporary Architecture – Minuses and Pluses' 18
'Problem of the Relationship to the Architectural Experience of Capitalist Countries, The' 23
Kharitonov, Maksim 147, 157
 Exhibition House 152–5
Khazanov, Mikhail 158 n.13
Khazanova, Vigdaria 146
Khitruk, Fedor 151
Khrushchev, Nikita 26, 42, 108 n.4, 230
 pivotal critique of Stalinist architecture 33
Kingo, Tatsuno 207
Kirov Experimental Fishery, Viimsi, Estonia 126 n.13
Kirpichov, Vladislav 159 n.24
Kistelegdi, István 52
Kleihues, Joseph Paul 167
Klein, Lidia 9, 98
Klotz, Heinrich 157, 173
Kobe 206
Kodály, Zoltán 53
Kodres, Krista 124
Koetter, Fred 72
Kołakowski, Leszek 71
Kollhof, Hans 157
Komisja Episkopatu Polski (The Commission of the Polish Episcopate) 104
Komunikacija 68, 69, 74
Koolhaas, Rem 86, 163
 Delirious New York 156
Kós, Károly 53, 55, 58
Kosenkova, Iulia 20
Kosygin reforms 112
Koželj, Janez 70
Krauss, Rosalind 92–3
Krawecki, Janusz 183
Krier, Leon 114, 164
Krivý, Maroš 9, 33, 174
Kuba Snopek
 Belyayevo Forever: A Soviet Microrayon on Its Way to the Unesco List 159 n.18
Kučera, Jiří 173
Kuhn, Thomas 71
Kulev, S. I. 25

Kulić, Vladimir 1, 81, 227, 232, 234 234
Kultermann, Udo
 Contemporary Architecture in Eastern Europe 3
'Kultura' 71
Künnapu, Vilen 114–23, 126 n.22, 233
 'Environment Through A Myth' 115
Kurg, Andres 9, 111
Kurismaa, Mari 116, 120
Kurokawa, Kisho 29, 146
Kuwait 181–93
 Kuwait Engineering Office (later the Kuwait Engineering Group, or KEG) 183
 Kuwait Law Courts, Kuwait 185
 Kuwait Public Transport Company 188
 Kuwait's Stock Exchange, Kuwait 190
 Kuwait Urbanization (Saba Shiber) 185
 National Housing Authority (NHA) 186, 190
 Polish architectural exports to 10
 technologies 189–91
 urbanities 184–9

Labazov, Mikhail 159 n.24
labour of adaptation 189
Lach, Edward 182, 190, 191
Laekvere sovkhoz administrative and cultural building, Estonia 122–3
Lakomý, Zdeněk 44 nn.3, 5
 Civilization at the Crossroads 36
 as director of KTAŽP 35
land art 92
Language of Post-Modern Architecture, The (Charles Jencks) 19, 28, 173, 174, 216
La pensée sauvage (Claude Lévi-Strauss) 71
Lapin, Leonhard 124
La Poétique de l'Espace (Gaston Bachelard) 72
L'Architecture d'Aujourd'hui 67, 99

L'architettura della città (Aldo Rossi) 70
La révolution urbaine (Henri Lefebvre) 73
Larin, Aleksandr 21, 22
late capitalism 2, 4, 63, 87, 94, 98, 108, 165, 169, 173, 175, 176, 219, 232
late socialism 1–6, 46 n.44, 63, 98, 231
 cultural feedback loops of 163–79
 and paper architecture 146–7
 theory of architecture 33–46
Latin America 130
'L'Œil et l'esprit' (Maurice Merleau-Ponty) 73
League of Nations 228
Learning from Las Vegas 99, 137
Lechner, Ödön 53, 55
Lefebvre, Henri 37, 71
 Contribution à l'esthétique 73
 Critique of Everyday Life/Critique de la vie quotidienne 73
 De la modernité au modernisme: Pour une métaphilosophie du quotidien 73
 Fondements d'une sociologie de la quotidienneté 73
 La révolution urbaine 73
 Study of Architectural Program Principles in Relation to Other Disciplines of the Science of Space 73
Leipziger Messe 200
leisure environment 206
Lenin, Vladimir 213
Lenin on the Cinema Yara on La Rampa 135, 136
Lévi-Strauss, Claude 71
Lezhava, Ili'a 146, 152
Libya 192
Lichtenstein, Roy 133
Liebeskind, Daniel 156
Lincoln Center, New York 229
Linear Continuous System (Oskar and Zofia Hansen) 5
linguistics, politics of 87–93
Lipski, Zdzisław 100
Lissitzky, El 227, 229, 230
Little House-Sprit Kuzia 143

living environment 9, 33–46
Loegler, Romuald 102, 107, 110 n.21
Logic of Sense (Giles Deleuze) 157
Lomakin, Vladimir 158 n.13
Lõoke, Marika 114
Lost Meaning of Classical Architecture, The (John Hersey) 89
Lotus 67
Loudová, Jiřina 174
Lynch, Kevin 40, 84, 85
Lyotard, Jean-François 72, 74, 228, 232
 Postmodern Condition, The 227

MacFarlane, Peter 184
McKittrick, Katherine 140–1 n.2
McLeod, Mary 2
McLuhan, Marshall 177 n.14
Magyar Építőművészet 57
Main Office of Urban Planning (Centralny Urzad Planowania Przestrzennego) 99, 105
mainstream modernism 55
Major, Máté 54
Maki, Fumihiko 146
Makiya, Mohamed 185
MAKONA 57
Makovecz, Imre 55–8, 233
 Hungarian Pavilion 58
Maldini, Slobodan 62
Malevich, Kazimir 227
Mali urbanizam (Small Urbanism) (Bogdan Bogdanović) 64
Mandel, Ernst 231
Mandel, Luis Lápidel 137
man-made environment 44 n.1
Mao Zedong 4, 212
Marksizam u svetu 71, 73
Marshall Plan 231
Martin, Reinhold 10–11, 82, 226
Martínez, Olivio 133
Marx, Karl 176, 213
Marxism 36
 and phenomenology 36, 72
Marxist humanism 44
Marxist-Leninism 130
Marxist versions of modernity 145
Mary Queen of Peace Church, Wrocław-Popowice 105

Masák, Miroslav 166
Mašić, Slobodan 64
mass housing 2, 9, 48–54, 100–2, 114, 139
mass production 33, 50, 55, 101, 107, 108
Matkowski, Jan 105
Mayakovsky, Vladimir
 'The Unfinished' 144
Mazda 199
MEČ 62, 66, 69, 70, 95 n.10
 Urbana kuća 95 n.9
medieval culture 55
Meier, Richard 163, 169
mental mapping method 40
Merleau-Ponty, Maurice
 'L'Œil et l'esprit' 73
Merzbau (Kurt Schwitters) 85
Meuron, Pierre de 157
Mexico 138
Meyer, Richard 146
Microbrigades – Variations of a Story 142 n.17
Middle East and North Africa 109 n.19
Middle East Construction 185
Milenković, Branislav 74
 Introduction to Architectural Analysis I 73
Mel'nikov, Konstantin 149
Miljački, Ana 10, 163
Milne, A. A. 151
Milošević, Slobodan 81, 89
Ministry of Construction and Construction Materials Industry (Ministerstwo Budownictwa i Przemysłu Materiałów Budowlanych) (Poland) 99
Minoprio, Anthony 184
Mitsubishi 199
Mittag, Günter 199
'Mladost' Zagreb 71
'Modern and Postmodern Architecture' (Jürgen Habermas) 69
modernism 7, 43, 48–50, 53–5, 59, 64, 81, 86, 87, 92, 109 n.7, 131, 176, 200, 215, 226, 227, 229
 anti-modernism 165
 architectural 47, 52, 54, 214

functionalist 94
high 2, 11 n.1, 82, 95 n.6
industrial 59 n.1
neo-modernism 214
real existing 182, 194 n.9
routinized 50
Scandinavian 114
socialist 2, 62, 200
Third World 130
in the USSR 17–32
modernist urbanization 148
modernity 82, 95 n.8, 130, 133, 139, 140, 140 n.2, 155, 157, 230, 234
 capitalist 52
 Maoist notions of 219
 Marxist versions of 145
 postmodernity 140, 214, 226, 233
 social 47, 50
 socialist 10, 47–61, 83
 urbanized 148
Moles, Abraham 40
Molnár, Virág 9, 47
Mondadori 64
monotony 35, 40–1, 43, 44, 48, 50, 53, 64, 99, 101, 103, 139
 environmental 40
Moore, Charles 29, 99, 105, 108, 146, 163, 164, 173, 211
Moscow Architecture Institute (MARKhI) 23, 146
Mrtvouzice: Mentalne zamke staljinizma (*Dead Knots: The Mental Traps of Stalinism*) 89
MS 71 170
multiculturalism 43
Museum of Contemporary Art 70
Museum of Finnish Architecture 70
Musić, Mustafa 62, 67
mysticism 55
myth 86, 115, 119, 123, 124, 156, 227, 232

Nabokov, Vladimir 155
Nagasaki 206
Na Jedlově (At Jedlová) 166
Na Skarpie housing estate, Kraków 110 n.21
National Football Hall of Fame, New Brunswick, NJ 170, 172

nationalism 4, 81, 135, 141 n.11, 174, 232, 234
natural environment 37, 44 n.1
natural world, living environment and 36–7
Nekrasov, S. I. 25
neo-functionalism 115
neo-modernism 214
New Directions in American Architecture (Robert A. Stern) 214–15
New Element of Settlement, The (NER) 146
'New School, The' 72, 90
Nippon Steel 199
Nixon, Richard 4
Nolit 72
Non-Aligned Movement 6
nonsense versus absurdity 157
Norberg-Schulz, Christian 72, 73–4, 121
normalization 1, 4, 113, 166, 167, 169, 174
Norstein, Juri 155
North America 17, 226
 postmodern architecture 48
North Ursynów estate, Warsaw 102–3
Northwest Institute of Architectural Design and Research Shaan'xi Museum of History, Xi'an, Sha'anxi 219, 220
Nouvel, Jean 81
Nova 74
Novi Sad 71
Nový, Otakar 36, 168

OBERIU 155
October Collective Farm, Peetri, Estonia 119–20
Off the Beaten Track (Martin Heidegger) 71
OISTAT (The International Organization of Scenographers, Theatre Architects, and Technicians) 146
Okas, Jüri 114
Old Town (Tallinn) 116
oneiric 8, 147, 151

Ong, Aihwa 190, 192
organic architecture 54–9
organic eclecticism 58
ornament 1, 3, 9, 47–61, 83, 89, 92, 168, 181, 189, 190, 203, 206, 222
 role in mass housing construction 48–54
Országépítő 57
Ortiz, Fernando 129, 140
 Cuban Counterpoint: Tobacco and Sugar 132
Ostalgie 235
Otaka, Masato 148
Otto Wagner's School exhibition 69
Ourečký, Jaroslav 173
Ovsiannikov, Viacheslav 158 n.13

P2.11 construction system 41–2
Paetzold, Heinrich 74
Pakistan 184
Palladio, Andrea 66, 152
Pan-Africanism 234
paper architecture 2, 3, 10, 59 n.1, 145–8, 151, 152, 156, 157
Paris 63, 81, 85, 146, 205, 232
 La Villette 69
Pärnu 113–15
Partisan Cemetery, Mostar, Bosnia-Herzegovina 92
pastiche 104, 221, 234
Patočka, Jan 8, 36
Pavlov, Leonid 21, 22
Pécs 52, 58
 Pécs Group 52–5, 58
 Pécs Planning and Architectural Office (*Pécsi Tervezővállalat*) 52
Pejović, Danilo 71
Perestroika 17, 29, 112, 122
Perović, Miloš R. 75, 86, 90
Pharmacy No. 375, Moscow 21, 22
phenomenologico-psychological disorientation 40
phenomenology 35–8, 44
 architectural 8, 36–7, 63, 70, 73–4
 Marxism and 36, 72
Phenomenology (Milan Damnjanović) 72

physical environment 44 n.1, 218
Piaget, Jean 71
Piano, Renzo 157
Pietilä, Raili 184
Pietilä, Reima 57, 184
Pintér, Béla 203
Pisani, Mario
 Tendenze nell architettura degli anni '90 81
plantation (as theoretical lens) 130, 132–4, 138, 140, 140–1 n.2
Plattenbau, house-spirit in 143–59
Plečnik, Jože 64
Podrecca, Boris 63, 70
Polak, Nikola 70
Poland 9, 98–110, 180–93
 architectural exports to Kuwait 10
 church architecture in 104–8
 housing architecture in 100–2
 International Conference on Socialist Realism (1985) 42
 Linear Continuous System 5
 Ministry of Construction 182, 232
Polet: Journal of the Association of Socialist Youth of Croatia 66
Polianskii, Anatolii
 as secretary of the Union of Soviet Architects 24
Polis 66
Polish People's Republic 99
political futurism 43
politics of linguistics 87–93
Polja 71
Polservice 183
Popović, Koča 85
Portoghesi, Paolo 63, 70, 81 83, 165
Posokhin, Mikhail 24, 25
'Post-Contemporary Architecture – Minuses and Pluses' (Riabushin and Khait) 18
postmodern aesthetics 44
Post-Modern Classicism 67
postmodern collective farm centres 119–23
Postmodern Condition, The (Jean-François Lyotard) 227
Post Modern in Belgrade exhibition 69

Postmodernism and Cultural Theory (Fredric Jameson) 219
postmodernity 140, 214, 226, 233
Postmodern Visions (Heinrich Klotz) 173
post-oil urbanization 180, 181, 185, 188, 190
post-revolutionary architecture
 debating 217–21
 defined 213–17
(post)socialist postmodernism 5
Potůček, Jakub 168
power 130–2
Prague Spring 4
Praxis 71
prefabricated housing 2–3, 7, 9, 47, 48, 203
 elements of 53
 MS 71 170
 transforming 132–6
prefabricated panel construction technology 50
preservation, architectural 58, 184, 185, 201–3, 209
Přikryl, Emil 164, 166, 169, 173
'Problem of the Relationship to the Architectural Experience of Capitalist Countries, The' (Vladimir Khait) 23
Production of Space, The (Henri Lefebvre) 73
profane illumination 82
Protestantism 144
Protić, Miodrag 86
Pruitt-Igoe housing complex, St. Louis 3, 19, 215
pseudo-functionalism 38, 42
pseudo-humanistic psychology 38
psychological environment 44 n.1
psychology 35, 39–40, 86
 environmental 39
 pseudo-humanistic 38
Purini, Franco 70
pyramid-roof house (*sátortetős ház*) 51
Pyshkin, N. I. 25

Quijano, Carlos 141 n.8
Quintana, María 138

Radio Belgrade Program 3, 73, 77 n.4
Radogoszcz-Wschód housing estate, Łódź, Poland 100, 101
Radović, Ranko 62, 64, 72
 editorship 68
Ragon, Michel
 Where Shall We Live Tomorrow? 37
Railway Terminal, Santiago de Cuba 138
Rajniš, Martin 164
Rasmussen, Steen Eiler 73
rationality 115
 instrumental 82, 90
 irrationality 155
 overt 83
 scientific-technological 33
 techno-scientific 37
Ravnikar, Vojteh 70
Reaganism 2
real existing modernism 182, 194 n.9
real socialism 41–2
Red Vienna 167
re-enchantment 82, 144, 146, 152, 157
Rein, Toomas 114, 123
rejection of modern rigidity 101
religion 144
Remodel of Queen Natalija's Villa, Smederevo, Serbia 83, 84
Research Institute for Building and Architecture (*Výzkumný ústav výstavby a architektury*, VÚVA) 35
residential construction 50, 113
retro-problem 17–32
Revzin, Gregory 148, 152
Riabushin, Aleksandr 7, 13 n.19, 18–24, 26–9, 41–3, 116, 123, 233
 as chairman of 'Theoretical Club' 19
 Gumanizm sovetskoi arkhitektury (The Humanism of Soviet Architecture) 27
 'Post-Contemporary Architecture – Minuses and Pluses' 18
 as Secretary of the Union of Soviet Architects 19, 20, 41

Richta, Radovan 36
Richter, Vjenceslav
 Sinturbanizam 5
Rigol, Jorge 138
Ristić, Marko 85
Rivera, Alfredo 10, 128
Rizzoli 64
Rogers, Richard 157
romanticism 143
Roskam, Cole 10, 211
Rossi, Aldo 8, 13 n.24, 63, 70, 81, 84, 86, 114, 119, 164, 165, 219
 L'architettura della città 70
Rotterdam 58
routinized modernism 50
Rowe, Colin 66, 72
Rozanov, Evgenii 24
Rozenfel, Zinovii 21
Ruble, John 163
Rudofsky, Bernard 72

Sabah Al-Salem 185, 189
St Mary Queen of Peace, Wrocław-Popowice, Kuwait 183
Salama, Salah 190
Salhia Complex, Kuwait 190
Salon of the Museum of Contemporary Art, Belgrade 69, 75
Sapporo 206
Sarajevo 70
Sárospatak 56
Saussure, Ferdinand de 71
Savio, Isabel Rigol 137
'Sazvežđa' 71, 72
Schwitters, Kurt
 Merzbau 85
scientific-technological rationality 33
Scofidio, Ricardo 146
Scott, James C. 11 n.2
Scott-Brown, Denise 84, 85, 100, 116, 170, 180, 185
secessionism 55
Second Vatican Council 105
Second World postmodernism 1, 6–8, 10, 82, 94, 165, 173, 175, 227, 228, 233, 235
Second World Urbanity 12 n.15
Second World War 54, 63, 71, 81, 83, 124, 202, 203, 234

secularization 107
Sedláková, Radomíra 41–3, 46 n.30
Segre, Roberto 133, 137
 Arquitectura y Urbanismo Modernos: Capitalismo y Socialismo 131
Šein, Harry 114
self-incurred immaturity, anti-architectures of 143–59
semiotic objectivity 39–40
semiotic overload 40
semiotics 9, 35, 39–40, 87, 130, 132–7, 233
Serbia 81–97
 architect's library 63–70
 architectural discourse of postmodernism in 62–78
 Belgrade 9, 62–78, 81–5, 90, 95 n.9, 181
 Smederevo 83, 84
 University of Belgrade 62, 64, 72, 73, 90
Ševčík, Jiří 40
Ševčikov, Jiří 174
Ševčikova, Jana 174
Shaanxi Museum of History 219
Shiber, Saba
 Kuwait Urbanization 185
Shiber, Saba George 183
Shiber, Victor 183
Shiber Consultants 183, 186
Shimokobe, Atsushi 148
Shinkenchiku Residential Design competition 63, 146
Shukurova, A. 26–7
SIAL, Liberec 165–7, 169, 173
signs versus super-signs 41
Sinturbanizam (Vjenceslav Richter) 5
Sinteza 67
Sirimavo Bandaranaike Memorial International Conference Hall, Colombo, Sri Lanka 215
Sirp ja Vasar 115, 116
SITE 68
Skidmore, Owings and Merrill (SOM) 184
Skoček, Il'ja 33–34, 44
 'Housing Problems' 34
Školka 167–9, 177 n.11

Slavic languages 7
Slobodište Memorial Park, Kruševac, Serbia 92, 93
Smith, C. Ray 174
Smithson, Alison 115
Smithson, Peter 115
social environment 25
socialist aestheticism 72, 86, 87
Socialist Federal Republic of Yugoslavia 63
socialist internationalism 43, 181
socialist modernism 2, 62, 200
socialist modernity 10, 83
 discontents of 47–61
socialist realism 8, 31 n.33, 33, 35, 39, 41–4, 44 n.5, 46 n.34, 52, 85, 86, 124, 174
 discursive networks of 231
 relationship with postmodernism 26
social modernity 47, 50
social productivity 40, 41
Solar Architecture exhibition 69
Solidarity movement 102, 107
Solopov, Egor 146
Solpol department store, Wrocław 193
Songs of Bilitis, The 95 n.12
SOOR Engineering Bureau 183
sotsart 147
Soviet Union 1, 6, 9, 10, 33, 86, 132, 228
 avant-garde 8, 146, 147
 late socialism 4
 modernism and postmodernism in 17–32
 Plattenbau, house-spirit in 143–59
 socialist realism 52
Soviet Woman 147
Sovremennaia arkhitektura 26
Special Period 4, 10, 128, 130, 138–40
Spencely, Hugh 184
spontaneous architecture (*spontán építészet*) 50–1
SSH 183
stagnation period 112
Stalin, Joseph 4, 8, 26, 89, 94
Stalinism 45 n.18, 52, 89
Stalinist architecture 26

Stambolić, Miloš 71
standardization 33, 34, 38, 40, 41, 53, 100, 101, 146, 159 n.18
Stanek, Łukasz 10, 180
State Art Institute 114, 115
Stavoprojekt 33
Steiner, Rudolf 55
Stern, Robert A. 108, 211, 214
 New Directions in American Architecture 214–15
Stirling, James 81, 99, 146, 164, 167, 170, 173, 185
Strada Novissima exhibition 1, 165
'Street of Memory' (Mustafa Musić) 67
Strip House (Elemér Zalotay) 5
Students Cultural Centre (SKC, Belgrade) 69, 70
Studio S12, 166
Study of Architectural Program Principles in Relation to Other Disciplines of the Science of Space (Henri Lefebvre) 73
Studio Strukture 64, 76
Suchomel, Jiří 164, 166, 169, 172, 177 n.12
Superstudio 5
Suq Dawliyah, Kuwait 186, 189
surrealism 82, 85, 86, 91, 94, 156, 157
surrealist postmodernism 81–97
 autonomy and criticality 86–7
 politics of linguistics 87–93
Suzuki, Daisetz T. 71
Švácha, Rostislav 167, 173
Syria 192
Szymanow, Michał 110 n.21

Tallinn School 111, 114
Tange, Kenzo 211
Teatro Olimpico 152
technical determinism 27
Technoexportstroy 184
techno-science 36–8, 190
techno-scientific rationality 37
Tegel Harbor, Berlin 164
Teige, Karel 35
Tendenze nell architettura degli anni '90 (Mario Pisani) 81

Thames and Hudson 64
The Architects Collaborative
 (TAC) 184
Theater for Future Generations 146
theatre of the absurd 151–7
Theoretical Club 19
theory of place 73
Thinking and Singing (Martin
 Heidegger) 72
Third Wave, The (Alvin Toffler) 217
third way 102–3
Third World 6, 42, 130, 131, 137,
 175, 227, 228, 234
Third World modernism 130
Three Generation of Belgrade Builders
 exhibition 95 n.9
Through the Looking-Glass (Lewis
 Carroll) 155
Tito, Josip Broz 1
 death of 4, 63
Toffler, Alvin
 Future Shock 217
 Third Wave, The 217
totalitarian paradigm 6
totalitarian politics 6, 52
*Tradition and Identity – Architecture in
 Finland* exhibition 70
transcendental idealism 36
transculturation 129–32
translatability 174
Transylvania 57
Treier, Heie 111–12
Trifunović, Lazar 86
tropical architecture 189
tropical socialism 137–40
truthfulness (*pravdivost*) 39
Tschumi, Bernard 86, 157
Tulip Debate 9, 49, 48–54
Tulip-Houses 48–54
Tumarkin, Mikhail
 'Genesis of the Architecture of
 Postmodernism in the USSR,
 The' 29
Turgenev, Ivan
 Fathers and Sons 144
typification 33, 34, 38, 174

Ugljen, Zlatko 70
Umění a řemesla 173
undeveloped socialism (*bufada de
 shehui zhuyi*) 213
Ungers, Oswald Mathias 86
'Unfinished, The' (Vladimir
 Mayakovsky) 144
Union of Architects Youth
 Section 114
Union of Soviet Architects 19, 20,
 41, 147
United Kingdom 184, 190, 228
United Nations 227–30, 235
United Nations Charter 228
United Nations Security Council 229,
 230, 234
United States (USA) 2, 6, 49, 115,
 130, 131, 137, 147, 184, 190,
 212, 228
University of Belgrade 62, 64, 72,
 73, 90
University of Göttingen 72
Unt, Mati
 'Werewolf on Cattle Street, A'
 116
Uran, Česká Lípa, 1975–92 169–72,
 174, 175
urban environment 101, 159 n.18
urbanist-populist discourse (*népi-
 urbánus vita*) 49–50
urbanization 112, 183, 184,
 189
 capitalist 40
 modernist 148
 post-oil 180, 181, 185, 188, 190
urbanized modernity 148
Urbanowicz, Jan 183
USSR *see* Soviet Union
Utkin, Il'ia 145–8, 151
 'The House of Winnie-the-
 Pooh' 148–50
Utzon, Jørn 184

Vago, Joseph 228
Vándoriskola 57
Vanna Venturi house,
 Philadelphia 211
Vattimo, Gianni 74
Venice 63
Venice Architecture Biennale 1
Venice Biennale 58

Venturi, Robert 11, 81, 84, 85, 98, 99, 114–16, 170, 173, 180, 185, 211
 Complexity and Contradiction in Architecture 21, 174
vernacular architecture 9, 42, 43, 48–51, 57, 59, 123, 181, 185, 186, 189, 228, 231, 234
Veselý, Dalibor 8, 36–7, 85–6
Vidici 71
Vidler, Anthony 147
Vienna 70, 157
Vietnam War 90
V. I. Lenin Museum, Moscow 21, 22
Viljandi 112–13
Villa Müller, Prague 167
Villa Panamericana, Havana 139–40
visual environment 192
Vodopivec, Aleš 70
Vokač, Dalibor 164
völkisch ornament 3
Vronskaya, Alla 10, 143
Vujica, Vesna 62
Výtvarna práce 177 n.14

Water Architecture exhibition 69
Weber, Max 143–4
 Der Freischütz 203
Wei Dazhong 219, 221
'Werewolf on Cattle Street, A' (Mati Unt) 116
West Berlin 10, 165
Western art markets 5
Western Europe 2, 17, 58, 147, 226
 postmodern architecture 48–50
West Germany 3, 200
Where Shall We Live Tomorrow? (Michel Ragon) 37
whiteness 7
Wiener, Norbert
 Human Use of Human Beings, The 71
Winnie the Pooh and Piglet 151
Wiśniowska, Anna 183, 188
Wiśnowski, Krzysztof 182, 183, 185

Wohnpark Victoria 167, 168
Wojtyła, Karol 107
World Architecture 81
World Bank 227
World Congress of Architecture 141 n.4
'Wozu Dichter?' (Martin Heidegger) 71
Wright, Frank Lloyd 55
Wrocław Polytechnic 182, 183
Wujek, Jakub 100

Xiao Tong 217

Yang Yun 211, 215, 216, 233
Ybl Prize 56
Youth Recreation Center, Haining, Zhejiang 219, 220
Yoyogi National Gymnasium, Tokyo 211
Yudell, Buzz 163
Yugoslavia 1, 90, 181, 200
 Constitution of 1974 63
 history of publishing 9
 late socialism 4
 Non-Aligned Movement 6
 Sinturbanizam 5
Yurchak, Alexei 4

Zagreb 70, 71, 74, 75, 83
Zakharov, Grigorii 23
Zalotay, Elemér
 Strip House 5
Zeilenbau 3
Zen Buddhism and Psychoanalysis 71
Zenit and the Avant-garde of the 1920s exhibition 74
Ziablikova, Aida 158 n.1
Zielone Wzgórza housing complex, Poznań 100
Živi prostor 65
životní prostředí 44 n.1
Zou Denong 222
Žutić, Stevan 62

www.ingramcontent.com/pod-product-compliance
Lightning Source LLC
Chambersburg PA
CBHW070027010526
44117CB00011B/1735